1993

Yale Publications in the History of Art

GEORGE HERSEY, *editor*

George Kubler

Esthetic Recognition of Ancient Amerindian Art

Yale University Press New Haven and London

Designed by James J. Johnson.
Set in Sabon Roman type by
The Composing Room of Michigan, Inc.
Printed in the United States of America by
BookCrafters Inc., Chelsea, Michigan.

Library of Congress Cataloging-in-
Publication Data

Kubler, George, 1912–
 Esthetic recognition of ancient
Amerindian art / George Kubler.
 p. cm.—(Yale publications in the
 history of art)
 Includes bibliographical references.
 ISBN 0-300-04632-4 (alk. paper)
 1. Indians—Art. 2. Indians—
Antiquities. 3. America—Antiquities.
I. Title. II. Series.
E59.A7K82 1991
704′.0397—dc20 90-35209
 CIP

The paper in this book meets the guidelines
for permanence and durability of the
Committee on Production Guidelines for
Book Longevity of the Council on Library
Resources.

10 9 8 7 6 5 4 3 2 1

IN MEMORY OF

Herbert Joseph Spinden 1879–1967

*Historian of art among anthropologists
and archaeologists since 1909:
Lecturer at the Institute of Fine Arts, New York*

AND

Donald Robertson 1919–1984

*Americanist among art historians
Professor at Tulane University*

I will postulate the esthetic impulse as one of the irreducible components of the human mind, as a potent agency from the very beginnings of human existence.

—R. H. Lowie, *Primitive Religion*

Contents

Contents

Contents

Illustrations

Where copyright credit is not specifically recorded, it is due solely to the museum or collection given as the location.

Preface

THE PURPOSE OF THIS WORK is to find how ancient American objects of esthetic value in the visual order have been considered since the Discovery by Columbus. Writers about ancient America are here selected for their ways of evaluating such products, rather than for their conclusions about them. The different bases for the gathering of data about the New World are defined.

These studies began in 1949 with a graduate seminar at Yale University for anthropologists and art historians on anthropological theories of art. Philip Dark, William Sturtevant, and the late Stephen Borhegyi were among the participants. It grew from a similar course in 1948–49 in Lima at San Marcos, for the Institute of Social Anthropology at the Smithsonian Institution. Among the participants then were José Matos, his future wife, Rosalia Davalos, Miguel Maticorena, and José Maria Arguedas. The focus then was more on ethnohistory than on esthetics. Texts for ethnohistory were still few.

Today esthetic discourse seems less pertinent than biographical indications of esthetics in experience. I did not return to the subject until 1980, with the thought that biography would be more rewarding than formal esthetics. Hence the many-headed character of this presentation became necessary, under a tripartite division as esthetics in experience, idealist esthetics from above, and experimental esthetics from below, reflecting the history of esthetic thought itself in a chronological chain of biographical detail from the Discovery of America to the present, as phenomenal (that is, experiential), philosophical, and experiment-oriented stages in the history

of esthetic thought. The second division, on esthetics from above, is the shortest, because of the completeness with which Antonello Gerbi treated the problem in 1955.[1]

To distinguish the activities of historians, archaeologists, and anthropologists is to distinguish among actions, things, and cultures. But many scholars and scientists have moved easily among history, archaeology, and anthropology since long before the emergence of such professions. It is in these professions where the dividing lines were drawn during the nineteenth century in universities and museums, following Kant's dissection of experience, whence we have the idea of the "pure" artist, the "pure" religious, the "pure" politician, and all the special vocations of modern time.[2]

The gray area between artifact and work of art was a problem resolved in this century by the statistical concept of the graded series between such polarities; no artifact is conceivable without art; no work of art can be divested of its function as a tool, and the interval between art and artifact is a graded series: there literally is art in every artifact and, vice versa, in every work of art there lies the shadow of an artifact or tool.[3]

Not included are important scholars and scientists alive at time of publication. The other condition (than being dead) of inclusion is that any writer about ancient Amerindia have some awareness of the relation of esthetics to the rest of history and be able to impart his awareness. For instance, William Henry Holmes published two essays on esthetics that are rarely mentioned, and Columbus wrote letters about the beauty of native life. By this token not every account is relevant to ancient Amerindian art. But any and all views discordant with those of the present are eligible for inclusion, as is customary in present-day historiography.

These seventy brief biographical soundings were chosen to portray the many paths of the human brain in the never-ending task of esthetic cognition. Its limbic system is the seat of reactions of pain and pleasure, the oldest part of the mammalian brain. Interpretations of the past change when the brain perceives change in the understanding of what happened. Actually what happened is harder to determine than what was thought about it. I write more about esthetic thought concerning Amerindia from 1492 to 1984 than about Amerindia itself of that era. Present-day change is beyond the defined scope by a restriction to the work of persons now dead.

Acknowledgments

WORK began in 1983 with retirement from teaching to continuing appointment at Yale University as Senior Research Scholar. Much of the writing was done at the Center for Advanced Visual Study at the National Gallery in Washington as Kress Professor (1985–86).

Opportunities to continue research and seminar study came at the University of California in Los Angeles as Arts Council Professor in 1988, and in 1989 as Visiting Scholar at the Getty Center in Santa Monica. In 1990 the Kennedy Professorship at Smith College made another seminar possible.

The writer thanks students and colleagues at these institutions, as well as Judy Metro and Lawrence Kenney at Yale University Press, for their help.

Esthetic Recognition of Ancient Amerindian Art

Introduction

WAYS OF WRITING a history of art are as various as the genera-
tions since Pliny the Elder. Yet the main topics—architecture,
sculpture, painting—remain the same, and they include every
craft. Local changes from century to century seem to be morphological,
and from culture to culture they seem ideological.

Different bases for the gathering of data about the New World may be
discerned in the historiography of ancient America. The first was as-
sembled in Renaissance travels and military actions (1492–1532). The
second data base was the work of church missionaries in converting and
resettling native peoples during the sixteenth century. The third was as-
sembled from native records by native and European historians in the
seventeenth century. The fourth includes opinions in the eighteenth and
nineteenth centuries about the worth of America to the world. In fifth place
the drawings and photographs by nineteenth-century travelers and ex-
plorers provided a new visual base of data. The sixth includes archae-
ological and anthropological research since the mid-nineteenth century.[1]
The seventh began in the 1830s with the esthetic recognition of ancient
American manufactures on historical principles, and the slow formation of
a hermeneutic system for the principal remains. Of this last stage the
beginnings appear in all preceding bases and periods.

Esthetic Speculations about and by Amerindian Peoples

Recent studies on pre-Conquest concern with esthetic problems may be drawn here into the study of the recognition of ancient American art. Miguel León-Portilla has defined the conception of art among ancient Mexican peoples by extracting from Sahagún's native informants their opinions in the sixteenth century on the historic origins of sculpture; on the ancient estimation of artists; and on the kinds of recognized artists. For these speakers that conjunction of practices and ideals known as *tol-tecáyotl*, or artistry, was historically associated with an older Toltec civilization in the Valley of Mexico at Tula, flourishing before A.D. 1300. In Náhuatl-language interviews, Sahagún's informants spoke of the artist (*toltécatl*) as having marked individual identity, a striving for excellence, and as being of moral worth. In addition to sculpture, other types of artistry were painting, pottery, and metalwork. The origin of artistry was ascribed to earliest times, when the calendar was invented, in ancient modes metaphorically named. "Flower and song" stood for symbolic knowledge; "lord of face and heart" signified the nature of humanity; "speaking with own heart" was concern with ideal forms; "the heart made godlike" alluded to divine presence in material things; "teaching the clay to lie" was to simulate appearances.[2]

On the mythological plane, a complex of attributes known as Quetzal-coatl (bird serpent) was worshipped at Cholula as god of arts, learning, and sciences as well as of abnegation of self, serving too as patron of divination and commerce.[3] All sources for Quetzalcoatl, however, synthesize colonial and precolonial traditions as a mosaic drawn from pictorial manuscripts and Spanish histories. Taken as history, no post-sixteenth-century text yields an account free from European interpretation.

Ancestral Figures

Today esthetic recognition for ancient American art remains incomplete. But if the conscious threshold is accepted as having been crossed from pleasurable awareness to concern with the place of ancient America in the history of world art the date would be 1841. Then the *Handbuch der Kunstgeschichte* by Franz Theodor Kugler was published in Stuttgart, and *Incidents of Travel in Central America* by John Lloyd Stephens appeared in

New York. Both concluded from visual evidence without knowing of each other's work that ancient American artifacts were unrelated to any tradition of Old World art,[4] rejecting those diffusionist fantasies that seek unconsciously or automatically to provide respectable Old World lineage for American cultural attainments rather than leaving them as homemade. Diffusionists defend ancient America as derivative, but they also reject its autonomy, and most of them have been concerned with the history of tools, which differs from the history of art as does the artisanate from the liberal arts.

The most useful trail through these five centuries of Americanist studies from stone tools to cosmic probes might join two epochs at 1841. This year marked the end of many generations of diminishing information. It also began a new age of humanistic study with Kugler and of archaeological exploration with Stephens. Both men had predecessors, but both saw more clearly than their preindustrial forebears the esthetic implications of the works they discussed. Both men's books were exploratory and both relied on similar philosophical and historical traditions for their conclusions.

For the first period (1492–1841) the principal writings may be divided as firsthand accounts of America and speculations without direct knowledge. In the second period (1841–1942) the main works are in anthropological science and humanistic history. The earliest deliberate and conscious history of the art of ancient America was Kugler's in 1841, but the earliest anthropological syntheses did not begin to appear until 1914–40.[5]

Indian Historians

Before 1650 most historians of Indian birth were descendants of the powerful families that had ruled in ancient America. Ixtlilxóchitl, himself a descendant of Nezahualpilli in Texcoco, listed eight of them,[6] most of whom had been schooled by Mendicant teachers. The existing corpus of ethnohistorical information about ancient America is mostly the work of such informants and historians.

For instance, Fernando de Alva Ixtlilxóchitl (c. 1568–c. 1648) depended on sources showing Texcoco in relation to Tenochtitlán. Born of Spanish and Indian parents, he descended from a family in power at Teotihuacán as followers of Nezahualcóyotl, who ruled at Texcoco in the fifteenth century.[7] E. O'Gorman notes that Ixtlilxóchitl referred to *Códice Xólotl*,[8] which is a series of changing maps of the same area showing

dynastic events in the valley from the arrival of Xólotl as first Chichimec ruler until the reign of Nezahualcóyotl.[9] Readers today find Ixtlilxóchitl's periodization more serviceable than many colonial efforts, once the adjustments are made to his phrasing and terms. On the other hand, his concern with esthetic questions is less prominent than that of other Indian historians.[10]

Conquistador and New Moses

It approaches reality (though it is incongruous with received ideas) to think of Hernán Cortés (the New Moses, as he was called by the Franciscans) in his letters as the first European writing about the beauty of Mexican life.[11] He saw it clearly; it was part of his rhetoric of persuasion with the emperor; and it was validated by other eyewitnesses. These declarations of esthetic enjoyment in foreign places, however, are far from approaching the critical analysis that characterizes most histories of art written since Greek and Roman antiquity.

The letters of Cortés show him as visually alert, having both perception and memory in exceptional degree, retaining events in unusually detailed impressions of places and things, noting arrangements of people and minute details of costume. At the first meeting with Moctezuma[12] in Tenochtitlán he describes swiftly what he could see of the regular plan and good construction. In Honduras, Cortés repeats his admiration of Indian skill and art.[13]

Having resided in the Caribbean islands, Cortés knew before the beginning of the invasion of Mexico that he must strengthen his power with the emperor by restraining the abuses of natives by Europeans. This would be best done in his opinion by placing Franciscan missionaries between the Spanish colonists and the Indians. In effect, Leo X authorized the Franciscan mission in August 1521, followed by Adrian VI, who entrusted the new Mexican Christians to the Mendicant orders rather than to the secular clergy.[14]

Missionaries

On review, the Mendicant conversion of Indians to Christianity achieved the esthetic recognition among them of European arts, through the church

schools founded in the sixteenth century. The missionary friars were formally requested by Cortés when he urged the emperor to confine "bishops and other prelates" to "divine offices and worship," and that friars be sent among Indians to build "houses and monasteries."[15] Cortés sought to create in European minds an ideal Indian type of "the clever and discreet Indian . . . singularly well endowed for art and industry"[16] even when denied the responsibilities of his birth in the overthrown governing class.

The history of the Mendicant conversions in New Spain is known from many points of view, all agreeing that the ultimate aim of the Franciscans was a millenarian vision of the Indian Church in America and of the friars as followers of the new Moses, who was Cortés.[17] This view was first codified by Fray Toribio Paredes de Benavente, or Motolinia, after 1555.[18] Motolinia's deep conflict with Las Casas anticipated the failure of Mendicant activity (clear after 1565) to create a church without bishops on a pre-Constantinian model.

Bartolomé de Las Casas (c. 1474–1566) wrote a rudimentary history of world art between 1552 and 1559.[19] His chapters place Old and New World arts in parallel comparisons serving to prove the rationality of Amerindian peoples. Las Casas's enemies among the Franciscans were less interested than he in the description of Amerindian manufactures. Thus Fray Andrés de Olmos, commissioned in 1533[20] to write a book about the antiquities of the Indians, actually wrote much more on witchcraft and sorcery in the tradition of the reformed Franciscans of the province of San Gabriel in Spain, where he assisted the future bishop of Mexico, Fray Juan de Zumárraga in 1527.

Fray Toribio de Benavente (c. 1490–1569), Motolinia, called Cortés "el príncipe y capitán general de la conquista cristiana" in 1529[21] in recognition of Cortés's design to introduce the Mendicants in New Spain, of his protection of their work, and of his shaping them into his structure of command.[22] Motolinia probably directed construction from its beginning at the new monastery of San Francisco in Mexico City in 1525–26 and in 1530–31 at Puebla.[23] This vocation is reflected in Motolinia's remarks on pre-Columbian architecture, written before 1543. Describing the double-temple Aztec pyramid at Tenayuca, he stresses its rectilinearity and terracing in language that reveals a struggle to define the design, such as *relejes* for the sloping profile, or batter, and *sobrados* for the lofty attics above the sanctuary chambers.[24] A long section[25] is in praise of Indian quickness to learn and master arts and crafts because of their "lively but bashful and

calm understanding, neither haughty nor indifferent, nor extravagant as among the peoples of other countries." The passage shows Motolinia writing of what he had seen and experienced on his many travels.

Fray Diego Durán (c. 1547–1587/8) learned Náhuatl as a child in Texcoco. His account is exceptionally rich in native expression, but none is used for its esthetic interest alone.[26] Fray Juan de Torquemada (1557–1624) began writing *Monarquía indiana* in 1591.[27] His instructions were to counter the bestial character given Indians in Spanish writings while narrating the Franciscan conversions and the history of Indian acculturation since Cortés. He was to use all oral and written and painted sources as well as make visits to ruins and monuments.[28] In retrospect, while the Mendicants promoted the recognition of Old World art by Indians, their work also prepared Indians to recognize the esthetic merit of the art of the New World before the Conquest.

Indianist Historians

By Indianists are meant those scholars, usually European or born in America, whose interests are mainly directed to ancient American Indian studies. Beginning after 1600 the clergy (both secular and monastic) and the civilian settlers began to think of the New World as their own country and of the Indians as converted to Christianity.

The Quarrel over America's Worth

While Americanist scholars toiled during the eighteenth century with antiquated ideas and unverified information, their writings became a debate over the stated superiority of the Old World to the New.[29] But this issue between defenders and detractors can at most points be reduced to a primitive esthetic argument as to the more and less pleasurable nature of the subject: is the New World less agreeable than the Old?

The emerging quarrel began as an esthetic revulsion. It was originally stated by Francis Bacon in *New Atlantis* (written 1622–24).[30] The thesis of an inadequate Nature in America was systematized by Buffon, extended by de Pauw, and continued by Kant and Hegel, on such topics as the absence of the largest land animals, the smallness of the American species, the hostility of nature, the sexual impotence of American humanity, the frigidity of the climate, and the newness of the environment. Amerindia was seen

as subsisting on a corrupt nature destroyed by floods and occupied by bestial degenerates who are natural slaves in a hostile climate.

The contrary argument in the writings of the champion of the New World, Clavigero, was based on the esthetic attractions to an American setting experienced by one born and reared there. Its ultimate defender was Herder, the philosopher of the history of man, who insisted on the unity of humanity, the providential nature of history, the redeeming mission of young nations, and the fresh genius of primitive peoples.[31]

Buffon's thesis (1750) of the inferiority of American mammals rests on more than his claim that torrid-zone Old World species are absent in the New World and that South American species are absent in the Old World: it depends mainly on negative esthetic comparisons unfavorable to America (as between lordly elephants and groveling tapirs). The largest American animals, he claims, are four to ten times smaller, and the species of quadrupeds are fewer than 70 in America to 138 in the Old World. His conclusion that nature in America was weaker and more hostile than elsewhere rests on this mixture of esthetic and quantitative judgment.[32] As Gerbi notes, Buffon's first position in 1750 pertained only to inferior animals in America, but when criticized by Corneille de Pauw in 1778 his new posture was to include humanity with the animals, saying that America was immature and Americans therefore less active (*agissants*) than Europeans.[33]

Corneille de Pauw was more categorical: Americans were degenerates and monsters under a harsh nature hostile to society. Because Americans are bestial their arts are undeveloped: even Cuzco was merely a group of huts without windows.[34] But G.-T. F. Raynal was far more widely read in the world, yet maintained that Americans were weakly and timid, beardless and deficient in virility.[35] William Robertson, however, wrote as a rationalist unaffected by Buffon, de Pauw, and Raynal. He evaluated the sources and used firsthand evidence as an early anthropological historian.[36] But he was blind to art, and he ignored cultural classification in his view that "in America, man appears under the rudest form in which we can conceive him to exist."[37]

After Robertson, and as readers of his *History*, both Kant and Hegel concurred with anti-American feelings. Kant praised de Pauw as "worth reading in order to think, but not in order to read thoughts." Elsewhere he wrote of Americans as "a half-developed Hunnish race" and as "incapable of self-rule and destined for extermination" and as "incapable of any

civilization, [being] far below the negro."[38] G. W. F. Hegel carried anti-Indianism to new extremes: Mexico and Peru were seen as "withering wherever Europe came near" and "even now unable to resist physically or spiritually."[39]

On the opposite side, being Indianophile by definition, Indianists were among those who found esthetic satisfaction in the study of ancient America. Lorenzo Boturini Benaduci (1698/1702–1756), born in Milan, followed the lead of Giambattista Vico in Naples, as published in the *Scienza Nuova* of 1725, in considering history as a sequence of periods (divine, heroic, and human) that could be studied by using myths and poetry as sources.[40] Going to Mexico in 1736, he became absorbed in collecting documents, assembling hundreds throughout New Spain, and being appointed Cronista en las Indias.[41]

Boturini's young Creole friend Mariano Veytia (1718–80) began as his disciple in 1738 but turned away from Viconian theories in his own book.[42] Educated as a lawyer, Veytia was not inclined to the arts and presented Texcoco as the center of monotheism in contrast to idolatrous Aztecs. He retained only Boturini's three ages, altering their content: first, Creation to Flood, second, to the time of Jesus, and third, the Chichimec nations from Xólotl to Nezahualcóyotl.

Francisco Javier Clavigero (1731–87) was born in Veracruz, the son of a high-minded colonial official. The boy lived with his family among Mixteca Indians under conditions favoring his sympathetic knowledge of their history and became a Jesuit at Puebla in 1746, where Sigüenza had left his library of Indian sources, inherited from Ixtlilxóchitl, in the Colegio de San Pedro y San Pablo. Here Indians studied with the children of Spaniards. After being exiled to Italy with all other Jesuits in America in 1767, Clavigero wrote the *Historia antigua de Méjico* in Bologna, dying there in 1787.[43] This book was the unchallenged authority on ancient America for over a century, being published in Italy, Germany, France, England, and the United States.[44]

Recent opinions on the Jesuit eighteenth-century position about America point out that those expelled in 1767 opposed de Pauw's arguments and were fomenting independence from Spain.[45] In effect, Clavigero's expressed purpose was to refute Buffon, de Pauw, Raynal, and Robertson in the *Disertaciones*, declaring "equal rights" for America by saying "our world is as old as your world," and that Spain should have encouraged

marriages with American lineages (meaning Amerindians) until a single separate nation emerged.

Clavigero's defense of ancient Mexican art against its European detractors appears in the section on government, economy, and the useful and liberal arts. The part on painting[46] depends on his own knowledge of pictorial manuscripts. He describes their materials and colors before he discusses the mode of representation, where he notes disproportion and deformity, lack of good drawing, perspective, and shading. The painters, he says, were too hurried and prone to abbreviations that would convey meaning without being letters as in writing. He held the sculptures in higher regard, as being ancient and worked with stone tools, in full round and relief, with good proportions and motions. Clavigero returns to the arts in the sixth *Disertación*.[47]

J. G. von Herder, finally, concluded the refutation in Europe of the "anti-American" propositions by Buffon and others without attacking their works directly and referring only briefly to Clavigero.[48] Herder's novel esthetic phenomenology gave esthetics a place within anthropology, in reaction against a philosophical esthetics divorced from human conduct. Having studied with J. J. Winckelmann, he could expand from ancient art to world art by including these in nature and in the senses as expression, which he meant as a relation of soul to body in the artistic thought of all peoples and ages.[49] Herder is regarded as a "forerunner of historical relativism," insisting on the "unique quality and innate validity of each civilization."[50] But Herder was obliged for the sake of the unity of mankind to derive China from Egypt and to see America as related to Africa by a remote, common Asiatic origin. This led to paradox. Herder admitted Amerindians to full historic status while characterizing them as being "as kind and innocent as infants" because they were young and ingenuous.[51]

The New Visual Base of Data

The nineteenth-century enlargement of the visual base of information in America began with Alexander von Humboldt, who was in Mexico in 1803, but more active as a naturalist than as an art historian.[52] His contemporary Guillermo Dupaix was a military officer commissioned to discover and record antiquities on a three-year reconnaissance extending

from Mexico to Puebla, Oaxaca, and Guatemala,[53] in ninety stages. His party included a draftsman, José Luciano Castañeda, who taught drawing and architecture at the Real Academia de San Carlos, as well as a clerk and two soldiers. Dupaix left all the drawing of places and objects to Castañeda, who sketched quickly in bare outline using many schematic indications. These first sketches were later reworked from memory with detailed shading. While Castañeda sketched, Dupaix daily dictated his observations and comments to the clerk. Dupaix always saw more than Castañeda, whose final drawings benefited from Dupaix's comments. Being both verbally and visually adept, Dupaix also guided the first sketches, composing himself the log of the journey and noting thoughts and descriptions rewritten, often several times, as commentaries on the finished drawings.[54]

Dupaix rarely mentions other writings and relies on his own direct perceptions in the field. He notes the "difficulty of explaining such monuments, as to their execution and original style, which are proper to this school and scorned as unskillful in the arts."[55] Soon after he remarks that he will refrain from trying to separate deities from other figures, in favor of "that which clearly pertains to the arts of design."[56] Thus he turns to the question of human proportions as shown in Mexican sculpture: "They sometimes erred grossly from accepted proportions, but not for want of art," being "as if in accord with political or religious law, requiring artists to express in the statues of gods a constant attitude and style or character similar to that of ancient Egypt."[57] Purely geometric figures display "powers inherent among the natives" contrary to "those sinister ideas that we receive without criticism," alluding again to the anti-Indian school of de Pauw, Raynal, and Robertson.[58] Though we recognize an art historian's method in Dupaix today, he would not have been known by this name, which was in general use only after 1840.

After Dupaix, the insights of Stephens and the plates by Catherwood worked a change in the study of American antiquity, as did the vision of Kugler in the *Handbuch* for the future of the history of art, of which the effects are still being explored. On the Americanist side Maudslay's photographs and Annie Hunter's drawings (1848–1902), Morley's epigraphic studies (1937–38), and Thompson's glyphic dictionary (1962) may all be regarded as extensions of the rigor and precision of the work by Stephens and Catherwood.

On the art-historical side Spinden's study of Maya art (1911), Kel-

emen's photographic repertory (1943), Toscano's survey (1944), Pijoan's encyclopedia (1946), Proskouriakoff's stylistic graphs (1950), Covarrubias's diffusion study (1954), and Justino Fernandez's study in depth of tragic beauty (1954) may all be considered as descending from Kugler's *Handbuch,* whether or not their authors knew his name.

I

American Antiquity

Recognizing Esthetics

AT THE HOMINID beginning of the stone-tool series "activities
for activities' sake" appeared, including "play, curiosity, self-
expression, investigation," without "ulterior motives" but driven
by "surplus nervous energy."[1] Other behavior emerged among early pri-
mates as "animal art" in courtship displays, nesting, and territorial markers
in sound and space.

At this base level in esthetic stratigraphy, today as among primates
before artifacts, a condition of noisy motion existed, close to language and
like a state of excitation in matter. Morris also describes the picture making
of apes, especially chimpanzees, as "self-rewarding activities" (for later
people these became "self-referential," or recursive, and even circular in
argument, such as mathematics, music, and art).[2]

Michel Foucault's notion that a vast void surrounds the meager knowl-
edge of historians, like his idea that art is imprisoned by archaeology,[3]
admirably fits New World antiquity. Yet, if history can be treated as *events*
on varying levels of abstraction a finite taxonomy is possible.[4] Thus the
history of art is even more finite, being reducible to objects of human
manufacture. Such objects assist in defining biographical identity; group
and class character; national and cultural affiliation. But these levels can
reveal nothing about the objects before attention turns to them in their full
visual presence.

When this "objectal" perspective is taken, our classification changes

from sociological categories of group, class, and society to more exactly defined locations, such as the place of work and the seat of government or its ministries, as places where esthetic choices are defined in action. If states and culture ought to exist for the well-being (an esthetic condition) of their members, then society cannot preexist its arts, which determine the forms of expression by which a society is known.

Such esthetic decisions have been seen as related to the continual ordering of all experience by imagery and symbolism,[5] equally central with language, social organization, and economics, as "a higher form of communication" than language, by being "manifestations of the cognitive process itself."[6]

As the title of this book indicates, esthetic recognition is its central concept. Such recognition is an act possible to a self confronted with an otherness. The self, whether individual or societal, must decide whether or not and how to accept the otherness. The term "otherness" came into use about 1922 as a generic term presented by Martin Buber in Germany. It included love and charity and their opposites. This continuum of love and hate was a neutral area of discussion, presented as if free of values.

In the relation of the Old World to the New, recognition of the New by the Old was withheld by most Europeans in the Old until the mid-nineteenth century. The issue between defenders and detractors of America[7] was at most points reduced to a trivial esthetic argument, as to the more and less pleasurable aspects of the subject: is the New World less agreeable than the Old? Buffon, de Pauw, Robertson, Kant, and Hegel were disgusted by American peoples, while Jefferson, Franklin, and Herder (the philosopher of the history of mankind) were attracted to those same peoples, arguing from them the unity of humanity, the providential nature of history, the mission of young nations, and the genius of primitive peoples.

Recognition thus moves in three tenses, past, present, and future. Present recognition, in the sense of acceptance, is refused for lack of some key, either in subject or object, that opens understanding. Past recognition is knowing again or remembering a similar prior entity. As to the future, recognition occurs at moments when forces emerge at center stage in a place of confrontation.[8]

But in all tenses, recognition presupposes a cognition, as an act of knowing past events. In this case, it was during much longer than forty thousand years of Amerindian peoples since the appearance of larger human societies than primate bands in both New and Old worlds. The

mode of this knowledge is historiographical, with central attention to esthetic events.

The history of esthetic recognition in this book became general here and in Europe only after 1850. But the recognition was already partly present (little more so than today) in the letters of Columbus and Cortés or the diary of Albrecht Dürer in 1520.

The historiographical units of this work are biographical more than topical, because the persons who wrote histories are its fabric. A topical arrangement would mirror the present more than the twenty generations of writers on America since its discovery in both New and Old worlds. These generations all were differently concerned with the same subject, the history of the New World, but in a variety of modes: ethnic, genealogical, philological, and archaeological. The sequence began with tribal peoples, coming into the present with a long-delayed concern for the otherness of native groups in iconographic and hermeneutic methods. The turning point from chronicle to history was about 1840, when scholars in America and Europe first began to see the New World as *unrelated* to the Old World, yet like it, because of its artifacts, which differed by persisting as lithic until the discovery by Columbus. As such, esthetic recognition of ancient Amerindia has a history of nearly five hundred years.

Inventing America

World geography is an ethnocentric appropriation by the cartographers of Western civilization. In its present coding as five continents, America alone has been mapped as hemispheric. Europe, Asia, and Africa are connected land masses, and Australia is a large island. But America extends from pole to pole, separated from all others by oceans and separating Europe from Asia, in a pattern suited to call it the New World, as first perceived by European mapmakers.

Hence America, from the beginning of the name, has been regarded as a unit, as when Waldseemüller in 1507 named the New World for the navigator Amerigo Vespucci,[9] but the unit always required division into lesser territories by conquest or appropriation or expropriation.[10] Only the rebellious British colonists of 1776 appropriated it to name the United States of America, calling themselves Americans, which was then a name of opprobrium in Europe for returning colonials. The Spanish usage was to refer to the colonies in America as *las Indias* and the colonists as *indianos*,

to include the Philippines, Australia, and Asiatic stations that came under Habsburg dominion after 1580, when Philip II added Portuguese possessions to the empire.[11]

The Spanish "finding" of Australia before 1562 thus documents O'Gorman's postulate[12] even more clearly than does America: discovery "implies that the nature of the thing found was previously unknown to the finder." But another who formulated the concept self "may properly be said to have invented that class." Hence the discovery is of "the idea" that any place may give its finder the illusion of having "invented that class." The discovery of America was by persons having the idea of America, but only as a result of its "finding" by Columbus, who dies not knowing that his voyages had been to America.

Recognition occurs after the sequence of finding, invention, and then discovering what has already been invented. Such recognition is knowing something again, by retracing lineaments already seen or remembering paths learned before. It occurs also by acquiring a procedure from another group or person or by reading of it. But recognition in the sense of acceptance can be refused, as in forgetting, when the key is lost in either subject or object, or if a forgery is attempted, as in the general social case of colonialism, when profit and labor no longer accrue together to the same person or class. Here we can understand esthetics also as a discipline with a social history.[13] Michel Foucault (1926–84) evoked "emergence" rather than recognition.[14] In his three uses of history—(1) parodic or farcical in the veneration of monuments, (2) systematic dissociation of identity by respecting ancient continuities, (3) sacrifice of the subject of knowledge by critiques of past injustices—Foucault's emergence is "the moment of arising . . . an apparition . . . the . . . entry of forces . . . to center stage . . . place of confrontation," rather than the cognitive act discussed here, as to esthetic invention of recognition in feeling or emotion, of something already found and invented. Here recognition presupposes an act of knowing that was a past event.

Foucault labeled his historical studies by a term of his own coinage as "archaeographies."[15] The term is central to what he calls the "new history" of discontinuity,[16] to which he brings an analysis drawn from French models in the quantification of history, that "distinguish various sedimentary strata" as "discoveries in depth." These strata are separated by interruptions corresponding to G. Bachelard's "epistemological acts and thresholds," as well as to G. Canguilhem's "displacements and transforma-

tions of concepts" at "microscopic and macroscopic scales of the history of sciences." In the history of mathematics, M. Serres identifies "recurrent distributions." L. Althusser, finally, "detaches science from the ideology of its past, by revealing this past as ideological." Foucault brings these positions together as having changed the problem: it is "no longer one of tradition, of tracing a line, but one of division, of limits." He finds "general history" emerging as using "the space of a dispersion" in the appearance of "discontinuities, systems and transformations, series and thresholds" in all historical disciplines which are now "not so much history . . . as an 'archaeology.' "[17]

Finally, the aims of *Archaeology of Knowledge* (15–16) are stated as (1) "transformational" more than structuralist; (2) abandonment of "totalities" by questioning teleologies; (3) to "define a method of historical analysis freed from the anthropological theme."

Esthetic recognition (as studied here) may be subsumed under Foucault's "episteme [both object and subject] addressing itself to the general space of knowledge, to its configurations, and to the mode of being of the things that appear in it."[18]

Paul Veyne (b. 1930) is a French historian who admired Foucault enough to write a long essay on his work entitled "Foucault révolutionne l'histoire,"[19] as a play on words, translatable as "Foucault revolves [or spins] history," in allusion to J. B. L. Foucault's pendulum of 1851 to show the earth rotating around it. Veyne's purpose is to acclaim Michel Foucault as "le premier historien complètement positiviste" and "auteur de la révolution scientifique autour de laquelle rôdaient tous les historiens" (204), in *Archaeology of Knowledge*, (1960) and *Order of Things* (1966). That scientific revolution was the discovery that "les faits humains sont rares, ils ne sont pas installés dans la plénitude de la raison, il y a du vide autour d'eux pour d'autres faits," and Veyne proposes that "ce philosophe est un des trés grands historiens de notre époque."

For Veyne, Foucault's revolution of history derives from his proposal that relationships among practices are the "center of production" for functions and institutions (236–37). Ideology has no reality, being only a word (224), nor have things. Only practices are real (226). To rephrase Veyne on Foucault in regard to esthetic recognition: practice corresponds to arts and crafts, function to esthetics, and institution to communications, within the limits of periodization.[20]

"Information theory and esthetic perception" are joined in a grand

theory by Abraham Moles writing in Paris under that title.[21] By simple graphic distances along intersecting coordinates he quantifies thirteen paintings from Hieronymus Bosch to Bernard Buffet according to their semantic and esthetic "complexity content." Observing that this classification is incomplete without at least another axis, "the emotional dimensions," he adds that he has "ignored this dimension entirely, although it is extremely important for the work of art, because it has been poorly explored and is still poorly known." The semiological reduction is closely parallel to the same reduction by social scientists since 1860. In their writings about ancient Amerindian works, the "emotional dimension" is ignored. The difficulty in both cases is to "find the art in the artifact."[22]

As noted above, the gray area between artifact and work of art was clarified in this century by the statistical notion of the graded series between such polarities: no artifact is conceivable without art, no work of art can be divested of its function as a tool. The interval between art and artifact is a graded series: there literally is art in every *art*ifact and, vice versa, in every work of art there lies the shadow of an arti*fact* or tool.[23]

This question arose with the Amerindian objects reaching European courts in the sixteenth century, and later they were kept in "curiosity cabinets" as "objects of virtue" (fig. 1), a phrase borrowed in English from Italian *virtú*, for "a taste in the fine arts, or skill in them."[24]

The historiographical standard for inclusion here is met when an author's interest in ancient America can be described as visual, accompanied by the awareness that works of art are more than historical documents, being also historical forces affecting the course of events as well as expressions of emotion.

In recent Mexico, Justino Fernandez (p. 151) and Edmundo O'Gorman were part of a nonpolitical and academic community that emerged after the revolution (1910 to 1920). Its intellectual leaders after 1936 were Spanish exiles such as José Gaos (b. 1900), who had been close to Ortega y Gasset before the Civil War in Spain. Gaos translated Rudolf Odebrecht on contemporary esthetics (Mexico, 1942),[25] and he introduced his students to the thoughts of Heidegger, Husserl, and Scheler.

O'Gorman's purpose in *The Invention of America*[26] is ontological, "a process producing historical entities as something logically prior to it" (4). Thus the idea of the discovery of America is necessarily absurd when understood as being based on three logical impossibilities: (1) Columbus intended and found an unknown continent; (2) the discovery was "imma-

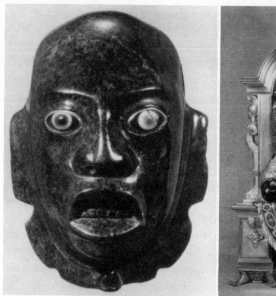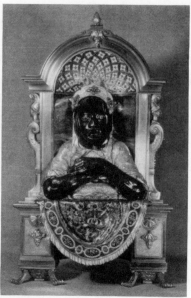

Figure 1. Greenstone Mexican mask of Olmec type, possibly of Guerrero origin in southwestern Mexico. The biblike lower profile appears in similar jades of pre-Classic date. The Olmec connection is "remote." Heikamp and Anders (*Pantheon* 28 [1970]: 213) identify the setting as possibly the work of Guillaume de Groff in Munich about 1720, in the style of *chinoiserie* decorations of gilded bronze and enamels, enhanced in gold and silver settings. The arms (of a different greenstone) are also of that date. (After *Pantheon* 28 [1970], cover)

nent in history"; (3) it was a chance discovery (40). O'Gorman then transforms S. E. Morison's metaphor of a rape[27]: "The American continent entertained the desire of discovering itself when Columbus established physical contact with it" (44). In short, the discovery was of the *idea* that "America appeared as a result of its discovery by Columbus" (11). O'Gorman concludes (143–45) that the two Americas, Spanish and English (Latin and Saxon), made a second, new Europe in the "new hemisphere," or *Novus Orbis* (new island) of Peter Martyr writing in 1493 and 1495.[28]

The Spanish part, according to O'Gorman, was the liberation of mankind "from the fetters of a prison-like conception of his *physical* world," while the English part freed him "from subordination to a Europe-centered conception of his *historical* world" (145). Peter Martyr wrote that America

had been hidden "since the beginning of creation."[29] O'Gorman closes by suggesting that "American man was the new Adam of Western culture," as the "hidden" and true significance of American history since its "invention."

Originating and Peopling Amerindia

Writing in participles, as in this title, has the merit of continuing the "ontological perspective," in the processes that produced historical entities, such as "origins" and "peoples," instead of believing that "the being of such entities" is "something logically prior to those processes,"[30] as in the case of "America" existing "before Columbus," which had no name known to us. A participle refers to our participation in the action or state of a verb, whereas such nouns as "origin" and "people" designate extant entities. The participial mode therefore inhibits the belief that any theory about origins or peoples is valid without historiographical study of such theories. "Originating" is unlike "origins" and "peopling" is unlike "peoples" in not presuming a prior state of being "in fact." The participles induce a query as to the reality of the corresponding nouns.

The effort to represent human history in the New World began before such caution about wording as early as 1493. The letters of Peter Martyr (1457–1526) to Ascanio Sforza announce the finding by Columbus of a "new hemisphere," and in 1495 he called it *Novus Orbis,* commonly translated as "New World," although *orbis* is "island" in Latin.[31] But Martyr was thinking of the hemisphere in 1493 as a world that had been "hidden since the beginning of Creation." He was looking into a void that is both Amerindian and European: nothing was yet known about the New World or its reception in the Old.

How to represent or portray that hidden world has been under way since Columbus, by chronicles and missionaries, by government officials and native historians, and most recently by prehistorians, archaeologists, and art historians. To begin the discourse on the esthetic content of the Amerindian lithic ages, one can turn to Old World prehistory some three hundred centuries ago[32] for a model of events in the hidden world of Amerindia during the same eras from the Wisconsin glacial sequence to the warming climate of the boreal age after 10,000 B.C. Other models exist, but most appropriate is the one by André Leroi-Gourhan, whose early work

was in Arctic Alaska and Eurasia until 1946 and then in European palaeolithic studies.[33]

Before discussing his history of palaeolithic art in Europe, I need to consider the esthetic faculty among humans biologically the same as ourselves, yet limited in experience to the condition of ice-age hunters with an extremely long tradition of stone-tool industries behind them. The limbic system of the human brain is "equivalent to the old mammalian brain," and it is concerned with "attention, emotion, learning and resultant memories."[34] It is the seat also of that distinction between pain and pleasure shared by all sentient species. Esthetic reactions too are in part limbic.

Old World figural art in the palaeolithic ages is abundant, but it is extremely rare in the New, while the stone tools in both are developmentally similar. The question as to *why* this should be has not to my knowledge been asked. As to *how* the beginnings of visual figurations might have happened in both worlds, without prior stocks of figural conventions, eidetic imagery may be proposed because some excellent minds since the eleventh century thought of it, and many psychological experiments since 1920 seem to support it. A possible assumption is that the beginnings of human figuration are in these genetically continuous phenomena of eidetic imagery, as experimental evidence relevant to the "mental imagery"[35] of the human species.

Prehistory as Art History

The proposal examined here, beginning in Aurignacian time, c. 50,000–30,000 B.C., is that the neurological circuits among human eye, brain, and hand[36] were in place. They supplied internal imagery by memories of eidetic vision to people who were then lacking any large prior store of images of artifacts. These circuits permitted the hand to reflect any internal imagery in a widening supply of models to improve the relation between the seen and the imaged, by trials and in types that constitute the corpus of Palaeolithic art in parietal and mobiliary forms.

André Leroi-Gourhan (1911–86) was generational successor to Henri Breuil (1877–1961). As a physical anthropologist and archaeologist of palaeolithic peoples, his work began before 1935 both as an art historian and anthropologist. His collected essays span nearly half a century between and in these fields at the Musée de l'Homme. Most of these remarks will be about his work as a historian of art.

His early articles (1935–46)[37] were poised between Asia and America, when his Eskimo, Eurasian, and Japanese studies opened a career that soon shifted to prehistory in Europe during the Palaeolithic glaciation. His methods as a prehistorian were affected by the history of art of his youth in France, as when he reviewed S. Giedeon's *The Eternal Present* of 1962.[38] He criticized Giedeon's acceptance of totemism and shamanism as well as his tendency to "examine everything of modern man which is recognizable in palaeolithic man."

Among his first lectures published in 1936[39] was a study of the animal style of Chinese bronzes. He cited no authorities and used only his own drawings. This isolation persists throughout his works, and it may be because of French publishing habits in the format of *haute vulgarisation*, where exact references are not thought necessary.

Another essay in the same volume, written in 1960,[40] opens with a respectful renunciation of the chronology by Breuil in favor of his own statistical tabulation. He had used a perforated-card sorter to explore many other hypotheses on contemporaneity in palaeolithic art; on the succession of styles, and the association of figures by subject, by style, and by placement in the figure space. This chronology was based also on radiocarbon datings, and it spans the period from 30,000 to about 8500 B.C., or half the Breuil estimate of four hundred centuries. Figural art appears only about 20,000 B.C., developing by "coherent stylistic periods," each enduring two to three thousand years. The whole span offers, in his words, "a normal trajectory" by slow beginnings, followed by a "strong apogee" and a "rapid failing" in four styles appearing both in parietal and portable (*mobilier*) art. Abstract signs like ideograms accompany both kinds of art spanning 15,000–13,000 B.C. in style III.

His statistical method for grouping the works by period was criticized[41] as being concerned only with the "measure of association" among animal figures and disregarding small percentages, reaching arbitrary interpretation without adequate proof. Yet historians of art have long risked such stylistic and chronological guesses on small samples without any statistical analysis and in many cases without successful contradiction.

Leroi-Gourhan says here that palaeolithic art is like all other art in "being born, developing and dying upon a regulated path." It is equal, he says, to the great "artistic movements" of the historic world and inseparable from a coherent "religious system" that it illustrates. In effect he turns palaeolithic archaeology into a history of art seen under a biological meta-

phor. In so doing he converts a theory by G. H. Luquet, the psychologist, that prehistoric art began as "art for art's sake" into a new version. Here palaeolithic industries and figuration are to be understood as a history of art and meaning and as a history of art for art's sake.

As to Leroi-Gourhan's predecessors, at least four earlier psychological explanations of palaeolithic figuration exist: (1) Lartet and Christy in 1863 saw the art as a product of the leisure afforded by an abundance of late glacial fish and game; (2) Galton in 1883 proposed eidetic imagery as the origin of earliest art; (3) Breuil and Luquet in 1926 separately suggested that palaeolithic art was made for art's sake as a "disinterested" activity; (4) Groos, in 1898 and 1901, offered play as the origin of all art, animal and human.[42]

The current belief that palaeolithic art is of magical origin is not psychological but religious. Its origins are in the work of Tylor on totemism (1881), followed by Frazer (1890), Durkheim (1912), and Reinach (1913). Ucko and Rosenfeld (1967) are its contemporary apostles.[43]

Breuil later (1952) abandoned the "disinterested"[44] for the "magical" explanation, while Luquet had already distinguished between Aurignacian *art désintéressé* and Magdalenian *art magique*.[45] Luquet's position seems the least unhistorical among these four explanations, simply by recognizing that the earliest artist knew no accumulation of previous imagery, while those of twenty-five thousand years later possessed rich museums of works of art in caves and shelters. In that late glacial world this art was about to cease. Thereafter neolithic signage and scenic representation displaced the tangled networks of previous animal figuration.[46]

Although Leroi-Gourhan in 1965 blamed art for art's sake as the "worst" of explanations,[47] he offered no supporting evidence other than to state his preference for magic as "the only legitimate path." An extended attack by others on "disinterested art for art's sake" appeared only in 1967,[48] based on the primacy of religion as magic among "modern non-literate tribes" (119) especially "totemic" in the tradition of Durkheim, "sympathetic" in the wake of Reinach (1903) and "fertility" (163).

Yet these arguments from religion fail to account for the beginnings of all figuration by human eyes, brains, and hands about 40,000 B.C., in the absence then of any more figuration than there is among other animals and primates today.[49]

Leroi-Gourhan turned away from ethnology in 1971 to combine archaeology and art history. He discards completely the traditional reliance

on comparatist ethnology as a *manteau d'arlequin,* consisting of cults of
jawbones, spirit traps, fecundating ancestor figures, magical burials, rites
of imitation, totemism, and "all other ways of explaining prehistory by
analogy."[50] In its place he suggests that palaeolithic themes demand more
from psychoanalysis than from the history of religions, believing that nei-
ther metaphysical thought nor magical practices can appear until after the
implantation of a setting made from works of art. In this declaration the
stage is cleared of all anachronisms and anticipations in favor of an effort to
recover "the animal simplicity of early humanity," a simplicity repeating
that of infancy. In a later essay he presents art (1960) as the primordial
bond between the appearance of religion and esthetic emotion at the
"threshold of imagination."[51] His categorical rejection of all ethnological
reductionism ends with the declaration that the "palaeolithic world was
not very different from the historical world."[52] In 1965 Leroi-Gourhan
dated his parting from Breuil as in 1957,[53] when he decided to concentrate
on signage as a key to chronology together with the "internal dynamism of
the compositions."

Leroi-Gourhan's masterpiece is *Le geste et la parole* (1964), in which he
condenses his experience as a physical anthropologist. Recapitulating his
theory of "palaeanthropian" mentality during the fifty thousand years of
Neanderthal existence, he says that language already "differed little from
that of people today." The main biological change marking "anthropians"
was the "unlocking" (*déverrouillage*) of the prefrontal brain cortex as an
"instrument of affective regulation, control and judgment" (1:185) be-
tween "Australanthropian" and "Palaenthropian" eras.[54]

Thus figural art began for Leroi-Gourhan in direct union with lan-
guage (1:266), by mythographic confrontations, where phonation and
graphism had the same purpose of representation as image and idea
(1:269) in coordination (1:272). His complex explanation is unitary and
speculative.[55] Nowhere is he concerned with the psychological problem of
the earliest figurations, but his discussion of the role of the prefrontal brain
cortex (fig. 2) may open a connection with the eidetic imagery that is
documented by figuration from the Aurignacian period to present time in
the history of human vision.

As to the existence of eidetic imagery in the vision of primates or other
animals, no experimental evidence appears after search in biological and
psychological abstracts since 1920.[56] But recent discussion of afterimages
as "continuing firing of the retina and optic nerve after stimulation" with

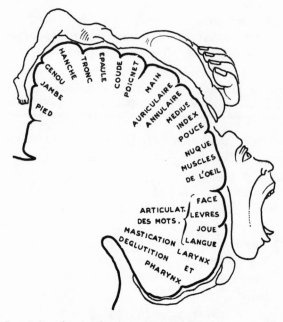

Figure 2. A. Leroi-Gourhan's schematic diagram (his drawing) of the voluntary acts controlled by the human brain. The drawing evokes a medieval grotesque miniature: the brain functions of the head from throat to scalp are made visible by a shouting human profile. The muscular functions of the body from hand to foot appear in a large fist upon a contorted leg. Both the face and the handed leg convey the title of the book. (After *Le geste et la parole* [Paris, 1964])

"bleaching of the photo-pigment" in "negative afterimage" would not rule out the possibility in all seeing animals, especially in other primates (apes and monkeys). There the persistent and recallable imagery of eidetic vision would be present also in some measure in the eye-and-hand linkages to the brain.

In *Le geste et la parole*, Leroi-Gourhan also writes about the palaeontology of an esthetic behavior that can assure the subject "an effective insertion in its society" at "deep visceral and muscular levels," shared with other species (as in mimicry and dance among birds and mammals) in a "continuum of esthetic evolution" (2:82–89), and a panorama of "ethnic styles" among biological species. Here the separate values (functional, physiological, and figural) are present to perception in all species as esthetic (2:134–35) by the "ambiguity" of attraction and repulsion.

At this point (2:136–37) Leroi-Gourhan voices his animosity to the historical phenomenon of *l'art pour l'art* about 1900, calling it a "crisis of figuration." Here perhaps is a clue to his rejection of the name of art for art's sake as anachronistic in its application to prehistory. Language is seen as "directly bound" to figural art at their origin (1:266) without intermediary in the relationship assumed between language as speech and drawings as gesture. It was "coordination, not subordination," when "mythology was only verbal, and mythography, manual" (1:272), and when gesture interprets speech, while "speech comments on graphic work" (1:291) as when two mirrors, gesture and sound, display the close synchronism between language and lithic industries (1:296).

As to esthetics, Leroi-Gourhan postulates levels—functional, physiological and figural—as a cycle always present in esthetic perception (2:134) from palaeolithic beginnings. Speech and figuration are together "the cement binding the ethnic cell" with an apparatus of emotional language and visual forms (2:207–08), as early as Mousterian (50,000 B.C.) use of red ochre, incised lines, cupules, stone balls, and *ludi naturae* (that is, figures "seen" in unworked natural forms) as prefiguring the later "language of visible forms" (2:215,255). In this major work sources are rarely cited: there is no ladder of authorities, and the language recalls that of Focillon, Malraux, and Breuil, remaining closer to the history of art than to anthropology, yet widening both methods by interweaving them in a cable of physical anthropology and psychological esthetics.

These arguments find support in current work on the history of language. Morris Swadesh is not used by prehistorians concerned with Pleistocene events, partly because his "lexicostatistic method" becomes uncertain for events older than five thousand years, although he believed it remained useful up to twenty thousand years if corrected for "the probable slower rate of vocabulary change in earlier time periods." On the origin of vocabulary[57] he thought that the "single root-word" of millions of years ago separated into "imitative and exclamative" systems. The latter divided as "expressive and demonstrative" paradigms in an "eoglottic state" at oldest age of stone artifacts, developing from vocabularies of "a few hundred to a thousand or so elements."

Among Americanists, with whom he belonged, Swadesh's "glottochronology" or "lexico-statistical dating" has been found useful as to "proto-languages" among the Maya in 2500 B.C., despite the criticisms of other linguists.[58] Swadesh reduced the origin of language to a single, first

root-word, from which all others divided as ramifications, by an initial perception like Helen Keller's at age seven when "she abruptly realized that the substance water could be represented by an arbitrary sequence of finger movements."[59]

Thus at a time when the world still was without imagery of human devising, and at the Mousterian threshold in Middle Palaeolithic, Hewes suggests that people began to draw and model by lines, spots, shapes, and colors.[60] The shapes were seen in the mind after the stimulus had ceased, as an "insight of symbolization" like the "articulate speech" that had appeared among *Homo erectus* about 1 million B.C.–300,000. Wescott adds[61] that "the earlier the protolanguages were, the more alike they were—back to the point at which they converged" between twenty and fifty thousand years ago.

With these assumptions and speculations we have at present the existence of speech and of imagery, both about 50,000 B.C., when the first human bands may have come to the New World via Beringia.[62] At this point the role of dreaming arises in palaeolithic imagery. Ethnologists have surveyed the subject among tribespeople of the present world population,[63] finding several "sociocultural functions" for dreaming by individuals; these are "direct input" into culture; "problem solving"; "status definition"; "maintenance of social control"; "adjustment between nature and nurture." This distillate is based upon the "manifest meaning" as reported by dreamers, and it includes experimental results in dream deprivation. But the dreamer's eyes are not presented with reality visible by light, and the imagery of dreams is not registered by after-images or eidetic retention on the retina.[64]

Among the ideas of Leroi-Gourhan, his history of four palaeolithic styles of figuration spanning between 150 and 200 centuries is divided as primitive (periods I, II), archaic (III) and classic (IV).[65] This is patterned in the traditional periodization of the history of art, which he explains as a sequence (159) from "beginning" to "maturity" and "academic" stages, "dying" about 6000 B.C. after having "exhausted all the resources of the concrete and the abstract" possible with "graver and brush." These stages are thousands of years long, accompanied by changes in stone tooling that are even slower.

Measured by the objects, rates of change in tools and imagery appear to differ greatly. The developmental duration of stone tools is on the order of millions of years, but the duration of palaeolithic imagery is at most (by

Leroi-Gourhan's chronology) on the order of twenty thousand, giving a difference in rate of change on the order of fifty to one hundred times greater for imagery than for stone tools.

Yet figuration is a limited domain, unlike the seemingly boundless domain of postlithic technology. Leroi-Gourhan faced this question in the final chapter of *Le geste et la parole*, titled "Imaginary Freedom and the Fate of *Homo Sapiens*." He projects the final nuclear accident, contrasted with a gamble for humanity (*jouer sur l'homme*); and another pair, the insectlike society contrasted with recovering the "equilibrium that brought the species to become human."

Among the main traits of Leroi-Gourhan's work are his concern to reach the large public, and more important, his reduction of the complexities of the subject to easily understood principles. A major turning point was about 1960, when he adopted a statistical method and a mode of analysis taken from the history of art he had used since his days as a student. About 1960 he also abandoned the ethnological analogizing that is basic to anthropological archaeology. His work then also became more speculative, by reaching for neglected connections within the corpus of anthropological knowledge, and attaining an unprecedented synthesis in *Le geste et la parole* (1964), of which the wide applications still remain latent.

Diffusionist Faiths New and Old

Historians since Herodotus have commented on cultural diffusion. It is doubtless as necessary and as pervasive as physical friction to existence in time. The question here about diffusion is not as to its existence, but as to ways of detecting its presence. "Traits of material culture" are the usual coin of arguments seeking to prove long-distance diffusion, as from ancient Asia to ancient America, of objects of material culture, like barkbeaters for making paper. In the absence of objects, "stimulus diffusion," or the adoption of foreign principles, is assumed. As with animal and agricultural domestication, the modes of transmission are the movements of peoples and infiltration of ideas, either from one center or several.

The field of study is here reduced to the Western hemisphere as of about A.D. 800, in order to present a categorical unity in space and time and to limit the area to land and coastal transmissions, without having to consider transoceanic navigation, or "whole earth studies."

Within this field it may often be observed that a visual complex of artistic ideas as we apprehend it today, such as the pre-Columbian Amerindian portraiture of individual humans (fig. 3), has an intermittent distribution. For instance, Olmec and Maya portraiture are one prolonged focus in eastern Mesoamerica, enduring two thousand years. Mochica portraiture is another focus on the central Andean coast, lasting half as long. But as of about A.D. 800, late Maya and late Mochica portraits are coeval. No evidence links the two manifestations historically, nor is portraiture of this quality and abundance known elsewhere in ancient America. No traces appear of either trait- or stimulus-diffusion at this stage. Yet the visual resemblances between Mochica and Maya techniques of portraiture justify a close consideration.

In diffusionist studies, such visible resemblances are accepted without further question as evidential proof of historical connection. But in the history of art, the proof has yet to begin with a search for the artisans carrying the techniques, for the route of their travels, for the motivating force of the diffusion, whether religious or economic, and for parallel conditions in the two societies that would support the appearance of portraiture. In ancient America such evidence for communication between Maya and Mochica portrait sculptors is still absent.

That they are coeval traditions, as of A.D. 600 ± 200, and that both satisfy our idea of portraiture is strong reason to consider a method for treating this and other isomorphic phenomena in world art. These problems, whether short- or long-range, are now insoluble without other approaches than traditional diffusion studies as isolated traits of visual resemblance. One such approach would be to experiment with semiotic analysis of the pragmatic school, initiated in America by Charles Sanders Pierce after 1865. In one present-day form, semiotic study regards the artifact itself as having (1) an autonomous esthetic function of self-referential character, serving as a sign or signifier; (2) one who perceives this artifact or work of art construes it as that which is signified according to when and where it is perceived; (3) these perceptions are affected also by the social context at the place and time of the perceiver.[66] By this analysis the work of art mediates between the artist and the community, being itself related to other cultural activities as *signans*, or signifier, in its own time. But as signified (*signatum*), its perception changes with time and place and social setting.

1. As to their being signifiers, Maya and Mochica portraits are isochronous (or coeval) in sidereal and in cultural time. As artifacts, neither is

Figure 3. The choice here—a less-than-life-size Mochica pottery portrait (sixth century A.D.) (*top*) and contrasting colossal Maya stone portraits (eighth century A.D.) of the same person (*bottom*)—presents coeval but unrelated examples for the practice of individual portraiture in rain forest and coastal desert environments. The Maya stone portraits are of the same ruler in different roles at Quiriguá in Guatemala. He was then about fifty (Stelae E and A). (After E. P. Benson, *The Mochica* [1972], and G. Kubler, *Studies* [1969])

impersonal. Both show individuals of identifiable age, moral stature, and social standing. Neither is of low rank or deformed nature. Both are idealized as of physical beauty and high social rank. Both are portrayed in multiple copies.

2. As to their being *signata,* in the varying opinions of observers in various centuries and places, we know only those of recent times and European origin. All commentators agree that ruling persons from class-structured societies were represented. Slightly older minority opinions (c. 1940) were that high priests serving identified cults are shown.

3. As to the social situations of the perceivers since 1850, few opinions survive from the centuries between Discovery and Independence, and none denies the high quality. Great differences as to ideology barely exist. Today all factions approve the superb craft, the rich texture of meaning, and the masterpiece status as signifiers of these works of art.

Because of the restriction to works of high quality, these results are more bland than incisive. The analyses by signifier, signified, and social context display uniformities rather than differences. These uniformities, however, describe what is meant here by isomorphy. The analyses confirm an impression that the same complex idea of individual portraiture was independently manifested in the artistic practice of two separate and evidently unconnected cultural areas of America.

The next step would be to search for significant differences distinguishing the two traditions in their morphologies and contexts. The semiotic instrument is the binary opposition between similarity and contiguity. Such analysis requires for historical studies that both poles be considered in any crosscultural conflation. Any similarities require rigorous testing, by assuming that the resemblances are only superficial disguises for deeper differences. On the other hand, contiguity, or the association by proximity of traits into large local patterns, such as forms or cells, will further test the credibility of an alleged acculturation or diffusion. This double approach is like a stereogram instead of a single-tube telescope. It might also be called ideogrammetric, in relation to the comparative study of coeval ideas in the past or about it.

Phrased more generally, having *n* expressions all different as to configuration, of the same ideas (whether integral to the time or interpretative and later), is comparative in a far higher degree than a simple linear diffusional study of an isolated trait separated from context.

Essentially the method is an expansion from present-day interest in

close-range, interregional contact and exchanges to the study of long-distance identities. These raise diffusional mirages that can first be analyzed by morphological (or formalist) and semiotic methods.

In the 1840s both Kugler and Braunschweig used monuments (*Denkmäler*) as the cornerstone of prehistoric study. But Kugler may have advanced his unitary conception of an autonomous Amerindia to counter a book appearing in Berlin before his own on ancient American monuments. In it Braunschweig argued that the monuments in Central America, Peru, Colombia, Mexico, and the Mississippi basin were divided as the works of two peoples, Polar and American. The latter included Carib, Mississippian, and South American peoples. He then enumerated the "foreign elements" in the "indigenous development" as South Sea islanders, Germanic voyagers of Scandinavian origin, and Asiatic, east Indian, Indonesian, Japanese, Korean, and African origins, all shown by traits diffused to America in a remote past.[67]

Braunschweig took his cue from Alexander von Humboldt, who had forcefully written about ancient America in this manner,[68] discussing the "races" of aboriginal America. The argument by physical appearances reappeared recently in a work on pottery portraits, presented uncritically without other evidence[69] than "faciologie," and finding parallels with Etruscan, Palestinian, Roman, Phoenician, Semitic, and Mongol "types" as well as "negroid."

After R. Heine-Geldern and G. Ekholm advanced their ideas at the Congress of Americanists in New York in 1949,[70] they found wide acceptance, even among official anthropological archaeologists in Mexico. Their support continued until six congresses later, when Alfonso Caso, who had supported the diffusionists, turned on them with ridicule, which led to the end of their support in Mexico.[71]

A less simplistic argument is Werner Mueller's.[72] He followed Braunschweig in dividing polar peoples from other Amerindians. He also suggested an "amphiatlantic" origin for the boreal peoples of the mesolithic stage after deglaciation (fig. 4), as spreading from the arctic "source of the late palaeolithic strata of Europe," in "proto-American cultures" along an eastbound North Atlantic route to Europe. Here Ireland and Scandinavia were "bridgehead and center of American cultural forms" for later neolithic developments in the Old World. Mueller's model may have been Alfred Wegener's theory of continental drift (1911), long rejected but lately recognized at least as a forerunner of platetectonic studies.

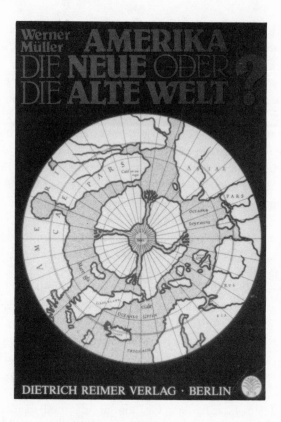

Figure 4. Mercator's map in 1591 of the polar ice cap served historians speculating on the migrations of early peoples, but its modern use as a document supporting polar migrations in palaeolithic time has been proposed only by Werner Mueller (*Amerika, die neue oder die alte Welt* [Berlin, 1982]). He suggests that the arctic regions were where the diversity of origins of the peoples of America before Columbus may have occurred during the ice ages prior to 1000 B.C.

The same year, 1982, saw the appearance of still another diffusionist study that continues the tradition of visual comparisons inaugurated by Carl Hentze.[73] Terence Grieder is an Andeanist who began as an art historian and became an anthropological archaeologist.[74] Architecture, sculpture, and painting are not treated as such but as settlement and shelter, pottery and textiles with the artist as a shaman.

Grieder based his "genetic theory of culture" on Edward Sapir's principles of transmission[75] in 1916 and on Alfred Kroeber's thesis in 1948 that cultures generate each other.[76] Grieder's theory also includes Gordon Ekholm's in 1964 on colonizing waves striking America at intervals from Europe and Asia.[77] Grieder avoids simplistic visual parallels in favor of behavioral horizons striking America in three waves: (1) Upper Palaeolithic cosmic symbolism based on sexual imagery and face and body painting; (2) about ten thousand years ago, shamanic ritual in a layered cosmos where male dominance displaces "female terrestrial power"; and (3) after 400 B.C.–A.D. 600, calendrics, dynastic rule, tripartite universe, books. A fourth wave is Eskimo and the fifth is European.

A sumptuous book by José Alcina Franch[78] promises more than it gives because the art of the hemisphere north of the Rio Grande remains nearly unmentioned excepting on the maps, and as to palaeolithic art in a few pages on geography, cultural areas, and glaciation. In addition the text avoids the issue of cultural diffusionism by stressing old and questionable ideas about race and language[79] in such a way as to endorse cultural diffusion without mentioning it by name.

Alcina thus adopts Imbelloni's division of Amerindia in 1938 (571–75) into eleven "racial groups"[80] defined by location and physical traits of stature, skull, limbs, skin, and hair,[81] staying close to Hispanic models of Mongolian taxonomy and avoiding mention of other theories such as E. A. Hooton's multiple origins (Indo-Dravidian, Australian, and Ainu), J. B. Birdsell's dihybrid origin (Amurian-Mongoloid), and G. K. Neumann's eight varieties (north of Mexico only). Yet, as Willey notes, both Imbelloni and Neumann agree that "man did emigrate from Asia to America at different times and in recognizable different sub-racial or varietal types" (14), continuing to diverge in America "through selective adaptations and genetic drift" (15).[82]

Alcina's arrangement is novel, dividing the subject among art, image, and sites. Part I on art has ninety-four pages of print, mostly given to an anthropological introduction (25–71) and the rest as eighteen regional styles in sequence from "paleolithic" to "postclassic" in eight periods. Part II, "The Image as Document," offers 593 black-and-white photos of objects identified by material techniques, subject, place of origin, date, location, and measurements. None of these images is specifically described in the adjoining texts of parts I and III, and the user is alternately a reader and a

spectator. Part III on archaeological sites brings images together with description and archaeological information in close association between 74 pages of text and 279 drawings and photographs of sixty-four sites.

Alcina is clearly an anthropologist writing for a publisher of art books (as Willey wrote for the Propyläen Verlag). Alcina's publisher, Lucien Mazenod, explains in a nine-page (unnumbered) preface that "the notion of progress has finally become obsolete," to express Alcina's "personal sensibility." That Europeans had considered "the inhabitants of the New World to be barbarians" justifies the publication.

In his section (47–51) "Art and Anthropology" Alcina explains his view of "cultural relativism": as each group has a unique system of values, comparisons are "fallacious and deceptive." Among writers "on esthetics or theory of pre-Hispanic art," Alcina most esteems Paul Westheim for his views on the "magico-religious nature of the art," derived from Wilhelm Worringer, as in the work of Eulalia Guzmán, who saw "magico-religious meaning" as the "real key" to "abstraction" marked by an acute sense of stylization. Alcina also admired the work of Salvador Toscano (45), finding in pre-Columbian work the Kantian concepts of terrible and sublime beauty, as did Toscano's teacher, Justino Fernandez.

Beyond these concessions to the users of books on art, Alcina has little more to say, beyond setting out again the relationships of Amerindian art in space and time. But his method of turning the problem of cultural diffusion back into racial diffusion is relevant to the historian of that question.

Since 1960, the term "diffusion" is used less insistently, after its history was reviewed as a comic charade[83] and as flawed historiography.[84] Thus the fallacies of diffusion have persisted since the Discovery, despite objections in Acosta's *Historia* of 1590. Some colonial evidence, however, exists for the common origin of Mexican and Andean cosmogonies, possibly in the Palaeolithic era.[85]

Chronology: Measurement or Allegory?

Chronology is a double exercise, both to compute the periods of time and to assign events to their dates. Any scale of measure may be used to place periods, but an event cannot be graduated as a scale. Being a happening, an event occupies a period of time. All periods are alike in being positions on some scale, and events fill them, but no events are alike in the sense that periods are alike in being empty until occupied by events. Chronology

therefore consists of fixed periods containing variable events. Shall the historian stress periods or events? To give precedence to period disregards the uncertainty of events, but if the events are made to shape the container, the structure of time is denied. Hence chronology is better designated by empty periods than by events in any of them, because their sequence is given by their numbering, and not in an allegorical system, by their contents.

The segmentation of ancient American art remains problematic both in space and time. Separate nomenclatures are in current use for Meso-america (where the European concept of "classic" remains the keystone separating "formative" from "epiclassic" and "postclassic") and the cen-tral Andes (where "horizons," early, middle, and late, are separated by "Early" and "Late Intermediate periods") (fig. 5). All placements in time prior to A.D. 1300 can be regarded as elastic at least in the degree required now by the margin of error used in radiocarbon measurements.[86] Similar vagueness surrounds the spatial relationships of horizon styles. Teoti-huacano and South Maya art both still have defenders of their priority and influence as horizon carriers,[87] all while their geographical extent remains uncertain.

In the near future it is likely that sidereal time in the form of centuries will replace the stages and phases of developmental archaeology, both in Meso-america and the Andes. At present twenty centuries on the south coast of Peru correspond closely to ten periods of Paracas stylistic history and nine periods more of Nazca.[88] In Mesoamerica, Uaxactún–Maya and Tajín pottery periods likewise approximate hundred-year durations each. An-other table by thousand-year intervals separates the nine major "archae-ological and sociocultural stages" between 70,000–30,000 and A.D. 0.[89]

These sociocultural stages and horizons first appeared together (fig. 6) in *Andean Culture History* (New York, 1949), 112, in parts 1 and 2 as written by W. C. Bennett (Bird wrote only part 3 on techniques). The term "horizons" had earlier been used only by A. L. Kroeber.[90] Also to be noted is that Ignacio Marquina applied the term "horizons" to Toltec, Chichi-mec, Olmec, Teotihuacano, and Aztec "spreads" in Mesoamerica (*Ar-quitectura prehispánica* [Mexico, 1951], 19, 56, 145, 164, 180).[91]

Both the archaeological and sociocultural stages in such tabulations (as the Smiths') use events to name periods: lithic, archaic, and classic for archaeology; hunting, tribal, chiefdom, and state for socioculture. These carry seven thousand years with a map of stone projectile–point traditions

	LOWLAND MAYA			HIGHLAND MAYA AND PACIFIC SLOPES	EASTERN CENTRAL AMERICA
	NORTH	SOUTH			
		Pottery	Sculpture		

Left axis (top to bottom):

—1500 POST-CLASSIC

1300

1100

—900 CLASSIC

700

500

300

—100 PRE-CLASSIC

0—

100

300

500

700

900

1100

1300

·1500

Table contents:

Date / Period	NORTH	SOUTH Pottery	SOUTH Sculpture	HIGHLAND MAYA AND PACIFIC SLOPES	EASTERN CENTRAL AMERICA
POST-CLASSIC (1500)		periods (Uaxactún)	(Initial Series)		Coclé
1300	Mayapán			TOHIL	
1100	Chichén III	PLUMBATE			Lake Nicaragua
					Reventazón
900 CLASSIC	LATE PUUC Río Bec Chichén II	TEPEU 3	10.4.0.0.0 = A.D. 909 10.0.0.0.0 = A.D. 830		Ulúa COPADOR Mercedes
700	Edzná EARLY PUUC Becán	TEPEU 2	9.15.0.0.0 = A.D. 731	Cotzumalhuapa	
	Uxmal Chichén I	TEPEU 1	9.10.0.0.0 = A.D. 633	Escuintla	
500	PROTO-PUUC	TZAKOL 3	9.5.0.0.0 = A.D. 534	Kaminaljuyú	
	OXKINTOK	TZAKOL 2	9.0.0.0.0 = A.D. 435	ESPERANZA	Nicoya
300		TZAKOL 1	8.14.0.0.0 = A.D. 317		
100 PRE-CLASSIC		MATZANEL			
0					
100		CHICANEL			
300				Kaminaljuyú MIRAFLORES	
500				Izapa	
700		MAMOM			
900	XE (Seibal)			Kaminaljuyú LAS CHARCAS	
	Dzibilchaltun				
1100					
1300				Chiapa de Corzo I	
				Ocós	
1500					

Figure 5. The still-current periodization for Mesoamerica (*left*) and the Andes (*right*) is mainly anchored upon radiocarbon dates and stratigraphic sequences,

	NORTHERN ANDES		CENTRAL ANDES				
	Colombia	Ecuador	Northern Peru coast highland	Central Peru	Southern Peru and Bolivia coast highland		
1534	CHIBCHA	INCA	INCA			CUZCO	Late Horizon
	Darién		CHIMÚ	CHANCAY	ICA		
			LAMBAYEQUE				
		Esmeraldas					Late Intermediate
1000	QUIMBAYA			Pachacamac			
	Tierradentro			Huari	VIÑAQUE Tiahuanaco		
		Manabí	HUARI		NAZCA 9		
	San Agustín		V MOCHICA	LIMA			Middle Horizon
Integration 500					8	QEYA	
	CALIMA		IV		7		
			III		6		
	TOLIMA				5		
			II				
0					4		
			I		3	Pucará	Early Intermediate
			Recuay		2		
Regional Developmental			SALINAR		1		
500		GUANGALA			PARACAS 10 Chiripa		
					9 Chanapata		
					8		
			CUPISNIQUE		7		
			Moxeke Chavín		6		Early Horizon
			Cerro Sechín		5		
1000					4		
			Huaca de los Reyes		3		
					2		
					1		
Late Formative 1500		CHORRERA	Kotosh				
		MACHALILLA		Chuquitanta			Initial Period
2000							
2500							Preceramic VI
			Huaca Prieta				
Early Formative	Puerto Hormiga	Valdivia					
3000							

but it is weakened by pivoting on the "classic" era with its connotation of a level of quality that was approached and then departed from. (After Kubler, 1984)

37

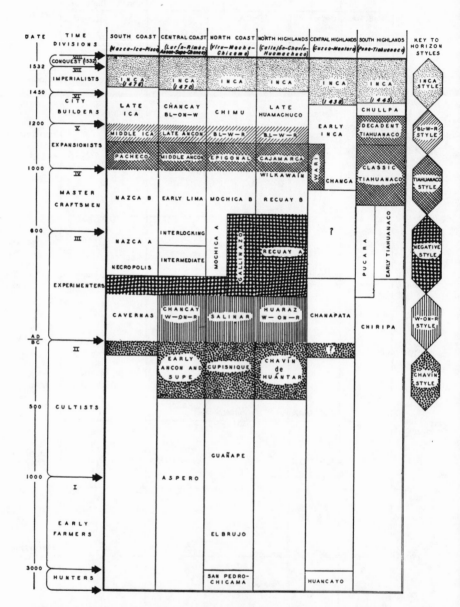

Figure 6. Andean chronology in 1949 (*left*) was still patterned upon the Mesoamerican model of fig. 5, which Rowe altered to a "value-free" sequence in the 1960s (*right*). Both are close to the seriation of historic chronology by

CHRONOLOGICAL TABLE OF THE PERUVIAN COAST

Comments	North Coast	Central Coast	Master Sequence Ica (South Coast)		Relative Chronology
			Ica 10		Colonial Period
nts, bronze tools	Inca Influence	Inca Influence	Inca Influence Ica 9	1500	Late Horizon
	Chimu	Chancay	Ica		Late Intermediate Period
vault				1000	
a jewelry	Derived Huari-Pachacamac	Derived Huari-Pachacamac	Derived Huari-Pachacamac		Middle Horizon
	Huari Influence	Pachacamac Huari Influence	Huari Influence		
lead	V	Nieveria	Nasca	500	
adobes	IV	Moche	Lima		
rtified towns)	III	(Mochica)	(Interlocking)		Early Intermediate Period
	II		Nasca	A.D.	
molds	I	Gallinazo	Miramar (White-on-red)	B.C.	
		Salinar			
ind copper metallurgy	Tembladera (Tecapa)			500	Early Horizon
ad towns		?	Ocucaje (Paracas)		
cities (may be earlier)	Cupisnique (Chavin)	Ancon (Chavin)	Chavin Influence	1000	
				1500	
	Guañape	Haldas	Consuelo		Initial Period
			Erizo	2000	
r (South Coast) (Central Coast)					
temples llamas	Huaca Prieta	Rio Seco (Chuquitanta)	Casavilca	2500	Preceramic
nent buildings cultivated				3000	

CHRONOLOGICAL TABLE OF THE PERUVIAN SIERRA

Relative Chronology	North Ancash	North-Central Ayacucho	South-Central Cuzco	South Puno	Bolivia La Paz
Colonial			Colonial Inca (K'aychi)		
Late Horizon	Inca Influence	Inca Influence	Imperial (Cuzco) Inca	Inca Influence	Inca Influence
Late Intermediate Period	Local Styles	Tanta 'Urqo	Early Inca (K'illki) ↓	Local Styles	"Chullpa"
Middle Horizon	Huari Influence	Huari	Huari Influence	Tiahuanaco	Tiahuanaco
Early Intermediate Period	White-on-red	Huarpa ↓ ?	?	?	Early Tiahuanaco (Qeya)
	Recuay	?		?	
		Derived Chanapata	Pucara		
Early Horizon	? ↑ EF	Ceb Rancha ?	Chanapata		Chiripa
	Chavin	? D C	Marcavalle	Qaluyu	
		Wichqana ?			
		AB			
		! Suc			Huancarani
Initial Period					
Preceramic					

numbered centuries as used in Europe since the medieval era. (After Bennett and Bird)

39

drawn as spreads in time from four origins, arctic, Southwest, Venezuela, and southern Chile. The projectile points, however, are the only evidence (14,000–6000 B.C.) charted on their map, while the table includes events until after the Discovery of America. Such allegorical use of chronology has the merits of poetical condensation and mnemotechnic recall. But it also requires measurement by empty periods such as centuries, years, and days.

The most recent version of the issue is among statisticians using hologeistic (whole earth) methods, which assume the probable presence of cultural diffusion everywhere. This assumption was questioned by Sir Francis Galton in 1889, when Edward Tylor read his paper on laws of marriage and descent. Galton asked only for evidence, which Tylor could not supply, concerning the independence of his observed cross-cultural occurrences. Galton's Problem has persisted to the present without any irrevocable answer, first among cultural anthropologists from Boas to about 1950 and since then among statisticians using "mathematical control factor procedures."[92] J. M. Schaefer repeatedly suggests that "without direct diffusion tests we cannot be certain of the degree to which Galton's Problem is or is not with us in our hologeistic tests."[93] In effect, the problem remains even when a diffusion can be measured.[94] But the problem becomes the hologeistic assumption.

2

Salvaging Amerindian Antiquity

before 1700

Some Early Notices

To APPROACH THE GENERAL historiography of New World events before Columbus as to their esthetic valuation, it is necessary to review surviving efforts before 1700 to salvage American antiquity, beginning with Columbus. Early scholars of the subject follow, who at first were European and only later of Amerindian origin. Most of the former were friars and priests, but only one of the Indian group, Diego Valadés (whose mother is thought to be Tlaxcalan), was allowed to be of religious profession as a Franciscan friar after 1550.

CHRISTOPHER COLUMBUS (1451–1506). Concurrent with Discovery came a rapid inversion of the concepts of old and new worlds. The land trodden by Columbus and his crewmen became suddenly the *Novus Orbis* of Peter Martyr's letters, although sixteenth-century scholars soon declared that its humanity was of the same creation as that of the Book of Genesis and older than the biblical Flood of six thousand years ago, as if "hidden from history"[1] until the arrival of Columbus.

Among many consequences of this sharpened view of the difference between old and new geographies was a rapid shift in the definition of things ancient and new. Old World exports like firearms were regarded by Amerindians at first as intrusions from a newly revealed future and later only as novelties, for which their own very old weapons of stone were

discarded. In these ways the Old World was received as profligately new, and the New came to be seen as obsoletely ancient.

When the "western Indies," as Columbus thought of them, came to be renamed, it was by a German geographer to honor the navigator Amerigo Vespucci.[2] Thus the native universes of Mexican Anahuac and Peruvian Tawantinsuyu and many others receded into antiquity. The island hemisphere was renamed New Spain and New Granada and New Castile, as if the Old World were finding itself new again by consigning Amerindia to the past.

Columbus had the first word when writing to Ferdinand and Isabella of his first landing in 1492 on a tiny island he named San Salvador, that it was "the best and most fertile, temperate, level and excellent in the world."[3] He was in the eastern Bahamas, but he never would know how Waldseemüller would name his discovery the year after Columbus died (1506). The people on it called it Guanahani, and they pleased him too, as he wrote when taking possession for Spain. The young men who swam out to his ships "were well made with handsome bodies and faces, coarse hair like horses' tails cut short and gathered in topknots with uncut locks hanging behind. . . . They neither bear nor know weapons, because when I showed them swords they grasped them by the cutting edge, wounding themselves foolishly" (30–31). Their houses were large *alfaneques,* like tents, but scattered without streets and very clean and well ordered. Many wooden statues of women and well-worked heads (*caratona*) were found. "I do not know whether they regard these as beautiful or for worship" (50, October 29). On October 30 the diary mentions his belief that the land of Cathay was near, where the *Gran Can* would be found.

Such perceptions and notions never left Columbus. In 1498 he thought he had found the land of the Garden of Eden on the shores of the Caribbean Gulf of Paria.[4] But the vivid detail on what he saw gives a measure of his visual acuity and esthetic sensibility. These imprints upon his senses and memory, however, were doubly biased as he wrote, by the need to impress his royal sponsors and by the discovery of the total vulnerability of the natives of Antillia.[5] Columbus himself was a mystic visionary who thought he had discovered the Garden of Eden in the Orinoco basin. He died still thinking he had discovered China.

The awareness among Europeans of a native Amerindian history did not find a base until they began to see and discover calendars, genealogies, chronicles, and cosmologies among Indians not long before 1550. They

had been surrounded by such records in Mexico and Peru since they arrived. Yet serious study had to await the arrival of Spanish missionaries and civil servants capable of discovering and preserving them with help from native scholars.

PETER MARTYR [OF ANGHIERA] (1457–1526). To begin a historiographic account of the esthetic reception of America in Europe with Pedro Martir (as he was known in Spain) is triply justified. He was "the earliest historian of the New World";[6] he was a humanist scholar and teacher from Milan at the Spanish court; and his cumulative account came from Crown correspondence, as he was a high-ranking official of the Council of the Indies, with the title of "royal senator for the Indian matters" in 1519.[7]

He never saw America, but his judgments about reports of "noble savagery" among the Taino and "obscene anthropophagy" among the Carib peoples obliged him to accept both beauty and horror without direct concern for morality, being aware of the relativism of beauty and ugliness.[8] He saw in Valladolid the gifts and Indians sent by Moctezuma to Charles V in 1520,[9] saying that "though I little admire gold and precious stones, I am amazed by the skill and effort making the work exceed the material. . . . I do not recall ever seeing anything so appealing by its beauty (*hermosura*), to human eyes."[10] These remarks are the words of a connoisseur of wide experience. The hurried traveler's notes by Albrecht Dürer about the same things, which he saw at Brussels in the royal palace that year, express similar feelings with less perception, but Dürer adds the information that the disks of gold and silver were of the sun and moon.[11]

Elsewhere Martyr noted that gold in Antillia had "no value as such, but only in so far as it had been worked by artistry in agreeable and durable form."[12] Some natives, he adds, "shared land as they do the sun and water, innocent of mine and thine, content with little, lacking nothing, living in open garden without laws, books or judges, knowing of justice by natural instinct. They consider bad and criminal that which offends others."[13] These raptures of the time of the first voyages yield to horror in the conquest of Mexico, when Martyr tells of human sacrifice at the temple and his "inexpressible disgust and loathsome nausea" in reading of "their eating their victims."[14] Yet whether early or late in the thirty-seven years of his service at court, Peter Martyr's writings display a consistent preference for

agreeable information that will satisfy his esthetic sense as a courtier and collector.[15]

HERNÁN CORTÉS (1485–1547), the New Moses (as he was proclaimed by the Franciscans whom he entrusted with the first stage of the "spiritual conquest" of Mexico),[16] esteemed Aztec newness, grandeur, and strangeness or originality in the skilled artisanship of craftsmen able to achieve a naturalistic representation that also characterized European art in his time (fig. 7). This historical fact was documented by Justino Fernandez, following Ramón Iglesia and L. Villoro.[17]

J. H. Elliott was not concerned with the esthetic awareness of Cortés, other than to mention that his correspondence "gives the impression" of "a man with exceptionally sensitive mental antennae," and to characterize his mental world as "rich in imagination" and "infinitely adaptable,"[18] as he judged by his letters to the emperor. Their purpose is not to tell about his esthetic perception of the beauty of native life, yet he repeatedly describes objects and places with an incisive command of language, betraying rather than parading a vivid sensibility in visual matters.

His visual memory is exceptional, reporting events in unusually detailed impressions of places and things. He notes arrangements of people and minute details of costume. At the first meeting with Moctezuma in Tenochtitlán,[19] he describes the street from the Ixtapalapan causeway to Moctezuma's palace (fig. 7) as being "very wide and beautiful, and so straight that you can see from one end to the other. It is two-thirds of a league long and has on both sides very good and big houses, both dwellings and temples." At the exchange of gifts on the roadway Cortés presented a necklace of pearls and cut glass in return for Moctezuma's two necklaces made from red snails' shells, "which they hold in great esteem; and from each necklace hung eight shrimps of gold almost a span [9 inches] in length."

Later that day other gifts were brought: "various treasures of gold and silver and featherwork, and as many as five or six thousand cotton garments, all very rich and woven and embroidered [fig. 8] in various ways." When accounting to the emperor for the royal fifth of the bullion demanded from Moctezuma's vassals, Cortés mentioned objects saved from melting for the emperor, "modeled . . . with such perfection that they seem almost real."[20] He adds of a dozen blowpipes (flutes) given him by Moctezuma

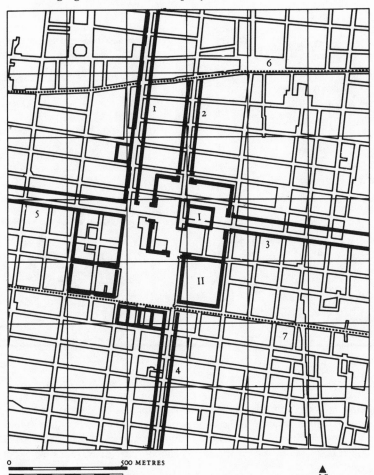

Figure 7. Plan of present center of Mexico City based on excavations and the woodcut published in 1524 as illustrating the letter of Hernán Cortés to Charles V in 1520. The present center of Mexico City is drawn in less thick lines. The Ixtapalapan causeway from the south shore of the lake is number 4. The main temple-pyramid (I) faced west. The walled enclosure shown as a square rampart is doubtful. (After Kubler [1983], 94)

that "they were all painted in . . . all manner of small birds and animals and trees and flowers . . . round their mouth pieces and muzzles was a band of gold . . . finely decorated."[21] His admiration of what he sees is multiplied by his telling it to the emperor.

Much later, on the expedition to Honduras in 1524–25, Cortés wrote

45

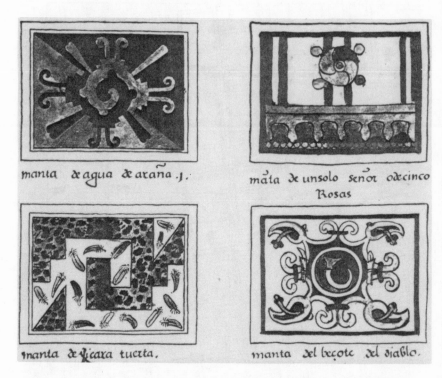

manta æ agua æ araña .j.

mata æ unsolo señor oæcinco Rosas

manta æ ſicara tuerta.

manta æl beçote æl diablo.

Figure 8. Codex Magliabechi. Designs of cotton mantles in reversing fields, of types illustrated also in Codex Tudela. The two manuscripts discuss the same subjects and can be assigned to the same period before 1550. Here the top left mantle is figured with spiders (arañas) arranged in fourfold design. The lower left blanket is figured by a reversing step-design of Aztec date at the time of the Conquest.

of his admiration for craftsmen from Tenochtitlán in building a bridge of tropical hardwoods across a lagoon in the province of Acalán with timbers up to ten fathoms (sixty feet) long, under conditions of starvation. When he promised to reward them most richly on return they "at once began to divide the task between them; and so hard did they work, and so skillfully, that in four days they had finished the bridge . . . made of more than a thousand timbers, of which the smallest is almost as thick as a man's body, from nine to ten fathoms in length, not to mention an immense quantity of lighter timber."[22] These passages are spontaneous records of instantaneous moments, communicated as much for their pleasurable content as for

the practical or political purpose. Cortés never portrays himself at a loss, and he often repeats his admiration for Indian skill and art.

Nothing written by Cortés claims that Moctezuma or the Mexicans thought of him as a long-lost deity, nor does Moctezuma's speech when Cortés first entered Tenochtitlán mention Quetzalcoatl.[23] Moctezuma, however, is reported by Cortés as saying that by ancient writings of their forebears, the Indians learned that they came to this land many years ago, brought to it by a lord who returned to his place of origin (*naturaleza*). He later came back to ask the descendants of his companions to return with him to his country. They refused his demand and his authority and he went away again. Moctezuma's people believed that his descendants would come to conquer this land and them as his vassals. Then Cortés said that he came "from where the sun rises."

The Mexicans believe (the letter goes on) this lord or king who sent him here to be their natural lord, wherefore they obey his commands. In effect, Moctezuma is reported by Cortés as accepting the overlordship of the emperor Charles V. Quetzalcoatl is never mentioned, but this text might have induced Bernal Diaz to suppose the tribal god Huitzilopochtli as the lord Cortés writes about.

Huitzilopochtli in turn was a tribal leader named in the migration histories, of which Bernal Diaz may have heard or read. He represents Moctezuma as laughing when he declared that he had never taken the strangers for gods.[24]

During the siege of Tenochtitlán, Cortés was told at the barricade by Indian envoys that "they held me to be a child of the Sun which, in the short space of one day and one night could make a circuit of the whole earth." He follows this with an Indian's question: "Why did I not slay them all . . . ? for they already wished to die and go to heaven to rest with their Uchilobus, who was awaiting them; for it is the idol whom they most venerate."[25]

The account of writings by Cortés given by Ramón Iglesia[26] places them in context with those of Peter Martyr, Gonzalo Fernández de Oviedo, and Francisco Lopez de Gómara. This *Ciclo de Hernán Cortés* is taken as a historiographical unit directly deriving from the letters to Charles V. Iglesia characterizes the captain's narrative method as sober, serene, and bare; precise and laconic; concerned with external appearances and visible acts. Cortés's esthetic perceptions form a continuous voice in the *Letters*, emerging in his enjoyment of the Mexican landscape and of the native

societies surrounding him. All are described in the same level tone of admiring pleasure in what he saw and valued in Indian life. This he would defend by urging the emperor to send friars rather than priests to shield the Indians from the colonists' rapacity.[27] He wrote that he hoped in October 1520 that the "good will and delight on the part of Moctezuma and all the natives of the aforementioned lands . . . seemed as if *ab initio* they had known your sacred majesty to be their king and rightful lord,"[28] as if Cortés were then thinking of an inclusion of Moctezuma's dominions with those of Spain.

He later had to deploy a campaign of terror to overcome Indian resistance, besieging the city during forty-five days and destroying it to fill in the canals. Yet Cortés said, "Their city . . . was indeed the most beautiful thing in the world."[29]

It is possible that Cortés knew from his former life in the Caribbean islands that the abuses of natives by colonists should be restrained by placing between them the institution of *encomienda* and the pressure of Franciscan missionaries. These moves would strengthen his own base of power with the emperor. Cortés's words in the Fifth Letter[30] speak of himself as a poor *escudero* (squire) who had "put an end to many idolatries" and made possible the appearance of "a new Church, where God, our Lord, may be better served and worshiped than in all the rest of the world."[31]

From the letters addressed by Cortés to the emperor the outlines of his strategy for the colonization of New Spain can be deduced.[32] In 1519–21, "Cortés committed his own personal act of revolt against lawfully constituted authority [in the Antilles], and went on to conquer Mexico for his imperial master,"[33] in an illegal private adventure justified in Cortés's mind by his knowledge of the medieval law he studied in the *Siete Partidas* of Alfonso X.[34] As an act of revolt, Cortés's adventure has been compared to the revolt of the *Comuneros* in Spain.[35]

Yet the role of Cortés was less strategic than governmental, in the sense of constructing a viable colonial society that would correspond to his esthetic awareness of Indian humanity, especially when his actions are compared with those of Gonzalo Sandoval as the military brain or of Alonso Hernando Puertocarrero as the field commander.[36] Cortés's diplomatic achievements until the Noche Triste and his military action in the siege were preparatory to the great work of organizing the Mexican economy on Spanish principles,[37] in a dual society in which both Spanish and

Indian rights were to be defended by the state, under growing opposition from nobility, civil servants, and secular clergy in Spain and in Mexico. This difficult task was interrupted when Cortés left for Spain in 1528.

Indianist Europeans

Indianism applies to the scientific and humanistic study of the pre-Conquest past. Only after the Mexican revolution could such thinkers as Manuel Gamio try to build Indianist policy on archaeology and ethnology. Today the deep Amerindian past appears tangible and datable. The effort to reconstruct its history becomes a measure of the affective value of the ancient remains themselves. Neither a renascence nor a Renaissance of American antiquity is now likely to occur, but it is probable that Indianist studies on many fronts will continue for as long as scholarly efforts are possible.[38]

BARTOLOMÉ DE LAS CASAS (1474–1566), the bishop of Chiapas, appeared to the Franciscans in New Spain as their principal enemy in the Mendicant effort to create in America a church without bishops on a pre-Constantinian model.[39] Motolinia and Mendieta as friars were against the bishop, but they were unaware of his valuable contribution to an early form of cultural anthropology in the *Apologética historia de las Indias*.

Known as the apostle of the Indies, Las Casas wrote this work in 1552–59 to prove the rationality of Amerindians within Aristotelian theory, reinforced by a Dominican missionary's knowledge of Indian life. To him, Indians were only as barbarous "as Spaniards were to Indians."[40] Chapters 61–65 are about the manufactures of laborers and artisans, such as flint-workers, featherworkers, metalworkers, scribes, and woodcarvers, in part with the authority of direct observation. He compares New World practices with those he garnered from Greek, Roman, and biblical writings on the arts of the ancient world, to support his polemical purposes favoring native rule and the preaching of peace. In effect these chapters resemble a rudimentary history of art, taken from firsthand knowledge and from early reports. The order is by regions or provinces of the New World, with Old World parallels and precedents presented merely as such, with no attempt to interpret them as proofs of diffusion. His sources are rarely named, but a profusely illustrated account (perhaps unknown to Las Casas) may typify

the earliest Mendicant efforts to describe the history and ethnography of Mexico.

MARTÍN DE LA CORUÑA (c. 1480–1568), among the Apostolic Twelve arriving in Mexico in 1524,[41] was assigned to the conversion of the Tarascan people. Beginning about 1536, Coruña assembled the pictorial narrative called *Relación de Michoacán*, ending it before 1549.[42] Coruña may have instructed native painters himself in European conventions of narrative illustration, as taught in the Colegio de Santa Cruz at Tlatelolco after 1538.[43] But there is no trace in the narrative of an esthetic concern

Figure 9. Written 1539–41, the *Relación de Michoacán* was compiled by Fray Martín de la Coruña for Viceroy Mendoza. This copy in the Escorial library records pre-Conquest events in Michoacán under Chichimec rule in the lake country among the Purépeche at Zacapu. Here the ruler Tariacuri before 1469 punishes his family for building temples. The action is from right to left, showing the events in separate moments. The forty-four colored drawings are by Indians trained in Franciscan schools, portraying government, warfare, justice, marriage, and Purépeche tribal history. (After *The Chronicles of Michoacán*, trans. and ed. E. R. Craine and R. C. Reindorp [Norman, 1970])

beyond the missionary aim (in his own words) "to polish and adorn these people with new customs."[44] He begins with Tarascan mythology and liturgy, proceeds to political, juridical, and administrative organization, and goes on with the history of the Tarascan people and their conquest by Chichimec tribes in an area surrounding Lake Pátzcuaro. The manuscript is illustrated by another hand or hands, probably Indian, schooled in drawing at the church school in Tzintzuntzán (fig. 9). Many scenes describe Tarascan life and history. It is an inventory in pictures of house-types, temples, musical instruments, weapons, clothing, furniture, and utensils.[45]

ANDRÉS DE OLMOS (1480–1568). In 1528, four years after the Apostolic Twelve arrived, Mexico City received Bishop Zumárraga accompanied by his *íntimo y único compañero,* Fray Andrés de Olmos,[46] who had been with Zumárraga in Vizcaya in 1527 to extirpate witchcraft and sorcery.[47] In Mexico Olmos was stationed at Tepeapulco (1530), Tlatelolco, the Indian settlement of the capital (1533), Hueytlalpa (near Tlaxcala, 1539), and in the Huasteca (1544–68). In these towns and regions Olmos preached in Náhuatl, Totonac, and Huastec languages while carrying out the orders of the *Audiencia* (high court) of Mexico in 1533 to collect the "ancient beliefs of these peoples, especially in Mexico, Texcoco and Tlaxcala."[48] On this long tour of duty it was also his responsibility to investigate slavery before Spanish arrival under native nobility and in relation to tribute.[49]

Olmos may have stimulated the native composition of the *Historia de los mexicanos por sus pinturas* as well as the Codex Tudela (fig. 10), which are believed to anticipate Sahagún's method of interviewing native informants.[50] These sources—one written, the other pictorial—are primary by date and origin for the study of native Mexico. Both relate to esthetic experience in being works about Indian values of life. Olmos interpreted them as witchcraft (*hechicerías*) and sorcery (*sortilegios*), although Ramirez de Fuenleal in 1532 noted that painters, scribes, and singers were exempted from tribute as transmitters of native histories and beliefs.[51]

Like Sahagún's encyclopedic efforts later in the century, Olmos's initiatives with native sources were gathered from a wide variety of traditions, all subjected to mixture without exact identification as to place, time, or informant. Thus the sections illustrating mantles are without provenance

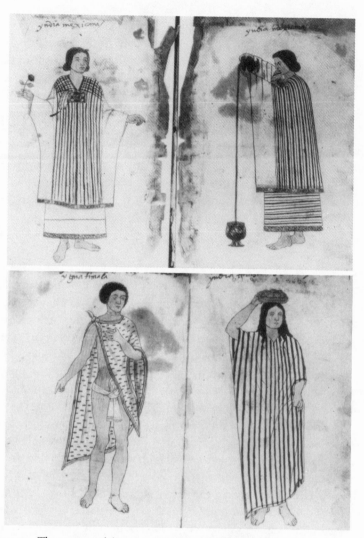

Figure 10. These pages (folios 3, 4, 88) from the Códice del Museo de América in Madrid (known also as Codex Tudela) represent costumes from central Mexico (*top*) and the Guatemala coast and Michoacán (*bottom*). The handwriting is of sixteenth-century date, but the drawings, which can be paired with those of the Codex Magliabechi, differ radically from the rest of the manuscript. The handwriting on the costume sheets is like that of Magliabechi 87 v., explaining the ritual of human-heart sacrifices in the conventional ideographic style of pre-Conquest Mexico. The costume sheets 1–4 were thought by José Tudela to be by Spanish artists ("Las primeras figuras de indios pintadas por Españoles," *Homenaje a Rafael Garcia Granados,* ed. R. Martinez del Rio [Mexico, 1960], 377–88), but present opinion can also regard them, until proved otherwise, as the work of Indians trained by Europeans before 1553 (E. H. Boone, *The Codex Magliabecchiano* [Berkeley, 1983], 87, establishes this date).

or explanation and set forth as in a marketplace for goods from various times and places, in both Tudela and Magliabecchi versions.[52]

TORIBIO PAREDES DE BENAVENTE, MOTOLINIA (c. 1490–1569).

Sixteenth-century Franciscans in Mexico may be divided as to generations: those who were adult before the Conquest and those born after it. The first group was apostolic and millenarian. Motolinia was its moral guide: his aim was to build a promised land under viceregal rule in the expectation of the Last Judgment. The second generation was swept into the Counter-Reformation and its orthodoxy. But the original Apostolic Twelve paved the way for their successors, whose work was cut short when the king and the secular clergy of the bishops after 1570 enforced the ending by the New Laws of 1542 of the colonists' use of Indian labor under the institution of *encomienda*.[53]

The barefoot friars Motolinia and Martín de la Coruña came to Mexico from the Franciscan reformed province of San Gabriel in mountainous northwestern Spain, where isolation and remoteness had long favored the increase of idolatries alien to Catholicism. From this austere group of the Franciscan Order many friars came to New Spain, prepared for their work among Mexican Indians by the labor of bringing neglected mountaineers back to Catholic observance.

While walking barefoot from Vera Cruz to the Valley of Mexico on his arrival in 1524, Fray Toribio heard a Náhuatl word for poor used to describe his barefoot condition and adopted it as his name in Mexico. He also conceived of Mexico as a millenarian Utopia under the secular leadership of Hernán Cortés, whom he called prince and captain general of the Christian conquest and, as noted, the New Moses.[54] Other Franciscans mistrusted Motolinia's dream. Sahagún and Olmos saw Satanism everywhere and the Counter-Reformation as its opponent. But Martín de la Coruña, like Motolinia, and Francisco de Las Navas were awaiting the Last Judgment.

Motolinia was both Las Casas's bitter enemy and, like Las Casas, most understanding of native art and architecture.[55] He was devoted to Hernán Cortés in recognition of the design by Cortés to introduce the Mendicant friars in New Spain, to protect their work as teachers and builders, and to shape them into his structure of command. Both Mendieta (before 1604) and Bernal Diaz (before 1578) tell of the first entry of the Franciscans at Mexico-Tenochtitlán on June 18, 1524, when Cortés knelt to kiss their

hands, followed by Spaniards and many Indian chiefs,[56] in a demonstration preparing the city for Cortés's departure four months later to Honduras, whence he returned in January of 1526.

BERNAL DIAZ DEL CASTILLO (1496–1582/4) was a participant in the Conquest and last of the conquerors to write about it, ending his autobiography between 1566 and 1568.[57] Describing the wonders of Mexico-Tenochtitlán, he mentions three Indian artists: Marcos de Aquino, Juan de la Cruz, and Crespillo, sculptors and painters whom the old soldier compares to Apelles, Michelangelo, or Berruguete.[58] The latest mention of their names changes Marcos to Andrés and adds another Spanish master of Burgos whose name he had forgotten. As the *True History* ended in 1568, this "newly famous" master there was probably Diego de Siloé, who died in 1563 and of whom Bernal Diaz had learned as "another Apelles" when he was in Spain.

BERNARDINO DE SAHAGÚN (1499–1590) outlived all his contemporaries of the first generation before the Conquest. He continued to be guided by attitudes in his order of the time of Cortés as the new Moses. Before 1530 until his death, he was still writing and speaking of the early Franciscan dream. It was of an "autonomous native Mexico under the . . . viceroy, structured and ruled by friars . . . with millenarian and apocalyptic ambitions" to found a "new church based on the pre-Constantine model" rather than upon the metropolitan ecclesiastic "model of episcopal rule and secular clergy."[59]

Modern scholars grant him no special place in history other than as an editor of native sources or as the director from 1547 to 1585 of an encyclopedia formed from materials (fig. 11) supplied by upper-class native informants.[60] But closer to the morality of Sahagún was his belief, expressed in the *prólogos,* that America was the seat of Satan, inhabited by peoples whom God abhorred as his enemies for living in sin, all the while seeking to preserve the "natural laws" of Indian civil polity. Sahagún admired their arts, poetry, and building, their dance and song, their art and industry, but they all were attained as, in his words, "captives of Lucifer in the guise of Tezcatlipoca, by human effort without divine assistance by Christian conversion."[61]

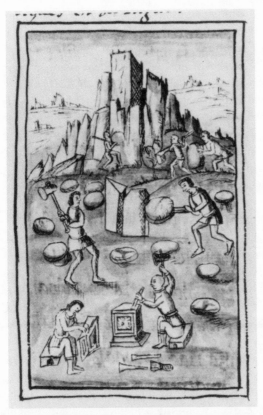

Figure 11. Sahagún (Florentine Codex [1961], bk. 10, 25–28) treats of artisans in general: "The craftsman is well instructed, he is an artisan . . . able, discreet, prudent, resourceful, retentive . . . a willing worker, patient, calm. He works with care, he makes works of skill; he constructs, prepares, arranges, orders, fits, matches." Of stonecutters: "One who works with a wedge; who throws, who swings . . . wiry, powerful, energetic . . . a good builder. . . . He draws plans, devises a house . . . provides footings, builds up a foundation; establishes the corners . . . builds the smoke hole, improves it with clay."

Sahagún's reliance on abundant illustration by native painters trained in church schools continued the method of Fray Martín de la Coruña [de Jesús]. Sahagún is our only source for the native esthetic concepts of *toltecáyotl* and *tolteca* as related to artistry. Others write[62] in support of an origin for these ideas in preclassic Mesoamerica at about the time of the "invention" of the calendar (usually fixed before 500 B.C.). This is the

method known among ethnohistorians as upstreaming, or applying ideas of late origin to early states of thought in the same region. It is questionable when no close continuity of situation can be shown.

Sahagún's chapters on arts and crafts treat mainly of merchants and the wares of craftsmen in markets. There is no distinct perception of esthetic value: thus, workers in metal (*plateros*) "are of little importance either for faith or for virtues, because the work is a merely geometric exercise. . . . As for words or refined expressions one can ask craftsmen, who are everywhere."[63] Sahagún was in search of technical terms in Aztec usage and of the qualities of objects which he saw as under medieval rubrics of the virtues and vices of mankind.[64]

DIEGO DE LANDA (1524–1579), born at Cifuentes in Spain in a family of hidalgo rank, became a Franciscan in 1541 and went as missionary to the newly pacified province of Yucatán in 1549. He was its first *provincial* (chief officer) in 1561, after having served as guardian at Izamal in 1552 and at Mérida in 1560. At Izamal he projected a design "larger than Baalbek" upon a vast Maya platform, assisted by a conquistador turned builder, Fray Juan de Mérida, and competed in 1561. At this time, however, the effects of Christian religion upon native life had led to a recrudescence of idolatry. As *provincial*, Landa was empowered by the civil authorities to investigate with inquisitorial severity, such as torture to obtain evidence, fines, whipping, and imprisonment. Idols and books were destroyed; over one hundred *caciques* and native schoolmasters were arrested and punished.[65] The proofs of apostasy throughout the core of the colony among native church assistants, rulers, and lineages were the main reason for the Spanish destruction of codices and idols. Central to the presence of idolatry were the native priests, who now were *maestros cantores* in the churches and continuing idolatrous sacrifices.[66]

Because of charges that Landa had usurped the prerogative of the bishops, he was ordered in 1563 to stand trial in Spain. Appointed bishop of Yucatán in 1572, he returned to preach abolition of the use of Indians to bear burdens, incurring the enmity of the *encomenderos* (Spanish colonists). But during the long residence in Spain he had written the *Relación* as part of his defense in 1565 and 1566. It is the coeval basis of knowledge about sixteenth-century Maya life and society, supported by native infor-

mants and Landa's expert control of Maya language.[67] Unlike Sahagún shredding the work of his Mexican informants into the mold of a medieval encyclopedia,[68] Landa was confined to the information given him by three informants, Juan Cocom, Jorge Xiu, and Gaspar Antonio Chi, who magnified their roles in the history of Mayapán, Chichén Itzá, and Uxmal, where their lineages had long been established.[69]

The only text of Landa's *Relación* is in Madrid at the Academia de Historia. Discovered by Brasseur in 1863, it is in a seventeenth-century handwriting that postdates Landa's death by thirty years. The text is in disorder, consisting of discrete sections as in Tozzer's edition of 1941: section 1 (pages 3–16) is about Spaniards in Yucatán from 1511 to 1518. Section 2 (17–46) begins by enumerating Indian towns in relation to their Spanish administrative centers called Salamanca, Valladolid, Mérida, and Campeche and praises the "beautiful buildings" as being of stone hewn without metal. Chichén Itzá and Mayapán are described and chronicled as being of Cocom and Xiu rulership until a hurricane and pestilence (41). Section 3 (46–80) relates the conquest years from 1519 to 1562, telling of the Montejo campaigns.

Landa's horror at Spanish cruelties to Indians without Montejo's knowledge (59–62) precedes a section (62–70) repeating his admiration of Indian townlife and praising the Montejo government. Sections 4 and 5 (80–85) explain the hostility between Bishop Toral and Landa as Franciscan *provincial* after 1562. Section 6 (85) reverts to Indian housebuilding and continues with Indian sociology (91–132). Section 7 (132–69) deals with calendar and writings. Section 8 (170–84) continues the theme of arts among Indians: the "beautiful" architecture and sculpture (170–71) and descriptions with pen-and-ink illustrations of buildings at Izamal, Tihoo (Mérida), Tecoh, and Chichén Itzá (Castillo and Cenote). Section 9 (184–86) is thought by Tozzer to be the work of another author. Entitled "For what purposes the Indians made other sacrifices," Landa deplores "such miseries," leaving them quickly to make a long prayer to God (185–86). Section 10 (186–205) reverts to the beginning: the geography and natural history of Yucatán. Section 11 (205–08) recapitulates the gains to Indians from Spain, ending with Landa's skepticism about Christianity having preceded Spain to America (207–08).

Seen in this segmentation, the *Relación* falls apart into portions that may reflect Landa's preparations to defend his case before the Council of

the Indies at Madrid. His success is proven by his consecration as bishop of Yucatán in 1572 and return to Yucatán with thirty friars "whom his friend Philip II had allotted him."[70]

As to Sahagún and Landa, their contrasted positions as encyclopedist and trial lawyer are similar in being complementary, each defining part of the same reality. Though both Sahagún and Landa began as Franciscan friars, Landa became bishop of Yucatán at the age of forty-eight. During the years when the Franciscan mission was under attack, he could as bishop also belong to the secular clergy under the rule of the papacy. Thus he could shift between humble Franciscan authority to the more powerful institutions of the Church and papacy. He belonged to a later generation, being

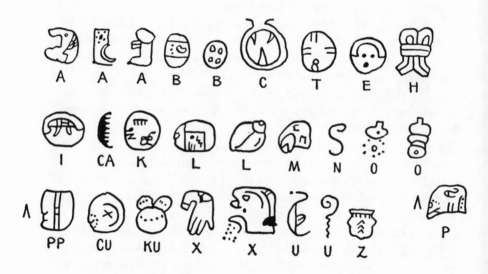

Figure 12. Landa's attempt (1562–66) to correlate Maya glyphs with the Spanish alphabet was rejected until this century, although Landa knew it was defective and that Maya writing had not only letters but also aspirants, characters, figures, and signs. Yet Landa's alphabet points the way to a phonetic decipherment that was not carried farther until this century with the work of Y. Knorozov in Russia (*American Antiquity* 23 [1958]: 284–91). The drawing of the plan of the Castillo at Chichén Itzá (if it is by Landa) reflects an imperfect memory of the square plan of nine terraces with sharply rounded corners and four stairways.

twenty-five years younger than Sahagún. As a Franciscan he had missed the severe training of the earlier generation in Spain among the northern mountaineers. Many of these had relapsed into idolatry, as the result of neglect by the secular clergy. The hardy friars from northwest Spain could not be replaced after 1550, for there were no more like them in Spain.

If Sahagún belonged to a more gentle generation of missionaries, Landa's was more brutal in its exercise of religious authority. The contrasts between these men outweigh their resemblances as Franciscans. Sahagún became more and more an encyclopedist,[71] seeking to compress all he had observed into the medieval Christian system of cognition. But Landa of the *Relación* resembles a lawyer pleading for exemption from the grave charges against him. Accused of usurping the authority of a bishop, he was exonerated when the king made him bishop after his nine-year trial. The *Relación* was his defense, and it gleams with the light of his penetrating understanding of Maya life. Its clearest proof is in his alone having conveyed a key to the phonetic structure of Maya writing (fig. 12). This was a result of his control of the language and of his empathy with the people who were his informants.

JERÓNIMO DE MENDIETA (1525–1604). The early friars born before 1500 had no models to guide them in their writings about Amerindia, but those born after the Conquest arrived when their predecessors had already fixed on ways of writing New World history that would mold the younger writers. Mendieta's debts to Olmos, Motolinia, and Las Casas account for much of the information he incorporated in his own version of 1604.[72] Yet Mendieta's sensibility differs from the others' in its "serenity,"[73] not unlike that of Garcilaso in Spain writing about Peru. Francisco de Solano reproduced Mendieta's copies in pen and ink of the engravings by Diego Valadés, adding more scenes in the style of Valadés[74] (see fig. 16). Mendieta and Valadés were together in 1572 in Spain at Vitoria, the birthplace of Mendieta. There Valadés persuaded the Spaniard to return to Mexico.[75]

Mendieta's *Historia* (1604) gives his policy for Indian Mexico, urging the Crown to continue the doctrine of the coming millennial kingdom as propounded by Motolinia. The main points were for continuing support by the Crown to the Mendicant Orders; increased separation of Indian from Spanish towns; exemptions from tribute for Indian chiefs (*prin-*

cipales), minors, for the ill and wounded, and for elders over sixty and poor widows. These millenarian aims recall Motolinia's in 1540. Yet Mendieta, using drawings by Valadés of 1576, shows how rapidly and how far the best-informed European friends of the Indian had departed from exact knowledge of the Indian past. Their figural schemes fail to remember the actual look of Mexico untouched by Spain, or as it was a generation before their birth dates.

JOSÉ DE ACOSTA (1539/40–1600). By his work in both Peru (1572–81) and Mexico (1586) this Jesuit wrote the *Historia natural y moral de las Indias*.[76] Acosta was everywhere both reasonable and doctrinally correct, thereby reaching a large public continuing to the present without major censure. As to Amerindian origins, he suggested a migration by their still unknown land bridges and not by sea or Atlantis, nor by a Hebrew tribe.[77] From beginning to end Acosta viewed the hemisphere as a unit composed of separate peoples[78] worshiping natural, man-made idols, and he repeatedly compares and contrasts Andean with Mexican practices. The peopling of the New World was possibly from Asia, Europe, and Africa, through the use of simple ships (*pobres barcos*) permitting men and wild animals (*fieras*) to pass over.[79]

Acosta's scale of time was biblical and counted from the Flood.[80] Into its few millennia he fitted a scheme of cultural development from a "pandemonium" of "barbarous" tribes, as in Brazil and Florida,[81] to *behetrías* (free communes), to monarchy, and finally, tyranny. He presented this scheme as fitting both Mexican and Peruvian history as well as tribes in North and South America.

His esthetic sense is present within Catholic doctrine and Jesuit teaching: works of art soon "tire the eyes," while those of God in nature "delight forever."[82] In addition Acosta's praises of God's planning display a theological awe that corresponds to the esthetic perception of sublime subjects, as of the first migration to America: "That which seems chance to us was ordered by God's most deliberate thought."[83]

When Acosta was in Mexico he learned by hearsay that rather than continue human sacrifice the Indians had accepted Christianity, thus "defying the ingenuity" of Satan.[84] He later defends the ethnographic studies of missionaries, who by "penetrating their secrets, their style and former government . . . could form a judgment of how much order and reason

were among them," as exemplified by their superior lunar calendar marked by twelve columns surrounding the city of Cuzco.[85] His extended comparison of Inca and Aztec polities in books VI and VII anticipates the nineteenth-century discussion of the state as a work of art[86] by his many-sided esthetic appreciation of these modes of Amerindian civilization.

DIEGO DURÁN (C. 1547–1587/8). Born in Sevilla, this major chronicler arrived in Mexico as a child, learned the "classic" Náhuatl of Texcoco, and went to Oaxaca as a Dominican friar. Returned to the Valley of Mexico in 1565, he began his *Historia de las Indias de Nueva España* after 1574, finishing it in 1581.[87]

The work is divided as three books, reflecting the working missionary's daily concerns when policing unconverted Indian beliefs: (1) gods, cults, ceremonies, (2) native calendars, (3) the festivals. The form is more narrative than systematic, being based on direct observations in Oaxaca and the Valley of Mexico. He shows little interest in esthetic matters, although his many references to jewelry and costume and to temples, dance, and theater serve to describe Indian ritual life (fig. 13) more than to prove esthetic excellence.[88] Durán himself estimated his book as "pleasant and gratifying."[89] His account is exceptionally rich in native terms, as he was probably as fluent in Náhuatl as in Spanish. Garibay's vocabularies[90] show his interests as being in myth, ritual, and history, but no native term is used for its esthetic value alone.

Yet as a Dominican he was concerned with defending the ornamental richness of the churches built by his order in the bishoprics of Oaxaca and Mexico. At one point he praises the beauty of Aztec temples, justified by his fear of those colonists who say that a "small, squat adobe Church is enough for our God."[91] Later on he brings out the distinction between "superstition" and "ancient custom," noting that the latter is "now permitted," that is, to "decorate churches with foliage and adorn them with bouquets, flowers and grass."[92]

Throughout his work Durán returns to the theme of the apostle Thomas in America. He identifies him with Huemac, the high priest at Tula, persecuted by Tezcatlipoca and prophesying the Spanish advent.[93] Describing rituals, he is unable to refrain from admiration, as among the Tlalhuica of Cuernavaca, where he mentions dances revering an unnamed god of dance, taken by Durán as a token of the "native sense of order and

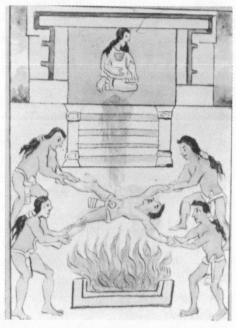

Figure 13. The Dominican Fray Diego Durán (born in Sevilla in 1537) never witnessed the ritual he described here: the goddess Cihuacoatl was kept in a dark chamber called Place of Blackness (Tlillan), but the people saw only her impersonator. She too was sacrificed with male captives in public. Durán assembled these details about 1575 to appear as loathsome caricatures of Christian ritual, used for the extirpation of idolatry: in his words, "Our own religious practices are different from the old since they are light and tender" (251). (After Durán, *Book of the Gods and Rites*, trans. and ed. F. Horcasitas and D. Heyden [Norman, 1971])

beauty."[94] M. León-Portilla, who introduced the English translation, wrote of Durán's "otherness," in being able both "to uproot the diabolical arts and show at the same time the positive aspects and the innate goodness of the ancient peoples."[95]

JUAN DE TORQUEMADA (C. 1557–1624) was of the second Franciscan generation, when the millenarian hopes of the early Franciscans in Mexico weakened after episcopal rule extended over the Indian communities. Mendicant authority was uncontested there until the New Laws of 1542. The rights of *encomenderos* to the labor of Indians were then abro-

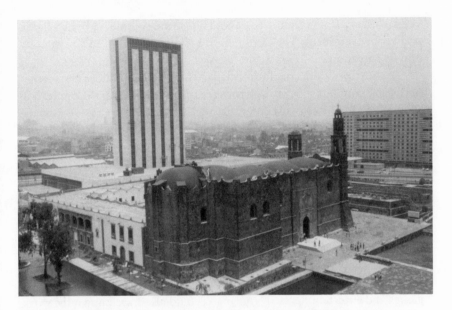

Figure 14. The Franciscan church of Santiago in Tlatelolco (the Indian ward of Mexico City) adjoined the Colegio de Santa Cruz, founded in 1533 as a school of higher studies for Indians. At the time Fray Juan de Torquemada rebuilt the church, before 1609, the Colegio housed between two and three hundred Indian pupils and still existed in 1728 (Kubler, *Mexican Architecture* (1948), 1: 219–20). View from northeast, overlooking the excavations of the marketplace of pre-Conquest Tlatelolco at the Plaza de las Tres Culturas. Photo c. 1965. (Photograph Collection, Art Library, Yale University)

gated, and secular priests began to replace the friars more widely in the bishoprics and more deeply in the towns built under Mendicant supervision. The process was gradual, and it returned the friars either to monastic seclusion or to missionary activity among still-unconverted peoples in marginal areas such as New Mexico, then California in the eighteenth century. Mendieta and Torquemada were among the last eyewitnesses to write histories of the Franciscan sixteenth-century "spiritual conquest" of Mexico.

Torquemada's method was to bring "to light all the things with which they [the Indians] preserved themselves in their gentile republics, and which excuse them from the charges of bestiality given them by our Spaniards."[96] He arrived in Mexico from Spain between 1562 and 1567 as a child and became a Franciscan friar in 1582. Nine years later he began to write an

Indian history from creation to 1600. His second volume is about religion and civil government. The third tells of Indian conversion to Christianity and its spread in the New World.[97]

As to esthetic concern, Torquemada was active as a builder of churches and water conduits, but his efforts were more practical than theoretical, in rebuilding the church of his order (fig. 14) in Tlatelolco (1603–10) and the causeways to Guadalupe and Chapultepec.[98] His method of comparing civilizations in Old and New Worlds may echo the work of Jerónimo Román (c. 1539–c. 1597), an Augustinian whose *Repúblicas de Indias*[99] is a comparative study of non-Christian peoples in ten books. Five are given to the Indies, three to India, one each to Turkey, Tunis, and Fez. European states are included in the edition of 1595 (Venice, Genoa, Switzerland, Lucca, and England) as well as Muscovy, Tartaria, and China. The sequence of topics in both editions repeats with each *república:* (1) religion and gods, (2, 3) ritual and priests, (4) princes, kings, (5) origin of laws, (6) wars, (7) literature and science, (8, 9) liberal and mechanical arts, (10) games and entertainments. Torquemada could also have known the work of José de Acosta, the Jesuit historian, first appearing in 1588 in Latin but written in Peru. Torquemada's European typology of governments as monarchy, oligarchy, and democracy[100] lacks relevance to Amerindian peoples.

If we compare Mendieta with Torquemada, Mendieta's was the expiring voice of Mendicant millennial aspirations, still clearly audible in Torquemada's nearly verbatim incorporation of Mendieta's words on the ecclesiastical history of New Spain. Torquemada omitted some chapters[101] of criticism of factions in Mexico with whom Torquemada, as a moderate, wished to make peace, choosing a role as the "chronicler of chronicles."[102]

In effect Torquemada was among the new voices seeking to prove (like Vico in 1724) that natural reason led to parallel developments in recognizable sequence throughout the history of the world, as exemplified by supernaturals with similar functions in Aztec Mexico and ancient Rome such as Huitzilopochtli–Mars; Tezcatlipoca–Jupiter; Tlaloc–Neptune[103] (ideas he could have read in Román or Acosta).

GREGORIO GARCIA (1575?–1627). A Dominican latecomer to America among the early Mendicants, Fray Gregorio arrived in 1592, spending nine years in Peru, interrupted by a visit to Mexico in 1597, and

returning to Spain in 1604. His book[104] patiently argued about twenty-three opinions he collected on the origins of Amerindian peoples. His criteria were "science, opinion, divine faith and human faith," leading him to accept only a theory of "multiple" origins (including Hebrew, Carthaginian, and Roman migrations) by comparing Virgil's descriptions of paintings in Carthage with those of Mexico and Peru,[105] as well as buildings in Yucatán and Chiapas and at Huamanga [Ayacucho] and Tiahuanaco in the Andes. In fact, he mentions almost as many sites in America as Kugler three centuries later.[106] Other sites he knew of were Isla de Mujeres, Teotihuacán, Ocosingo, Viñaque, and Cuzco. Like B. Arias Montano in Spain but contrary to Acosta, he believed that biblical Ophir was Peru[107] and that the Carthaginians had populated Antillia. Others were the lost tribes of Israel and those from Ophir, Atlantis, Greece, China, and Tartary. His reasons in America were the many languages, modes of travel, customs, laws, rites, and ceremonies, as well as their knowledge of the Creation, Flood, and of Satan. He concludes with Indians' own accounts of their origins in North America, the Antilles, and South America, as based on memory more than on writing, and as distorted by fantasy as well as guided by Satan. F. Pease brings out Garcia's concern with the evangelization of America by St. Thomas.[108]

Garcia pays little attention to pre-Columbian art, but he attributes the ancient cities he cited from Herrera, Cieza, and Acosta[109] to Carthaginian influence. He gives no evidence that he had seen any of them. Garcia's method was "scripturist," unlike Acosta's more "historiographic" approach.[110] Garcia's work prefigures the diffusional broth of recent years.[111]

ANTONIO DE REMESAL (OBIT 1619). As an early Indianist in Guatemala, Remesal was Las Casas's Dominican disciple who suffered censorship, imprisonment, and exile for his Lascasian ideals.[112] He wrote in 1617 a remarkable passage saying that as Indian idolatry had been "extirpated," he no longer needed to discuss the subject.[113] He says that the Dominicans had been "most perfect carpenters" in fashioning these natives as Christians in a labor long since accomplished. The passage has a parallel in Peru (and there are others to be found) in a manual printed for the use of parish priests in 1667.[114] Both texts depended upon an old scholastic distinction between idolatry and superstition that was useful to missionaries in America, with the difference that in Peru Christianization

was delayed until the 1570s by neo-Inca resistance to the Conquest,[115] as well as by the civil war between Spaniards.

Not all Indianists were favorable to Indians. Hernando Ruiz de Alarcón (1587?–1646?) began writing as an ecclesiastical judge about 1617.[116] When Ruiz mentions idolatry it is only about the worship of fire, narcotic plants, or natural features such as mountains and the sun. All the rest is about superstitions, charms, spells, and sorceries. Thus an offering made to no assumed divinity was regarded as superstitious and as only a venial sin. The main issue was one of divine essence: as long as the objects of worship partook of divinity, their worshipers were not Christians. When natives accepted Christianity, however, native religion ceased, although native ritual was still known to preserve pre-Conquest observances.

FERNANDO DE MONTESINOS (ACTIVE 1629–1644), an Andalusian scholar from Osuña whose knowledge of metallurgy qualified him to travel from Quito to Potosí on mining business, was in Peru from 1629 to 1644.[117] His history of ancient Peru came in part from works by Blas Valera SJ,[118] a mestizo author whom Garcilaso also used freely in many passages of the *Comentarios*.

Valera was the mestizo son of a conquistador by Francisca Perez, an Indian woman of Chachapoyas. Entering the Jesuit school in Lima, he was ordained in Cuzco c. 1574. His activity in Peru ceased in 1590 on his being transferred to Cádiz.[119] As noted by M. Gonzalez de la Rosa, Valera was partial to the Indian cause and critical of Spanish actions, both as mestizo and as a missionary. It is unlikely that he wrote the passages cited as by him, which closely resemble the *Memorias* by Montesinos. These passages are actually known only in the excerpt by Juan Anello Oliva SJ.[120]

Thus both Montesinos and Valera knew of such a lost tradition that would predate Valera's departure from Cádiz in 1590. That tradition antedates Montesinos's presence in Peru, but it is discordant with all other records, finding little approval except among two records, by North American scholars of Andean history.[121] Marcos Jiménez de la Espada in Madrid carefully edited the book which Montesinos claimed as his. In his preface, Jiménez notes that the text amplifies Peruvian history to 103 rulers instead of the usual 13, and the tone of the book as a whole reminded him "of a sort of Old Testament."[122]

The chronology Montesinos presents as his expands Andean time to forty-five thousand years instead of Garcilaso's four hundred, and it was taken from Blas Valera,[123] whose sources for the expansion are still unknown. The linkage from Montesinos leads to Blas Valera, but the Jesuit may have adapted a tradition for which we have no other source than the one current in Mexico as the "legend of the suns."[124]

The frame of time used in these colonial adaptations of the Mesoamerican system is constructed by the Peruvian texts as successive ages of creation of "suns," each ending by a cataclysm (flood, fire, quake, sin) on a thousand-year scale, as in the Old Testament, and marked by nine *pachacuti* (four world renewals, each millenary, and five half-millennial "reforms").[125]

Garcilaso tried to conciliate Indian with Spaniard, but in his generation were others to whom Spain was vile and Amerindia noble. These are Blas Valera and Guaman Poma, who were also mestizos in Spanish life, both related to origins in Chachapoyas. Blas Valera is the more difficult to know, as part of his papers disappeared in 1596 when the English sacked Cádiz. But Guaman Poma had the rare luck that his manuscript was preserved in Copenhagen[126] and was studied in many languages.

JUAN DE PALAFOX Y MENDOZA (1600–1659) was at the top of the hierarchy in New Spain, as the godson of the Conde-Duque de Olivares. He came to Mexico in 1640 as bishop of Puebla and served as viceroy in 1642. Being a committed admirer of Indian life, he wrote a treatise he entitled the *Naturaleza del indio* in 1649[127] and founded the Colegio de San Pedro in Puebla in 1648, where Indians studied with Spanish children and were admitted to teaching posts and scholarships.[128]

The *Naturaleza del indio* was written for the instruction of his successor as viceroy. In it he explains that New Spain and Peru were as "a single birth of twin brothers born of one womb at the same instant and hour . . . and resembling each other in innumerable ways."[129] Of the Western hemisphere he says that America alone has been "a virgin most fecund and constant among the continents in Catholic faith." Of the Indians he notes, "Their patience, tolerance, obedience and poverty do not come from lack of intelligence, for Indians speak with discretion and elegance, alert and ready, industrious, just, brave, humble, courteous, clever and cleanly, but not without thieves and drunkards among them."

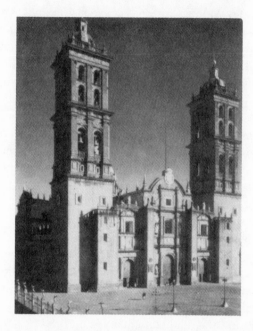

Figure 15. Cathedral, Puebla, Mexico. Begun in 1575 on a plan with four towers as a hall church of nave and two aisles all of equal height, the design was altered in 1634 to resemble the Cathedral of Mexico City and was completed in 1649 by Bishop Palafox. He also began a cloister in the front that was later destroyed to leave the present paved parterre. (Manuel Toussaint, *Colonial Art in Mexico,* trans. and ed. E. Wilder Weismann [Austin, 1967], 183–84)

One chapter is given to "Indian industriousness, especially in the mechanical arts." Here he speaks with the authority of a builder, having erected the Milagro church below Cacaxtla in 1631 and brought the cathedral of Puebla (fig. 15) to completion by 1649 before his return to Spain. The chapter on Indian arts cites an Indian at the cathedral nicknamed Seven Crafts because of his mastery of them all: a Tarascan who built an organ of European design in six days with wooden pipes and others of metal pipes; their village choirs of voices and instruments comparable to those of cathedrals in Europe; their skill in "surgery with lancets of stone" [obsidian].

CARLOS DE SIGÜENZA Y GÓNGORA (1645–1700). At the mid-seventeenth century, a generation of scholars both native and European appeared, to whom America had become ancient in all meanings. It

now became a theme for historical study among a new group who can be called Indianists in all parts of Latin America. Sigüenza was the best placed among them by birth, ability, and access to Indian histories. A nephew of the Spanish poet Luis de Góngora y Argote and of the governor of New Mexico (Domingo Cruzate y Góngora, born in New Spain), Carlos was a creole, received as a Jesuit novice in 1660 (but expelled for reasons unknown in 1668), professor of astrology and mathematics in 1672, and royal cosmographer in 1680. His studies of ancient America began in 1668, when he knew the family of Fernando de Alva Ixtlilxóchitl and his library, which became his before 1689.[130] With these papers by Tezozomoc, Chimalpain, Juan de Pomar, Gutierrez de Santa Clara, Zurita, and Bishop Zumárraga, Sigüenza wrote a Chichimec history (lost), *Phoenix of the West* (lost), and histories of the Indians of Texas and New Mexico, as well as an account of his voyage to Florida in 1693.

That the cosmography of Gutierrez de Santa Clara affected him is shown by his view that the first Mexicans entered America soon after the biblical Flood, being thus of an antiquity like that of the peoples of Europe not long after Creation. In 1680, for the arrival of the new viceroy (Conde de Paredes), Sigüenza devised a program for decorating a triumphal arch in Mexico as customary, but his program substituted painted figures of Aztec emperors for the usual classical allegories.[131] The emperors' portraits (now lost) were explained in verses. The whole design, ninety feet high and scanned by classical orders, was Sigüenza's, including the "hieroglyphs" and "emblems."[132]

The Aztec emperors all wore feathered robes. Acamapichtli, "elected" in "A.D. 361 on May 3" (a mythological date), was shown cutting reeds in the lake of Mexico to enlarge the island of Tenochtitlán, as the allegory of Patience and Hope under the tyranny of the mainland Tepanecs and Culhuas. Hope shows Fame a humble hut of reeds for her to crown it with laurels (75). Huitzilihuitl appears as a giver of laws (85). Chimalpopocatzín (93) appears protecting Mexico from lightning as a martyr freeing his country. Itzcouatl (102) the Prudent, strong as a serpent, is shown reclining on a globe entwined by the snake. Motecuzoma Ilhuica I hurls a spear to the sky near a flaming altar. Axayacatzín (16) is shown bearing a globe on his shoulders and crowned for resisting the rebellion of Moquihuix, his brother-in-law. Tiçoctzin (120), who was martyred for his peaceful reign, appears between Peace and War among brambles wounding his legs. Ahuitzol (124), the waterbringer in aqueducts, is accompanied by an otter with the city of Mexico painted as flooded and Ahuitzol sinking, but the

elders ashore consult Wisdom, and the council gives him a hand to save him. Motecuzoma Xocoyotzín (128) takes pearls, silver, and gold from a lion's mouth to scatter them. Cuitlahuatzín (134) appears on the Noche Triste (August 19, 1520) in the attitude of Alexander and the Gordian Knot. Quauhtemoc, as falling eagle (137), is shown on a column attacked by War, Hunger, and Death.[133]

Other figures and verses explained the ancient history of America: Neptune was shown as descended from Noah as great-grandson and *Progenitor de los Indios Occidentales*. The triumphal archway was fifty feet wide and twelve feet deep, scanned by *Hermathenas Aticas* and *Bichas Persicas* on the ground level among cornucopias and winged figures, all designed by Sigüenza, whose knowledge of the history of painting in New Spain is revealed in his *Parayso occidental* of 1684.[134] Jacques Lafaye said of this triumphal arch, customary in the viceregal world for over two centuries, that it was "nothing less than a revolution to substitute for the traditional quasi-sacred Greco-Latin mythology the mythology of the Mexican Indians." But it was unprotested by the new viceroy, the Conde de Paredes, whose arrival the archway celebrated in a "sudden appearance" of "indigenist sentiment."[135]

The same arch was used again, and more appropriately, on December 18, 1696, for the entry of another viceroy in Mexico City, the Conde de Moctezuma y Tula[136] (José Sarmiento y Valladares), who governed when Sigüenza joined the expedition to Pensacola Bay. The viceregal archway of the Aztec emperors shows Sigüenza's ascendancy at court in Mexico, and it is the measure of his influence in altering the status of Aztec history under viceregal rule.

But four years earlier, when Indian and mestizo rioters, angered by famines, sacked and burned the viceregal palace in June 1692, Sigüenza did not support their cause, recommending as a remedy the separation of Spanish and Indian populations[137] in a prefiguration of South African apartheid. He wrote of the Indians as "ungrateful, grumbling and restless peoples" plotting "to destroy the Viceroy and his Palace."[138]

The famine returned in March 1697 when the Conde de Moctezuma had been in office for four months. Five years after the riots of 1692, the Zócalo at the palace filled with rioters demanding bread, and the viceroy ordered troops with mortars to occupy the streets entering the plaza while his emissaries calmed the people with promises of wheat and maize until harvest in May.[139]

Sigüenza, besides traveling to Florida, corresponded on scientific and historical matters with colleagues in Europe and America such as Kircher (Rome), Caramuel (Milan), and Cassini (Florence), who valued his Indianophile views.[140] After the voyage to Pensacola, Sigüenza's health failed, and in 1699 his actions in Florida were investigated by a viceregal commission.[141] He died in 1700 without any action having been taken by Viceroy Sarmiento, the Conde de Moctezuma y Tula.

Indian Historians

In retrospect, while the Mendicants promoted the recognition of the Old World art by Indians, their work also prepared Indians to recognize the esthetic merit of the art of the New World before the Conquest.

Before 1650 most historians of Indian birth were descendants of the powerful families that had ruled in ancient America. Ixtlilxóchitl, claiming descent from Nezahualpilli in Texcoco, listed eight of them,[142] most of whom had been schooled by Mendicant teachers. The existing corpus of ethnohistorical information about ancient America is mostly the work of such informants and historians.[143]

HERNANDO ALVARADO TEZOZOMOC (1520–1609), author of the *Crónica mexicana,* written about 1598, used another native history compiled in Náhuatl about 1536–39, now lost, called Crónica X.[144] Tezozomoc wrote from the point of view of Tenochtitlán, although his family bias was Tepanec of Atzcapotzalco at the beginning, and Mexica after the Tenochca ascendancy under Itzcouatl, whose imperial style he describes.[145] Being a grandson of Motecuzoma II and of Tezozomoc Acolnahuacatl of Atzcapotzalco,[146] he sought to represent both Tepanec and Mexica interests in a history saturated with native values and terms. Stressed throughout is the usual Mexican commercial strategy shared among the competing rulers in the valley, a strategy of sending envoys to infiltrate hitherto uncolonized neighbors, followed by trade relations. When these provoked resistance, military invasion was followed by colonization with settlers sent from the valley.

The *Crónica mexicana* describes many works of public art and reasons for their existence in a language with indigenous overtones suggesting the survival of recitals learned in religious schools (*calmecac*) for the training

of students of the ruling class. For example, when the Xochimilca uprising was defeated in the reign of Itzcoatl, the stone causeway (later used by Cortés in 1519) to the capital was built as a reparation, ninety feet wide, and the people of Cuitlahuac nearby were ordered to supply girl dancers and singers.[147]

A later campaign in the Huaxteca brought booty and tribute as well as draft laborers to rebuild the main temple with a revetment of cut stone rising 360 steps, and an amplification of the approach court. A *rodezna,* or millstone (possibly like the Tizoc stone of a later reign), was installed facing an image of Huitzilopochtli.[148] Motecuzoma I maintained sumptuous dress, jewelry, and table, and he furnished the north building (excavated in 1980–81) with statues brought from the provinces.[149] His portrait was carved on the cliff at Chapultepec.

But Tezozomoc's approval of splendor in Tenochtitlán dwindled as he recorded the rise of the *Cihuacoatl,* or war leader, to a power greater than the ruler's after the death of the elder Motecuzoma.[150] The great temple was whitened to make it visible from afar,[151] when the strategic importance of craftsmen and artisans to the state in its merchant penetration of unaligned states became important. Tezozomoc's awareness of art as part of government was acute and it may be more indigenous than European.

DIEGO VALADÉS (1533–AFTER 1582). Like Garcilaso, his younger contemporary, this son of an Indian mother became a resident in Europe. But Valadés was an artist and Latinist writing a book in Europe on the art of rhetoric, illustrated with copperplate engravings of his own design and signed by him (see fig. 16).[152] Palomera places him aged twelve in the church school at Mexico–Tenochtitlán under Pedro de Gante, whom Valadés twice portrayed among crowds.[153] After eight years of studies as a Franciscan friar, he was ordained. Sent to Zacatecas and Durango to pacify and convert Chichimeca hunting tribes from 1558 to 1562, he portrayed himself in two episodes.[154]

Returning to Mexico City, he spent eight years teaching in schools before leaving for Europe. He was emissary of his order in Rome, 1575–1577, and its legal representative (*procurador general*) at the Vatican.[155] As an artist his work is known only by his engravings in *Rhetorica cristiana.* These display at least seven different manners among its twenty-eight plates. They are the earliest published visual records of the evangelization of

Mexico. Some may have been based on Motolinia's written account of 1538–42.

Palomera and F. de la Maza both depart from the order given by Valadés in his placing of the engravings. Both differ as to the meanings when Valadés gave no short title.[156] Thus Valadés plainly labeled the scene of the pyramid by the lake (13) as *Tipus sacrificiorum,* but Palomera labels it as *ritos y costumbres* and Maza calls it the *templo.* By retaining the sequence intended by Valadés as well as his words about the content of each we remain closer to his intention, as with the scene called *atrio* (18) by Maza and Palomera.[157] This scene is placed between the *Triunfo del Cristianismo* (17) and *Predicación* (19) from a pulpit in church with the friar explaining pictures of the Passion. It (18) connects *Triunfo* and preaching by instruction in a churchyard on the sacraments, doctrine, and creation to men, women, and children in the presence of St. Francis, the Apostolic Twelve, and their leader Martín de Valencia as well as Pedro de Gante. The care of the sick and a court of justice are included at sides and bottom.

By extending this manner of interpretation to the entire sequence of engravings, one brings to light the intention of their author as being in three parts. The first includes the ten engravings on pages 5–25; the second, the seven on pages 88 and 100–01; and the third, the eight from pages 213 to 225.

Among the first twelve, the progression is from Old World knowledge surveyed in nine engravings to three concerned with native knowledge before Discovery. The unifying theme of the second group is the first conversion until 1558. The last two are about the second conversion in northern Mexico, in which Valadés took part as a missionary, extending and continuing the work of his predecessors. The accompanying table sets out the relation of these themes to the arrangements of the engravings by Palomera and Maza.[158]

Palomera unobservantly broke apart the unity intended by Valadés, and Maza also was unaware of the divisions within the engravings, which appear mostly (twenty of twenty-seven) without titles or legends, being keyed by letters or numbers to explanations in text. The intention of Valadés was to have the series of engravings convey the historical meaning of the evangelization of the New World in his life, beginning with Christian knowledge, and epitomizing both generations of the Mendicant conversions from a Franciscan point of view. The emblematic and historical arrangement offered in the engravings clarifies and adorns the austerity of

D. Valadés 1579			F. de la Maza 1945	E. J. Palomera 1962
1 title page		Title page	Fig. 1	p. 19
pars. I				
2	5	Pagan philosopher	2	23
3	7	Good Shepherd	13	234
4	10	Christian philosopher	3	30
5	14	Theology	4	49
6 opp.	16	Seven liberal arts	5	2
7	25	Hebrew pontiff	6	69
pars. II				
8	88	Senses and mental powers	7	91
between 100 and 101				
9		Mnemotechnic images, A–L	19	105
10		Mnemotechnic images, M–Y	—	106
11		Mnemotechnic images, Indian	20	107
12		Pre-Spanish calendar	18	312
pars. III none				
pars. IV				
13 between 168–169n		Indian platform temple	15	208
14 between 176–177		Ecclesiastical hierarchy	9	233
15		Pontifical dignity	10	242
16		Civil hierarchy	8	241
17 opp. 206		Crucifix of liturgy	11	xv
18 opp. 210 [106]		Mexican churchyard	24	135
19 opp. 213 [110]		New World preaching	25	217
20 opp. 214		Allegory of matrimony	23	217
21 unn. 216 [214]		Image of the sinner	14	266
22 unn. 217 between 218–19		Stages of sin	22	284
23 unn. 217		Tortures of sin	21	284
24 between 220–21		Allegory of creation	12	136
25		Indians at Calvary	28	122
26	224	Chichimec mass	26	156
27	225	Chichimec sermon	27	265
pars. V none				
pars. VI none				

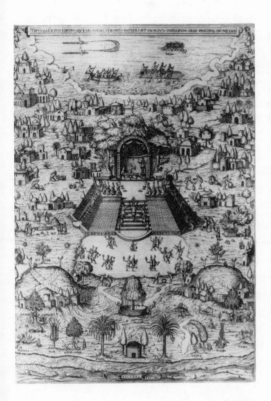

Figure 16. The scene of Indian human sacrifice ascribed to Diego Valadés in the edition of 1579 (*left*) reappears in Mendieta's manuscript copy of 1604 (*right*) (Palomera, *Valadés* [1963], opp. p. 92) without attribution but adding *immaniter* (monstrous) across the top. Thus Mendieta left uncorrected the hearsay version received by Valadés twenty-five years earlier, excepting to exaggerate the horror of the rite and annotate the dance (*saltatio indorum*), as if to stress it farther in the negative esthetic direction.

the treatise on Christian knowledge, while exemplifying the lessons of rhetoric that fill the volume and relating the events of Valadés's life in Mexico.

Valadés left America in 1571, eight years before the publication of *Rhetorica*. Nearly half of the engravings (thirteen of twenty-eight) have some Amerindian content. The one opposite page 168 (13) displays a lakeside temple where a human sacrifice is in progress. It suggests that Valadés, who signed the plate as of his making ("Didacus Valadés fecit"), never saw such a sacrifice and that he did not remember what such a temple looked like. It is an apsidal, half-domed chapel standing on an ashlar masonry platform with stairs on three sides. In the foreground are eight trees and plants labeled with their names, but an ear of maize is named Flor, and several other domed buildings (unknown before Discovery) appear among the scattered houses (fig. 16).

The diminutive Indians whom Valadés instructs while assembled at a colossal scene of the Calvary (25) are clad in garments more like Roman togas than the Aztec cloak.[159] In the large courtyard displaying the Franciscan evangelization all Indians appear wrapped in such cloaks, as they do in the Predication scene (19). The rebus signs equating signs and sounds (11) lack correspondence: a house (*calli*) is labeled as standing for *E*, and a deer (*mazatl*) for *Q*. The letter *h*, lacking in Náhuatl, is shown as standing for beans, and *R* stands for jaguar (*tecuani*).

No explanation of these discrepancies appears in the text, but it is possible that Valadés had forgotten many details when drawing and engraving these plates in Rome or Perugia, after his residence of many years in Europe. Born eleven years after the Conquest, his memories of the pre-Conquest Valley of Mexico would not have included the appearance of Tenochtitlán before its destruction.

GARCILASO DE LA VEGA, EL INCA (1539–1616). Leaving America for Spain in 1560 at age twenty-one, this relative of Inca rulers and of the Spanish poet Garcilaso de la Vega (1503–36) first served Philip II as a captain in the Morisco war in Andalusia in 1570.[160] His most famous writings were on Inca history, begun in Cordova about 1590,[161] using information from Blas Valera and José de Acosta.

But before 1586, Garcilaso had translated the *Dialoghi d'amore*[162] by Leo Hebraeus (1460?–1535?). Garcilaso's Spanish titles for the three

Diálogos were *De amor, De la communidad del amor,* and *Origen del amor.* He explains in the dedication of 1586 (11r.) that he "did the translation bit by bit, for himself alone," with assistance from four scholars in Montilla.[163] The most revealing detail of the title of his work was his presentation of it as the "translation by the Indian." At this point in his life, Garcilaso was in a period of esthetic resonance, saturated with the neoplatonic content of the dialogues, yet speaking for his mother's people as an *indio,* on behalf of the "natives of the New World."[164]

The argument of the *Diálogos* is on two levels, between the seeker and wisdom as well as between a woman (Sofia) seeking enlightenment from her lover (Philon). The second dialogue is a course of instruction on medical, astronomical, and allegorical topics all provided by Philon, not Sofia, who mostly asks questions. Dialogue 3 opens with her complaint that he is inattentive, and it continues in a quarrel when he compares her to poison.[165] The platonic discussion often turns erotic, as do the medical and allegorical explanations. Leo was indebted to the Kabbala in the idea of man as microcosm[166] and to "pre-Platonic materials," such as a cosmogonic system of seven-thousand-year cycles, to be destroyed by water or fire, and return to chaos after forty-nine thousand, with renewal after each fifty thousand, upon an astrological cycle of thirty-six thousand years.[167]

Garcilaso's mestizo status was a double heritage requiring resolution by his temperament leaning to assimilation in the European tradition.[168] His military service during the Morisco war in 1560 would have brought him near other mestizos engaged in subduing the rebellion in eastern Andalusia. It ended tragically. Garcilaso had seen despoliation in Peru, but the massive exile of vanquished natives would have been new. After their uprising on Christmas eve in 1568, 20,000 were deported to Africa and other parts of Spain. In 1598 the government renewed the policy of expulsion that was imposed in 1609 on at least 270,000 exiled to Islam. Those remaining in Spain suffered varying degrees of slavery.[169]

The Jesuits, however, began work in 1609 in a Jesuit house called the Sacromonte in Granada, at the site of alleged Early Christian burials of martyrs. This "sanctuary of conciliation"[170] was intended to reconcile Christian Granada with the remaining population of Morisco antecedents, among whom were many scholars. Their assimilation was the purpose of the Sacromonte of Granada, but the gypsy caves there are a reminder more of the rebellion than of the Mount of Calvary. Garcilaso lived until 1591 at Montilla (twenty miles south of Cordova), from which 1,480 Moriscos

were expelled in 1610.[171] There he was surrounded by the remaining
Morisco population in Andalusia during their despoliation, before he be-
gan to write that of the country of his birth. His concern with racial
assimilation suggests an effect of his long preoccupation with the neo-
platonic *Dialoghi*.[172] The scales of professional historians' evaluations
have shifted away from Garcilaso. He was revered for a century, from
William Hickling Prescott to Philip Ainsworth Means. But he has now been
replaced by Guaman Poma in the shift away from chronicle to social
commentary as the more valid mode. Yet Garcilaso's assimilationist views
do not contradict Guaman Poma's social protest: their positions seem
complementary as evidence more than contradictory. They are actually
differing dimensions of the same world.

FELIPE GUAMAN POMA DE AYALA (C. 1550–C. 1615).
Guaman Poma (the "falcon puma") is cloaked in his Spanish names. He
claimed to be Garcilaso's cousin and a grandson of Tupac Inca Yupanqui,
but he denied Garcilaso's assimilationism with an opposite mestizo intran-
sigence, in twelve hundred complaining pages in his own hand to the king
of Spain,[173] about his twelve years' shuttling between Huamanga (now
Ayacucho) and Cuzco as interpreter, secretary, and servant to a young
inspector of idolatries, Cristobal de Albornoz,[174] for the town council of
Cuzco. Guaman Poma's father, Martín de Ayala, is said by his son to have
written a letter to Philip II in 1587 to say that the work had been being
written for twenty years.[175] This may be taken as the author's wish for our
view of its whole gestation.

As self-appointed cosmographer and chronicler, Guaman Poma wrote
in both Quechua and Spanish, imitating European scholastic discourses in
Latin and Romance languages. He portrayed in handwriting and drawings
the emblems and scenes of colonial life. His manuscript is like an early
printed book with woodcuts imitated by him in some four hundred draw-
ings of Inca life and history. It is his "letter to the king," as he says, about the
history of his people and their need for better government.[176] John Murra
finds his "ethnographic information on social, economic and political
organization in the Andes" unique in many aspects, reflecting the "Cuzco-
centered criteria of his informants." His recommendations on the improve-
ment of government in the viceroyalty are equal "to those of the most
advanced minds of his time, in the Andes or in Europe."[177] For the present

work, however, his main contribution is to the history (since the Flood of Noah) of the Amerindian universe before the Inca dynasty.[178]

Guaman Poma's thought reflects that of the Mesoamerican and Andean traditions of multiple cyclic creations each ending by a cataclysm, already discussed here[179] through his relationships to Cristobal de Molina in Cuzco, to Blas Valera's works as quoted by Garcilaso, and to Fray Martín de Murua, all of whom he mentions.

The many sources that were available to Guaman Poma as an illustrator have never been assembled from among early imprints in Europe[180] that reached Lima and Cuzco. He may also have found his style of illustration with Martín de Murua after 1580.[181] It was suggested in 1946 that some illustrations accompanying Murua's *Historia del origen* were either by Guaman Poma or that he copied versions by someone else in the Mercedarian friar's service.[182]

Other than these comments, the only recent studies of Guaman Poma's graphic compositions are semiotic. Rolena Adorno analyzes the relation of frame to background and representation as well as text,[183] in respect to four-part divisions of pictorial space as corresponding to sociological space in the manner of N. Wachtel or J. M. Ossio.[184] Adorno defines five modes of "centrality" and "privileged" position among left–right and upper–lower quadrants of the rectangular imagery and its diagonals. These "signifying attributes" are "organized" by Guaman Poma "into a secondary level of signification" (with right side connoting positive and left side negative values) in the world he regarded as "upside down" since the intrusion of Spain upon the Inca state (fig. 17). This ended the previous era of the cyclical history of the Andean universe. The convergence of Guaman Poma's system of values (left–right, below–above) with those of the manuscript illuminators of the Middle Ages in Europe is not examined.[185]

The question of Guaman Poma's influence after his death has not been discussed, but to readers of the work of Fray Buenaventura de Salinas y Cordova it is clear that Guaman Poma's position was known in Madrid, Rome, and Mexico before the death of Salinas at Cuernavaca in 1653 as bishop-designate of Arequipa.

In his *Memorial de las historias del nuevo mundo,* written before 1630, Salinas had adopted Guaman Poma's pre-Inca chronologies as well as his defense of Indian rights under Spanish rule. Warren Cook, as Salinas's editor in 1957, states this clearly (*Memorial,* x/iii ff.), noting also the chronology as being from Guaman Poma's manuscript (xxxviii–xxxix).

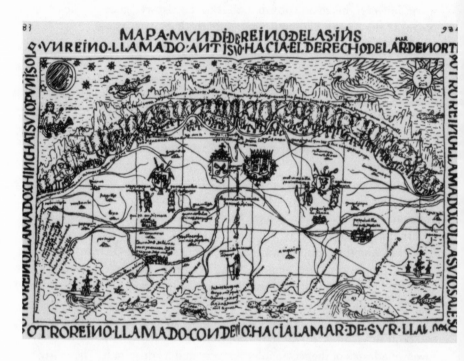

Figure 17. Felipe Guaman Poma (*Nueva corónica,* ed. Murra [Mexico, 1983], vol. 3) mapped the Andean world as he knew it, by warping the four quarters of the Quechua world around the corners of a rectangle in order to preserve an Amerindian conception of the earth. It is divided in quarters defined by the seasonal course of the sun from north to south and by the extent of the Inca state from ocean to Andes. The map is divided accordingly in four quadrants bounded by the corners, marking the northern and southern passages of the sun at winter and summer solstices. The Atlantic Ocean appears beyond the Andes. The northern Andes (Cartagena) and the Isthmus (Panama) are outlined in the lower left corner as passing from Pacific to Atlantic oceans.

The pre-Inca chronology came to Salinas's attention while he was serving as archivist to Viceroy Montesclaros.

Born in Lima, Salinas had been educated by the Jesuits in Lima, but he became a Franciscan in 1616. He was known as a defender of Indian rights before 1630 and again in 1656. He had incurred the enmity of Fernando de Vera, bishop of Cuzco, on this account and was in effect "exiled" to Spain and Rome (liv), where he continued to voice the protest he had learned

from Guaman Poma. He was on trial in Valencia in 1644, pleading in favor of "los nacidos en Indias, hijos de españoles."

FERNANDO DE ALVA IXTLILXÓCHITL (C. 1568–C. 1648). Like Garcilaso in Peru are several Mexican historians of mestizo birth who were related to ruling families in the Valley of Mexico. Principal among them were Tezozomoc, Ixtlilxóchitl, and Chimalpain. These later historians had been schooled by Mendicant friars wherever they could be gathered for Christian instruction. The existing corpus of ethnohistorical information about ancient America is mostly the work of such native scholars.[186] But their activity had been made possible earlier in the century by Viceroy Martín Enriquez in 1536–39, who commissioned various native "historians and scholars" to "interpret" the "libraries" of painted manuscripts then surviving the Conquest. Ixtlilxóchitl, writing after 1600, listed some of his predecessors whose works are lost.[187] But he described the native sources he used as "paintings done at the time, songs, annals, genealogies and tables of descent, paintings of boundaries, lots, and distribution of lands, and books of laws, rites, and ceremonies, as well as of festivals and calendars."[188]

After beginning his historical studies, which include "five separate works,"[189] Ixtlilxóchitl was appointed as judge-governor of Texcoco by Viceroy Guadalcazar for 1612–13, being designated by the headmen and the people (*principales y común*) of Texcoco as the "direct and legitimate successor of the Kings who had ruled this city."[190] His chief duties were to preside at court for criminal and civil cases and to collect tribute,[191] with salary and servants provided from the income of town lands. In 1616–18 he was posted to the same duties in the town of Tlalmanalco, and in 1619–22 to the province of Chalco. In these towns where he also served as judge and governor, he had access to surviving records both pre-Conquest and early colonial, of which most now are lost.[192]

With three Spanish grandparents and one Indian, Fernando was considered in New Spain as a *castizo* of noble descent and as an *hombre novohispano*, in whose histories pre-Conquest America is portrayed as prefiguring the advent of true religion.[193] Being Texcocan, Ixtlilxóchitl thought of himself as being of Chichimec ancestry and descended from Nezahualpilli.[194] His principal informants were also Chichimecs. Their history begins with the reign of Xólotl in the eleventh century, displacing

Figure 18. Similar to Guaman Poma's cartographic sense is a map of 1734 probably based on native models displaying the streams, paths, and towns from the lake of Mexico to the eastern volcanoes (Iztaccihuatl and Popocatepetl). The sunrise between them establishes the solstitial frame north to south and back rather than the European convention of the cardinal points anchored upon magnetic north. (After Chimalpain, *Relaciones,* ed. S. Rendón [Mexico, 1965])

Toltec rule, which was "ancient history," enduring 572 years until the destruction of Teotihuacán about A.D. 1000. As to Amerindian geographic origin, Ixtlilxóchitl wrote that the *Gran Tartaria* of central Asia was likely, at the time of the "Babylonian dispersion" of those "nomads under Chichimec leadership,"[195] who became his ancestors, the *Cemanáhuac Tlatoani* (lords of the world from sea to sea).[196]

FRANCISCO DE SAN ANTÓN MUÑÓN CHIMALPAIN (1579– 1660?) wrote a history of the Chalca peoples spanning the years 670– 1620 in Náhuatl.[197] The work has been praised for its "precision and truth,"[198] as a history of five nations living in twenty-five settlements southeast of the lake of Xochimilco, from Chalco to Amecameca (fig. 18). Tezozomoc had related the balkanization of this area by the Mexican confederacy, but Chimalpain told the same story from the point of view of its victims. It is the most coherent of all the Indian histories, clearly showing the esthetic values attached by Indian intellectuals to their own history. It is an esthetic sense shared by all Indian historians about their vanished world.

Chimalpain was concerned with the native state, seen as a group of city-states, as a work of art in Jakob Burckhardt's sense.[199] The opening section of his study in 1860 of the Renaissance in Italy is entitled "The State as a Work of Art" and its headings deal with tyrannies, greater rulerships, and the opposition to tyranny. Foreign policy and warfare are seen as art.

Burckhardt's insight was that between emperor and pope were scores of city-states having "a new vitality in history from the concept of the state as a calculated and conscious creation as a work of art." For such novel entities there were even "artists of the state" like Machiavelli, revising the political machinery that replicated in small units all the functions of large states. These maintained foreign relations among one another and outside Italy as if they were "artful machines." Burckhardt's concepts fit well over the native histories of ancient Mexico, where city-states and their clients and colonies are similarly bracketed between ecumenical religious authority and local dynastic power.

Why do native historians reappear so late? Possibly they had to wait for the relaxation of Spanish fears of Indian competition on all levels, which had already led to the closing of the Colegio de Santa Cruz at Tlatelolco. By 1625, however, even the secular clergy were admitting that the Indian return to superstition was over and not to be feared (p. 65 and n. 114).

3

Idealist Studies of

Amerindia from Above

THE TITLE OF THIS CHAPTER refers to the idealist philosophical method of considering "values" as resident in speculation about absolute ideas of good, truth, and beauty during the European Enlightenment. Its fierce critic in this century was Antonello Gerbi.

Enlightenment history may be divided as early and later periods, separated by the revolutionary turmoil of the final quarter of the eighteenth century. Thus early enlightenment is more reactionary and, after 1800, more racist than the late period. The many new forms of political and esthetic conduct became public in the wave of romantic emotionalism until the 1840s.

After the Jesuit expulsion in 1767, writings about the New World became more visual, first with Martinez Compañón and then with many travelers after the wars in America for independence both from England and Spain, who recorded views and collected antiquities. Those writings in French were most common, beginning with Dupaix early in the century and continuing with Brasseur, Nadaillac, Charnay, Viollet-le-Duc, and Beuchat. Writers in German were fewer: Humboldt and Braunschweig. The writings vary from accounts of travel to textbooks and encyclopedic essays, but the coming separation of anthropology from history was apparent only after 1850. The most complete account of European attitudes on America during the Enlightenment is by Antonello Gerbi in Italy.

ANTONELLO GERBI (1904–1976). As a Jewish lawyer and historian of ideas both political and economic, Gerbi suffered exile to Peru from

84

Italy under German pressure in 1940.[1] In his own words, the "germ" of his life's work on the historiography of the New World appeared in print in 1928 on the *feroce giudizio di de Pauw* condemning the native population of America.[2] He was neither an art historian nor professionally interested in esthetics, but his sense of outrage at the racist component of the political thought of the European Enlightenment never left him. He continued backward to the age of discovery[3] in a historiographic analysis of the phenomena of anti-Indian racism that serves here as an anatomy of the distaste for America in European thought and literature. The distaste was and remains a negative esthetic expression about America and Americans during the Enlightenment, and it survives in Europe and elsewhere today.

Gerbi's work has little to do with art and archaeology. But its reason for being is a dominant belief in enlightened Europe, from 1750 to 1900, that America was inferior as to its natural and racial endowment. Buffon as a naturalist in 1750 deprecated the animal species as inferior and the humans in ancient America as "impotent and savage." Kant's verdict as philosopher in 1778—that Amerindians "were incapable of any culture, still far behind the Negroes—was followed by Hegel's "immature and impotent continent."[4] Such judgments had their origins in early colonial observations by Oviedo (1526, 1533), Acosta (1590), Herrera (1601–15), and Cobo (1653), but their more neutral opinions were systematized by Buffon as a "categorical inferiority" of all animal species in America and extended by de Pauw in 1768 to man in America, as "bestial Indians" who are "natural slaves" in a "hostile climate." As Gerbi notes, Buffon's position pertained to the inferiority of animals and environment in America, but when criticized by de Pauw in 1778 his new position was to include humanity with the animals, saying that America was "immature" and Amerindians "less active" than Europeans.[5]

Corneille de Pauw in Berlin was, as I mentioned earlier, more absolute: among other deficiencies of Americans he noted, their iron was inadequate for nails.[6] G.-T. F. Raynal was far the most popular writer, with seventy editions in twelve languages during twenty years.[7]

Gerbi ended his long study of the dispute about America with a review of its persistence from Hegel to the present.[8] None of his themes, however, bore on the esthetic recognition of ancient American art as discussed here. Having returned to Italy in 1948, Gerbi began another book on America, from Discovery to the death of Gonzalo Fernandez de Oviedo (1478–1557), whom the work is mostly about.[9]

Gerbi's inquest here was on European expressions of the deprecation of

Figure 19. These illustrations of an Amerindian hammock (*top*) and a fire drill (*bottom*) before 1547 are like the drawings of machinery in plane projection that became essential in the industrial world of the nineteenth century. Oviedo, however, was more a naturalist than engineer. These two drawings (whether or not by his hand) would have had his approval. (After Gonzalo Fernández de Oviedo, *Historia general y natural de las Indias,* facs. ed. [Chapel Hill, 1969]).

Amerindians as bestial, therefore inhuman. Doctor Alvarez Chanca, the medical officer aboard the second voyage of Columbus (1494), passed the examination by Gerbi as a naturalist but failed as an ethnological observer, for describing Antillian housing as bestial, being built of damp grasses. The doctor was approved for admiring their knives of stone. Yet he ridiculed their animal costumes and body paint as well as their appetite for snakes, lizards, spiders, and worms, as "more bestial than that of any beast." Gerbi, always on the attack of racism, commented sadly that Dominicans, jurists, and landowners were then still not in sight, talking of Aristotle and

natural slavery, and that travelers were already writing of Amerindian bestiality.[10] Michele da Cuneo's letter of 1495 also anticipates the arguments of the Enlightenment against America by commenting on how few and small the animals were and explaining how the cannibals ate other Indians.[11] Among these travelers before the Conquest of Mexico, only one was an admirer of Indian arts, Martín Fernandez de Enciso, whose *Suma de geographía* was first printed at Sevilla in 1519. At Santa Marta he noted cotton weavers and featherwork as superior to anything he had seen in America.[12] Antonio Pigafetta (one of 18 survivors among Magellan's company of at least 237 on five vessels) explained in 1522 to Charles V that the cannibals of Brazil ate only their enemies as a rite of war, and that they were easily converted to Christianity.

Gerbi noticed Oviedo's interest in sculpture and painting in the *Historia general y natural de las Indias*,[13] which was illustrated in 1547 with his own drawings (fig. 19). For Gerbi, Oviedo's visual perceptions were ingenuous and suitable only for a "didactic esthetic in which the conviction of the perfection of the arts [in Europe] and the discovery of a new world are parallel and concurrent phenomena of an unique and unheard-of historical process."[14]

LORENZO BOTURINI BENADUCI (1698/1702–1756). Boturini marks the continuing vacuum in Spanish America between teachers of the Indians and their exploiters. Gerbi explored a racism that still surrounds European ideas about America, while Martinez Compañón continued a tradition of native studies and Indian education that had been deeply rooted in America since the sixteenth-century Mendicant conversions.

Boturini, influenced by Vico's *New Science* (1725), came to America as an avid collector of Indian histories and as a devout student of colonial piety in the cult of the Virgin of Guadalupe. Educated in Milan and Vienna, he became a follower of Vico before emigrating to Mexico in 1736. Vico remained a stimulus until Boturini died, after transmitting his enthusiasm to a Mexican pupil, Mariano Fernández de Echeverría y Veytia, who became a better rounded historian than Boturini.[15]

The range of Vico's ideas about history is perhaps best stated by Isaiah Berlin,[16] who defined Vico's seven theses as follows (p. xvi):

> Human nature is variable;
> makers know more than observers;
> natural science and humanities differ;
> each society has a pervasive pattern;
> history requires knowledge of all arts;
> art is relative to societies;
> changing expressions allow new discovery.

As to repeating patterns of history (the *corsi e ricorsi*) Berlin added that "it is not the least among the misfortunes of this singularly unlucky writer that he should be best known to posterity for the least interesting, plausible, and original of his views" (64).

Boturini's own book in 1746 was Viconian in spirit: *Idea de una nueva historia general*. It alludes to the idea of *corsi* and *recorsi* that in Vico's language governs the whole of human history. Isaiah Berlin described it as the "idée maîtresse" of Vico's "whole thought,"[17] and as "a pattern of development which human society, wherever it is found, must obey." But Vico rarely mentioned America.[18]

Boturini's life began under Habsburg rule in Milan and Vienna. Arriving in New Spain in 1736, he found himself in a viceroyal bureaucracy under Bourbon control in the reign of Philip V. Being without the required passport from the Real Consejo de Indias, he was in trouble. His only stated purpose for being in Mexico was to recover funds belonging to his patroness in Madrid, the Condesa de Santibañez, who was a descendant of the second Moctezuma. Also, being devout, his other purpose during the great Indian epidemic of 1737–39 became a history he planned to write of the apparitions of the Virgin of Guadalupe to the Indian Juan Diego. This interest also led him to expand his collection of documents about native life in early colonial Mexico. His steps in this were guided by the works of the scholar Carlos de Sigüenza y Góngora (1645–1700), who was introduced to ancient America by the family of Fernando de Alva Ixtlilxóchitl before 1689. Here Sigüenza acquired his library, much of which passed to Boturini in the *museo indiano* he collected before 1740.[19] But two years later, the newly arrived Viceroy Fuenclara ordered the arrest of Boturini and the confiscation of his *museo* as lacking authorization from the Consejo de Indias. Deported in 1743, he was returned as a common prisoner to Spain. There he began the *Idea de una nueva historia de la America Septentrional*. After its appearance in 1745 he was appointed Cronista en Indias but never returned to Mexico.

Written without mention of Vico, Boturini's *Idea* was to be divided as the three ages of humanity in America: divine, heroic, and Indian. But it actually was published only as the first of four volumes he had projected, after the appearance of Vico's third *Scienza* in 1744. Vico appears only in the *Historia general*[20] as follows:

> Vico, águila y honor inmortal de la
> deliciosa Perténope [Naples] que por
> espacio de treinta años sucesivos
> meditó en la común naturaleza
> de las naciones gentílicas,
> labrando un nuevo sistema del
> derecho natural de las gentes
> sobre las dos columnas de la
> Providencia y del libre albedrío.

Boturini's *Idea* was received in Madrid with some offense among the creoles resident there because of his approval of Indians. Yet the European-born critics thought it was plagiarized from Vico.[21]

The Viconian association with Boturini then lapsed until 1903, when José Fernando Ramirez, the Mexican historian exiled in Madrid, found Boturini's unpublished manuscript of the *Historia general* as well as his *Oración sobre el derecho natural de las gentes indianas,* written in 1750 for his entry to the academy in Valencia.[22]

BALTASAR JAIME MARTINEZ COMPAÑÓN (1738–1798). The young priest's career began during the Jesuit expulsion from the peninsula before 1767, when the society was dissolved and its members banished to Italy. In that year on October 4, Martinez was embarking at Cádiz for Lima with a royal appointment to the chantry of the cathedral of Lima.[23] He rose rapidly, becoming head of the Seminario Conciliar in 1770 and bishop of Trujillo in northern Peru in 1778. Among his duties were to serve also as rector of the Seminario de Santo Toribio [de Astorga], which became the leading cultural center of the viceroyalty after the expulsion of the Jesuits.[24]

The sixteenth-century archbishop Toribio Mogrovejo visited his entire diocese three times, baptizing and confirming an estimated half-million natives. He was surely the model whom Bishop Martinez Compañón emulated two centuries later in northern Peru. Like Fray Bernardino de Sa-

hagún and Fray Diego Durán in New Spain two centuries earlier, Martinez had access to many skilled cartographers and architectural draftsmen as well as artists to record the events of his tours of inspection (fig. 20). During his term as rector (1772–79) the seminarians numbered seventy, falling off after 1800 to forty-one in 1810.[25] These seminarians began in 1780 with the preparation of nine volumes of maps, tables, plans of needed buildings,

Figure 20. The headline of the plan and elevation explains that they are for the school and residence of "girls both Spanish and Indian" in the highland town of Huamachuco, as "delineated" by Bishop Martinez during his stay there in 1785. The plan is that of a convent with but one entrance from the street. The mother superior had direct access to the girls' dormitory, for Spanish and Indians at H. Two reception rooms near the only entrance may have been for the visits of the families of the girls. (After J. Dominguez Bordona, *La obra del Obispo Martinez Compañon* [Madrid, 1936])

and pictorial records of daily life in all parts of the bishopric, ordered to illustrate[26] a history of the bishopric which he never completed. The visitation by Bishop Martinez lasted four years (1782–86). The finished 1,411 drawings and maps showing buildings, plants, animals, and daily life in the colony were gathered as nine volumes:

I. Trujillo, city and bishopric. Demographic tables. Maps and plans of principal settlements. Portraits of bishops. New settlements
II. Ethnography and folklore
III, IV, V. Flora
VI, VII, VIII. Fauna
IX. Pre-Inca and Inca remains, sent to Spain in twenty-eight cases in 1778 and 1790 for the royal collections.

Returning to Trujillo in 1786 after four years of traveling through the bishopric, Martinez prepared a report to the king.[27] He opens by saying that before leaving Spain in 1767, he believed, by what he had read and heard about the calamities and misfortunes of the Indians of the Americas, that

> their lot was unhappy in general, but I did not expect what experience has taught me in these nearly nineteen years in this world. I have constantly intervened in one or another respect in the affairs and business of these Indians, with an impartial and attentive observation of all events and circumstances, during the personal inspection I have just completed in the twelve provinces from coast to mountains and wilderness comprising this vast bishopric, including the record of their curates even down to the smallest villages and properties.
>
> In truth, Sire, the Indians of this Bishopric who are my concern and about whom alone I now will speak, are people whose misery is beyond every measure wherever one looks. It is certain that they are miserable in their souls, in their bodies, in their pride, and in their fortunes. In their souls,—in their deep ignorance, without the idea of goodness, of evil, nor of virtues, being plagued and corrupted with vices. In their bodies—because both the healthy and the diseased, they treat and are treated with positive indolence, inhumanity and cruelty, meeting a thousand hindrances and obstacles on all sides against keeping healthy while enjoying health, and finding not shelter or aid for their recovery when health is gone, not even such remedies as are commonly applied to animals. In their pride—because the most fortunate mestizo, or

sometimes a negro, wishes to be superior to the most distinguished Indian chief, even vilifying him with outrageous words or blows. In their fortunes—because it is an empty word without meaning, wherefore they lack foresight for themselves and their posterity. Thus if they are not the only ones to work, they at least work most without equals, becoming those who take the fewest rewards from their sweat.[28]

Martinez Compañón then tells the king of his remedy: to found two seminaries, one for Indian boys and another for Indian girls in Trujillo brought there from all provinces, between six and eight years of age. The Indian parents of these children would pay two reales annually for their care.

In 1787 another letter to the king by the bishop reviews the fifty-two schools he had founded for non-Indians since 1782[29] in all provinces of the diocese. According to the accompanying demographic tables 24,172 Indian persons of all classes[30] were the total Indian enrollment. But the fifty-two schools for non-Indians served 207,730, (nine times as many as Indians) or 3,995 persons per school, while the two Indian schools were to serve 34,010 persons (or 1.4 percent). Thus schooling would have been restricted to fewer than 370 Indian pupils of both sexes whose families and towns were to pay most of their tuition and board.[31]

In 1788 Martinez became archbishop of Santa Fe de Bogotá in New Granada (now Colombia). Remaining at Trujillo until his successor arrived in 1790, he declared St. Toribio [de Astorga] as principal patron of the diocese with an altar in the cathedral adorned by a reliquary of gold, pearls, and diamonds containing a bone of the saint.[32]

The pious hope of Bishop Martinez for the education of Indians, denied since before St. Toribio's death in 1606, did not become reality within the limitation of royal patronage of the Spanish church in America until republican government in Peru, where it still remains a distant objective. But Martinez Compañón stated it in his way in 1786: "The only need is to increase the [Indian] population and make it more useful . . . by bringing the inhabitants into society; educating the children of both sexes; advancing agriculture and mining; movement and action in commerce both internal and external, and increase of industry."[33]

GUILLERMO DUPAIX (C. 1750–1818/20). Twelve years younger than Archbishop Martinez, Dupaix served the Spanish government as a

military envoy on a mission to discover and record antiquities in New Spain. His predecessor, Captain Antonio del Rio, had been sent from Guatemala in 1787 to reconnoiter and report for two months at Palenque,[34] accompanied by the architect Antonio Bernasconi in 1787. But the mission of Captain Dupaix started from Mexico and extended to Puebla, Oaxaca, and Guatemala.[35]

Dupaix was especially alert to examples of the reduction of living forms to their geometrical ciphers. This was in defense of his contention that Amerindian peoples possessed a theoretical base in geometry for their representations of natural forms (1969, II, fig. 63, pl. 39). Of Mixtec jades at Yanhitlán in 1806, he says they are "purely Mexican, found in infinite numbers in the tombs of this ancient Mexican nation . . . of prismatic configuration, in three or four planes . . . needing no cutting instrument, but having 'natural' angles."[36] From this he turned to say that "the essence of the arts is decided neither by material nor magnitude" (105).

Monte Albán reminded him of Pompeii, where he had been at the time of the early excavations before 1760 (117), but he noted (116) that this "most ancient, original American school" proceeded from theory to practice on geometric plans devised before building began, and that in addition its artists possessed the ability to portray individuals recognizable as such (116). Interesting is his repeated use of "ideal" as signifying the "schematic" or stylized opposite of academic design by rules (62, 155).

Confronting Mitla (121) (fig. 21) Dupaix divulges at last the underly-

Figure 21. Mitla, Hall of the Columns, façade in 1806 (after Dupaix, *Expediciones*, ed. Alcina [1969], vol. 2, pl. 46. Drawn by an assistant under the direction of Dupaix, this elevation suggests an anthropomorphic use of geometric units to represent an extended mask, as of a human mouth (stair), nose (central doorway), and eyes (frieze panels over door supports between doors).

ing rule of his procedure as a historian of non-European art, saying that "the only data and authority to which we need to appeal are the artistic monuments. They in their mute but expressive and meaningful language will perhaps explain to us some of our problems." One of these is the function of the "palaces" at Mitla: he prefers, after considering ritual halls or temples, to think of them as tombs (139).

Of the mosaics on their walls, he is unable to decide whence the artists "took the *type* of this beautiful thought" or which of them could be earliest (138), since complex and simple were mixed among them. At Zaachila, thinking of types and prototypes, he supposes that clay sculptures must have preceded (as prototypes) the same expressions in stone and in metal (153).

At Palenque, finally, Dupaix was faced with some of the major monuments of Mesoamerican antiquity. First he had difficulty describing the corbel-vaulted system, but he resolved it by writing of vaults both plane and in bulk (*bovedas recta y de vulto*) in angles varying from acute to obtuse (202). After identifying the subject matter of the figural reliefs as rulership and conquest (207–08) (fig. 22) and analyzing the technique of building the stucco reliefs (206), he went on to say that "the style of Palenque being original, it cannot be related with Mexican or Zapotec remains [229], nor are these indebted to any other known nation on earth" (225).

These remarks were his final observations based on twenty years of residence in New Spain (232). He concludes by saying that he had labored greatly to find those technical terms with which to describe the arts of design in ancient America, because the works themselves were "original and unprecedented elsewhere in the world," and useful as illustrating "the general history of the fine arts of these ancient and celebrated nations." He also noted that "another ancient and underground world of the heathen era still existed on this continent," and that it could "be entered only by excavations" (188).

Reading Dupaix, however, one cannot today escape the conclusion that this work by him and his draftsman Lucano Castañeda provides us with the earliest approach to a history of ancient American art. It makes use of the concept of the fine arts as architecture, sculpture, and painting to cover a broad range of material culture and to discuss craft, meaning, and expression in America as original rather than derivative from any recent Old World tradition.[37]

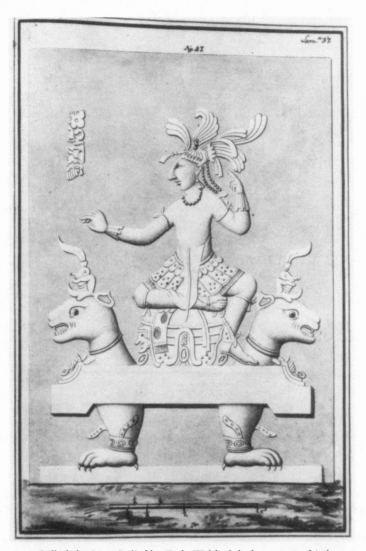

Figure 22. Called the Beau Relief by F. de Waldeck before 1838, this lost monument from Palenque is known by Waldeck's drawing in the neoclassical manner of J. L. David (1745–1825). Hence an earlier drawing in 1808 by Guillermo Dupaix is its earliest record (followed by J. H. Caddy's drawing in 1840 (*Palenque*, ed. J. M. Pendergast [Norman, 1967], 133 and pl. 35). Dupaix and Caddy are more credible and in closer agreement in their respective drawings than Waldeck. But Dupaix saw and "improved" more of the un-damaged relief than either Waldeck or Caddy. Waldeck in 1838 may have seen the Dupaix drawing in Kingsborough's *Antiquities* (1831). (After Dupaix, *Expediciones*, ed. Alcina [1969], vol. 2, pl. 46.

Figure 23. Architectural relief panels from Oaxaca in the now-lost collection of Mexican antiquities taken to Peru by Bishop Moxó. They are shown framed and engraved in the book published in 1805. The shallow fire basin may refer to his sense of their pagan sacral use. Both occur at Mitla, as shown by Holmes (Kubler [1983], 74, fig. 128, VI and VII). The plantlike scroll is a misreading of the wing scroll at Mitla.

BENITO MARIA DE MOXÓ (1763–1816). One way to accepting esthetic "otherness" is manifested in collecting, as Moxó was in Mexico City in 1804–05, having been professor of *Humanidades* at Cervera in Catalonia in 1792. Appointed as auxiliary bishop of Michoacán in 1802, he was reassigned as bishop of Charcas in South America and spent a year awaiting his orders. He read widely on Aztec history and assembled a

museo of Mexican antiquities, which he took to Lima. There he sent fifty-
three letters in 1807 to Godoy, the Príncipe de la Paz in Spain, which were
published in 1838.[38] In them he cites Nuix and Clavigero to refute de
Pauw, Robertson, and others on Indian inferiority. The letters discuss Mex-
ican arithmetic compared to Tarascan, Indian idolatry, anthropophagy,
suicide, and music. The last two were written in Peru, mentioning Pacha-
camac and the sadness of funeral music (*yaravíes*). Moxó esteemed "los
americanos" as "equal in everything to Spaniards." The accompanying
engravings (fig. 23) illustrate sixteen objects in his museo, now lost.

ALEXANDER VON HUMBOLDT (1769–1859). Among his many
abilities, the explorer and naturalist Humboldt was also an artist who
learned etching with D. N. Chodowiecki (1726–1801) in Berlin. He ad-
mired François Gérard (1770–1837) in Paris, having sat for a portrait by
him in Berlin in 1795 when he was chief inspector of mines in Prussia.[39]
After the revolution he welcomed P. J. David d'Angers (1788–1856) in
Berlin as an emigré sculptor, whom Humboldt may have known at
Gérard's salon.

Humboldt's deep interest in paint appears in *Views of Nature*, the most
widely read of his books, and in *Cosmos*.[40] In these passages he hoped that
a "landscape painter" would find it "an enterprise worthy of a great artist"
to record in the tropics the ecological interrelatedness of all plants there,
which would "resolve itself . . . like the written works of men, into a few
simple elements."[41] In the *Cosmos,* Humboldt presented landscape paint-
ing as belonging "to the poetry of nature"[42] and as recalling "the ancient
but deeply-seated bond which unites natural knowledge with poetry and
with artistic feeling."[43]

His observations on ancient Amerindian art appear mostly in *Vues des
Cordillères*[44] as comments on the accompanying *Atlas pittoresque* of
plates prepared by Humboldt from various sources. He explains that he
was "biased by no system" and confined "to a succinct description of the
objects" in the engraving,[45] divided as two of "monuments" and sixteen of
"views" (fig. 24). Discussing the monuments, however, Humboldt stresses
resemblances to Egyptian, Babylonian, Hindu, Moorish, Asian, and
Shamanic parallels. Thus pyramids of the "New Continents" are alike in
form to those of the Old World but different in "destination" (by which he
may have meant function).[46]

Figure 24. Humboldt stressed the horizontality of the terraced platform at Cholula by omitting the colonial city and the remains of other pre-Conquest platforms and by placing the main platform halfway to the horizon. Its name in Náhuatl was Tlachihualtepetl, or "hand-made hill." His four terraces double the actual number, and the scale of the church is magnified to bring the pyramid into a size comparable with the mountains behind it. (After *Essai politique* [Paris, 1811])

Furthermore, he distinguishes "works of art" from "monuments." The former are by "people highly advanced in civilization," and they "excited our admiration by the harmony and beauty of their forms, and by the genius with which they are conceived." But "monuments can be considered only as memorials of history" and as "connected with the philosophical study of history."[47]

That his image of nature blended with his concept of the artistic "physiognomy" of landscape painting he declared before departing for America in 1799, saying that scientific observations were not his only purpose, but that "his eyes would also seek their harmonies in the synergy of forces and the effects of inanimate creation on living animals and plants."[48] These aims were learned from Goethe and Georg Forster, who also had sought unity behind appearances, in landscapes as the physiognomies or faces of nature. This unity was knowable only by mankind as the most recent and complex element of a living universe.[49]

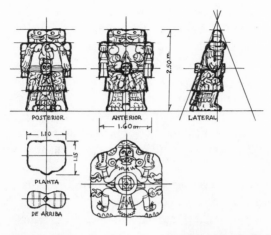

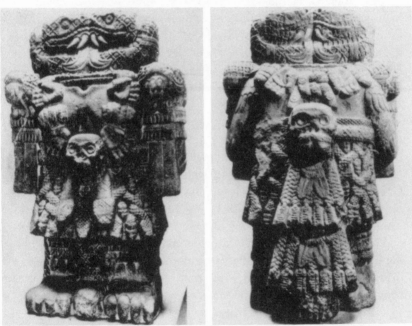

Figure 25. The outline drawings of the statue of Coatlicue (discovered in 1790 under the Plaza Mayor of Mexico City 2.50 meters high and 37 meters from the National Palace) display its cruciform silhouette and its forward lean as if toppling over the spectators. The death-god relief carved under its base is invisible, though reinforcing the deathly symbols of decapitation and skulls at head and belt. (After J. Fernandez, *Coatlicue* [Mexico, 1959], 210 and pls. 8, 9)

Yet Humboldt's opinion that monuments were lower in value than works of art led him to deprecate Amerindian efforts. Although he wrote about Xochicalco, Mitla, and Cholula, he actually saw only Cholula and never went to Oaxaca or Tajín.[50] He regarded the huge statue of Coatlicue (fig. 25) and the Tizoc stone as being from the "infancy of art" and as documents rather than works of art.[51] On ancient Mexican painting Humboldt lamented "the habit of painting instead of writing, the constant use of disproportionate forms, and the obligation to perpetuate them without change," as circumstances leading to the perpetuation of bad taste among Mexicans.[52]

Humboldt, however, is regarded by anthropologists and archaeologists in Mexico today as a founder of modern empiric study.[53] He rejected Buffon and de Pauw; he disagreed with Hegel and Schelling, but he accepted only some of Herder's views, such as "stress on environment" and historical relativism as to "the unique quality and validity of each civilization." Herder's "laissez-faire liberalism," and "evolutionist point of view" are also brought forward by B. Keen[54] as affecting the thought of Humboldt. Thus his position remains ambivalent, between esthetics from above and below, unresolved between ideal and material study.

CARLOS MARIA DE BUSTAMANTE (1774–1848) was among the last creole scholars who attempted to prove that Christianity came to Mexico with the apostle Thomas. Among these was Bishop Granados y Galvez, a Franciscan model for Bustamante's fifty-seven "conversations."[55] Lorenzo Boturini also believed in the American mission of St. Thomas,[56] by identifying him with Quetzalcoatl, as had Sigüenza, Veytia, and Mier,[57] in a creole effort to deprive Spain of the merit of first introducing Christianity to America. But he went much less far than Mier, who had preached at Guadeloupe in 1794 that the virgin of Guadeloupe was brought by St. Thomas to Mexico, where he was also known as Quetzalcoatl, and to Peru, where he appeared as Viracocha. Mier also equated Huitzilopochtli with Christ, Coatlicue with the Virgin Mary, and Tezcatlipoca with God the Father.[58] Such efforts to unify Amerindian religions were primarily political and pro-Indian, but they also correspond to an early effort in the direction of a comparative history of religions by creoles (who were Spaniards born in America).

Bustamante's delightful conversations in the public garden of Mexico

City were among an Englishman and Milady, his wife, with a young Mexican lady of much erudition and her brother. Margarita lectures on Indian origins, citing Clavigero and Veytia as well as Gregorio Garcia on the Jewish origin of Indians. She summarizes the migration history of the Aztecs, but the news of the day concerns the designs of the Yankees in Texas and the possibility of Mexican reprisals. Most of her history of Aztec rulers is from Ixtlilxóchitl. She makes his remarks serve as a commentary on the Mexican politics of the day, drawing lessons from Aztec experience. The fifty-seven conversations range over Mexican monuments then known from publications by Márquez and Dupaix,[59] thereby bringing the monuments into contemporary history for purposes more political than esthetic.

CHARLES ÉTIENNE BRASSEUR DE BOURBOURG (1814–1874). Having lost respectability among social scientists, Brasseur de Bourbourg's work is rarely read or cited among them, he being in limbo for "unfounded speculation," for confusing myth with history, and for using Indian legends as documents.[60] But Brasseur often anticipated theories that recently have gained wide currency. For example, Brasseur lived in 1855 among the Maya at Rabinal in Guatemala, where he became aware of manuscripts by Ramón de Ordóñez, who knew Palenque well in 1773 and argued that it was the Ophir of the Bible. Without accepting Ophir, Brasseur insisted that Palenque must have been the "entrepôt d'un commerce considérable,"[61] thus anticipating the recent theories of economic historians about internal "ports of trade" at the interfaces of distinct ecological environments[62] in Mesoamerica.

On the other hand, Brasseur also suggests that Palenque was anciently a *Xibalba*, as an entrance to the Maya underworld, which is more credible than the recent exegesis by M. Coe that the Xibalba of the Popol Vuh is the Maya underworld itself.[63] Brasseur never identifies Xibalba with the underworld but rather with a worldly capital and empire in Mexico.[64] He also believed that Topiltzin Quetzalcoatl was a contemporary of Charlemagne and a deity with kingly powers, somewhat as in a recent reinterpretation by G. Willey of Quetzalcoatl as a "transcendental ruler."[65]

Brasseur's first publication was his most adventurous in speculation, in part because of his astonishing discoveries of native manuscripts,[66] which he felt compelled to interpret before editing or publishing them. His later work[67] had as its purpose to avoid "explanation of origins" and "com-

parisons between the Old world and the New" (I,xcii), while seeking to "rétablir les faits altérés . . . ou cachés" (I, chap. 1, p. 3).[68] The quest for "true" or "hidden" facts reflects his education as a priest, in scholastic ways of thought seeking similitudes. These also appear in Eduard Seler's multiple interpretations of pre-Columbian sculpture and painting as well as in recent iconographical studies of medieval meanings by art historians from Emile Mâle to Erwin Panofsky and later.

The concern with similitudes kept Brasseur away from separating texts, in favor of coalescing them as expounding a common message. He was uninterested in separating the Christian elements of the texts he discovered from their native components, even using Mexican and Maya explanations, such as Chimalpopoca and the Popol Vuh interchangeably as needed (*Histoire*, bk. I, chap. 2, p. 58) by a Christian apologist, which he always remained.

In book IV Brasseur constructed a narrative of ancient Mexican states in which the "Toltec empire" of the eleventh century is presented as a *pacte fédéral* under the ruler Huemac, who sought to "enfranchise the lower classes" and abolish the emergent feudality of Culhuacán,[69] in an interpretation prefiguring that of the cultural materialists in recent years.[70] But Brasseur's secular guide in Mexico in respect to Mexican manuscripts was Lorenzo Boturini, the disciple of Giambattista Vico,[71] and Brasseur's mentality is distinctly Viconian and idealist via Boturini in Mexican matters as explained here (p. 88).

In another passage (*Histoire*, bk. IV, chap. 2, p. 356) Brasseur explains that when the "northern princes" of the Toltec state felt "menaced by royalty," they opened their frontiers to the invading barbarians as their allies against the sovereign. The model here is that of European feudality in relation to monarch and invasions by Islamic and Gothic peoples, in a positivist explanation from "deductive law."[72]

Book V of the *Histoire* presents Maya history as deriving from Toltec civilization after A.D. 174, on a "simple" Maya base of creator-and-sun cult, deified rulers, and a rural festival calendar (chap. 2, p. 42). This early base prefigures in its simplicity Eric Thompson's view of the Maya before Mexican preclassic contact.[73] But Brasseur's impressively complicated list in books V and VIII of place names, dynasties, and personal names, in a text based on early accounts of incidents and episodes, has never been used by archaeologists.[74] Yet the unraveling of his accounts might still lead to many surprising discoveries. His narrative, like that of J. L. Stephens,[75] is

an "elemental broth" still needing qualitative and quantitative analysis in relation to postindependence geography.

Brasseur's strengths as a narrator come from his sympathetic reading of Vico and Vico's Mexican pupil, Boturini. By all three scholars, epic poetry was perceived as history. And their coordination of poetry with history was in full recognition of esthetic values as being important in history, both archival and archaeological.[76]

JEAN FRANÇOIS DE NADAILLAC (1818–1894). Nadaillac's obituary, signed by A. Gaudry,[77] characterized him as of "an intelligence exceptionally open to scientific matters" and as especially "well informed about the New World," on which he did not "pursue personal investigations, although he was able with great art to bring the public the results of the labors of scholars." His primary interest was in the prehistory of Europe and the success of his book *Les premiers hommes et les temps préhistoriques* (Paris: Masson, 1881) led him to "trace the analogous period in America seeking the first evidences of a culture parallel to our own and bringing the recital down to the sixteenth century of our era." He had read what was available in print, and he relied principally on the reports of travelers and early chronicles in seeking evidence of the "onward march of human progress." He concluded that "science in its freedom and its strength cannot disown its author," who is "he who created man" (vii). Stone Age men in the New and Old worlds were "alike in habit, physique and mental culture" as well as "passing through strictly analogous phases of culture." Following O. C. Marsh (1877), he places the appearance of man in America in the Pliocene[78] (45).

Being always on guard "against brilliant hypotheses, startling guesses, and over-rash conclusions" (197), Nadaillac gives few chronological suggestions. The oldest human remains are those associated with extinct species or found in middens and caves. "Mound-builders" continued their work until Discovery, but it had begun after the extinction of early animal species. Cliff Dwellers finally succumbed to Apache attacks (258). In Mexico, earliest settlers were of "Náhuatl race," preceding the Mayas (262). In Peru, Aymaras preceded Quechuas (390). The chapter on physical anthropology supposes many waves of invasion (517), and the final section on the origin of man in America admits the possibilities of northern and western penetration into the hemisphere (523).[79]

CLAUDE-JOSEPH-DÉSIRÉ CHARNAY (1828–1919) first visited Mexico in 1857, returning in 1880 with funds provided by Peter Lorillard and the Ministry of Instruction in France. Under instruction to make casts of monuments for the Smithsonian Institution in Paris, his own intention was to write in the "dual form of a journal as well as a scientific account."[80] Its illustrations, redrawn from photographs, are often of places and things unrecorded by others. His staff dug superficially and made plans (fig. 26) of a part of Tula called Palpan.[81] His ideas are no more confused than those of others working more with documents, like Brasseur, than with objects. But his luck in finding new types, such as the "toy wagons" of clay from cemeteries at "Tenenenepanco" in Veracruz,[82] makes his work of interest. He covered as much territory as Dupaix, and his discoveries have the same random character. But his observations are less credible, as when he dismisses all he has seen as "rude manifestations of a barbarous race," without "intrinsic value" or "higher traditions."[83]

His main belief is stated in the dedication to Peter Lorillard dated

Figure 26. Charnay, to honor whom an area is named at the ruins of Tula, ordered these excavations, which were drawn by his colleague Albert Lemaire. Later archaeologists preferred undisturbed sites, and there is no report on these other than in Charnay's pages. (After *Ancient Cities* [1888], 104–07)

November 1, 1884: "Ancient American civilizations . . . had but one and the same origin . . . they were Toltec and comparatively modern."[84] He also believed that "the autochthones of America" came "from the extreme East" with architecture "like Japanese," decoration like Chinese, and like "Malays both in Cambodia, Annam and Java" as to customs, habits, sculpture, language, castes, and polity.[85] In this assertion he conforms to the theory of Asian origins, contradicting his earlier statement about Toltec "origin" and avoiding controversy with Brasseur's supporters.[86]

The most remarkable aspect of Charnay's work is its brilliant illustration in 108 woodblock engravings. For the first French edition in 1863 Charnay invited E. Viollet-le-Duc to collaborate with an extended *étude technique* on ancient American architecture,[87] based upon plans, drawings, and photographs by Charnay's "private secretary," Albert Lemaire, and by unnamed photographers and engravers on wood from their work.[88] Thus Charnay's view on architecture may owe much to Viollet-le-Duc and Lemaire, as when he characterizes the palace at Palenque (fig. 27)

Figure 27. The plan of the palace at Palenque by Albert Lemaire (Charnay's "private secretary") is surprisingly accurate, but it omits the southern half of the platform, which may have housed services for the southern palace courts. (After Charnay, *Ancient Cities*, 255)

not as a "royal" palace, but as "a holy place . . . an important religious centre . . . a place of pilgrimage . . . a much-sought burial place . . . a priestly habitation, a magnificent convent" (245–46); all these terms retain some credibility. Charnay adds (269) that on his first visit in 1857, "these ruins fixed my resolve to make archaeology the business of my life."

Among his better ideas was the effort to correct the visionary name given by Auguste Le Plongeon to a recumbent stone male figure as Chac Mool (fig. 28). Charnay regarded these, following his colleague E. T. Hamy in Paris, as more correctly to be named for Tlaloc. Examples found at Tula, Tenochtitlán, and Tlaxcala led Charnay to use them and the mansard-roof profile as proofs of his theory of "Toltec" (Nahua) domination throughout Mexico and Central America (366–68).[89]

If Charnay's theories are extravagant, they were less so than Brasseur's, whom Charnay acknowledges only for his edition of B. de Lizana [1633] on Izamal (307). His American editor, Allen Thorndike Rice, at the *North American Review,* explains in the introduction to *Ancient Cities* (xiv–xv) that Brasseur had become a convert to the Atlantis theory, by interpreting *Codex Chimalpopoca* as a Viconian allegory of a submersion of part of the American continent including Yucatan, Honduras, and Guatemala, followed by its second upheaval.[90] Contrasted with Brasseur's dark flights, Charnay's ideas, observations, collections, and visual documents were rational and useful, many remaining so today.

But both men, Charnay the traveler and Eugène Viollet-le-Duc, the medievalist who restored cities and churches in France, drew support from Napoleon III in 1851, when the empire was reestablished in him by vote of the nation. Charnay was his agent in Mexico in 1857, and Gobineau gave voice to the new reign with the *Essai sur l'inégalité des races humaines.* Charnay and Viollet-le-Duc shared the first edition of *Cités et ruines* in 1863, with the medievalist taking precedence.

Viollet-le-Duc's pages begin (4–12) with a discussion of the "races" of the Amerindian peoples before Discovery. He presented them as arriving from Asia and from Scandinavia in A.D. 600–700, being composed of black-, white-, yellow-, and red-skinned peoples who all were subjected before the time of the Spanish conquest to "an inferior indigenous race" guilty of "hieratic massacres" (10). But their predecessors of "Scandinavian or indo-germanic races" had built the Ohio earthworks as well as Teotihuacán (13). The corbel-vaulted buildings of Monte Albán were the work of Scandinavian races using mortar, while "semitized Aryans" used "stone

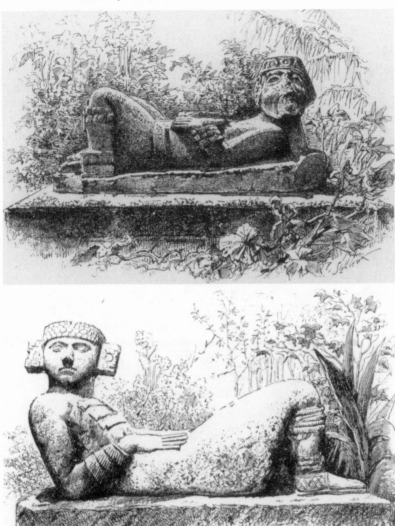

Figure 28. The Chac Mool figures of Central America (*top*) and Mexico (*bottom*) remain as enigmatic in their meaning as in Charnay's time. At Chichén Itzá they were closely associated with serpent-column structures. Their form became a lifelong preoccupation of Henry Moore in England, whose formal reorganization of the recumbent figure occurs in many major works by him, as one of the dominant themes in modern sculpture. The name is imaginary, the creation after 1861 of Auguste Le Plongeon (obit 1906?), a contemporary of Charnay. See M. E. Miller, "A Reexamination of the Mesoamerican Chacmool," *Art Bulletin* 67 (1985): 7–17.

laid without mortar." "Pure Aryans" built in wood, like the Japanese (25–31). The oldest American monuments at Palenque were built by "aborigénes, inorigines jaunes, migrations blanches, et Olmecas" (45).

Toward the end of the essay, the question of the horse arises: the white races "lost their mounts" during the migration (86–88). Viollet-le-Duc never mentions the Comte de Gobineau, but the entire work reflects his language: where black blood is without mixture, no civilization can exist, but the "élément blanc donne la vie à ces masses inertes" (90), for which he cited Las Casas, Ixtlilxóchitl, and Veytia by names alone, rather than Gobineau. In Yucatán, pondering Charnay's photographic atlas, he saw the work of Malays and *races jaunes,* who were overcome by white, feudal warriors (102). His essay ends with an assertion: 'architecture antique du Mexique se rapproche sur bien des points, de celle de l'Inde Septentrionale" (104). The debt to Gobineau is clear, but Gobineau's essay was written before he saw America, first in 1859 in Newfoundland and then as minister of France in Rio de Janeiro (1869–70).[91]

The dark line in idealist thought runs clearly from Kant and Hegel to the racism of 1850, as both anti-American and racist. My position is like Fechner's: without idealism there can be no love or hate, and without materialism no exact knowledge or science is possible. Each needs the other to correct its excesses.

4

Empiric Esthetics

from Below

To ENTER THE WORLD of esthetics from below is to examine the
experimental psychologies of the mid-nineteenth century as well
as the theories of Darwin and Marx and of some natural scientists.
The idea of "esthetics from below" first became current in Germany with
G. T. Fechner's *Vorschule der Asthetik* in 1876. Its use in America appears
in K. E. Gilbert's *History of Esthetics* in 1953, in relation to "esthetics from
above." Gilbert used the opposition to contrast philosophical absolutes
with scientific experiments. Thus in esthetics, idealist thought hangs from
absolute ideas such as beauty, whereas scientific experiments reach from
below to attain being as "laws" or mathematical "constraints."

Among those concerned with esthetics before 1850 were Fechner, Gott-
fried Semper, Charles Darwin, Karl Marx, and Herbert Spencer. None
wrote anything about Amerindian art but each in his way has affected the
concept of material culture. By this concept it is implied that all artifacts are
deserving of esthetic attention.

The phrase "material culture" first appears in English in the works of
Stewart Culin (1858–1929), who was director of University Museum in
Philadelphia from 1892 to 1899, writing about "functional objects and
their backgrounds in living, observable societies," especially the evolution
of games,[1] on which he spent much of his life, following in the steps of
Schiller, Semper, and Karl Groos.

Given this attitude, the older boundary separating the artist from the
artisan and the liberal from the mechanical arts began to fall into disuse.
Today the distinction between art and material culture has reached into the

core of the profession of the historians of art: Jules Prown separates an older taxonomic *history of art* from a world *art history:* "In the *history of art,* the subject is art, and the study is of the patterns of causation—stylistic, iconographic and technical—that have shaped its development."[2] Thus he defines the difference as being between *art as subject* and *art as history.* But in *art history* "the subject is history, especially social and cultural history," which thereby makes art history synonymous with "material culture" seen as "part of the social strategies of the individuals and groups that constituted a past society."[3]

Expanding Prown's diremption,[4] one might begin by splitting historians of art from art historians, on the binary contrast between taxonomy (classifying), and structure (functional analysis). Such a division of term reflects historical development by suppressing the possessional case (that one contains the other) and substituting a choice: art history instead of history of art.

Another dimension exists in Stewart Culin's invention of "material culture." Not only did he separate "material culture" from "the antiquities of archaeologists" at the Exposition of 1892 in Madrid,[5] but his own work was mostly restricted to games and gaming in cross-cultural perspective. This dimension can be traced to eighteenth-century encyclopedias.

Friedrich Schiller (1759–1805), when supplementing Kant with Fichte's "moral dynamism in 1793–94," enriched the duality of matter and form (*Stofftrieb* and *Formtrieb*) with the "play-impulse" (*Spieltrieb*) as "constituting beauty and art." This descent into psychology led to many studies of play, human and animal.[6] Schiller had written that "man only plays when in the full meaning of the word he is a man, and *he is only completely* a man when he plays."[7]

Darwin described play as common to men and animals. But the difference between them, described by Norbeck as "depending upon symbolism . . . beyond the understanding of non-human forms" [of life], was not stated until a century later as a truism.[8] Norbeck still relegates "play and art" to nonanthropology among "other topics," like Stewart Culin in the 1890s, for whom "material culture" continued the Kantian binary contrast of "form/style" with "use" (or function).

European and English Theorists

GUSTAV THEODOR FECHNER (1801–87) became a doctor of medicine at Leipzig in 1824 and turned to physics in 1834, investigating

Ohm's law and measuring the galvanic battery current. The power of his mind emerged when he was in his early thirties, as dedicated not only to galvanic phenomena but also to *eidetic* imagery, as sensations of contrast,[9] or the continuation on the retina of an image after the stimulus of its light ceases. Such aftereffects now are established throughout the range of physiological perception in relation to memory. As a psychologist experimenting more than speculating, he incurred a long mental illness (which he blamed on his experiments), making him resign his chair in 1839. He turned then to writing *Elemente der Psychophysik* (2 vols., Leipzig, 1860, 1889). Treating of body and mind as an exact science, he proposed that a graded series connected afterimage, eidetic image, and memory-image.

The general framework of *Psychophysik* (psychophysics) was based on Weber's law of 1846, in which the effects of different magnitudes obey a constant, in the ratio of the increase d to the stimulus B ($dB : B = C$). Fechner's own principle came to him at dawn on October 22, 1850: physical process matches psychic process, by which the latter may be measured. The scientific community was then so united in opposition to *Psychophysik* that Fechner reverted to the esthetic questions that had occupied him in early adult life. But his later studies were limited to proportional effects, and the effects of "most pleasurable form," when he focused on the disputed authorship of the painting in Basel known as the Holbein *Madonna*.

Fechner's importance to esthetics is as a transition from idealist speculation from above, from the "universals downwards to the particulars," as in the philosophies of Schelling, Hegel, and Kant. But Fechner, as the pioneer of experimental esthetics, builds from below,[10] as a "preschool" theorist concerned with psychology, biology, psychiatry, sociology, and ethnology. This began the era of esthetics in the age of science, until the appearance of a more "elastic and liberal conception" of "esthetics and general science of art," as proposed by Max Dessoir in 1906.[11]

During the late 1830s Fechner wrote extended reports on his experiments in vision, based on simple exercises with color perception and its complementary afterimages.[12] His aim at first was to determine whether colors resulted from a contrast of objective character. He concluded that the perception of subjective color was variable. He then studied complementary colors arising on inspection of color fields and tested alterations in subjective afterimages according to the colors of the field of display, such as a green object on white or black or red fields.

By 1840 he reported severe damage to his vision and state of mind from

such experiments, which included staring at the sun in a state he called "light-chaos"[13] (in the resting, closed eyes). He compared light-chaos to auditory aftereffects.[14] His final observations turned upon a theory that contrast was the condition of color perception, especially in the fading away (*Abklingen der Farben*) of complementary afterimages as if they were dying sounds.[15]

This dialectic method of conversion into oppositions is present all through Fechner's works, and it reappeared in an entertainment under his pseudonym, "Dr. Mises," as *Vier Paradoxa*.[16] In it God appears as a dialectician creating shadow from light and humanity as the shadow of a shadow [of Himself]. The four paradoxes are about shadows as alive, in a space of four dimensions, containing witchcraft, in a world made not by a creator but by a destructive principle (*zerstörendes Princip*). Fechner's part as author of the book was as a shadow retreating into itself (*ein in sich zurücklaufender Schatten*).

Fechner never wrote anything about America in his scientific or imaginative works.[17] Yet his experimental approach to the sensory world marks a shift in esthetics from pure speculation to testable propositions as well as laying the groundwork for later studies of eidetic imagery. This was all before *Vorschule der Ästhetik*. Begun in 1867,[18] the *Vorschule* undercuts idealist speculation. It can be translated as "preschool," not only in the sense of small children's exercises, but also as basic elements of training. Its two volumes appeared when he was writing on the Holbein *Madonna* and lecturing at Leipzig on esthetics in the *Kunstverein*.

Volume 1 opens by explaining esthetics from above as descending from ideas and from below as rising from details of observation, thus opposing Kant, Schelling, and Hegel to empiricists such as himself, J. F. Herbart, and H. v. Helmholtz. The main preconception (*Vorbegriff*) underlying esthetics from below is reduced to pleasure and displeasure (*Lust und Unlust*), as emotions under a eudemonic principle tending to happiness or well-being. Other principles in this system have to do with thresholds of psychological intensity (*Schwellen*); with enhancement (*Steigerung*); unity in multiplicity; absence of contradiction (these last three composing clarity).

Another main psychological principle is associated in memory and fantasy, as exemplified in the experience of landscape in vision and art and in relationships between poetry and painting. From then on Fechner presents further examples in music and mathematics. Architecture leads him to discourse on utility and beauty, closing with the topics of humor and taste.

The second volume continues with the analysis and criticism of works of art, especially as to the dispute between proponents of form in opposition to content, and as to the distance between nature and art. This topic leads to processes of stylizing, idealizing, and symbolizing as well as to a collection of essays on history and painting, sublimity, the sizes of genres of painting, and the question of color on sculpture and architecture.

Then comes a second list of principles, now augmented (230) as laws (*ästhetische Gesetze,* or *Principe*). He discusses only seven "of the most important": contrast, summation, perseverance, primary and secondary expressions of pleasure-displeasure, equilibrium as esthetic midpoint, and economy of means. An appendix presents optimal sizes of different genres of paintings in museums as a statistical problem, but without reference to historical time.

How much of this pertains to *Ästhetik von unten?* Pleasure and pain relate to experimental psychology, as do thresholds of sensation and their enhancement. But unity and contradiction belong to aprioristic categories, while use and beauty, like humor and taste, pertain to idealism more than empiricism.

The second series (of laws/principles) is also oriented more to ideas about artistic values than to scientific experimentation. Only the appendix, on the measured dimensions of painting, by genre, approached the experimental rigor Fechner was seeking.[19]

In England Herbert Spencer (1820–1903) extended Fechner's law to cultural dimensions. Spencer's early career was in the engineering of railways, until their rapid expansion led to an economic crisis, causing him in 1841 to turn to biology, where he was a follower of Lamarck (1744–1829), the pre-Darwinian evolutionist. When he came to writing his system of philosophy in 1858 he began with biology, then psychology, sociology, ethics, and "ceremonial institutions." These included mutilations, presents, obeisances, salutations, titles, badges, dresses, and so forth, garnered from reading in notes on human relations, called "descriptive sociology."

Spencer's comments on esthetics appear mostly in essays on topics like "personal beauty" and "the purpose of art." These derived from his principle that "any effect of culture must be consequent on the excitement of the superior emotions,"[20] thus extending Fechner's law from the individual to the cultural order.

Abraham Moles in Paris brings the Weber-Fechner law into the recent world of informational sciences known in France more simply as *informatique.*[21] Based mainly on music and discourse, the argument draws a dis-

tinction between *semantic* and *esthetic* information, the former "having a universal logic . . . serving to prepare actions" (129). The latter cannot in theory be "translated into any other . . . system of logical symbols because this language does not exist." Having no goal or intent, "in fact it determines internal states" (131), being "not *translatable;* it is only approximately *transposable,* that is, it has only equivalents, not equals." It becomes "personal in the field of esthetic information," unlike semantic information (131). Esthetic information is "randomized and specific to the receptor" and "difficult to measure." But "information or originality is a function of the improbability of the received message" that connects "information to improbability by Fechner's relation" (22). This is again the law of Weber-Fechner: "$\Delta E/E = K$, or sensation, varies logarithmically as excitation: $S = K \log E$" (12).

GOTTFRIED SEMPER (1803–1879) was closely associated with England in the mid-nineteenth century when he was in political exile there, after his activity as a partisan in the democratic revolution of 1848–49 in Germany.[22] Beginning at Göttingen with K. O. Müller, the classical archaeologist, he had sought to prove that ancient architecture was originally intended to be seen in a garment of color. He also opposed Hegel's dictum that both architecture and the árts were governed by the same esthetic rules. In England (1851–55) he declared for evolution, following F. Cuvier and G. Klemm in natural history and anthropology.[23] He often repeated that style was never extraneous, but always intrinsic to the material and techniques in which it is expressed. His only remark on Amerindian building occurred when he saw a contemporary Caribbean hut of bamboo and palm fronds[24] in the Great Exhibition of 1851 in London and wrote of its hearth, wall, roof, and platform as "archetypal."

It was extending his analysis to non-European peoples and to prehistoric remains that led Semper as an architect to deconstruct the arts into materials and crafts, such as stonework, clay products, wooden assemblages, or interlocking threads and all other combinations from which works of art may appear.[25] His primary purpose was to raise the level of the crafts at the time of the exposition of 1851 in London. The effects of his work enlarged anthropological archaeology and ethnology more by hearsay outside Germany than by his difficult text. Americans like W. H.

Holmes, when he studied painting in Munich in 1879–80, probably knew of Semper (see below).

How much could Holmes have learned in his short visit to Munich as a painter in 1879? Semper had been writing provocative studies since 1837. Most had appeared in print, and they were widely controversial in 1879, as esthetics from below. The subtitle of *Der Stil* as *Praktische Ästhetik* was in open conflict with speculative and idealist esthetics on the issue of evolution in art-historical materials.[26] Holmes began publishing in 1892 a series of papers on esthetics, which he regarded as like "the phenomena of biology."[27] Only Semper had used this language before Holmes. Semper himself was more affected by Goethe's thoughts in 1786–88[28] about the parallels between the arts and natural sciences (mineralogy, botany, and zoology) than he was by Darwin.

CHARLES DARWIN (1809–1882). The word "esthetic" does not appear in Darwin's writings, but his contribution to esthetics is appreciable, as in 1872 in *Expression of the Emotions in Men and Animals*.[29] Darwin writes of it thus:

> My book on the *Expression of the Emotions in Men and Animals* was published in the autumn of 1872. I had intended to give only a chapter on the subject in the *Descent of Man*, but as soon as I began to put my notes together, I saw that it would require a separate treatise.
>
> My first child was born on December 27th 1839, and I at once commenced to make notes on the first dawn of the various expressions which he exhibited, for I felt convinced, even at this early period, that the most complex and fine shades of expression must all have had a gradual and natural origin. During the summer of the following year, 1840, I read Sir [Charles] Bell's admirable work on expression, and this greatly increased the interest with which I felt in the subject, though I could not at all agree with his belief that various muscles had been specially created for the sake of expression. From this time forward I occasionally attended to the subject, both with respect to man and our domesticated animals. My book sold largely; 5267 copies having been disposed of on the day of publication.

Thus Darwin was thirty when he began these studies and sixty-three when the book appeared. Charles Bell's *Anatomy and Philosophy of Ex-*

pression (1806) was among Darwin's preferred readings (in the third edition of 1844 corrected by Bell), and it led him to differ with Bell on the primary role of the muscles of the face. Bell believed they were for the expression of emotion, contrary to Darwin's experimental works on their function in respiration.[30] Darwin's sixteen experimental queries were circulated in 1867 among thirty-six correspondents, "several of them missionaries or protectors of the Aborigines" in Africa and America (Fuegians, and North American tribes). The queries all bear upon the cross-cultural constants between emotion and its expression by the facial muscles, and Darwin valued most that "observation in natives who have had little communication with Europeans."[31] During his long investigation Darwin also relied upon the contemporary work of Herbert Spencer on the physiology of laughter in 1863 and 1872, making it clear that his own studies began in 1838.[32] In addition, Darwin read and cited Lessing's *Laocoön* but "without profit" because "in works of art beauty is the chief object; and strongly contracted facial muscles destroy beauty."[33]

KARL MARX (1818–1883) may have been among the university students to whom the art historian F.-T. Kugler lectured in Berlin during 1840–41. Marx began his concern with histories of art and literature at Bonn in 1835, and in Berlin he followed the lectures of A. W. Schlegel,[34] who had expanded the esthetic appreciation of world literature and art in the directions opened by Herder, Goethe, and Kugler.

During 1840–41 Marx was writing about artistic creativity, having read Lessing's *Laokoon,* Winckelmann on sculpture, and Hegel's *Ästhetik* (probably in 1837).[35] In 1842 he was in Bonn, reading on Christian art, on Italian painting (Rumohr), on fetishism (de Brosses), and on Gothic sculpture (J. J. Grund). He also collaborated on satirical writings pointing out the discrepancy between ancient esthetic democracy and the archaic barbarism of Christian art. In another satire of 1842 he developed the idea of fetishism into consumerism as basic to religious behavior.[36]

By 1842 Marx was ready to subordinate his wide humanistic schooling to the class struggle. Communist students have sought to clear his position on the esthetic components of dialectical materialism.[37] But in principle Marxist history leaves no proportional room for the large part of experience concerned with esthetic recognition, which emerges mainly when the vices of elites are satirized.

An American Counterpart

WILLIAM HENRY HOLMES (1846–1933). The long career of
William Henry Holmes began as an artist, turning to geology and Ameri-
can Indians and ending as curator and first director of the National Gallery
of Art. In 1879–80 he returned to art studies in Munich and Italy, con-
tinued in Washington during 1882–85 in "museum work and the study of
primitive art in its various branches."[38] He became head curator in the
Field Columbian Museum of Chicago in 1894, after having taken part in
the installation of the exhibits of the Smithsonian Institution at the Field
Columbian Exposition in Chicago. This was the most extended exhibition
of ancient American art that had been assembled in the hemisphere, with
effects soon appearing in architecture and art.[39] Full-size replicas of Maya
buildings from Labna and Uxmal were shown as well as houses of cliff
dwellers and other shelters of Amerindian peoples all arranged for "com-
parative study" under the direction of F. W. Putnam in the Anthropological
Building as "Man and His Works."[40] Later on in 1903, as chief of the
Bureau of American Ethnology, Holmes opposed Putnam on the subject of
palaeolithic remains in North America, saying that the stone tools from
Trenton in New Jersey were not of glacial age but only "crude unfinished
tools of later date." Stephen Williams says that both were right and wrong:
"Holmes was correct in his analysis that many of these were not finished
tools . . . but he was wrong in attacking the notion of glacial age man in
America as many Carbon 14 dates now amply testify."[41]

In 1920, after having been curator since 1906,[42] Holmes was named
first director of the National Gallery of Art, in the National Museum
building completed in 1910 on Madison Drive along the Mall (now the
Museum of Natural History). He thereby returned to his first interest in the
art of painting and left the then-controversial field of very Early Man in
America.[43]

Holmes's thoughts about esthetics began with papers in 1883 on "art
in shell" of Amerindian origin.[44] In 1886 his "ceramic art" in ancient
America appeared together with articles on Pueblo and Mississippi pot-
tery,[45] followed in 1888 by a similar general analysis of textiles.[46] In 1890
he was ready to discuss the evolution of ornament in America.[47] Two years
later he released the first of two essays on esthetic evolution, followed in
1894 by another on developmental order in esthetics.[48]

Holmes's views on esthetics resemble the "technicism" of Gottfried

Semper (1803–79), and they prefigure those of André Leroi-Gourhan after 1957 by proposing a biological metaphor for the developmental evolution of the forms of art.[49] He saw "the realm of the aesthetic" as the pleasures of seeing, hearing, and thinking (230) and as the "science of the beautiful" when the "simple, observable phenomena of the aesthetic" are "studied and classified, as the naturalist deals with the phenomena of biology" (240). Without "aesthetic sense," existence would be "ineffably stupid" (242). He then enounces his biological metaphor: "the creations of art are growths as are the products of nature," which "are subject to the same inexorable laws of genesis and evolution" (243). The physical and mental evolution of the individual appears on a curve, charted against growth from prenatal through periods of infancy, youth, and maturity in graphs[50] like trumpets (fig. 29), expanding physically to a closed bell in senility and

FIG. 1. Diagram illustrating physical and mental evolution of the individual.

Figures 29–32. Holmes's graphs were in his day a pictorial method (mostly in mechanical engineering) of showing quantities by lines, usually physical quantities, to exhibit the law by which phenomena vary, using two or more quantities. His bold attempt was to apply this method to esthetics, by charting evolutions of four kinds: individual, cultural, mode of expression, and technological stage. He called them diagrams, but their common trait is plotting one magnitude (time) against another (change). (After W. H. Holmes, *Proceedings, American Association for the Advancement of Science,* 41 [1892], 245, 246, and 42 [1894])

"mentally" opening steadily until death as to "aesthetic field," which here is scaled as a ratio of 3 : 7 of all mental powers at old age (without the closing down of the trumpet).

Holmes then alludes to the theory of child's play as esthetic, citing Schiller and Spencer, but finding it an inadequate account of adult esthetics (245) and passing on to an evolutionary diagram of national and total cultural evolution. He used open "trumpet" graphs with esthetic inner linings as before but showing "pre-human, savage, barbarous, civilized and enlightened" stages. Four "nations," their composite graph, and the graph for all biological history are shown (fig. 30) with a ratio about 6 : 5 between all experience and the inner lining of esthetics, diagramed in broken lines. Advanced peoples have wider esthetic range; less advanced are narrower. Finally Holmes diagrams the various arts of space and time in their order of appearance. Painting came first, then sculpture, followed by architecture, all three with wide-mouthed trumpets. They appear in chronological sequence, as shortening graphs—music, poetry, drama, romance,

FIG. 2. Diagram illustrating national and race culture evolution.

Figure 30.

and gardening, each diminishing as to the ratio between esthetics and all experience (fig. 31). He concludes in a mood typical of his time that the future is open to further stages beyond "enlightened," in a "magnificent sum total of the aesthetic that future generations will be privileged to enjoy" (255).

Two years later Holmes returned to the evolutionary interpretation on

FIG. 3. Diagram giving tentative order of æsthetic groups.

Figure 31.

the smaller scale of the shaping of stone tools. He refrained from any attempt to determine absolute chronology, insisting only on his ideas of the "order of development" and on the "phenomena of art" as giving "an insight into the initial stages of history."[51] He classed early manual arts (by materials, processes, functions, stages of culture, time periods, and peoples), concentrating on processes, especially manual, which he defined

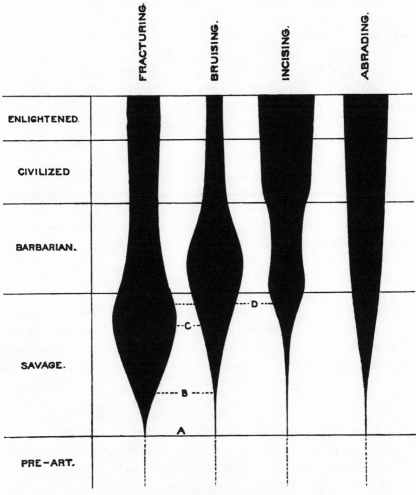

DIAGRAM OF RELATIVE PROGRESS.

Figure 32.

as fracturing, bruising, abrading, incising, modeling, and constructing, each in at least three modes (for example, "splitting, breaking, flaking, etc." for "fracturing"). At times his terms prefigure those of André Leroi-Gourhan after 1971, as when Holmes writes of "the pre-anthropic stage" of the "auroral days" of humanity,[52] including fracture, bruise, abrasion, and incision. These four processes are diagramed (fig. 32) as "genetic columns" showing "relative progress" from "pre-art" to "enlightened," through "savage, barbarian, and civilized" periods. Although the four processes are assumed to coexist before "barbarianism" and after "pre-art," he allows for the "existence of a flaked-stone period in Europe" only between points A and B in "savage" time (299).

Holmes has been presented as "virtually self-taught in the use of pencil, pen, and brush," against "parental disapproval."[53] Drawn to art, he decided in 1871 to study with Theodor Kaufmann at his studio in Washington (who had studied with Wilhelm von Kaulbach in Munich before emigrating to America in 1855). He was first encouraged by a fellow-student, Mary Henry, the daughter of the Smithsonian Institution's first secretary, to draw in the collections, where he met many of the illustrators with whom he would soon work on the U.S. Geological and Geographical Survey of the Territories, drawing palaeontological shells for F. B. Meek. Meek tutored Holmes in lithography and employed him as a piecework illustrator, among the young scientists living in the Smithsonian "castle" building.[54]

By May 1872 Holmes was considered ready to join the Yellowstone Division in Utah for geological illustration in the national park. His panoramas (fig. 33) and sections showed his "uncanny ability to portray accurately the details and depth of a geologic landscape."[55] His association with the photographer William Henry Jackson began with his investigations of archaeology and anthropology in Colorado and eastern Utah in 1875–76. The two men then collaborated on the "Pueblo Cliff House country" of Colorado, Utah, and New Mexico in studies, models, and collections that were displayed during the Philadelphia Centennial in 1876.[56]

Art again became Holmes's main concern when the government discontinued the territorial surveys as of 1880. Holmes went to Europe to visit museums in Italy and to study painting in Munich among the Americans around Frank Duveneck in 1879–80. He exhibited drawings and watercolors at the Corcoran Gallery and Cosmos Club[57] on his return, before

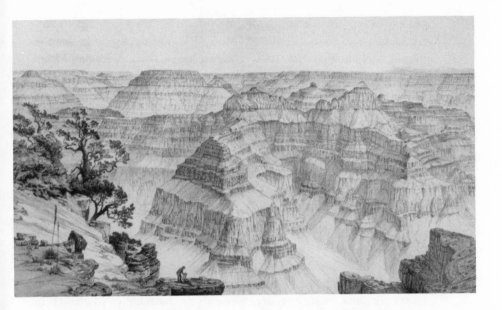

Figure 33. W. H. Holmes, Grand Canyon, panoramic drawing, c. 1881.

being reappointed as assistant geologist to the survey to draw the Grand Canyon. He was assigned to Clarence Dutton, in a combination of "an artist with geological training and a genius for the literal" with "a poetic and speculative geologist." W. Stegner wrote of Holmes's drawing here as "art without falsification."[58]

Returning to Washington in 1881, Holmes worked on the publication of the survey's drawings until 1889 between tours to Mexico and Yucatán.[59] In 1889 he was drawn into the Bureau of Ethnology to prepare exhibits for the World Columbian Exposition in 1893. He resided in Chicago as curator of the Department of Ethnology at the Field Columbian Museum but came home to Washington in 1897 to become chief of the bureau from 1902 to 1909.

From the viewpoint of an art historian, a major work by Holmes came from his travels to Mexico and Yucatán. In 1884 he and three professional photographers[60] traveled through Mexico on a private railroad car for two months studying museums, cities, and peoples. In 1894–95 he was invited to explore Yucatán from the yacht of Allison V. Armour of Chicago. The published results of these travels were two volumes entitled *Archaeological*

Studies among the Ancient Cities of Mexico.[61] Part 1 is mainly about architecture and part 2 about sculpture.[62] Plans and drawings were by Holmes, including panoramas of Chichén Itzá, Uxmal, Palenque, Monte Albán, and Teotihuacán (fig. 34). This panorama is grandiose and specifically exact, like the Grand Canyon drawings.

Holmes's descriptions of pre-Columbian architecture are still sound and his theories interesting, as when he offers a typology of roofing construction, from beam-span to single, double, and circular lean-in types. The "cuneiform arch" is the corbel vault of Maya building, and it is also, in his words, a "double lean-to."[63] Anticipating Spinden's detailed analyses, he described Maya ornament as owing most of its forms (nine-tenths) to "associated thought" in "geometric reductions" of animal shapes representing mythological figures. He estimated that "symbolism and aestheticism" take up three-fourths of the "labor and cost" of Maya architecture, with "symbolism" determining the "location" of work and "aestheticism" determining the "spread."[64] Maya drawing recalled Egypt, by its "lacking perspective" and mixing of sizes.[65] As to the meaning of Maya art, he believed, like Maya scholars today, that "names, titles or devices of rulers" were the subjects, in priestly accounts of rites and ceremonies. Like Ste-

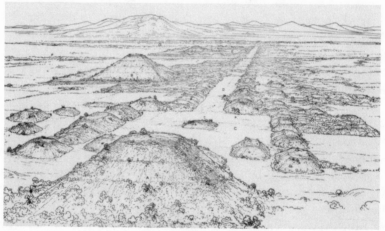

Figure 34. W. H. Holmes, panorama of Teotihuacán, 1884. Probably based on a photograph taken from the hill behind the northern ("Moon") pyramid looking down upon the site. The technique of drawing the eroded surfaces invaded by plants differs from the layered and striated folds of the Grand Canyon. Here, short, curving strokes denote low bushes and trees. In both panoramas, plant forms give the visual scale.

phens, he rejected all analogies with arts elsewhere in the world than America.[66]

Holmes's opinions anticipate Blanton's computer study in the 1970s. In part 2 he saw the significance of Monte Albán in southern Mexico as of "an actual city . . . of an agricultural people who utilized the valleys" up to the "very crests of the mountains."[67] Of Teotihuacán in the Valley of Mexico, he thought, as René Millon would in the 1960s, that "the city was largely one of residence" by "a culture differing decidedly from that of Tenochtitlán." He saw an "absence of indications of a warlike spirit . . . though it is next to impossible to think of a great American nation not built up and kept together on a military basis."[68]

Aztec sculpture was for Holmes dependent on "religious inspiration," marked by a portraiture more recessive than among the Maya. Its grace, symmetry, and refinement were in tribute to "forces of nature," as in feathered-serpent forms.[69]

When Holmes became chief of the Bureau of American Ethnology in 1902 he was responsible for the *Handbook of American Indians,* edited by F. W. Hodge.[70] Holmes wrote on topics that spread across the register of Amerindian craft practices and materials in 122 articles. His colleague N. M. Judd thought that Holmes wrote nothing of major importance at the bureau.[71] Yet for those needing information about specific crafts and materials, these *Handbook* articles by Holmes remain indispensable.

Paul Bartsch, writing for the *Dictionary of American Biography* in 1944 (Supplement 1 [New York, 1944], 427–28), noted that Holmes's "special aversions" were to the "theory of pre-glacial man in America" and to "Neoism" and "futurism in art." As first director, from 1920 to 1933, of the National Gallery of Art, Holmes wrote the catalogue of its collections in the north wing of the U.S. National Museum building (erected in 1910 to house the natural history collection of the country).[72]

The life of Holmes may be said to anticipate the present-day pattern of one school of Americanist studies: begun in the history of art, continued in anthropology and archaeology, finding support in ethnology, and returning to the art museum after appearance of the *Handbook.* Characteristic of this tradition is Holmes's "lesson": "Ideas associated with any . . . conventional decorative forms may be as diverse as are the arts, the peoples, and the original elements concerned in its evolution."[73]

From the point of view of people at the end of this century, preparing to face the five hundredth anniversary of Columbus's discovery, it is clear that

when Holmes was a young artist in 1865 there were few if any museums of art for him to display his now-acknowledged ability with collections. But today, his appointment as director of a still unborn National Gallery of Art would be unlikely as the anthropological archaeologist and curator he became, during the absence of great museums still to come. In brief, Holmes's long life was even more in search of Amerindian art than of anthropological science.

5

Americanist Historians of

Art since 1840

AMERICANIST HISTORIANS OF ART are discussed here because of their chronological priority: they appeared in the field of pre-Columbian studies more than a full generation before the social scientists in anthropological archaeology and sociology.

JOHN LLOYD STEPHENS (1805–1852). Being apprised of Herder's philosophy before 1822 at Columbia College in New York City, Stephens was prepared to approach another civilization and to see its own quality and worth when he landed among the Maya peoples late in 1839. He wrote with delight of discovering "that eye for the picturesque and beautiful . . . which distinguishes the Indians everywhere."[1] Some pages later he took issue with William Robertson's anti-Amerindian *History of America* (1777), denying every conclusion with evidence of his own eyes at Copán[2] (fig. 35) that the stelae and buildings were "works of art" more than "remains of unknown peoples," proving that the peoples of ancient America were "not savages" but possessing "architecture, sculpture and painting, all three arts which embellish life."[3]

He and Francis Catherwood had meanwhile recorded what they saw. Stephens's role was to prepare the objects for "Mr. C." to draw "by scrubbing and cleaning, and erecting the scaffold for the camera lucida" (reducing prism). Catherwood "made the outline of all the drawings on paper divided in regular sections, to preserve the utmost accuracy of proportion." For publication those engraved on wood were eventually discarded as

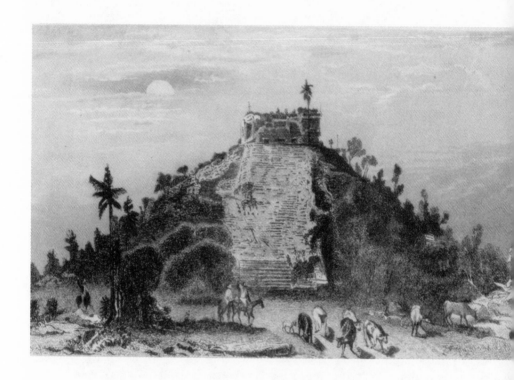

Figure 35. Drawn by Catherwood in 1843, the Castillo at Chichén Itzá is
viewed from west of north at its time of greatest disrepair. This condition
appealed to romantic travelers and the artists of picturesque ruins throughout
Europe and America, whose work is known today as *costumbrista*, being the
record of native customs. Thus the trees, bushes, travelers, and cattle are in a
tradition of landscape painting that originated in the sixteenth century. But
costumbrismo is the Latin American version, on which no comprehensive work
exists. (After J. L. Stephens, *Incidents of Travel in Yucatán*, vol. 2, opp. 312)

unsatisfactory and reengraved on steel with corrections by Catherwood.[4]
Both men expressed dissatisfaction with the published drawings made for
Antonio del Rio and Guillermo Dupaix, finding them "poorly served" by
the "incomplete and incorrect" work of their artists.[5]

At Palenque their judgment that the palace was a residence of rulers
adorned with their portraits and having their dwelling in the southeast

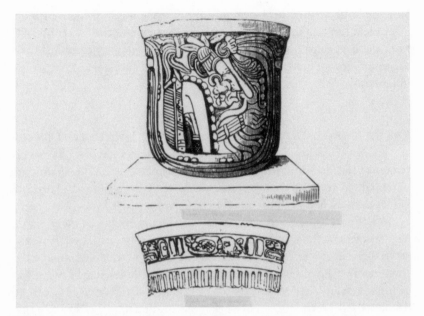

Figure 36. Catherwood's drawing of the Ticul vase is less concerned than
Spinden's two generations later to represent the deeply carved relief of this bowl.
Whether the bowl survived the destruction of Stephens's collections in this
country is uncertain, but it is recognizable as of the same redware class as
Spinden's bowl in fig. 37 below. The engraving after Catherwood is from
Incidents of Travel in Yucatán (1843), 2: 275.

portion, as well as rooms for "public and state occasions" in the north half,
is generally accepted today after a century of contrary opinion.[6] After ten
months among the Maya, Stephens looks back: "We began our explora-
tions without any theory to support," and he concludes that ancient Amer-
ican monuments "are different from the works of any other known people,
of a new order, and entirely and absolutely anomalous. They stand
alone."[7]

 Stephens and Catherwood returned to Yucatán in 1843 equipped with
Daguerre's paraphernalia, although the camera lucida prism continued in
use by Catherwood at Uxmal and Kabah.[8] At Ticul Stephens admired a
carved pottery vase portraying a Maya personage among glyphs (fig. 36),
which he presented as proof that the Indians he saw were of the same race as
the ancient builders.[9] In this second book on the Maya Stephens makes
much more use of his library preparation among colonial chronicles. He

anticipated the methods of ethnohistory in using recent evidence for ancient events among the same people, but he concludes: the "want of tradition, the degeneracy of the people, and the alleged absence of historical accounts" do not deny "the cities as works of the ancestors of the present inhabitants."[10]

FRANZ THEODOR KUGLER (1808–1858) wrote the *Handbuch* as a history of world art, establishing the form and method of such works of reference.[11] Udo Kultermann has called it a prototype of "democracy in scholarship," treating the arts of the world all on an egalitarian basis, for which the way had been prepared by J. G. von Herder.[12]

In both the *Handbuch* and his earlier *Geschichte der Malerei* (1837) Kugler's new method was evident in the introductory remarks deftly characterizing entire periods and schools, followed by detailed analysis of single works: Egyptian art is confined by the requirement of being like writing; Persian rises to courtly art; India has poetic fantasy; Greek art displays deeper feeling; Roman work is more rational; early Christian rises above nature to the life of the soul. In each instance—social structure, religious beliefs, visual morphology—the requirement of clients and ethnic characterization are considered, from earliest known monuments (*Urdenkmäler*) through the eighteenth century.[13]

Kugler's decision to produce an autonomous history of art had no now-known precedent. Indeed the idea was so new that he apologized for making a history of all art only by its own developmental stages (*ihrer eigentümlichen Entwickelung*), without concern, as he said, about the "precise millennium when the earliest developmental conditions for art are to be observed." His stated task was to "search out such monuments, no matter where, and to study in them how human artistic activity appeared in its first manifestations."[14]

His preemption of the whole history of art is explained in his preface as being concerned only with the narrow sense of *Kunstgeschichte*—the arts of spatial form—and so excluding the broader sense of music and literature.[15] He then defends his inclusion of ancient America, by stressing monumentality as the origin of art, because of the human need to tie thought to a fixed place by forms that conveyed those thoughts. As he says, "Art makes present that which is eternal in earthly things." Kugler rejects the sensory needs and imitative drives of men and animals as lacking prior

artistic sense (*Kunstsinn*), in a developmental conception that separates from the "monumental" stage the "childhood" of man's cultures, when simple signs expressed ideas. His purpose was here to seek out the "earliest expressions" (*erste Äusserungen*) he could find of primitive monumentality.

The result in 1841–42 was a four-part division of world art; early art (including ancient America); Classic art; medieval art; modern art. The second edition in 1848 was illustrated under Jakob Burckhardt's supervision. By 1855 Kugler had revised the entire *Handbuch* for its third edition. He had then read Stephens's travels (in the German edition of 1843) and reaffirmed the "originality of the whole of ancient American art" as being shown in what he called "a doubly clear light."[16]

The ancestry of Kugler's ideas about ancient America may be traced to historiographical concepts familiar to Germans of his generation. The notions about the "childhood of art" derive from G. B. Vico's on the primacy of imagination in "humanity's childhood."[17] A. G. Baumgarten (1714–62), the founder of German esthetics, considered art an active and autonomous mode of knowledge, admitting the ugly and the monstrous as parts of the infinite content unified in sensory awareness.[18] Kugler's periodization owes a debt to J. J. Winckelmann (1717–68), who first extended the biological metaphor of the stages of life as a system to the history of artistic style.[19] Kugler depended for his visual knowledge of ancient American works of art on plates published by Alexander von Humboldt. His world history of art also reflects Humboldt's vision of the world as including all civilizations.[20]

ANTON HEINRICH SPRINGER (1825–1891) in 1855 fell easily into Kugler's format of the history of world art, but his avowed model was Alexander von Humboldt's *Kosmos* of 1845–49 with its "natural history of mankind" in both science and esthetics, or outer and inner worlds.[21] He compared the 380-foot mound at Sarzeau (Morbihan) on the coast of Brittany with those of the Mississippi basin by American "Mound builders" (26); as well as Middle American monuments with east Asiatic ones, and Aztec with Chinese art (29–30), thereby forgetting the insights of both Kugler and Stephens (about the autonomy of Amerindian arts) fifteen years earlier. He did grant "Mexican culture" the strengths of having founded both state and religion but without the ability to fashion interior

spaces (32–33),[22] nor were the "horrid cult images" within the "aims of esthetic representation." The manuscripts were "completely worthless" as works of art (34). Yet long after his death, Springer's name remained attached to the many volumes and editions after 1855 of the *Handbuch der Kunstgeschichte,* which became the model of nineteenth-century historicism. Its Hegelian residues, however, of art as the unfolding of the idea in visible form, limited art to "greatness of spirit," being therefore unavailable to mere artisans.[23]

HENRI BEUCHAT (1878–1919) is notable here mainly for the complete frame he gave to the subject of American archaeology in his *Manuel* of 1912. The content of the book was sparse. He opened appropriately with an introduction on the Discovery in five chapters. Earlier works (*Les religions: étude historique et sociologique du phénomène religieux* [Paris: Rivière, 1910]) place him among the historians of religions and linguists in France. The subject is divided in four areas: "I North America" is seen as *préhistorique,* from the ice age to "Cliff Dwellers and Pueblos." "II Civilized peoples" include Mexico and Central America. "III the Antilles" does not venture on the circum-Caribbean mainland. "IV Panama, Colombia, Peru" includes the Diaguita of late periods (post A.D. 1000) in Argentina.[24]

The emphasis on North America had already been established by Nadaillac in 1883, and both believed that the mounds of North America could be either five or thirty centuries old.[25] Beuchat viewed the rest of Amerindia as dividing into six "empires": (1) Mexican (including "Tarasca" and "Mixteco-Zapoteco"; (2) Maya-Quiché (Yucatán, Chiapas, Guatemala, Honduras); (3) Nicaragua, Salvador, and the Antilles; (4) Chibcha; (5) Peru; and (6) "Diaguita-Calchaqui."

A long review[26] by Jorge Engerrand praised Beuchat as a linguist and as a compiler but criticizes the title because *archaeology* "was not yet a science anywhere, and least of all in America," being still in the "17th century condition of traveler's notes on natural history" and deserving only to be corrected. Also inexcusable was the failure to analyze the differentiating "action du milieu"[27] as "evident everywhere in America." Beuchat is seen more as historian than archaeologist and as repeating the format of Nadaillac's work (p. 103) thirty years earlier.[28] Both Beuchat and Engerrand were still unaware of H. J. Spinden's *Study of Maya Art* (written in

1904). But Engerrand listed praiseworthy works by E. Seler, F. Boas, and A. Hrdlicka (all unknown to Beuchat) as "learning the ground for a renovation of Americanist studies."

HERBERT JOSEPH SPINDEN (1879–1967). When Beuchat compiled his *Manuel* (1912) he did not know that Spinden (aged thirty) at Harvard University had presented his doctoral dissertation there in 1909. It was printed in 1913 (after expansion of the Spinden chronology in part III) as "A study of Maya art, its subject matter and historical development."[29] In Eric Thompson's opinion Spinden "was an art historian rather than an archaeologist" (vii). Thompson added that Spinden's "feeling for all forms of primitive art was extraordinarily perceptive" (vii).

In the "General Consideration of Maya Art" (15–95), Spinden's treatment is mostly by sculpture of humans and serpents, followed by other animals, grotesques, divinities, and astronomical signs. This iconographical repertory is followed by "the material arts," mostly architectural, then minor arts, ceramics, precious stones, metalworking, basketry, textiles, tattooing, minor carvings, and illuminated manuscripts (sculpture has no separate treatment after the "General Consideration"). The final section is chronological, arranging all monuments in First and Second Epochs. The book closes with a section on "connection with other cultures" in Mexico and elsewhere. After a brief study of Amerindian symbolism in the hemisphere, Spinden concluded that it was "autochthonous" and not of "sensational antiquity."[30]

Like W. H. Holmes, Spinden was a skilled draughtsman, illustrating his text with over six hundred drawings taken from original works (fig. 37) and from photographs and published illustrations such as those of buildings and objects in the works of Stephens and Catherwood, Holmes, Maudslay, Gordon, Maler, Charnay, Breton, E. H. Thompson, and Seler. But he rejected Waldeck's drawings as "inaccurate" and Brasseur's and Le Plongeon's theories as "untenable" (12–13).

Spinden's mentor at Harvard in drawing was probably Denman Ross (1853–1935). The lecturer on the theory of design was Harrison Allen (1841–97). As a comparative anatomist Allen had worked with Edgar Muybridge on animal locomotion, and Spinden learned graphic methods of analyzing living forms from Allen. Both Ross and Allen were concerned with design as science: Allen as to anatomy and Ross as to color. Ross

Figure 37. Spinden's drawing from a pottery bowl in Peabody Museum at Harvard can, like others, be attributed to him by his energetic pen and the presence of the specimen at Harvard. (After *A Study of Maya Art* [1913], 135)

ended his remarks on design as a science by saying that because science becomes a conception of nature as pure design, it follows that "the statement of scientific truth becomes an illustration of pure design, and art and science become one."[31] Dr. Allen in turn quoted E. B. Tylor in the motto for his "Analysis of the Life-Form in Art,"[32] as follows: "I attribute the now backward state of the science of culture to the non-adoption of the systematic methods of classification familiar to the naturalist" (1868). Allen's method was to analyze design under headings that would include fantastic and grotesque forms, symbols, myths, and errors in depiction as well as such variants among the forms of life in ancient Old World art as serpents, dragons, and gorgons.

Building on the work of these teachers, Spinden assumed that Maya art expresses "a national religion" (15) which in turn inhibits "disorganizing change" among "barbarous religious concepts" in grotesque figures of composite origin (16). Forms recurrent over time and space prove the homogeneity of Maya culture (21). Serpent forms are regarded as a "sign or

an attribute of divinity in general" (33), idealized by sinuosity and human aspects in processes of simplification, elaboration, elimination, and substitution (38–46). Realistic, geometric, and conventional forms coexist by "involution" (49–95) in serpent shapes as ceremonial bars, manikin scepters, two-headed dragons, feathered serpents, and serpent-birds. Animals likewise "involuted" are jaguars, snails, turtles, and bats. Skeletons and grotesques and at least fifteen anthropomorphic types of deity (as defined by Paul Schellhas)[33] complete Spinden's figural repertory.

His First Epoch is less chronological than geographic and defined by "cities": Tikal, Copán, Quirigua, Naranjo, Seibal, Yaxchilán, Piedras Negras, Palenque, and "other sites," all in existence before A.D. 600 by his correlation of Maya dates. The Second Epoch in the north comprises four periods separated from the First Epoch by a period of "cultural eclipse" or "transition," A.D. 600–960. The three other periods are the League of Mayapán (960–1195); of (Nahua) influence from the Valley of Mexico (1195–1492); and from the fall of Mayapán to the present.

Within these periods, local differences appeared between sites. At Copán Spinden grouped buildings and sculptures in four stages spanning 276 years (table 1, 162–63) on a relative scale:

0–129	"crude" and "archaic"
99–152	
144–207	"steady improvement"
207–276	"brilliant period"

But at Tikal he correctly detected earlier monuments than at Copán, beginning 125 years earlier. He believed the sequence of the five principal temple pyramids to be V, IV, III, I, and II, according to increasing interior "floor space" in the temple cellae (168, 170).

He also arranged the dated inscriptions according to his correlation[34] (table 2, 216–17):

FIRST EPOCH	Protohistoric	225 B.C.–A.D.	160
	Archaic	160–	445
	Great	445–	600
SECOND EPOCH	Transition	600–	960
	League	960–	1195
	Nahua	1195–	1492
	Modern	1492–	

"After the earliest period," Spinden argued in favor of Maya influences on other cultures (231). He assumed that the Mesoamerican calendar was of Maya origin (220), as were such iconographic traits as placing human heads in the mouths of animals in the arts of Oaxaca and other Mexican highlands. Plumed serpents too were credited to the Maya, although losing their "spirituality" (223) outside the Maya. Monte Albán was indebted to Maya architecture (225–26), and the pottery urns there were derived from the Maya "Long-nosed God" (226). All these claims were to support Spinden's thesis in 1913 that "in [his] middle period [of Transition?] the current was set from the Maya towards the people of lower culture on the highlands of Mexico," reversing only in the "last decadent period" when "influence from the Nahua" appeared among the Maya (231).

By 1917 Spinden had condensed his 1913 view of ancient America into a short, general handbook.[35] A chronological graph (fig. 38) plotted nine thousand years against a transect from Arctic to New Mexico to Amazonia to Tierra del Fuego, on which three "horizon"[36] lines marked the appearance of arid agriculture, humid agriculture, and recorded history, all surrounded by nonagricultural nomadism surviving marginally to present time, marked off in eleven areas on the supposition of "primary invasion from Asia via Alaska" between 15,000 and 10,000 B.C.

The text, however, mentions South American civilizations mainly in connection with the "archaic horizon"[37] under the category of female figurines ("fetishes") of pottery reflecting the dissemination of agriculture, and associated with weaving. The longest chapter, on Maya civilization, is more than half about the calendar. Periodization is simplified as Early (176–373), Middle (373–471), Great (471–629), Transition (629–964), League (964–1191), Mexican (1191–1437), Modern (1437–). Humans on Maya monuments are "captives, rulers, and priests or worshipers" (93), following Maudslay (1889–1902) and Maler (1901–08).

Among the "Middle Civilizations" described as deriving from Maya are the "Olmeca" (added only in 1928, 3d edition), Zapotecans, Mitla, Totonacan, Toltec, Teotihuacán, Xochicalco, Tula, Cholula, Northwest Mexico, Cozumalhuapa, Chorotegan, and Isthmian. This enumeration of sites and peoples from Zacatecas to Panama is to suggest the sphere of Maya civilization after its "height" (A.D. 400 to 600), although the "cradle of Maya culture" may have been near San Andrés Tuxtla (153).

The closing chapter, "The Aztecs," ends with brief accounts of Pueblo archaeology as "introduced from the South." The Andean cultures are

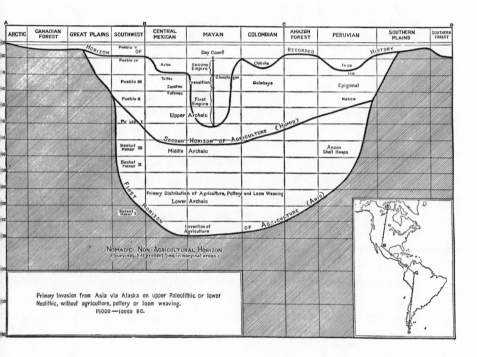

ARCTIC	CANADIAN FOREST	GREAT PLAINS	SOUTHWEST	CENTRAL MEXICAN	MAYAN	COLOMBIAN	AMAZON FOREST	PERUVIAN	SOUTHERN PLAINS	SOUTHERN FOREST

Figure 38. Like the graphs of esthetic activity by Holmes (figs. 29–32), Spinden's graph of hemisphere cultural activity is intuitive, grasping for complex relationships with spatial markers along a transect from Arctic to southern land's end, all surrounded by an amorphous "nomadic horizon." The relationships are surprisingly close to present-day views when the terms are translated into present usage, such as Formative instead of "Archaic," and Classic or post-Classic instead of "Empire." The differences of correlation for Maya inscriptions disappear as if into the thickness of the line marking the "Horizon of Recorded History."

where metalworking originated. "Mayan strains" are alleged to appear in Chavín and Recuay (252), without proof.

In review Spinden's early work to 1928 marked the appearance in Americanist studies of extended analysis of the forms and meanings of Amerindian visual representation. Thereafter he continued this concern at Brooklyn Museum as curator of American Indian art and primitive cultures until about 1957, dividing his time between the defense of his correlation for Maya chronology[38] and curatorial duties to increase the Brooklyn collections during travel in Latin America. Two lectures by him appeared in the collection printed in 1931 as the introduction to *American Indian Art*. F. W. Hodge, H. Spinden, and Oliver LaFarge were its editors (for exhibitions at the office of the Exposition of Indian Tribal Arts on Madison Avenue in New York). Two volumes appeared in 1931, and Spinden's lectures are in the second: "Fine Arts and the First Americans" (3–8) and "Indian Symbolism" (3–18). Both are poetic and evocative talks about Spinden's esthetic perceptions and episodes in his travels, like another in 1941, "As Revealed by Art," for the exhibition *America South of U.S.* (Brooklyn Museum, 1941).

Spinden's correlation still finds use in a few archaeological situations in which his solution is less contradictory than others. But general support in the profession is still for the Goodman-Thompson-Martinez proposal (almost 260 years different). *The Study of Maya Art* remains important to experts and beginners for his discussion of the processes of composition in Maya figuration in sculpture and painting.

JOSÉ PIJOAN Y SOTERAS (1881–1963). Born in the same year as Henri Focillon and Pablo Picasso, Pijoan entered an art-historical profession where the need still existed for histories of world art by one person.[39] That need continued until the commercially successful appearance of H. W. Janson's mature exercise in a smaller format, but with deeper research and more rigorous selection than at any time since F. T. Kugler's.

Summa artis was almost entirely Pijoan's work. The pre-Columbian volume—the ninth of the series to appear in 1946—was volume 10 and contained nearly one thousand illustrations. Pijoan's practice throughout the *Summa* was to start with the oldest written sources and to connect the visible evidence with the texts. Where texts were absent he fell back on archaeological writings, as at Cuicuilco, with B. C. Cummings's excavation

reports of 1933.[40] Sometimes his choice of texts was perforce only distantly related to the region, as with western Mexico, for all of which he had the only sixteenth-century illustrated history,[41] which confined him, like others before him, to presenting everything as "Tarascan."

In his pages the arrangement and titling of chapters by cities had no stated program or format for treating architecture, sculpture, and painting separately. But in each chapter the monuments and objects were deprived of their autonomy by being prefaced with unrelated selections from native writings collected in the sixteenth century that distort the visual evidence wherever older centuries are involved.

Where archaeological reports were available Pijoan sought to use the results, but he apologizes to the reader and hurries on to share the fruits of his own seasoned and lifelong acquaintance with world art. Thus he writes of the preclassic *Danzantes* (fig. 39) at Monte Albán (199): "Few works in the world give the impression of an archaic or anthropological mentality in the sense of utter remoteness, more than these friezes of dancers, merely silhouetted on rough surfaces of sedimentary rocks [*caliza*]." The stylistic perception as archaism is correct, but the historic placing is wrong. At the same time he could not refrain from comparing Monte Albán to Tenayuca as being "of indisputable Aztec character." Pijoan was unaware of the long gap between Olmec and Mexica at Monte Albán before the conquest of the latter about A.D. 1470. That chasm was as long as between Cretan and Roman civilizations in the Mediterranean.

More often than not, the mistakes of his contemporaries in archaeology were compounded by his own limitations as a consumer of archaeology, but when he was right, his perceptions transcend the limitations of that archaeology, as when he correctly assumed the historicity of Maya stela sculptures in portraying dynastic rulers (321–22). This view would not return to favor among Mayanists until after T. Proskouriakoff's work in 1960, which reaffirmed the long-discredited insight by Teobert Maler at the turn of the century.[42] Thus Pijoan followed Maler but without knowing of the noncalendrical glyphs in his interpretations of the stelae of Piedras Negras (317–18) or of the lords (*halachuinic*) of Tikal and environs (277–86). In brief, the opinions of professional archaeologists on these matters in 1946 could be more completely wrong than Pijoan's interpretations of such imagery.

On the other hand, as with Teotihuacán, the sequence of discussion begins with colonial texts and proceeds with buildings, style, frescoes,

Figure 39. These drawings from 1806, made under the supervision of Dupaix, are the earliest known records of the *Danzantes* group at Monte Albán. As a class of monuments they are now accepted as being of post-Olmec date (J. Scott, *Post-Olmec Art in Pre-Classic Oaxaca*, Mexico [Ph.D. diss., Columbia University, 1971], 106–213). Dupaix (not cited by Scott) described them as being "agigantados perfilados y siguiendo al parecer un mismo rumbo. . . . El relieve de gravado tendrá una pulgada." (enlarged profiles moving apparently in the same direction. . . . The relief is carved about an inch deep) (After J. Alcina, *Guillermo Dupaix* [1969], 1: 267)

masks, and the titular raingod (Tlaloc), in that order. At one point, votive figurines of jade at Teotihuacán are compared to *katchinas* with cloud headdresses from the pueblos of New Mexico and Arizona, but the linkage is merely visual (56).[43]

Pijoan never stood both in art history and anthropology, but always with both feet as an art connoisseur and "specialist in generalization," as he said of himself when he was writing this pre-Columbian volume. He was then on salary from his publishers, and his method was to be in constant motion among the relevant museums and universities. He saw objects "out of context," but he also visited accessible ruins and all the necessary coun-

tries. He was unusual in writing by way of preface about his predecessors as scholars in the fields of each volume.

To convey his style requires a short paraphrase. The art of "ancient Mexico" was seen as at sixteen places of "Nahuas and proto-Nahuas" and that of the "Maya and Mayoid peoples" in fifteen others, following the dynastic chronologies (in late versions) for Tula, Texcoco, and Tenochtitlán by Vaillant's correlations. For the Maya, the correlation is Morley's.

The clay figurines of the Valley of Mexico (compared to those of Hellenistic Tanagra) appear at the opening of the book, as sequential types, beginning with then-mysterious Olmecs of the "first centuries after Christ" in the early cosmic ages of fire and rain. An infant Olmec type evokes Adonis and Krishna, but an "ancient fire god" is described in sixteenth-century words by Sahagún. The early circular mound at Cuicuilco is assigned to the late Aztec raingod cult of Tlaloc and to Quetzalcoatl, whose city was Cholula, where the great pyramid served his cult. Thus both wind and rain were served by worship at round structures. Teotihuacán, where the present cosmic age began, had Aztec Tlaloc as its titular deity.

All these items of erudition have been disconnected since the Conquest, but Pijoan blended them, as many still do, into an even more incongruous mixture, by combining the texts of one period with the things made in another.

PAUL WESTHEIM (1886–1963) was a psychologist of art. He brought some of the *Kunstgeschichte* of Germany between the wars to Mexico in 1941 as a critic and historian of modern art, representing the "school" of Alois Riegl (1858–1905) and Wilhelm Worringer (1881–1965). They had championed a "will to art" (*Kunstwollen*), intended to liberate studies of any art alien to that of our own time from any esthetic bias other than that of its "own idea." Westheim wrote *Die Welt als Vorstellung* (1928) and books on Lehmbruck (1922) and Kokoschka (1925), and he had edited *Orbis pictus* since 1921 in Berlin. This work brought him together with the Americanist tradition of Eduard Seler, in the person of Walter Lehmann, on the editing of Lehmann's book about the history of ancient Mexican art.[44]

On arrival in Mexico as a refugee in 1941, Westheim said he found nothing written there as an introduction to ancient Mexican art on its own

"spiritual and creative premises, as an esthetic system of pre-Columbian art." His own work[45] to fill that gap divides in three parts:

1. The native conception of the world as to (a) theogony (the origin of the gods), (b) social organization, (c) spirituality, (d) the natural world;
2. the fields of expression, as pyramid, mask, and interlace (*greca*);
3. creative will (*Kunstwollen*), as expressed in the sequence of ancient art: (a) archaic, (b) Teotihuacano, (c) feudal Maya, (d) renaissance Maya (Chichén Itzá), (e) Zapotec architects, (f) Aztec Huitzilopochtli (god of war), (g) Tarascan profane art.

By his own declaration (10) this scheme was based on Worringer's *Esencia del estilo gótico.*

The idea of theogony is Ernst Cassirer's (*Antropología filosófica*).[46] There the contradiction between God and creation resolves as a dualism of opposing forces in continuing creation, divided also as creators and regents of actions. In this continuum between magic and religion, the universe is alive with occult forces. Aztec death depended on social class, as sacrifice to the gods for their renovation or in war.[47]

Westheim's concept of *social organization,* requiring adoration by all in collective sacrifice, agriculture, art, and dance, follows Alfonso Caso.[48] The gods are in the statues serving to maintain the community, and the artist is their cleric or servant. "Formal fantasies" predominate over narrative, in stable forms rather than shifting ones. Illusion is repudiated in favor of rhythmic repetition (44–65). As to spirituality, terror and sublimity make beauty and naturalism irrelevant (as in the work of Eulalia Guzmán),[49] requiring Westheim to deny portraiture and landscape in this art at this point, although not excluding them later. For Westheim, ancient Mexican nature is personified in deities as imagined forces, and all "life as waking dream" (80–98). The three topics of "expression" are pyramid, mask, and stepfret (101–20). The pyramids define vacant spaces (*espacios vacíos*) among them, thereby "humanizing nature." Masks transubstantiate their wearers by alter ego, by ideal image, and by *Wesensporträt* (capture of essence, citing Schopenhauer). Stepfrets are "talismans," even of death, in an "antagonistic relation of stair and spiral." Westheim saw an implied *greca* in the grid-plan of Teotihuacán as symbolizing Tlaloc (147).

The final historic unfolding of *Kunstwollen* in part III appears as a recapitulation of ancient Mesoamerican archaeological history (157–78).

In archaic culture, the psychologist of art detects an evolution from "imitative realism" to "imaginative creation," seeking the meaning of phenomena by "replacing realist reproduction" with "symbolic representation." This process corresponds to the new coexistence of hunters and farmers, emerging as the arts of Teotihuacán, Monte Albán, and Maya peoples.[50]

The following "Cultura Teotihuacana" corresponds for Westheim to Wölfflin's sense of Classic art.[51] "Maya feudal" art contrasts with it as baroque and rococo stages[52] (196–254). Tula, however, is named the "heir," as of Romanesque to Roman art (196), while Chichén Itzá falls into place as a "renaissance return" to "classic" form. The now-discarded designations as Old and New Empire,[53] borrowed from Egyptology, are seen by Westheim as distinct worlds in Maya "psychography" and art (265). He next writes of Aztec art as "surrealist in method" (313–15) and of West Mexican ("Tarascan") art as nonmetaphysical in character (*postura mundana*).[54]

Westheim's final words on ancient Mexican art[55] do not redeem his psychographic methods of writing art history. Given the opportunity to comment on selected masterpieces at length, he labeled the Chac Mool figures (fig. 28) as "an incarnation of maize cult" (11–19), and he decided that thirteen examples at Chichén Itzá had been brought from Tula (16). At Xochicalco he concluded that the feathered serpents were "fertility symbols" (33) and wrote of jaguar-gods as "expressions of human impotence facing nature" (63–71).

Yet his influence as critic and teacher remained intact among colleagues in Mexico and Europe. José Alcina in Spain writes in 1978 that "the originality of [his] concepts unquestionably outweighs the few negative aspects that one may find in his work."[56] This case reinforces the position that historiography is a way of determining the deviation or inherent error of the instruments in use. Westheim's method was too coarse to catch the fine distinctions then becoming apparent in the archaeological record.

RENÉ D'HARNONCOURT (1901–1968). When he became vice president of the Museum of Modern Art in New York in 1944, it was widely said among the museum staff that the "genial Austrian giant" (he was six feet, six inches tall) was the choice of Nelson Rockefeller to succeed Alfred Barr as director. This occurred in 1949. Henry-Russell Hitchcock,

then a member of the staff, said that René, whose family in Europe was long among the court of the Habsburgs,[57] had been in search of a new patron, whom he found in Nelson Rockefeller.

René became his curator of pre-Columbian and primitive art at the Museum of Primitive Art, founded in 1954. Rockefeller referred to him in 1957 as "my friend . . . for thirty years as colleague and as vice-president of the Museum of Primitive Art from its founding."[58] The implied beginning in 1927 refers to the exhibition of Mexican art sponsored by the American Federation of Arts from 1930 to 1932 (*Who's Who in America*, 1967–1968, 591) as organized by d'Harnoncourt, which preceded the exhibition catalogue published by the Museum of Modern Art as *Twenty Centuries of Mexican Art*.[59]

D'Harnoncourt rarely wrote for publication, preferring to appear as the *animateur* in the background, wherever he was. Thus Elizabeth Shaw:

> René d'Harnoncourt joined the staff of the Modern in 1944, the year Alfred Barr was shifted out of the directorship. His first title was vice-president in charge of foreign activities and director of the Department of Manual Industries. Because Barr's departure as director could have wrecked the museum, one of the very few conditions that I know René imposed upon any one was that Barr must be given a position of authority (Barr was named "advisory director" in 1944 and director of the collections in 1947). René then proceeded with great care to create an inner balance to the place and attempted to avoid the kind of infighting that has destroyed institutions of all kinds and that is inevitable where a talented, ambitious staff vies for limited space, time and money. In 1948 he was named director of curatorial departments and in 1949 director of the museum. Under his leadership the staff turned out a series of brilliant exhibitions and books and created innovative alliances with industry and government.[60]

His exhibition of North American Indian art for the San Francisco World's Fair in 1939 led to an invitation to be guest curator in 1941 for a similar show in New York at the Museum of Modern Art. This event was based upon his experience from 1937 to 1944 as general manager of the Indian Arts and Crafts Board of the U.S. Department of the Interior, traveling constantly from reservation to reservation, becoming chairman, 1944–61, and commissioner, 1961–66. Rockefeller asked d'Harnoncourt to join the staff of the U.S. government's Inter-American Affairs (as acting director

of the art section), recommending in 1944 that he be hired at the Museum of Modern Art.

D'Harnoncourt's early career in Mexico (1926–33) began as a free-lance artist. His sponsor there was the art dealer Fredrick Davis, for whom he arranged shows of pre-Columbian and folk art as well as of the works of Rivera, Orozco, and Tamayo. He thus came to know Ambassador Dwight Morrow and his family. Morrow introduced d'Harnoncourt to the Metropolitan Museum and Carnegie Corporation, to be the organizer of an exhibition of Mexican art for circulation in the United States. In 1933 he began employment in New York, directing a radio show on art in America and becoming a naturalized citizen in 1939. In 1936, d'Harnoncourt met John Collier, who invited him to work for the Indian Arts and Crafts Board.[61] In this office d'Harnoncourt was placed in the Roosevelt administration under Collier, the commissioner of Indian affairs, who in 1933 began to reverse the policy since 1863 of "industrializing" the Indians, until his resignation in 1944. As general manager of the Indian Arts and Crafts Board from 1936 to 1944, d'Harnoncourt sought "close contact and cooperation with local Indian leaders and local Indian Service administration" throughout the nation, engaging in constant travel and conference, all leading to the exhibitions of Indian arts in San Francisco and New York.[62]

Like his younger contemporary Miguel Covarrubias, d'Harnoncourt extended his interest in Mexican art to the Pacific area, but within a focus limited to the "arts of the South Seas" (Australia, to Easter Island, via Papuan, Micronesian, Melanesian, and Maori displays) in collaboration with Ralph Linton and Paul Wingert. As usual, d'Harnoncourt was concerned with significant display, and he left the anthropological discussion to the specialists in the book on the exhibition.[63] His work as the designer of effects was analyzed by Gregory Bateson at length, with a comment by d'Harnoncourt,[64] which explained some of his intentions. When objects were of insufficient "artistic merit" to be shown individually, he showed them en masse and in context. With "smaller geographic divisions" he used raised platforms "to make them stick out as a separate experience," rather than in separate recesses of *staccato* effect. He was attentive to the original tribal form of display, as "only one spectacular performance . . . in contrast to the permanence" of other people's displays. Bateson's analysis was based upon his perception in the show of a "reproductive sexual sequence": d'Harnoncourt was not aware of this during design and installa-

tion, but he replied that "a whole complex of other aesthetic conceptions" was present in addition to sexual themes.

In his own few writings in print elsewhere on his shows, d'Harnoncourt was usually concerned with visual experience independently of ethnology and archaeology, seeking unities of artistic process, as in a brief introduction by him twelve years later on Peruvian fabrics in the Museum of Primitive Art,[65] of which he was vice president. But he was there, in Nelson Rockefeller's words, as "friend and advisor on the collection" during thirty years[66] since its foundation.[67]

Of the show in 1958, he wrote briefly on the textiles, stressing the "motion of the artist's hand" and contrasting the difference between brushwork and woven patterns. He concluded that Peruvian textile design never attempts "to produce the illusion of physical likeness as we understand it" but consisted of details "fitted together" as "elements of geometric pattern" that arises in "the crossing of vertical and horizontal threads" so as "to put special emphasis on the right angle."[68] This stress on manual process is a characteristic of his thinking about art.

The articles he wrote about the shows of Indian art in San Francisco (1939) and New York (1944)[69] stress the adaptability of Indians to every environment by spatial groupings expressive of their range of habitats.[70] These and craft preferences are correlated: painters and carvers are among the Pueblo cornplanters, together with Navajo shepherds, Apache mountain people, desert dwellers, Far West seed gatherers, and Northwest Coast fishers. Engravers predominate in the Arctic. Sculptors appear in the central plains and eastern woodlands. Frederica de Laguna (an arctic anthropological archaeologist at Bryn Mawr) commented, "If we lack a sense of development of cultures and art through time and the presentation seems in consequence static and two-dimensional, the fault is the archaeologists' and not the authors'."[71]

D'Harnoncourt was struck by a car on Long Island and killed on August 13, 1968, ending a career dedicated to bringing studies of Amerindian art closer to modernism in all its aspects than anyone since Carlyle, Ruskin, and Morris, who first warned of the dangers of industrialization.[72] D'Harnoncourt was of another world, having lived his youth under the Austro-Hungarian empire among the courtly remnants of preindustrial society and government, from which he emigrated to Mexico and the United States.

MIGUEL COVARRUBIAS (1904–1957). Covarrubias's illustrations for *Island of Bali* (1937) were both mother and child to his works in Mexico and New York by their sprightly, café-society manner, formed at *Vanity Fair*. The caricaturist[73] came from Mexico to New York in 1923 after the end of the Mexican Revolution. Then the murals of Rivera, Orozco, Charlot, and Siqueiros were appearing on public buildings. The style of Covarrubias as a caricaturist owes much to their "overloading," and it is the style of his travel books, *Bali* (1938) and *Mexico South* (1946). Neither of these is archaeological because they are about "incidents of travel," like those of John Lloyd Stephens and Ephraim George Squier, which they resemble as to prose narrative.

At Bali and in Tehuantepec caricature gave way to an affectionate and lyrical manner of exaggerating the charm of village and peasantry, all cast in the monumental formal language of the Mexican mural movement (fig. 40). His later works of archaeological illustration, *The Eagle, the Jaguar, and the Serpent* (1954) and *Indian Art of Mexico and Central America* (1957), turn back to the murals for the graphic simplification that Covarrubias uses for archaeological illustration, especially to Diego Rivera's scenes of pre-Conquest Indian life, which also balance between caricature and tragedy.

As the "believer in Transpacific contacts," Covarrubias set forth his creed in 1954,[74] claiming that the "isolationists" reject all evidence and see in the "diffusionists" an effort to "rob the Indian of the glory of reinventing all by himself."[75] He continues to say that "more serious historians and archaeologists" in 1949 at the Congress of Americanists in New York presented "a disturbing exhibition" entitled *Across the Pacific: Did the Ancient Civilizations of the Far East Contribute to American Indian Civilizations?*, citing Gordon Ekholm (the curator) and others.[76] Gladwin, following in the footsteps of Imbelloni and Rivet,[77] had proposed six migrations of peoples: Australid (2500–1500), Algonquin (Siberian) (1250–1500), Eskimo (500 B.C.), Mongoloid (after 300 B.C.), and Melanesian-Polynesian (Carib-Arawak) (300 B.C.–A.D. 500). Covarrubias preferred "as most scientific" (*Eagle*, 32) the analogies with early Chinese archaeology claimed by Heine-Geldern, who was following C. Hentze,[78] who had already nearly exhausted the subject twenty years earlier. In Heine-Geldern's version, beginning in the third millennium B.C. or before, an "Old Pacific Style" met a "Dniestro-Danubian Style" in China about 1800 B.C. They there produced "Shang,

Figure 40. Miguel Covarrubias, *The Beach in Samur.* Illustration for *Island of Bali* (New York, 1937). Of this scene Covarrubias wrote, "The Balinese belong in their environment in the same way that a hummingbird or an orchid belongs in a Central American jungle" (11). Yet the style of the drawing belongs as much as its author in Manhattan and Mexico City during the Great Depression.

Chou and Dongson Styles" (1700 B.C.–A.D. 100), all coming by sea to western South America, Tajín in Mexico, Ulua in Honduras, and Northwest Coast, Amazon, and Panama—leaving deposits of style, in a list of motifs[79] "common to the Old World and the New" as well as "endless common traits in the general aspects of culture among America, Asia, and Oceania."[80]

His next remarks go directly to "Aesthetics"[81] in a section prophetically denouncing the term "primitive art" as originating "from a dogmatic application" of "evolutionary theories."[82] On the other hand, Covarrubias

chided Franz Boas[83] for not acknowledging in Northwest Coast art "motifs . . . more reminiscent of . . . pre-Buddhist China and the Marquesas Islands than of the arts of the American Indian."[84]

The second volume of the incomplete trilogy[85] still professed diffusionism (6) by "substantial importations [sic] from Asia and the Pacific Islands," but his main concern had shifted from "origins" to conforming with the methods and conclusions of anthropological archaeology. Comparisons with China now are less specific (7) and less frequent. The entire framework reflects his new dependence on "isolationist" North American and European social science, more than on diffusionist themes, although technical papers by Ekholm, Gladwin, and Kirchhoff are cited.

The rising interest of Covarrubias in Olmec archaeology (starting in 1942)[86] may have loosened his attachment to Old World "origins" as he began to shape his concept of the Olmec "problem" as "the most important, if not the only, mother culture basic for the development of Middle American civilization" (83), under the influence of M. W. Stirling (and W. Jiménez Moreno).[87] The excavation of Tlatilco (1942 and 1947–49) established the "contemporaneity and relationship" of Tlatilco (fig. 41) with Olmec sites such as La Venta as between 1000 and 500 B.C.[88]

Justino Fernandez noted in his review of *Indian Art* the constriction imposed on Covarrubias by his absorption in "the reports and theories of archaeologists, instead of pursuing the interests of the critic and historian of art."[89] Fernandez also objected strongly to Covarrubias's designation of late Aztec sculpture as "art for art's sake" in sculptures of people and animals, insects and plants. Yet Esther Pasztory in 1979 would come to a similar conclusion along another path in her effort to distinguish "individual originality" among the late works before Conquest.[90] Fernandez concluded by ranking *Indian Art* below the works by Salvador Toscano and Paul Westheim.[91]

Covarrubias was still professing diffusionism (*Indian Art*, 6) when he died, but he also admitted that Middle American art "seems to have no roots, no origins" (13) "without the formative stages . . . on a pre-ceramic, pre-agricultural level"; as though still hoping for their discovery. The recent opening of Amerindian prehistory to much earlier beginnings c. 45,000 B.C. might have reduced his uncertainty and made the third book of his trilogy, announced as being on South America, more urgent to him and less committed to merely visual arguments of diffusion from Asia.

Figure 41. Chart of relations among early Mexican clay figurine types. Covar-
rubias participated after 1936 in diggings at the brickyard of Tlatilco, twenty
minutes west of downtown Mexico City, where many burials of the first
millennium B.C. yielded pottery sculpture, some of it, as at C9 on this table, of
Olmec date before 900 B.C. This table, prepared in 1954, shows interrelations
among post-Olmec types of figures in central southern Mexico as classified by
G. C. Vaillant. The figurines are drawn by Covarrubias in his own graphic
convention of heavy and light body outlines. (After Covarrubias, *Indian Art of
Mexico and Central America* [New York, 1956], 29)

JUSTINO FERNANDEZ (1904–1972) first became an architect, later turning to the history and criticism of art in the circle around Manuel Toussaint, the founder of the Instituto de Investigaciones Estéticas in 1935, whom Fernandez succeeded as its director from 1956 to 1968.

He came late to the serious study of pre-Columbian art, with his monograph on a single later work of Aztec sculpture, the huge figure of the mythological mother of the war god.[92] This volume was the first in a trilogy planned to present the panorama of ancient, viceregal, and twentieth-century Mexican art in monographs on single subjects. After *Coatlicue* (1954) he chose the main altarpiece of the cathedral of Mexico by Jerónimo Balbás, and he closed the trilogy with the book titled *El hombre,* on the murals in Guadalajara at the Hospicio Cabañas by José Clemente Orozco.

Before *Coatlicue* Fernandez had spent the decade from 1929 to 1939 as an architect, first with Carlos Contreras and José Luis Cuevas, and also in government service engaged in the preservation and restoration of colonial cities, both in the Secretaría de Comunicaciones and the Dirección de Bienes Nacionales. He was then writing monographic studies on Morelia, Pátzcuaro, and Uruapan as well as directing the *Catálogo monumental* of the states of Hidalgo and Yucatán. During this period he was also active as a critic and historian of the art world in Mexico City. Orozco especially engaged his attention, and his first book on the painter appeared in 1942. Later on, both Tamayo (1948) and Coronel (1972) were his subjects for separate studies. In association with Manuel Toussaint, the authority on colonial art in New Spain, Fernandez wrote a history of nineteenth-century Mexican painting, first appearing in 1952.[93]

Thus *Coatlicue* in 1954 was an interlude between works by Fernandez on the history of Mexican painting since Independence from Spain. The volume opens with a *prólogo* by the philosopher Samuel Ramos, who notes six components in the esthetic system of Fernandez: (1) "Naturalist" and (2) "formalist" traditions accompany (3) the "psychologism" of Worringer, Toscano, and Westheim; (4) "historicism" and (5) "scientism," as in archaeology and ethnology, lead to (6) the "historical-humanist" Mexican school of Manuel Gamio (1883–1960), Eulalia Guzmán, Edmundo O'Gorman, Salvador Toscano, and Fernandez himself. This last group Ramos characterized as "alone capable of discovering beauty in history." Ramos notes Heraclitus as the prototype for the "tragic sense of life" in the conception by Fernandez of Aztec art. Whether he taught Toscano or learned from him is not known. It is certain that both shared a perception

of the tragic nature of Aztec art, together with Lessing on the Laocoön in 1766 and Schiller in 1797.[94]

Benjamin Keen calls *Coatlicue* "a climactic event in the inquiry into the aesthetics of ancient American art," beginning with (1) "the history of the process through the pertinent literature"; (2) "a critique of the process"; (3) "an intensive, detailed analysis of the formal and symbolic elements of the Coatlicue, regarded as an archetype of Aztec art." The analysis "makes use of all the resources offered by archaeology as well as art criticism."[95]

The trilogy by Fernandez spans the last two decades of his life,[96] and it ended with his last work on Orozco's tragic view in the hospital dome of the nude figure of man consumed in a flaming tornado of his own making. León-Portilla draws Vico and his Mexican disciple, Lorenzo Boturini (1746), into comparison with Fernandez as sharing the belief stated by Fernandez in 1972, that "del arte sólo se puede hablar históricamente como expresión de los hombres" [about art the only possible historical discourse is as human expression.][97]

Between *Coatlicue* and Orozco's tragic view of human history, Fernandez redefined Toscano's first approach to the historical problem of tragic beauty, as beginning and ending with human sacrifice. As to esthetics, he remains close to Ortega y Gasset,[98] as when he calls it "a generic name for innumerable values," and "impure, because it is historical." Finally Fernandez defined esthetics simply as the "history of esthetic ideas."[99]

TATIANA AVENIROVNA PROSKOURIAKOFF (1909—1985). Trained as an architect at the University of Pennsylvania, she was an artist for Carnegie Institution of Washington without becoming a field archaeologist. She concentrated in her office at Peabody Museum in Cambridge upon major problems, first of architectural rendering and later on sculptural style, both Maya and East Coast, and finally at Mayapán and on the jades of Chichén Itzá.

Her major discoveries were in her library on the historical content of Maya glyphic writing on stone, where she initiated the detailed reconstruction of Maya dynastic history from the inscriptions on stone monuments. Archaeologists were her friends, and she was their severe critic, by insisting on the primacy of visual evidence. To her the "gaps between archaeological evidence and historical reconstruction" and the "reconstruction of Maya religion from colonial sources" were constantly present in conversation and writing.[100]

On the other hand, her study *Classic Maya Sculpture,* appearing in 1950, surprised those critics of Carnegie Institution (p. 188) who had "fallen out of the habit of consulting Middle American archaeological literature for useful data." Robert Wauchope described her book as being about "aspects of culture change as reflected in art," by assuming that "the most significant criteria of time were abstract form, line, arrangement, and composition," as "qualities of the whole design that affected simultaneously all elements in it." In his review [101] of her works "the significant change was in the artist, not in the subject of his art." Wauchope then approves "her awareness that an art development cannot be understood except in its total cultural context." Yet neither Wauchope nor Proskouriakoff would have approved a premise of the present study, that esthetic activity not only precedes but may condition choices made in the genesis and early history of "culture" (p. 20).

She made her own view clear: "Critical study of art is not for the archaeologist. Aesthetic values have little bearing on immediate archaeological problems, and their elucidation in works of art has always been and should remain the function of art critics and art historians. . . . Our responsibility ends with supplying for the critic the necessary information on chronology and cultural affiliation of works of art and in publishing them with the least possible loss of aesthetic values." [102]

SALVADOR TOSCANO (1912–1949) was among the founding members in 1936 of the Instituto de Investigaciones Estéticas, while he was both secretary of the Instituto Nacional de Antropología, [103] and professor of prehispanic art at the Universidad Nacional. His book *Arte precolombino,* on the art of Mexico and Central America, appeared in 1944. [104] It was the first volume of a series, followed by Manuel Toussaint's *Arte colonial en México* and Justino Fernandez's *Arte moderno y contemporáneo de México.*

The original text of *Arte precolombino* opens with a short discourse on the esthetics of native peoples as being expressions of a "will to art" (citing Worringer without reference), followed by a report (14) on the "experiments" by Manuel Gamio in 1916. Gamio showed fifteen to twenty photographs of archaeological pieces to "individuals of evident European culture" who chose the Eagle Knight head and the Cozcatlan figure as "artistic" but rejected as "repulsive" the statues of the "death goddess" Mictlantecuhtli and the "goddess Coatlicue" (fig. 25). Gamio concluded

that only *desamor al indígena* (aversion to Indians) was the explanation. Thus Toscano aligned himself with both the psychological wing among art historians and the emergent *indigenista* block in Mexico.

Toscano also says of Riegl and Worringer that they opposed Winckelmann and Lessing (13) as to the superiority of classic ideals and the inevitability of artistic progress. He sees Riegl as "dominated by the formalistic ideas of Herbart" in validating the arts of Egypt, Islam, and the baroque world, with "will for form" as an "idealist affirmation."[105] Furthermore, Toscano invokes Romanticism (via Goethe's revalidation of Gothic art) as opening the ways to understanding non-European art in general and particular treatment (13).[106]

Toscano also recognized the importance of "terror and sublimity" in the "arts of the archaic age," stressing their "oppressive majesty" and "tremendous" forces (15)[107] as intrinsic to beauty. His position may have owed much to instruction by José Gaos and Justino Fernandez, but Fernandez codified his pre-Columbian ideas only in 1954.[108] Toscano separated the *tremendo* from the *bello,* as the cardinal difference between older sites (Monte Albán, Teotihuacán, and La Quemada) and later ones after A.D. 1000 (Xochicalco, Mitla, Tajín). The *sublime* is at Teotihuacán or Monte Albán, the *bello* is at Chichén Itzá or Kabah, Uxmal, or Mitla (18). The antitheses are archaism and naturalism; magic and realism, terror and harmony (19). Finally, quoting Spengler, Toscano believed in an *extinción interior* that had begun much earlier than the Conquest (20).[109]

The brief section on esthetics (13–20) precedes an archaeological survey (21–50) by cultural regions (archaic, Maya, plateau, Atlantic coast, southern, and western). Toscano rejected diffusionism: man in America came from Asia by land in several waves (as suggested by P. Rivet), but "his culture was unquestionably autochthonous" (23). Only stone industries and perhaps basketry came with him as a hunter and gatherer.

After disposing of these matters, Toscano turned to architecture, sculpture, painting, pottery, mosaic, featherwork, and metalwork, in an art-historical segmentation used by Pál Kelemen.[110] The architecture divides by typological varieties: the city (in orientation and plan), plazas and ceremonial precincts, pyramids, temples and palaces, colonnades and hypostyle chambers, ballcourts, triumphal arches, observatories, tombs and burial chambers, dwellings, and decoration. Some types escape mention: baths, gardens, aqueducts, and government buildings. Sculpture is divided by cultural regions. But painting is both typological, by codices and

murals, and regional, by cultures. Pottery is classed regionally, but mosaics are typological by the surfaces of application: masks, skulls, objects, and costume. Metals are classed by types of use.

In the *prólogo* to the third edition of 1970, M. León-Portilla correctly assessed the original edition of 1944 as "the first major work to view the art of Mesoamerica in its entirety, with an *esthetic criterion* and adequate archaeological information."[111]

GERDT KUTSCHER (1913–1979). Like the Mexican nobles of Tenochtitlán in 1519, Kutscher survived an apocalyptic destruction of a state and its capital, by the dedication of his career to Americanist studies of native texts and artifacts. Living after Hitler among the ruins of Berlin (the city of his birth), he studied in the rich library of the Iberoamerikanisches Institut in Berlin-Lankwitz from 1947 to 1972,[112] writing abundantly as well as editing the works of other scholars during more than forty years,[113] in an effort to rebuild German traditions of erudition. His debonair attitude appears in a letter of 1947: "It was in any case amusing to me to lose myself during the continuing destruction in the study of a long-vanished people and be concerned with their even now unknown culture."[114] He was driven by the almost complete paralysis in Berlin of the long Americanist tradition in which he was trained by Walter Lehmann (1878–1935),[115] who in turn had carried on the work of Eduard Seler in the Berlin Museum für Völkerkunde. The continuity of this tradition is apparent in Lehmann's early (1906) and last (1938–39) works, both on the *Historia de los reynos de Colhuacán y de México*. Kutscher told its story in more detail in 1966,[116] as not only about the millennial past but also about actual and future Amerindian meaning.

Kutscher's apprenticeship with Lehmann began when he was eighteen, assisting in the installation of *altamerikanische Kunst* in the Prussian Akademie der Künste[117] and continuing Lehmann's ethnohistorical work. Kutscher decided in 1938 to write a doctoral dissertation about Peruvian pottery of "Early Chimu" (now Moche or Mochica) date (200 B.C.–A.D. 750),[118] which he began with Lehmann. But he finished it with F. Termer and R. Thurnwald, basing the chronology on Rafael Larco Hoyle's.[119] He used his own drawings made after 1937 (fig. 42). The final manuscript now in the Iberoamerikanisches Institut was finished in 1944 (xxi, 951 typed

Figure 42. Stirrup-spout vessel, Chimbote, Peru (Museum für Völkerkunde, Berlin). Kutscher, as an art historian, was more interested in books than in drawing, like most of his colleagues in Europe and America. Thus his publications were illustrated with drawings of museum objects by others, like W. von den Steinen, who had illustrated many works for Eduard Seler. The work of such illustrators was rarely acknowledged or signed, but the drawings by Steinen usually bear his autograph. This rollout drawing from a Mochica IV stirrup-spout vessel (about A.D. 500) lacks signature or monogram. But as Kutscher scrupulously acknowledged all signed work, the drawings without credit to anyone are probably by him. His lifelong interest was in book design, and to sign a scholarly drawing would have seemed inappropriate for him as a library director and editor. (after G. Kutscher, 1954, pl. 58)

pages bound in six volumes).[120] Only the table of contents of the typescript in 1944 was published by Kutscher's successor as editor of *Indiana*.[121]

The topics were more art historical than archaeological, concerned first with pottery making, vessel shapes, and the meaning of the images. Animals and plants in landscapes with celestial bodies were discussed in part I, daily life in part II, warfare in part III, and religion in part IV. The illustration comprised 550 rollout drawings, 100 detail drawings, and 30 photographs. The most ample use of this material was made in *Monumenta Americana*, vol. 1.[122]

Kutscher was aware that E. P. Benson in Washington as well as C. P. Donnan[123] had access to material beyond his reach and that their method of rapid synthesis was unlike his searching analysis of specimens and themes.[124] The difference between them is that Kutscher thought as an art historian who had admired Eckart von Sydow's works on non-European arts,[125] while the Americans (A. Kroeber, D. Strong, W. Bennett, E. Benson, and C. Donnan) thought as cultural anthropologists who were seeking to "define a culture."

Kutscher's approach in 1954 departed from the cultural categorization in his dissertation. Before 1944 he began with the technology of pottery followed by typology, meaning, and ornament. The body of the text then was divided as environment, daily life, warfare, and religion, much as his anthropological teachers would have reported the culture of an Amazonian or Great Plains tribe.

In 1954 he adopted another format from art museums, in the illustrated catalogue of objects, each explained in as much detail as the state of knowledge would permit. The eighty plates were all from drawings published elsewhere[126] or prepared for this volume, where they are arranged merely by "thematic groups": environment, hunting and war, ceremonials, death, demons and gods, and mythical scenes. Thus free interpretation was restricted by descriptions of the visible drawings to what can be seen rather than spun out as explanation.

At this time, before 1954, Kutscher had edited a manuscript by Eckart von Sydow (1885–1942), who was among his teachers and from whom he learned to think as an art historian. Sydow's work had ranged widely from esthetics to medieval and modern art, but his publications were mostly about African and other non-European arts.[127] He had written a little about ancient America in the 1930s. One of his last studies was on Mexican pictorial manuscripts.[128] Like his contemporary Leroi-Gourhan,

Kutscher had moved from prehistory to art history, with the insight that the visual evidence was primary rather than only supportive of cultural theory.

DONALD ROBERTSON (1919–1984). In 1960 Robertson began to explore, being a historian with a "creativity" like that of painters and sculptors. He concluded that the answer lay in a response to the question "*How* is the historian an artist?"[129]—this by collecting data, creating a synthetic pattern, and writing to achieve "intellectual and emotional rapport" with the reader.

His remarks thus complied with the guideline by the editor, Lewis Curtis, Jr., to "explore the relationship between methodology and interpretation, premises and conclusions, evidence and hypothesis" as exemplified in each historian's own work (xiii). The anthology included sixteen contributors from many schools of thought. Curtis described Robertson's essay as illuminating a "creative and often overlooked form of historical inquiry," which is the history of art, for which Robertson was the only representative in the volume. The others, however, were also "established scholars" who ventured "beyond conventional methods and interpretations of their fields" (xiv). Robertson chose to discuss his dissertation[130] in the phases of its gestation, first before 1944 at Yale, and again at Yale after 1949, separated by periods of study at the Institute of Fine Arts in New York University and teaching at the University of Texas in 1947, where he studied manuscripts from Mexico at the Latin American Library. His conclusions were reviewed by Charles Gibson as having demonstrated that "pictorial schools . . . may be fruitfully distinguished an analyzed; all of the metropolitan codices to which pre-conquest origins have been attributed, including the Matrícula de tributos and Codex Borbonicus, are of colonial manufacture; a number of codices, e.g. parts of Codex Mendoza and Codex Osuna, derived directly from screenfold forms; the whole Techialoyan group represents a late campaign of production."[131]

In the words of Elizabeth Hill Boone, director of pre-Columbian studies at Dumbarton Oaks, Robertson was "an innovative and broadly humanistic scholar and a great man . . . one of the foundation piers of Pre-Columbian art history [who] virtually established the art historical study of Mexican pictorial manuscripts, and he continued in his other writings to present new ways of seeing Pre-Columbian and early Colonial art and architecture."[132]

Among his many insights, he perceived Sahagún as belonging to a medieval encyclopedic tradition, although he may have erred in believing that Isidore of Seville and Bartholomew de Glanville in England were the encyclopedists on whom Sahagún modeled the *Historia general*. Without commenting on Bartholomaeus Anglicus (as Glanville was usually known before John Trevisa translated Bartholomew's work from medieval Latin to Middle English prior to 1399), F. Saxl noted in his lectures only that the "encyclopedias" by Lambert and Herrad are more like etymologies.[133]

Sahagún's *Historia* is rightly seen by Robertson as dividing human and natural knowledge, but the source of this scheme is neither Isidore nor Bartholomew, who are more like each other than either is like Sahagún. Robertson's tabulation of correspondence between Bartholomew and Sahagún mentions books III, *de anima racionali;* IV, *de humani corpore;* X, *de materia et forma;* XI, *de aere;* and XV, *de regionibus et provinciis*. But Bartholomew's *prohemium* distinguishes only between "bodily and not bodily things." Among the latter are angels, some good and some evil. Nowhere does Bartholomew separate divine, human, and natural categories of being.

If we restore the missing books to Bartholomew and keep his seriation (table 1), he and Sahagún can be seen as more different than Robertson's table of likenesses might suggest. Sahagún used only twelve topics like those in Bartholomew's *Tabula*, but the correspondences are with medieval encyclopedias in general rather than with Bartholomew Anglicus, whom Sahagún still is not proven as having studied, even though both were Franciscans.

Sahagún was guided more by the cognitive system of European encyclopedic *etymologiae,* from Aristotle to Isidore,[134] than by Bartholomew (table 1). At all points of the final text of the *Historia general de las cosas de Nueva España,* Sahagún was confronted with organizing an immense archive of texts and pictures assembled by his Indian informants.[135] Lacking the necessary ethnogeography, Sahagún was unable to control the bewildering profusion of peoples, languages, and traditions in Mesoamerica. He therefore fell back upon the "shredding" that the medieval approach permitted. It could reduce ethnic complexity to simple entries by names, as in the ancient etymological encyclopedias that the medieval tradition offered, from Aristotle through Lucretius and Aetius to Pliny and Isidore. Thus Sahagún could encompass all his archive by rearranging its elements to fit the cognitive system of medieval encyclopedias. In effect

Table 1

	Tabula and Prohemium[a]

Bartholomaeus Anglicus	Sahagún, *Historia general*[b]
Bk. I, God	Bks. I, III, Gods
II, angels	
III, reasonable souls	
IV, bodily substance	
V, mankind's body	Bk. X, chap. 28
VI, ages of man	
VII, sickness and venoms	Bk. X, chap. 28
VIII, world and heaven	Bk. VII, astronomy
IX, time and its parts	Bks. II, IV, V
X, matter and form	
XI, air	
XII, birds and fowls	Bk. XI, chap. 2
XIII, waters and fish	Bk. XI, chap. 3
XIV, earth and its part	Bk. XI
XV, provinces	
VII history, rulers	
IX merchants, arts, and crafts	
XVI, stones and metal	Bk. XI chaps. 8, 9
XVII, herbs and plants	XI, chap. 7
XVIII, animals	XI, chap. 1
XIX, colors, odors, tastes	XI, chap. 11

Of nineteen topics, seven are lacking in Sahagún, who replaced them with five about Mesoamerica only.

[a]M. C. Seymour et al., eds., *On the Properties of Things. John Trevisa's Translation of Bartholomaeus Anglicus, De Proprietatibus Rerum. A Critical Text* 2 vols. (Oxford, 1975).

[b]*Florentine Codex*, ed. A. J. O. Anderson and C. E. Dibble (Santa Fe, 1950–75), 12 vols. pertaining only to New Spain.

he shredded the data instead of discovering their internal coherence as cultural documents.

Whether or not Sahagún knew of Bartholomew de Glanville is less significant than his medieval approach to knowledge of other peoples. Robertson first suggested this interpretation, perhaps stimulated by the title of the survey and photographs by Pál Kelemen.[136] Another instance of Robertson's use of medieval European art as a pattern for the interpretation of Amerindian history of art was his transfer of "international style" from the history of painting in western Europe during A.D. 1375–1425 to a coeval instance in Mesoamerica, when a Mixtec style of painting in south

central Mexico reappeared at Tulum and Santa Rita on the east coast of Yucatán. Robertson saw these examples as like the Late Gothic phenomenon in France, Italy, and Spain,[137] in a more playful manner than Kelemen's.

The inaugural issue of *New World* (1986) was dedicated to Robertson with a phrase by José Ortega y Gasset worth repeating here:

Were art to redeem man, it could do so only by saving him from the seriousness of life and restoring him to unexpected boyishness.[138]

6

Anthropologists and Archaeologists

after 1875

THE CONVERSION OF esthetic research from idealist speculation
on metaphysical principles to experimental procedures began in
1876. It rebuilt classical esthetics "from above" into the method of
science "from below," as Fechner then called it.[1]

That year also marked the first international congress convoked by the
Société des Américanistes in Paris, to be a forum for scientific work on the
history of man in the Americas. From their beginning the congresses were
openly concerned only with "ethnography, linguistics, and history." A
solitary Russian report in 1875 on the Amerindian collections in St. Pe-
tersburg announced "their total absence of beauty and morality."[2] Modi-
fied in 1900, the statutes specified only "historical and scientific study of
both Americas."[3]

After 1900, the congresses took place every two years, alternating the
sessions "as far as possible between the Old and New Worlds, and not
meeting twice following in the same country."[4] Comas reports many reso-
lutions amending the statutes: most of these concern archaeology, pre-
history, linguistics, history, and physical anthropology. Not until 1960
were pictorial sources placed on the list of symposiums. In 1962 "urban
process" was included; colonial concepts of the Indian in 1964; rock paint-
ing and baroque art in 1966; Nahua and Maya traditions in "Fine Arts"
(1968); native writing systems in 1970. In 1876 at the centennial congress
in Paris, seven symposiums (among thirty-eight) were about topics related
to art. The congress at Vancouver in 1979 had six symposiums, and two

general sessions (the first in ICA history) on topics related to art, including "pre-Columbian intellectual culture."

For over a century now, the congresses have been mainly about Amerindian history and science, with some attention to esthetics and art since 1960. But esthetic studies remain outside the stated aims of the congresses of Americanists as they were in 1900, despite the empiric approach they have shared since 1876.

This continuous wave of thought spanned two centuries from Schelling to Lacan and Foucault, by whom the emotive and esthetic factors underlying anthropological ideas about culture were explored. Adolf Bastian and Franz Boas occupied complementary roles, being born thirty-two years, or a full generation, apart. Bastian was the theorist of "inborn ideas," and Boas, without open criticism of Bastian, moved to the history of art as if in search of a missing dimension of social anthropology, to which he was drawn by his early efforts to question Fechner's psychophysical law.

ADOLF BASTIAN (1826–1905) was an early leader in the international anthropological field in Berlin. At first he used an arrangement by short essays loosely connected in a discourse upon a stated theme in *Die Culturländer des alten Amerika* in 1878. He returned to this format in a rarely cited work of 1896 appearing nine years before his death, when he was seventy. The title restates the work of his life as an ethnologist: "The creation in thought of the surrounding world from cosmogonic representations."[5] It returns to the "elementary ideas" that he enumerated briefly as a listing of one-page topics in random order, each designated by a word or phrase, on less than a page, yet all embedded in continuous discourse. This Joycean version of Frazer's *Golden Bough* (1890) has little value as an anthropologial study, but it prefigures C. G. Jung's dependence on Bastian's concept of "elementary ideas." In 1938 Jung called them "inborn ideas,"[6] using this term to mean primordial images undetermined as to content, each like the "axial system of a crystal." Here he included his own "archetypes" in 1946 taken from Plato.[7]

Bastian's "world view" by 1860 was recently related by K.-P. Koepping to Schelling's "monist vitalism." Both men stressed the emotive and esthetic aspect of human perception. The direction continued through Schopenhauer and Nietzsche to the psychopohysics of Fechner and Lotze and the

depth psychology of Freud at the end of the century. Koepping also connects the "elementary structures of the mind" in the writings of Claude Lévi-Strauss with Bastian's elementary ideas. He notes that both are determinists, looking for "final, atomistic entities or elements" making up universal patterns of thought of all mankind. Yet Bastian's anthropology is suggested as Einsteinian more than the Newtonian approach of Lévi-Strauss. Koepping suggests that a "return to Bastian in order to keep anthropology authentic"[8] is needed today.

Bastian's lecture on Mexico (January 18, 1868) skeptically[9] reviewed the state of received opinions about Mexico from Bernal Diaz to Prescott. He lamented the demographic catastrophe of the Spanish Conquest by embroidering his account with cross-cultural parallels, as in the tradition of Las Casas[10] and Jerónimo Román.[11] But he added his concern about the turbulent decay of Mexico since Independence as matching the disorder of the Conquest era, comparing Cortés with the emperor Iturbide (471). Such observations led him to reflect on the role of ethnology in modern statecraft and its ethnic problems, in the direction marked by Jakob Burckhardt,[12] at the time of the execution of the Mexican emperor, Maximilian, whose state funeral in Vienna was on the date of his lecture in Berlin.

In this year he became president of the Gesellschaft für Erdkunde. He then saw ethnology as "the mental life of people, in the research about the organic laws under which mankind rose to a state of culture in the developmental process of history."[13] Bastian's lecture on Mexico is the earliest expression of the disapproval both of Spanish colonial policies and of the process of cultural and racial creolization that appears more fully in *Culturländer des alten Amerika* (1878–89). But as a memorial or commemoration of the brief reign of Maximilian in Mexico, his lecture in 1868 reflects his acceptance of royal patronage in the making of the ethnological museum in Berlin, as much as his disapproval both of Spanish government in America and of the German policy of acquiring African colonies.[14]

EDUARD GEORG SELER (1849–1922). The placing of Seler between Bastian and Bandelier as their birth years require points to his position near the beginnings of anthropological archaeology in America, as a figure of central importance in Americanist studies, both then and now.

The frail son of an obscure schoolteacher, he was educated in Berlin and

Breslau. He chose to study natural science with botanists before 1870, teaching botany in secondary school until 1979, when an illness required him to live with a sister in the warmer climate of Trieste. His linguistic work began there with studies of the Indian languages of Ecuador and Guatemala, and a translation of Nadaillac's work on prehistoric America with his own additions.[15] This was in 1884, as Seler's first publication in an entirely Americanist bibliography of 257 articles and books.[16]

Thus Seler is rightly named the Nestor of Americanists, but his Maecenas was Joseph Florimond Loubat (1831–1927), who was created papal duke by Leo XIII after 1878. Born to great wealth in New York City, Loubat's family were landowners of part of downtown Broadway. He was educated like some other Americans of that time at Heidelberg, where his friends were German nobles of the midcentury. His lifelong interests were those of an Americanist. He served on a naval mission to Russia soon after the Civil War. His medallic history of the United States appeared in 1878. He also raced repeatedly as a yachtsman in the America Cup series. Close ties with France and residence in Paris led him to membership in the Société des Américanistes, where he took an active part in meetings and congresses.

Seler met Loubat within this society. Loubat then funded the archaeological expeditions to America that Seler and his wife made from 1887 to 1911. Loubat also paid for publications by Seler of six Mexican manuscripts from 1898 to 1903. In 1889 Loubat endowed a chair for American linguistics, ethnology, and archaeology at the University of Berlin, specifying that Seler should be its first occupant. He also endowed the Duc de Loubat chair at Columbia University,[17] and other endowments at the Collège de France and elsewhere were for Americanist studies.

Thus Seler's life as a scholar was entirely as an Americanist and was made materially possible by an American Maecenas.[18] Eric Thompson (the Mayanist and epigrapher) called him the "great Eduard Seler, Nestor[19] of Middle American studies" for "his greatest single contribution," which was "his demonstration of the essential unity of the advanced cultures of Middle America."[20] But what is this essential unity and what was this demonstration? Seler noted in 1895[21] that unitary origins stem from Genesis as well as from phylogenetic science. He ridiculed long-distance transoceanic diffusions[22] because, being reluctant to accept myths as history, he found the isolation of America from the Old World both a "special delight and a special advantage."[23] This is one of few places in his

many (275) publications where he allowed himself an expression of esthetic pleasure.

Like Brasseur and Nadaillac, Seler regarded the Toltecs as the earliest highland *Kulturvolk,* and he accepted the beginning of their rule (as given in the *Anales de Quauhtitlan*) in the eighth century A.D.[24] This date marked for him the spread of the 260-day ritual calendar and the 52-year cycle (now known to be much older).

For Maya writing he assumed an origin early in cycle (*baktun*) 8,[25] which he correlated with A.D. 700. Thereby he left open the question of highland or lowland priority, around which much disagreement arose after 1940, when Olmec civilization was first identified by Stirling as being far older[26] than Maya. Seler's argument had been that the cycle 8 date on the Leyden Plate recorded an event c. A.D. 950, thus making the monuments at Quiriguá (actually before A.D. 800) record events before A.D. 1400.[27]

Seler optimistically hoped in 1902[28] for the appearance of "solid ground" and the end of "unlimited speculation." Today, however, we still oscillate between isolation and diffusion and between unity and diversity among Amerindian civilizations before Columbus. Seler's uncertainties[29] persist after more than half a century of further excavation, theory, and talk. H. B. Nicholson (writing in 1972) said that the debate between "ideographic" and "phonetic" still "raged" then[30] and that Seler ceased epigraphic Maya studies after 1908 because of his conviction that the phonetic approach would become dominant.[31] In effect this has happened, and his ideographic method is in abeyance, as much as the phonetic approach was from 1908 until the 1960s, when it was altered and revived by Knorozov, Lounsbury, Kelley, and Schele.[32] In Seler's words, his method about 1890[33] was to reject "general ideas, interpretations and conceptions which do not lead to clear understanding. First one must determine what is factual." The study of details then "will not preclude wider perspectives, but even make them possible in many cases." These positivist declarations reflect Seler's early studies of botany and comparative philology.[34]

They were later contradicted when Seler became interested in the ethnological study of ancient religions. His mentor after 1897 was another comparative philologist in Berlin, Ernst Siecke, whose works influenced Seler, especially as to the relation between astronomy and religion.[35] Siecke's ideas first affected Seler's study of the Codex Borgia in 1906 and "all his later writings on Mesoamerican religion," with "results" which were "disastrous," such as applying the Venus calendar to "pictorial nar-

ratives of a genealogical-historical character in the Codex Zouche-Nuttall." This Nicholson regards as the "only complete failure of Seler's entire scholarly career."[36]

Siecke's influence did not affect other kinds of research by Seler. Nicholson names seven "important contributions" by Seler to the study of Maya hieroglyphs.[37] But Nicholson also believes that Seler's "prestige and influence" obviously played a significant role in bringing about the long eclipse of the "phonetic approach" after 1904.[38]

Seler rarely criticized other Americanists, yet in 1904[39] he disagreed with K. T. Preuss over his theory of guilt in the history of Aztec religion, as well as over Preuss's reading of *atl tlachinolli* (usually read as "war") as "divine punishment." Preuss had also interpreted cotton and butterfly signs as emblems of sin. Tamoanchan, for Preuss, was the underworld realm of the firegod. But Seler paraphrased Preuss as saying that the Mexicans regarded all human misfortunes, especially death, as the consequence of sin and as punishment sent by the gods. Hence death by sacrifice was regarded by Seler as the punishment of sin and as the judgment of the god.[40]

Seler returned to attack Preuss in 1907 for his views on the "magical reinforcement of the victor" in the Mesoamerican ballgame. Behind this polemic is Seler's dislike of what he called "fanatical" anthropological theories of the time. He mentioned no names, but it is likely that he meant E. B. Tylor, F. J. McLennan, H. Spencer, A. Lang, and J. G. Frazer when he said that Preuss had adopted "English views" in his magical interpretation of the ballgame.[41]

How Seler could reconcile his acceptance of Siecke with his rejection of English anthropologists is unclear, unless by 1907 Seler had rejected both Siecke and the English, returning to his own natural positivism. Yet in 1915 he wanted the mural cartouches he discovered in House E at Palenque (fig. 43) to prove a close relationship with Teotihuacán. From this he concluded that Toltecs from highland Mexico left early traces at Palenque. He thought that from later Maya glyphs and Maya art both arose.[42] Here he coincided with Brasseur, Charnay, and Bandelier in a theory of Toltec priority and domination in an initial period. Thus Seler stands in an earlier age before the replacement of philology by anthropology, and of humanistic studies by social sciences.[43]

But unlike Lévi-Strauss's Amazonian mythologies that remain cloudy worlds, Seler's Mesoamerican subjects are visible in their own shapes and

Figure 43. In 1915 Seler assumed that the west hall of House E in the palace was renovated "at the beginning of each important time period." Assisted by the official inspector Benito La Croix, Seler exposed a frieze 26 cms. high showing eyes representing stars, which were taken to be the "oldest decorative layer" of the palace (*Observations*, 79, figs. 125–38). These he related to the style of Teotihuacán (figs. 142–44) in clay ornaments and identified the west hall of House E as a Xochicalli, or Flower House (86). The comparison with Teotihuacán is possible, as both were in being about A.D. 700, but Seler cautiously fixed no date on this connection.

colors as vivid images and objects from past realities, closer to art history than to anthropology. Art history may be more like botany than any other exact science, and Seler may be said to have remained a botanist all his life, interested mostly in taxonomic classification. He, more than anyone before him, made Amerindian art visible.

ADOLPH BANDELIER (1850–1914). The letters by Bandelier to the anthropologist and archaeologist Lewis H. Morgan (1818–81) reveal his debt to Morgan, whom he adopted as a scholarly father. When Bandelier converted to Catholicism in 1881 at Cholula, the Mexican historian Joaquin Garcia Icazbalceta (1825–94) was his chosen godfather, and he corresponded with him from 1875 to 1891. In 1888 he began for Pope Leo XIII the manuscript of *A History of the Southwest,* as if dedicated to the last of the surrogate fathers he needed to replace the bankrupt and fugitive father who had deserted the family in 1885.[44]

Bandelier's principal motive when beginning *Delight Makers* in 1883 at Cochiti was to discredit the "romantic" fictions about Indians that were then current,[45] but at the same time Bandelier would "tell the truth about the Indian" by "clothing sober facts in the garb of romance."[46]

The narrative of the love between Okoya and Mitsha occupies twenty-one chapters in which Bandelier told what he knew as an ethnologist about his Indian friends and their Navajo enemies at Cochiti and Santa Clara pueblos. But, following their traditions, he placed his romance in the ruined towns of the cliffdwellers at Rito de los Frijoles and Puye, abandoned many centuries ago. He assumed that three centuries of Spanish government and Catholic missionary indoctrination had left no traces on the Keresan and Tewa peoples, whom he resettled in his imagination at Tyuonyi and Puye, including Navajo enemies nearby.

His underlying principles were stated in a lecture.[47] First, "religious creeds" and "social organization" were "molded on the same pattern" among all tribes *"over the whole American continent."* Second, "ruins in existence prove *not* a contemporaneous large population, *but the successive shiftings of that population over a vast area within a correspondingly long time."*

Self-taught and turning to American ethnology and archaeology under the influence of L. H. Morgan, Bandelier had published papers in 1877–79 on ancient Mexican warfare, land tenure, social organization, and govern-

ment, all based on source material in many European and native American languages and making "fairly accurate guesses about [chronological] sequences."[48] Thus prepared, he began many years of fieldwork, beginning in New Mexico at Pecos pueblo, Cochiti and Santa Clara, where he combined archaeology and ethnology.

He interrupted these studies to visit Charnay in Mexico. Disappointed by Charnay's return to France, Bandelier visited Cholula, Mitla, Tlacolula, and Monte Albán in 1881, then returning to New Mexico to describe ruins until 1886. His frame of mind during these arduous years is described in his paper seeking to replace "romance" with historical criticism, following the methods of Humboldt and Morgan.[49] At this time, however, he wrote *The Delight Makers* in order to discredit predecessors: "We have, Mr. Morgan and I under his directions, unsettled the Romantic School in Science, now the same thing must be in literature on the American aborigine. Prescott's Aztec is a myth, it remains to show [that] Fennimore [*sic*] Cooper's Indian is a fraud . . . THEY—I want to destroy first if possible."[50]

Bandelier's private opinion of Indians appears in *Delight Makers*: "The Indian views nature with the eyes of a materially interested spectator only." He thereby grafted his own view on the Amerindian substratum, which remains unmentioned. His main concerns had been with maternal descent: exogamous clans; government by clan representatives (he despised "democracy" in his time); nuclear family separated, by maternal and paternal clans. All these ethnological findings[51] are applied by analogy to interpret the lost antiquity of Tyuonyi canyon (Rito de los Frijoles) and Puye. But his hermeneutic system requires an "Indian who speaks like a child," who "lacks abstract terms" and lives by "religious acts called forth by utterances . . . of higher powers."[52]

In fact, Bandelier denied or ignored an esthetic sense among his Cochiti Indians of 1884, although he was driven himself by their esthetic absorption in ritual.[53] His criterion is to make Indians so similar to whites that they will understand Indians as he does: "Indian gossip . . . is as venomous . . . as among us" (286), and "children conceal their guilt, and so does the Indian" (303). Thus, in circular progression, Bandelier declared that Indians today [1890] "are at heart nearly the same Indians [as] we found them in this story" (485), in this way revealing that he was portraying them both, old and new, as identical in his private imagination (489).

Bandelier's meaning, when he rejected the "romantic school in American aboriginal history," is that lacking criticism of sources, it "creates

illusion, propagates fiction."[54] But Bandelier abandoned these principles when writing *Delight Makers*[55] without historical criticism of any kind. His pronouncements about the nature of Indian thought are nevertheless frequent, in a text written to be read aloud, without interruption from footnotes, in a family gathering. Being such, they are commonplaces, as of that period.[56]

From 1892 to 1903 he was in Peru and Bolivia extending his research to sites and sources there, from Chan Chan to Lake Titicaca.[57] In La Paz he coincided during 1894 with Max Uhle,[58] whose work and fame correspond to a later "horizon" of American archaeology, when it became possible to begin to correlate stratigraphic sequences with historical sources.

MAX UHLE (1856—1944). Trained as an ethnologist in Dresden (1881–88) and in Berlin with Bastian, Uhle knew both Wilhelm Reiss, the excavator at Ancón in Peru, and Alphons Stübel at Dresden, who encouraged his interest in Andean anthropology.[59] His early training in linguistics yielded a classification of Chibcha languages in Colombia. Based on the comparative method of Indo-Europeanists, it uses correspondence of sounds to relate Chibcha to Talamanca in Costa Rica and to Guaymi in Panama.

John Rowe, his biographer, credits Uhle with laying "the foundations of Andean archaeology" from 1892 to 1905, starting from "modern principles of stratigraphy and seriation," on field trips that kept him in America for forty years achieving "the relative chronology of Peruvian styles."[60] When Uhle found stratigraphic seriation, "styles" were his main evidence for historical reconstructions, as of continuity, period, and influence. But he proceeded from "laws" he believed, such as that "art develops always from the realistic or figurative to the conventionalized or geometric," as in the lectures he gave at Quito in 1923.[61] By then his ability to distinguish styles had become "definitely impaired."[62]

His early preoccupation with long-distance diffusion can be traced before 1892. By 1917, Central and South American connections "were very probable," and by 1923 "he was sure he had the full proof."[63] In 1935, Uhle wrote of his belief that the ancient calendars and histories in Mexico and Central America would correlate with South American events, to "limit wide-sweeping fantasies" about their duration.[64] By these he meant,

for example, the use of Montesinos in the studies by Ameghini, and in archaeology by Bingham at Machu Picchu.

FRANZ BOAS (1858–1942) worked with Adolf Bastian in 1885–86 at the ethnographical museum in Berlin on the display of the collections. Bastian wrote ten years later of him as "friend Boas, with whom after many years of connection during his residence in Berlin (and as associate on the installations of the ethnological museum), frequent opportunities for discussion (according to our understanding at that time) arose."[65] In 1885, Bastian was at the peak of his career, and Boas was beginning his Arctic fieldwork. When he applied to Bastian for such funds, Boas says that Bastian "was rude to him,"[66] we may suppose because of needing the help of Boas in the museum. In the next decade Boas was in the field for eighteen months on funds from England and the United States.[67] The two men shared views that spread worldwide in the 1920s with the psychiatric works of Jung and Freud, and again with the mythographic studies by Lévi-Strauss. Among his early scientific studies in physics, geography, and mathematics, Boas was most active during 1881–82 in the physiology of sensation, then known as psychophysics. His first effort was to modify Weber's law (1834) that sensory effects of different magnitudes obey a constant, in the ratio of the increase d to the stimulus B or ($db : B = C$). His conclusion on differential thresholds of sensation[68] that "the smaller the difference between stimuli, the greater is the physical effort required for their recognition," seemed to reformulate the Weber-Fechner law.

Another essay appeared one year later, on the differential threshold as a measure of the intensity of psychic processes.[69] Two more papers then analyzed the differential threshold values (*Unterschiedsschwellenwerthe*) as to eleven possible conditions, thereby weakening the position of G. E. Mueller's work (*Zur Grundlegung der Psychophysik* [Berlin, 1878]).[70] Weber's formula was modified in 1850 by G. T. Fechner, the founder of psychophysics, who concluded that "magnitude of sensation is a logarithmic function of the stimulus."[71] Boas had studied Fechner's work, being entertained also by Fechner's satires, of which *Vier Paradoxa* (Leipzig, 1846) ridiculed Hegel's dialectic method. Boas's lifelong distaste for grand theories was behind his efforts to dislodge the Weber-Fechner constant, and when he knew Adolf Bastian's theories of the psychic unity of

mankind, he turned away as he had turned from Fechner, in distaste for unproven "laws" of ethnology.

A third essay then turned to G. T. Fechner's "psychophysical law." This had equated physical process as a measure of psychic process (that is, physical events match psychic ones, by which the latter may be measured).[72] Boas concluded that Fechner's formulation had confused "intensity" with "quality" of perception, which were Boas's terms of analysis.

This excursion into psychophysics gave Boas a needed connection between psychological sensation and esthetics. It underlies his later work between 1897 and 1927 on Amerindian ethnographic art, which he called primitive. But in these early essays testing the credibility of psychophysical "laws," Boas rejected them in history while accepting them in the physiology of sensation. In the history of art, which occupied him steadily until 1927, Boas could analyze many factors of process, but his book *Primitive Art* remained without history, because the corresponding archaeological framework was still rudimentary. Yet Boas gave system to the stratigraphic excavations clarifying the sequence of pre-Conquest civilizations in the Valley of Mexico with Manuel Gamio in 1911–12.[73]

Although Alfred Kroeber insisted that his teacher was more scientist than historian, the science by Boas ended in 1882, when he ceased to worry about Fechner's psychophysics and became an ethnologist. To Kroeber Boas replied that he had alway "tried to understand the culture . . . as the result of historical growth."[74] Their public disagreement had begun in 1929, when Kroeber wrote of *Primitive Art* that "of history in the sense of the historians and culture historians . . . there is not a trace."[75] Boas replied in 1936 that *Primitive Art* had "a whole chapter on Northwest Coast style" and that he had "spent years of his life in trying to unravel the historical development of social organization, secret societies, the spread of art forms."[76]

Primitive Art was at once accepted by art historians as being consistent with their aims, and in the mainstream of art-historical writing at that time.[77] Kroeber wrote his own treatise on style thirty years later, concluding with a concept of the "styles of culture"[78] (discussed here on p. 177), in a work that marks him as a follower of Boas. But when Kroeber began to formulate grand theory,[79] he omitted to recall the caution of Boas in *Primitive Art*, who gave one-third of it to Northwest Coast styles of art without formulating a scheme for all the New World.[80] Boas had aban-

doned the study of diffusion (which he called dissemination) between 1910 and 1922.[81]

In 1903 Boas had already adopted a binary approach to the history of art by division as to decoration and representation, and by rejecting the theory that representation preceded decoration (citing F. Cushing and W. H. Holmes as following G. Semper, H. Schurtz, and A. D. F. Hamlin). At this time the anthropological staff at the American Museum of Natural History were engaged in a systematic study of decorative art in the museum.[82] They noted that ceremonial objects were more representational than everyday objects of use among the same tribe at the same time. A. D. F. Hamlin added that motives exported to other peoples were subject to "divergent" change. The design was primary and the associated idea was secondary, having no relation to the "historical development of the design itself" (555) and undergoing changes from tribe to tribe, like the techniques themselves. Boas concluded that "a gradual transition from realistic motives to geometric forms did not take place. The two groups of phenomena—interpretation and style—appear to be independent" (562).

In 1916 Boas presented another binary division as valid among "primitive people," between an art of technical mastery and another of graphic representation. Here "skill" had replaced "decoration" in the sense that "esthetic effect" is a "secondary product" of "mastery skill." Boas cited only W. H. Holmes's articles for the *Handbook of North American Indians*,[83] omitting their common source in the studies by Gottfried Semper (see above, pp. 114–15).

Between these essays Boas wrote another on Alaskan needlecases of walrus ivory, in which he enriched the analysis by introducing the "tendency to play" and "the play of the imagination with existing forms," in the "enjoyment" of the maker as a virtuoso.[84] He returned to this theme in the conclusion of *Primitive Art* in 1927, but deprecating it as "pleasurable, not elevating."[85]

Ruth Benedict's obituary[86] on him noted that Boas's dissertation at Kiel on the perception of the color of water[87] was the work of a young "philosophical materialist" who went to the Arctic, in his own words, with an "exaggerated belief in the importance of geographical determinants" and returned "with the conviction that to understand human behavior we must know as much about the eye that sees as about the object seen." Boas's lifelong interest in the history of art is behind his erudite book in 1927, of

which the misleading title, *Primitive Art,* conceals a major advance in the comprehension of non-European esthetic systems, by treating the eye as "a means of perception conditioned by the tradition in which its possessor has been reared." This was the purpose of his early interest in psychophysical investigations from F. Weber and G. T. Fechner to G. Müller and M. Wundt. *Primitive Art* he wrote, however, as a history of art, drawing upon much of that literature, while aware of its limitations and his own as an ethnologist.

ALFRED VIERKANDT (1869–1954), a sociologist, sought his philosophical foundation in phenomenology with Edmund Husserl (1859–1938) and later in psychology following William MacDougall (1871–1938) with a theory of goal-seeking in response to inherited tendencies of "instinct."[88] Neither Hochstim nor his teacher Theodore Abel[89] discusses the essay by Vierkandt presented in 1924[90] at Berlin to a congress on esthetics, convoked by Max Dessoir. It was this editor of *Zeitschrift für Ästhetik* whom Mrs. Gilbert characterized as "hedging esthetics in" with an "elastic and liberal conception of Esthetics and general Science of Art" beginning in 1906.[91]

Vierkandt was in reaction against positivism as well as being anti-behaviorist, and antievolutionist in respect to art. His reasoning was aprioristic because of his need to understand the otherness of another human in any era of time. He assumed the psychic similarity of all humans as a self-evident postulate (342) that deprives mankind of the right to deny early humans (*niedere* = [early] *Menschheit*) full esthetic and religious behavior (as of equal value). He thus set a limit (*Abgrenzung*), rejecting the evolutionary conception that denies esthetics to early man, in favor of his "aprioristic" view that every culture displays a unitary quality in all its arts. Hence the "apriorist attitude"[92] (in esthetics, art history, philosophy, and psychology) rests upon the possibility that "otherness" (342) is necessary to cognition (*Erkenntnisnotwendig*).

His second point concerns the origin of art (344), which he misplaces as "after prehistory." Third is "attitude," a primary behavior in "logic, causality and genesis" within "inner life" (345). Fourth, he discusses the "reality of evolutionary forms" (*Entwicklungsformen*) passed on from Darwinism to ethnology. Vierkandt denies that primitive arts lack com-

mon principles because he regards their differences as cultural "varieties" (347). Finally he notes a typological difference between narrative art and music or dance as to change and permanence (350).

The commentary by the Africanist Richard Thurnwald at the congress in 1924 (349–55) objected that the "evolutionary approach" to art cannot now be avoided in its "revised form." Thurnwald as anthropologist says that "studies of manual technology" (*Technik der Hand*) and "cerebral techniques" (*Technik des Kopfes*) in the storage of information have altered understanding of ethnic and social stratification, by adding specialization, slavery, and luxury goods. Cultural foci (*Brennpunkten*) and their radiation upon other peoples also emerge as well as alterations in taste and tendency among artisans in differential development under the influence of strong personalities.

Thus the general aim to reconcile science and esthetics was expressed according to the policy of the editor, Max Dessoir, who remained in office until 1937. After the long disappearance of *Zeitschrift für Ästhetik* under Nazi rule, the *Journal of Esthetics and Art Criticism* began in the United States, where under the editorship of Thomas Munro (1897–1974) it became associated with his evolutionary doctrine in esthetics, which appeared as *Evolution in the Arts and other Theories of Culture History*.[93] Of it P. Walsh wrote that it is "a singularly unexciting and undebatable thesis . . . close to the trivial."[94]

ALFRED KROEBER (1876–1960) began academic life at Columbia, studying English literature in 1896–97 and "cultural history."[95] He taught English as an instructor and studied with Franz Boas in 1899–1901, writing a dissertation on Arapaho art. Of this work Robert Lowie wrote that it appeared when "primitive art was the cynosure of anthropological eyes, in America as well as abroad" in 1902, and that Kroeber revealed "the amazing subjectivism" of Arapaho "design and interpretations" by "illuminating the basic problem of conventionalization, from realistic model versus secondary attachment of meaning."[96]

His work in Peru was based on that of Max Uhle. Rebecca Stone gave Uhle credit in the 1880s for first sorting pre-Tiahuanaco, Tiahuanaco, and post-Tiahuanaco styles in Dresden by "an aesthetic, object-based orientation" without having been in Peru to find stratigraphy.[97] Following Uhle, Kroeber added Chavín to Tiahuanaco and Inca horizons in 1944, writing

that "horizon style" meant a style of "distinct features" extending over "local styles," the latter being a "priority, consociation, or subsequence."[98]

In 1904 Kroeber was first exposed to archaeological methods with Max Uhle at the Emeryville shell mound on San Francisco Bay near Berkeley. Uhle's broad anthropological interests were formed in the Dresden and Berlin museums of anthropology from 1881 to 1982. Uhle left Germany for Peru until 1897, wrote his report on Pachacamac in Philadelphia, and returned to various field and museum projects in South America from 1903 until 1933. Uhle's last years in Peru were from 1939 to 1942. A serious head accident in 1904 began a decline in the quality of his work, which became "more concerned with interpretation at the expense of description."[99]

Kroeber's own work in Peru was stimulated by the presence of Uhle's Peruvian collection at Berkeley, where Phoebe Apperson Hearst had financed his research for the projected university museum that would house the material assembled by Uhle from 1899 to 1905. These collections were well published at Berkeley by Kroeber and his students, D. Strong, A. Gayton, and L. O'Neale (1924–30) in studies that "mark the beginning of modern archaeology in the Andes."[100]

Yet Kroeber's commitment to history as anthropology prevented him from ever fully admitting the full range of esthetic perception. This he limited at most to the "value segment of culture." He saw this segment as "embodying expressions or sublimations of play" in styles as "systems of coherent ways or patterns of doing certain things."[101] Thus he wrote in 1951 his only essay explicitly about "great art."[102] In it he declared that "the consideration is aesthetic: it is directed at qualities of style," which showed "a sequential drift" among fifteen styles "from grandeur to manners that are less imaginative and much flatter in meaning and feeling" (296), as "patterns."

Meyer Schapiro, reviewing Kroeber's *Style and Civilizations* of 1957,[103] characterized his argument as "circular and no explanation at all" because "all the possibilities in the development of a pattern" are "something that we don't know even after the history of a pattern is written." Schapiro further remarked that "pattern" is ambiguous both in Kroeber's use and in the literature of art, being "both an element that recurs in different fields and the unique structure of the whole of a culture."

Another underlying limit in anthropological views of the nature of esthetics is the denial that esthetic decisions might be external and prior to

"culture" and culturology.[104] It is, however, probable that esthetic choices originate in limbic neurology, while anthropology usually treats art only as part of "cultural" behavior. Anthropologists therefore reject the proposition that art or esthetics could be located outside the "culture" of mankind in free choice, and so escape the domain of "culture." Unlike Boas, who suggested in 1908 that "anthropological phenomena . . . may be at bottom biological and psychological,"[105] Kroeber never defected from the anthropological party line, but the idea of the "superorganic" was his escape from single "culture as the all-inclusive boundary." The "superorganic" is about "values."[106]

Kroeber's writing after 1940 spiraled outward to cover all cultures, from his most closely grained studies on the Indians of California to the "configurations" of all cultural "growths." In the process the study of America lost preeminence. California and Peru yielded to an encyclopedic search for the phenomena and processes of his anthropological concept of culture. But he never examined the esthetic assumptions on which that concept depends, evading them by the substitution of style as a descriptive scheme or index for civilizations.[107] Thus esthetic values safely became end products in the main business of "culture history" rather than initial conditions at the beginning of human time. He saw "culture" as "organic" and "superorganic," not looking behind or under "culture."

HERMANN BEYER (1880–1942) never studied with Seler, but that scholar's published work, which resembles an archipelago of Amerindian worlds in the pre-Columbian past, guided Beyer from his first publication in 1908 until his death in 1942, as a German interned in a camp for enemy aliens at Stringtown in Oklahoma.[108]

Like Seler he was deeply concerned with symbolism in Mesoamerican archaeology and ethnography, as to time and space, the gods, animals, colors, and writing. Alfonso Caso was among his students in Mexico in 1924 until 1927, when Beyer became professor at Tulane University in New Orleans. According to Caso,[109] Beyer probably studied with Karl T. Sapper at Würzburg. He first visited Mexico in 1910 for the 17th International Congress of Americanists, reading papers on Venus periods in the Borgia and Porfirio Diaz manuscripts as well as on images of Huitzilopochtli.[110] He was then already known as a young Mexicanist for his article "Der drache der Mexikaner" (in *Globus* 1908). This study is related to the work by Ernst Siecke which had influenced Seler on ancient Ameri-

can astrology, but it attempts also to find correspondence between mythology and constellations as proposed in 1856 by Max Müller and his followers.[111]

Beyer, who often declared himself an "enemy of fantasy" in historical writing, outpaced even Seler in theories of astronomical symbolism. In an article in *Globus* of 1908 he proposed a "Toltec invention" of a thirteen-part zodiac with Quetzalcoatl as the first sign and Xólotl his twin as the last. Here Beyer claimed that the role of the dog[112] (Xólotl) was intelligible only if the dog stood for a constellation.

These ideas about the "natural origin of Mexican deities," which he retained even in 1924,[113] led him into other disagreements with Seler, as in 1912.[114] He had been concerned before 1909 with astronomical correlates for Mexican mythology,[115] on which his interest continued into the 1920s.

A striking case is in their differing interpretations of the parallel passages from Codex Borgia 18a–21b and Fejérváry-Mayer 26a–29b (fig. 44). Seler had designated the figures of the Borgia pages as different regions of the sky and those of Fejérváry as of a period of fifty-nine days. Beyer, however, noted that in both series every pair included a supernatural facing a mythical personage or emblem. These figures are both large and small, corresponding to greater and lesser powers. Thus the same themes could be seen in each panel of the two series, which he interpreted as oppositions of day and night and/or darkness and wetness.

Seler: Borgia, 18a–21b	*Fejérváry, 26a–29b*
I Tlaloc (raingod) (fig. 47a)	Ilhuicatl (uppersky)
II Tlamanaliztli (offerings)	Tlillan (darkness)
III Tlenamacac (copal priest)	Tonatiuhichan (east sky)
IV Otlatocac (traveler)	Teoquauhtla (west)
V Atlacuic (water bearer) (fig. 47)	Tamoanchan (west sky)
VI Tlatlatacani (digger)	Tlalocan (east)
VII Ollamani (ball player)	Teotlachco (north sky)
VIII Quaquauhani (woodsman)	Anauatl (south)

The languages corresponding to these manuscripts are still uncertain, but Seler took all his terms from Náhuatl (Aztec) dictionaries for the activities and places described in the paintings. Beyer would not accept such *aztequismos,* in the following oppositions, as being present in both manuscripts.

Beyer: Borgia		Fejérváry
I 18a (fig. 47a)		26a LIGHT-dark
II 18b		26b DARK-light
III 19a		27a NIGHT-dusk
IV 19b		28a DUSK-night
V 20a	(fig. 47b) 27b	DRY-wet
VI 20b		29b WET-dry
VII 21a		29a NIGHT-day
VIII 21b		28b DAY-night

Figure 44. Seler's reading of Borgia 18 (*top*) as "night" (*Tlillan*) and of Fejérváry 27 (*bottom*) as the "upper sky" (*Ilhuícatl*) was converted by Beyer into "LIGHT-dark," and "DRY-wet." Seler was guided by Aztec models, while Beyer searched for more directly visual readings that were not confined to one language.

Thus Beyer refused to make both Borgia and Fejérváry into Aztec books, by returning to the pictorial analysis of dominant qualities.

Beyer departed from Seler again in 1910 by denying his identification of Huitzilopochtli in the Fejérváry manuscript in Oaxaca.[116] He also denied Seler in 1910 the naming of the right-hand relief figure, in the basin (fig. 45) on the back of the colossal jaguar in the Museo Nacional, as Tezcatlipoca and substituted Huitzilopochtli because of the solar attributes of the relief.[117]

In 1913 he berated Seler for "allowing an expectancy to deflect interpretation" in the case of a Xólotl helmet in Codex Borgia 27 which Seler had named as the head of a monkey.[118] Beyer's point was that Seler had overlooked or denied many instances of figures that were verbally com-

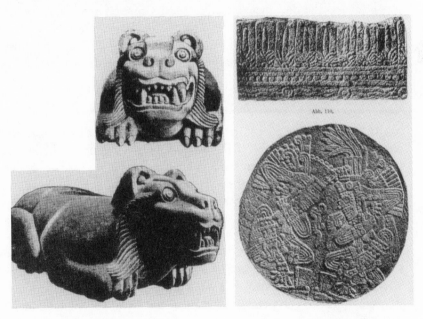

Figure 45. Stone jaguar vessel for blood sacrifices from Tenochtitlán, c. 1500 (*left*) (after Seler, *Gesammelte Abhandlungen* (1904), 2: 901–02 (now Museo Nacional de Antropología). The large cylindrical vessel in the back (*right*) is identified as being for sacrificial blood by the seated deities drawn from their earlobes. But the traditional name of Tezcatlipoca (smoking mirror) is supported by these reliefs only in the "eagle bowl" (*quauhxicalli*) showing that deity's attributes of smoking mirror and missing foot on the left figure.

pounded more than visually. This task was accomplished only in 1964, when Bodo Spranz tabulated all the Borgia figural variants.[119]

Leaving aside the question of the credibility of either interpretation, it appears at once how different are Seler's associations from Beyer's. Seler, like Sahagún, still seeks with every figure or sign to supply or invent its Náhuatl name, without concern for the ethnic origin of the document or object. Having a name, he looks for calendrical meaning and for mythological themes, within Náhuatl language. But Beyer searched for patterns common to documents of varying origin, finding them in diurnal or seasonal contrasts and likenesses, rather than in calendrical and supernatural structures.

In short, Seler drew a curtain of Náhuatl language and concepts between us and the documents. Beyer tried to discover resemblances that emerge directly from the visual evidence rather than from other sources whose relevance is uncertain. It is unlikely that either scholar consciously used the methods of psychoanalysis in their studies as Americanists, as suggested by Carmen Cook de Leonard.[120]

ROBERT H. LOWIE (1883–1957) said in 1924, "I will postulate the esthetic impulse as one of the irreducible components of the human mind, as a potent agency from the very beginnings of human existence."[121] Elsewhere, in 1937 Lowie drew back from this position, by warning that "an ethnographer . . . renounces aesthetic impressions except as a by-product."[122] This expression, *aesthetic impressions,* suggests that Lowie knew the works at Columbia College of Henry Rutgers Marshall,[123] where physiology, psychology, and neurology were being related to esthetics as written since Alexander Baumgarten before 1750. Lowie himself understood esthetics "from below" and before culture, both by insight and early exposure in Austria as a child and in New York after 1893 among highly educated, German-speaking Americans. But he wrote little on esthetics as such.[124] Lowie never developed this theme farther, nor did other American social scientists.

Lowie reviewed Hjalmar Stolpe's *Collected Essays in Ornamental Art* (Stockholm, 1927), rejecting as untenable his view that "all ornamentation must have a deeper significance than its ostensible aesthetic one" (7, 92).[125] In this respect Lowie expressed a view favorable to the "self-referential" character of mathematics, music, and visual art,[126] perhaps reflecting the thought of Bertrand Russell in *Principia mathematica* (1910).

SYLVANUS GRISWOLD MORLEY (1883–1948). For Morley, as for other Mayanists of his day, such as A. V. Kidder, the first interest had been Egypt.[127] Turning to Maya studies at Harvard under the influence of Professor Putnam and Alfred M. Tozzer, Morley became an explorer and epigrapher.[128] As explorer he was among the last of a long line from Alexander von Humboldt to A. P. Maudslay, coming, like Maudslay, to the glyphic texts, of which he compiled the corpus (1937–38). His last book, *The Ancient Maya*,[129] has been a standard reference during four decades. Its organization in 1946, however, resembles that of a series by Edgar Lee Hewitt in New Mexico at the School of American Research on ancient Amerindian life, published as *Handbooks of Archaeological History*. The first was *Ancient Life in the American Southwest*, followed by *Ancient Life in Mexico and Central America*[130] in 1936, and *Pajarito Plateau and Its Ancient People*,[131] in which Hewitt published his excavations at Tyuonyi, Puye, and the Rito de los Frijoles as if to accompany Bandelier's *Delight Makers* of 1890.[132] "The Ancients are there. The Trues are always near. Could anyone ask more of life? You, too, can quietly dream yourself into unity with this immutable universe." This romantic approach to archaeology was also Morley's in his lifework. The topics of *Ancient Maya*, like Hewitt's *Handbooks*, give Morley's appraisal of Maya civilization as based on maize under a conception of history being a return to prior events ruled by a fateful calendar ordaining repetition every four centuries. Morley's "quiet dream" was of "50 Maya Superlatives," from "oldest city" to "most beautiful" objects and "latest" events and objects.[133]

To account for change, however, Morley defined five stages: (1) control of fire, (2) invention of agriculture, (3) domestication of animals, (4) tools of metal, and (5) the wheel, but he denied the Maya the last three in his conception of "Old Empire" history from A.D. 337 to 889 as dated by the list of inscriptions he compiled.[134]

In this work, he provided separate periodizations, one for Maya history and another for epigraphic style, as follows:

Old Empire History	Epigraphic Style
337–633 Early Period	320–534 First Stylistic Period
633–731 Middle Period	485–835 Second Stylistic Period
731–889 Great Period	849–889 Third Stylistic Period

The division of Maya history was according to the "epigraphic and architectural material." An Early Period (c. A.D. 337–633, or c. 8.15.0.0.0–

9.10.0.0.0) marked the spread of Maya civilization from the Petén to "all parts of the Maya area" (4:325 [1938]). A Middle Period (c. A.D. 633–731, or 9.10.0.0.0–9.15.0.0.0) embraced a "more intensive occupation . . . by the growth of the older centers" and the "appearance of new sites in the monument-erecting confraternity all over the same general region." The Great Period or Golden Age spanned the period between A.D. 731 and 889 (9.15.0.0.0–10.3.0.0.0). The Old Empire structure collapsed after A.D. 790, and monumental activity ceased by A.D. 889.

As to the "stylistic development of Old Empire sculpture," Morley (like Spinden) was more interested in establishing criteria for early inscriptions than in factoring out the elements of middle or late epigraphic styles (4: 296–306). In what he called a "logical stylistic development throughout the course of the Old Empire" (4:303), Morley divided early from late glyphs as simple followed by elaborate forms, varying as to low or high relief and as to irregular or rectangular outline, with or without interior enrichment. For glyphic style, he used a three-part periodization.

Morley's conclusions (4:296–303) describe the spread of an ornate sculptural style without establishing its characteristics or its regional variations, leaving the reader in uncertainty about the differences separating the second period from its neighbors. Yet Morley struggled with these problems at various places.

Morley's appraisals (4:151) of the quality of carving are firmly stated opinions about superlative or unique attributes. Thus he regarded Stelae F and D at Quiriguá as "the finest" in the Maya area, with D "a shade the finer" (139). Stela E he had believed to be "slightly inferior," and he placed the sculptural apogee at Quiriguá between 9.16.10.0.0 and 9.16.15.0.0, falling off with Stela E in 9.17. Finally he placed Zoomorph B (9.18.0.0.0 ± 2) as having glyphs that are "the most ornate, the most involved, the most complicated . . . the ultimate expression of glyphic intricacy, never achieved before, never equaled again" (169), and he also regarded Zoomorph P and the altar of Zoomorph O as "among the greatest masterpieces of ancient Maya art" (196). The topic may have drawn his attention only late during the writing of *The Inscriptions of Petén*, as when he made special mention of differences between the early and late styles of Naranjo. There the reused door lintel (2:39) of A.D. 633 presented a problem: the glyphic style was neither late nor early by Morley's criteria. Yet it coincided with the opening of Morley's middle period of Old Empire history.

Writing about Naranjo, Morley codified more clearly than elsewhere

his ideas about early and late glyphic form, but it did not occur to him to consider a middle stylistic period that would resolve the difficulties with his chosen binary system of early and late styles. It would also have reduced the excessive lengths of the first and second stylistic periods.

In the brief third and final stylistic period the number of inscriptions diminished rapidly, offering less quality, quantity, and subject matter (4: 303) than before. Morley noted a return to simple, flat glyphs, still rectangular but with diminished interior decoration, and of "inferior execution" from central Chiapas to northeastern Yucatán after A.D. 850.

The third edition of *Ancient Maya* was prepared by G. W. Brainerd, who died before it was finished. His assistant, Betty Bell, rewrote the final chapter, bringing it more into line with the opinions of anthropologists in 1956. Following Brainerd's plans, she deleted most of the 1946 "Appraisal" which originally ended the book and substituted a summary of the unsolved riddles as Brainerd and Bell saw them:[135] (1) being rated as a "high civilization," how can the Maya have escaped "characteristics necessary for the development of a complex society"? (2) Classic-stage decline "must be sought within the society itself," (3) as "the result of some hidden but long-enduring weakness in the society."[136] Bell concludes by agreeing with Morley that the Maya "must surely emerge for dispassionate comparison among the great world cultures."[137]

The fourth edition, rewritten by Robert J. Sharer (1983), contains two new chapters by him ("Demise of the Classic Maya" and "Trade and External Contacts"), topics to which Morley had given little attention. The "Appraisal" chapter was replaced by Sharer's "Future Prospects for Maya Research."[138]

MANUEL GAMIO (1883–1960). The Mexican agrarian revolution found an eloquent voice in 1916 when this anthropological archaeologist, who studied at Columbia University with Franz Boas from 1909 to 1911, wrote *Forjando patria* (Forging a nation).[139]

Justino Fernandez commented on the "humanistic aims" of Gamio, whose "esthetic sense" he regarded as being that of a scientist for the "improvement of indigenous people" by the fusion of races, converging cultural manifestations, linguistic unification, and economic equilibrium. Both art and literature were needed to express national ideals, with an awareness of ancient sources through archaeology and ethnology.[140]

Born in Mexico City, Gamio left his studies at the Escuela de Minería after 1903 to live for two years on a rural property at Zongólica belonging to his family, among Indian peasants from whom he learned Náhuatl language as well as their underprivileged way of life before 1906. Ill with malaria, he returned to the capital to study in the Museo Nacional with Nicolás León and Jesús Galindo y Villa in their courses on archaeology, ethnology, and anthropology. Later in 1908 he was commissioned to excavate at Chalchihuites in Zacatecas.

Impressed by his published reports, Zelia Nuttall recommended him for a scholarship at Columbia University, where he also accompanied Marshall Saville to Ecuador in 1910. Returning to Mexico City in 1911, he joined the Escuela Internacional de Arqueología y Etnografía Americanas, where Eduard Seler, Franz Boas, Jorge Engerrand, and Alfred Tozzer were the directors. In 1911 Seler and Gamio told Boas of the deep deposits of pottery in strata at Atzcapotzalco, and Gamio[141] excavated as a student of the school at Atzcapotzalco and at San Miguel Amantla in the Valley of Mexico during 1912.[142] In effect he determined the first-known stratigraphic sequence (fig. 46) of early remains of those peoples.

In 1917 he succeeded in establishing under the Ministry of Agriculture the first governmental *Dirección* [Department] *de Antropología* in Latin America.[143] He resumed archaeological work in 1922 with a concept he had developed in 1916, of studying the entire ecology of native groups in order to improve their miserable conditions. Otherwise "governments must fail because of their own ignorance and the legitimate protests of the population in continuous revolutions."[144] This areal approach by Gamio anticipated in part that of others, such as Willey in Virú valley and Mac-Neish in Tehuacán a generation later.[145]

ALFRED VINCENT KIDDER (1885–1963) was appointed in 1926 to direct the Division of Historical Research at Carnegie Institution in Washington and Cambridge. It functioned until 1958 as the "perfect laboratory" for research in human relations and culture. But it was then criticized as having "contributed little material useful to anthropology." Robert Wauchope answered this charge in a review in 1951: "The kindest explanation is that synthesis and interpretation have only recently become possible."[146]

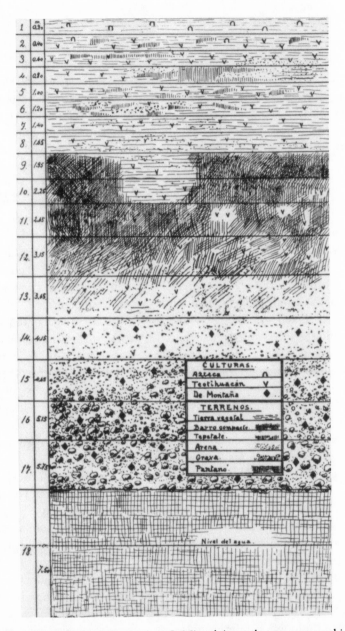

Figure 46. Manuel Gamio's test pit at S. Miguel Amantla was excavated in 1910 during six months. The pit was 25 m², revealing eighteen strata varying from 20 cm at surface to 1m75 at the bottom. The Teotihuacano layers began under Aztec sherds at 40 cm to 4m15 depth, there overlying the layer called *montaña*. The sherds were weighed by layers: those from Teotihuacano layers (3–14) weighed the most, then the *montaña* or pre-Classic layer (14–17), while the Aztec remains were the fewest (layers 1–2). (after Gamio (1913), 187)

Thus Kidder's generation and their students, followers, and critics mark the beginning of the separation of archaeology as history, from its primary consideration as art (as with W. H. Holmes), in the expanding merger of archaeology into environmental and anthropological sciences. At the same time, however, Kidder was recognized as "deeply humanist in outlook" by G. Willey,[147] who refers to Kidder's "aversion to the idea that human culture, being a fabric of the actions and belief of men, could be understood in accordance with any rigid doctrine or scheme." Many humanists today like Kidder, caught between history and science, are neither artists nor scientists but consumers of archaeology in their positions as historians of art.

During Kidder's education at Harvard, he was just such a consumer of archaeology, ingesting chronology, including stratigraphic theory and trade relations, with the Egyptologist G. A. Reisner. He also studied with Franz Boas as well as George Chase on Greek vase painting.[148] Kidder "definitely linked archaeology with history" in 1926 as being "to recover and to interpret the story of man's past."[149] These self-imposed limitations were modest, like the man, whose work was attacked in 1940 by C. Kluckhohn and in 1948 by W. W. Taylor, after Kidder had been head of Carnegie Institution's Division of Historical Research for twenty-two years. Kidder had already organized studies in 1929 on a "pan-scientific" front,[150] including physical anthropology, medicine, social anthropology, and ethnology as well as linguistics, archival research, and environmental studies in plant and animal biology and physical sciences.

When Vannevar Bush, a physicist, became president of Carnegie Institution of Washington (1939–55), he had different aims from J. C. Merriam's (1921–38) in 1929, who had appointed Kidder. Thus the division was closed down in 1958, as having been an unviable administrative grouping of humanistic studies that comprised history of science, United States history, and history of Greek thought.[151]

Kidder's own works and his associates' are still a monument to his chairmanship of the Division of Historical Research, and they are indispensable to Americanist studies everywhere. Yet their importance bred discontent among local anthropologists and archaeologists who felt excluded by the division's concentration on Maya studies.[152] Kluckhohn called them "antiquarians" without "methodological and historical development," and Taylor attacked Kidder as failing in "cultural synthesis" and "cultural process," without "historiography or cultural anthropology" (47–48). Kidder answered in his final annual report before retiring that the

"pan-scientific" program of 1929 was "made to cover too great a range of time and too extensive an area."[153]

Kidder's defenders are many[154] and still growing in number. In the words of Wauchope, Kidder was at his best with "synthesis of cultural history, of broad developmental trends, of general life patterns, of foreign relationships," but not interested in "anthropology's concern with specific culture processes and specific cultural dynamics" enough to "investigate them empirically and in depth himself."[155]

Since 1967, the "New Archaeology" has emerged, to insist that the archaeological record "contains no facts" without a theory "which links statics with dynamics" in order to reconstruct "past lifeways, understand past cultural processes, and write culture histories of the past" (Sabloff et al., "Understanding the 'New Archaeology,'" *Antiquity* 61 [1987]: 203–209).

ALFONSO CASO Y ANDRADE (1896–1975). Best known as an archaeologist and university and museum administrator, Caso's first published work was an abstract of his *Ensayo de una clasificación de las artes*[156] when he was twenty-one. It reflects the influence of his brother Antonio, whose philosophical writings are as well known as Alfonso's archaeological books and papers. The abstract defines all esthetic intuition as "disinterested." From this proposition by Kant,[157] Caso divides the arts as those of sight and hearing, and he qualifies disinterest as an ethical criterion. The arts are classed in relation to the motions they suggest. The arts known by sight are architecture and ornament. Those representing motion are sculpture[158] and painting. Those known by the hearing of motion are poetry and music. Those known both by sight and hearing are drama and dance.

Caso began his imposing achievements as a lawyer and teacher who first came to the formal study of Mesoamerican antiquity with Hermann Beyer at the University of Mexico in 1924, studying with him until Beyer moved to Tulane in 1927. Thus Caso's Americanist studies can be linked with Seler's, although Caso never knew Seler (whose last appearance in Mexico was in 1911) but used his studies while working with Beyer. Caso's thesis in law school during 1919 was entitled "Qué es el derecho?"[159] and in 1920 his first public service was to assist in the "Proyecto sobre organización bancaria" under the secretary of the treasury.[160]

In 1919 Caso turned his full attention to anthropological archaeology

as professor at the university and in the Museo Nacional. His first book was in 1927, about a stone model of an Aztec temple, the size of a throne,[161] discovered in the foundations of the National Palace. His study combines comparative visual analysis with Náhuatl texts as in the method of Seler[162] and with the precision of Beyer, establishing Caso firmly in their academic lineage. By 1931 Caso was prepared to excavate for the Museo Nacional at Monte Albán in Oaxaca, as director until 1943, making a sensational discovery in Tomb 7 of Zapotec construction but later reused for Mixtec treasure.[163]

Caso's later scholarly work was mainly on Mesoamerican calendars and Mixtec genealogies,[164] the two subjects being related in the search for native history. Caso's initial discovery here was a copy of a Mixtec genealogy for Teozacoalco in Oaxaca, listing, as Caso believed, twenty-two generations of local rulers with their marriages and offspring in a sequence spanning eight centuries.[165] This key allowed him to attempt a genealogical history of Mixtec rulership based upon a large group of native manuscripts incorporating pre-Conquest data.

From beginning to end Caso's career was in government, as a lawyer and in various ministries after the Mexican Revolution. His part in the program to improve the conditions of native life among the Indian peoples of Mexico was within the *indigenista* movement, of which he long remained a leader after his fieldwork ended in Oaxaca.[166] His associates in archaeology were Mexican more than foreign, and his interests in archaeology, genealogy, and ancient religion[167] were all national and indigenous in political purpose.[168] His predecessors were Seler and Beyer as to iconography, but he was more indebted to Beyer than to Seler, whose conclusions he questioned. His own "final purpose" (to quote his thesis of 1917)[169] was probably the making, in postrevolutionary Mexico, of an environment more favorable to its indigenous peoples than under any preceding government.

JOHN ERIC SIDNEY THOMPSON (1898–1975) gave few signs of esthetic concern in his life or among two-hundred books and articles he published.[170] Yet one article[171] by him gives a clue to his governing lifelong attitude as a Mayanist. Among ethnographers and archaeologists he was in close agreement with the work of Dr. Morris Steggerda,[172] who had persuaded them and the missionaries working among the Yucatec Maya "to rate" the Maya scientifically "on certain psychological traits." Thomp-

son's digest of Steggerda's book is in close agreement: he concludes that modern Maya "upbringing, the practice of self-restraint, cooperative work, and the inculcation of the spirit of moderation produced a tranquil Maya character which was introvert, but of a disciplined rather than an individualistic nature" and that "the Maya character before the Spanish conquest was essentially the same. . . . That it was the same twelve centuries ago is the assumption I must make," favored by "the tranquility, the conservatism, and the orderliness of Maya art of the Classic Period."[173] In this he too reflects the irenic posture of his archaeological predecessors from Maudslay to Kidder.

This argument was widely shared among Maya scholars until 1959, when it was recognized as "upstreaming," or assuming that present-day ethnology can be projected intact into the past as explanation of archaeological behavior. But in Thompson's case the upstreaming was as close to an esthetic recognition of Maya art as he could come, being confined to the scientific programing of his generation and dedicating all his effort more to calendar and epigraphy than to esthetic questions. The murals of Bonampak were the test case: Thompson and Proskouriakoff first published them in detail[174] without treating their violent scenes as of central interest. This irenic interpretation was accepted as truth until the work of M. E. Miller.[175]

But whether irenic or violent, either interpretation partakes of esthetic decisions needing historiographic measure. Their finality is never attained, as Octavio Paz has seen. In the case of the Maya, "one generalization has been replaced with another."[176] For Thompson, works of art were to be used as sources of information, but he never saw them as expressive realities that can escape "culture" by going outside its confines, in acts of esthetic invention[177] as old or older than humanity.

The recent revisionist posture of the Maya as being more cruel than peaceful is called a revolution by M. Miller and S. Houston,[178] but it may more accurately be called at best an advance. No new state of knowledge is present, the thesis having been anticipated even before Teobert Maler in 1900 and as long ago as the anti-American voices of the Enlightenment in the eighteenth century.

GEORGE CLAPP VAILLANT (1901–1945). Vaillant's brief and widely active life was divided between field archaeology and museum service. He used art history to convey the content of his excavations to a

large reading public in the many editions and translations of *Artists and Craftsmen in Ancient Central America,* and *Aztecs of Mexico: Origin, Rise and Fall of the Aztec nation.*[179] The period of his fieldwork in Mexico and Central America was from 1928 to 1940. Thereafter he was more engaged in museum administration, and in cultural relations during the war until his death.[180] Other widely read books by him are *Indian Arts in North America,* (New York: Harper, 1939, reissued in 1973) and *Masterpieces of Primitive Sculpture* (New York, reprinted from *Natural History* 43, no. 5 [1939]).

Vaillant's thinking about the place of the history of art in ancient America is clear from the chaptering of *Aztecs of Mexico.* The first six chapters explain the history (archaeological and textual) of the Valley of Mexico. The last four explain Aztec actions at the time of Spanish conquest. In between, chapters 7–11 are graduated from economy and craftsmanship through the "fine arts" (9) to religion and ritual (10–11). Thus the arts occupy a central position between subsistence and cult, but he points out that Náhuatl language had no term for "fine arts": "they recognized the value of superior workmanship and used its products to honor the gods,"[181] their art being "no different from the great traditions ancestral to our modern aesthetic."

Vaillant's work still depended on the "pottery yardstick" for relative chronology in the absence of any absolute earth clock such as Willard Libby's radiocarbon chronology would provide in the later 1940s.[182] But Vaillant used stratigraphy and formal variations among styles of human and animal figurines of baked clay (fig. 47) to seriate changes in a relative chronology fitting together the phases of Indian history during sixteen hundred years in Central Mexico.[183]

His conclusions were like those of art historians: "The plastic art of this Lower Middle Culture passed from a period of convention to one of experiment and then settled back to convention again. Contact with a foreign source of inspiration brought in a new manner of presentation . . . such rhythms appear over and over again in art history."[184]

A. V. Kidder, who taught Vaillant at Harvard and in the field at Pecos, New Mexico, wrote in an obituary of Vaillant how he "pioneered" the idea of Olmec culture, by studying museum collections, in which "baby-faced" figurines from Mexico appeared. When his wife excavated them at Gualupita (Morelos), "he pointed out their importance as indicators of a hitherto unidentified complex, and his prophecy that a center for their distribution would be found in Veracruz has since been proved correct."[185]

When he lectured at Yale in 1940 on the archaeology of Middle Amer-

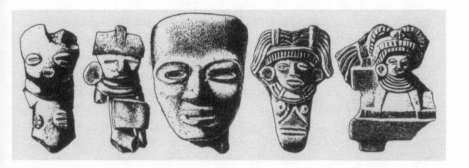

Figure 47. Teotihuacán figurines, periods I–V. Vaillant was among the last archaeologists who still named Teotihuacán as a Toltec center in 1941. His own contribution had been to excavate and seriate the remains of peoples preceding the immense urban achievements of the builders of Teotihuacán, whose efforts began about A.D. 100, ending about six or seven centuries later. Vaillant was using the language of those early students of the texts who ascribed large cities to Toltecs. He was also relying upon stratigraphy unaided, since he was working before the era of radiocarbon dating, which began about 1950. In effect he reverted in 1941 to nineteenth-century terminology. (After Vaillant [1941], fig. 51)

ica, as it then still was called,[186] he complained that every excavation was becoming a new culture, and he expressed his hope that such verbal inventions would become unnecessary with a chronology exact enough to allow correlations among archaeological sites by "horizons,"[187] in an areal ordering of space and time. His view reconciled anthropological archaeology and art history in 1941, and it still guides many who enter both fields of study.

WENDELL CLARK BENNETT (1905–1953). *Andean Culture History*[188] is mostly the work of Bennett, who wrote on environment, people, and subsistence, followed by archaeological history. Bird closed with techniques, mostly on textiles. The text was ready for publication in July 1947 as a museum handbook, appearing in 1949. Widely used in university teaching as an introductory text, it summarized the discoveries in field archaeology by both authors. A chronological chart groups six "styles" (defined by their pottery) in six regions of the central Andes. The

dates were "relative, not absolute," being guesses made before the appearance of radiocarbon chronology, based on "depth of the refuse deposits." A century was thought to be reflected in one meter of coastal refuse and in one-half meter in the highland. Coordinating the archaeology, Bennett devised eight names for the divisions of time indicated by pottery and other remains in Andean refuse. These names were intended to describe in one expression all cultural activity in an area during a period, on the analogy of the historic "styles" of European art: I Hunters and Early Farmers, II Cultists, III Experimenters, IV Master Craftsmen, V City Builders, VI Expansionists, VII Imperialists, VIII Conquest. I–V refer to "functional-developmental" classification: I–II "characterize subsistence technology" 3000–1000 B.C.; III relates to the neolithic early agriculture and arts, 1000 B.C.–0; IV–V to the development of craft technologies (0– 1000). The later periods, VI (1000–1200) and VII (1450–1532), refer to sociopolitical events.[189]

Andean Culture History, however, omits mention of a topic then (1947) preoccupying Bennett. It was to replace Wissler's "culture area" concept,[190] as of "limited applicability to archaeology" and being "too inclusive" and "too static in time." Another concept of "cultural *continuum* in an area," to be called "area co-tradition,"[191] was given Ralph Linton's term. Bennett proposed nine for the hemisphere: Peru, Ecuador, West Indies and Venezuela, Patagonia, Honduras to Zacatecas, southwest and southeast United States, northwest Coast and Alaska. But "co-tradition" is much like the art historian's use since the 1840s of "historic styles" as recognizable markers of cultural continuity. Today, recent critiques of the concept of style[192] are echoed in the disappearance of "co-tradition" from archaeological diction since 1950.

Other Andeanists led by John Rowe now use a triple-horizon scheme sandwiched between Intermediate layers: Late Horizon (Inca), Late Intermediate, Middle Horizon, Early Intermediate, Early Horizon, Initial, Preceramic. Their aim is to achieve a "value-free" chronology, although the term "Horizon" remains value-ridden,[193] as "unity" alternating with "disunity."

The extent to which Bennett was aware of this bipolarity of values in his archaeological work appears in his last major article on the subject,[194] where he failed to find "cultural uniformity" in the Titicaca Basin, but "local diversity" appeared in its seven "sub-areas" and in six periods spanning A.D. 900–1500.

Epilogue

FROM DISCOVERY till now, both delight and horror have been complementary esthetic responses to the arts and customs of Amerindian peoples, from the *Décadas* of Peter Martyr to the *Blood of Kings* by Linda Schele and Mary Miller. Yet neither delight nor horror is an adequate description of esthetic content. Put into context they begin to outline the continuum of esthetics. Given the human condition, this continuum embraces all possible experience and emotion.

The persons in this study compose its subject, by disclosing the different grids through which Amerindia has been viewed since Discovery. The panorama consists of points of view, from poetic insights to statistical tables. The composition of each grid or screen is as complex as the number of persons chosen for inclusion. Some are so much alike that one writer can represent a group; others are unique. Not all share in the idea of America.

The biographical focus is meant to serve as a scanner sensitive to esthetic condition. Unlike scanning for minute traces, it operates in a poorly mapped part of cognition, traditionally guessed to be one-third of awareness but perhaps suffusing the entire spectrum of mind as esthetic perception.

The historiographic intent of these biographic notices is assured by a suspension of belief in the conclusions of the authors who are their subject. The notices are culled from many fields as essential clues to esthetic concern in the past five hundred years about art among Amerindian peoples. The need for such concern does not diminish as knowledge increases. That increase will include more esthetic content than now, if only to acknowl-

edge the nature of cognition itself, as being about quality as much as about quantity.

Esthetics "from above" and "below" persist today in the complementary relation of art history and social science. Their explanatory methods pursue convergent and uncontradictory aims.[1] But the position here is that the indefinite backward extension of human art to hominid levels over a million years ago has the effect of bringing esthetics closer to being a cause of cultural variety, rather than being merely an external effect (p. 20). Such an assumption leads one to think that esthetic choices were internal "engines of change" from the remotest ages of humanity.

The phrase *engines of change* presupposes an acceptance of causation in history, by assigning to esthetic preferences and repulsions a causal function that has not been previously discussed among philosophers and scientists. Thus Mario Bunge[2] writes that early causal categories cannot "today account for the whole variety of types of determination . . . by scientific research and by philosophical reflections upon it." Yet E. R. Wallace finds from his psychoanalytic work that "causation in history is relevant" to psychic causality, although no mention is made of esthetic causation in his review of theories of causation in history.[3] The topic of esthetic causation may therefore have more future than it had in the past.

Ignacio Bernal says in a postscript[4] that his "was the first generation in Mexico to have the chance to pursue professional studies in archaeology. . . . Even between 1900 and 1940, everyone—with the exception of those who had studied abroad—was devoting his time to what was more or less self-taught. There was no such thing as a training structure." He goes on to say in the last sentence of the book that "happenings, finds, excavations, studies that we regard as absorbing today may seem at some future date to have been not so important after all."

And Carlos Fuentes, also Mexican, now says, "The writer must write knowing that the reader knows something the writer and his editor do not. He [the reader] knows the future, he will be there when we are gone."[5] As Bernal says, the archaeologists' state of doubt may increase as to the abiding value of their efforts.

The excavators work in the past, while humane scholars face a future that springs from the present. Their meeting is beyond the constraints of science. Human studies are guided by the whole of experience, both actual and possible. For archaeological and humane studies the future is now only in the present. Their yields will vary as their cognitive limits extend to

esthetic questions and beyond them to others still to be asked when their need becomes known.

Historiography

The historiographic problem presented by ancient America lies in the difference between the general history of mankind since Darwin and the distinctly shaped histories of the New World peoples. The multiplicity of tribal histories—North, Central, and South American—breaks apart the sidereal time they all shared, into separate mythological traditions.[6] Yet no evidence denies the historical connectedness of the arts of ancient America after glaciation, and none affirms enduring unity with the Old World before Columbus.

At all points, however, archaeological science, being modern, remains external to its subject. But esthetic choices were always engines of change in America as in Europe, from the remotest ages of humanity there, in a search for the "form of the forms" of perceived reality.

Of that search, various expressions in historical studies have come and gone in the twentieth century, being remembered more in historiography than in history. In the first third of this century "functionalism" was proclaimed as a program of reform for architectural design.[7] But this word took a different meaning from social studies, where "fixed patterns of relationship" among "social forces" were sought, as in Bronislaw Malinowski's cultural anthropology. In literary studies, on the other hand, the preferred term was "structuralism," meaning "patterned relation" among texts, sometimes as "central metaphor" affecting many seemingly unrelated events.[8]

At this time after the 1930s the history of art was occupied with iconology, defined by Erwin Panofsky as "the study of cultural symbols." Since then semiology (in Europe, or semiotics in America) has attracted attention as a "science of signs," of which language is only a part. Today at the end of the century, an even wider "hermeneutic" field considers the problems of interpreting signs of all kinds in historical perspective and in the "productive, receptive, and communicative modes."[9]

What have so many observers "recognized," each guided by different aims during five hundred years? The ideas of each obliterate one another in succession, being discarded as incomplete or inadequate. But the residue across time is a tangle, suggesting an approach to the recovery of previously

unknown entities. Recognition occurs in time, subjected to repulsion and attraction, being itself an esthetic action, in a continuing assessment of the present that varies among observers who themselves are in change.

To change the query: What remains to be recognized in the perception of America as a hemispheric unity from pole to pole and ocean to ocean? We are not in the eighteenth century of the America-hating philosophes of the Enlightenment. America now is part of every issue; no solution is acceptable to all its peoples: it is still a "new" part of the world, long hidden from view but historically as old as humanity. At present, however, the eighteenth-century fears and loathing of America remain renewed daily by news from America to a world in fright.

The history of art about 1840 was the locus in both Old and New worlds of the esthetic recognition of an Amerindian antiquity. Kugler and Stephens first proposed that Amerindian arts before Discovery were historically unrelated to any in the Old World, and that these arts should be studied in their own forms and values.

After 1840 American archaeology, which now is more "North American" than Amerindian as to cognition, has drifted further into the closed world of evaluations that are "made in USA," to use the peninsular Spanish expression for distinguishing USA from "America" as all of Latin America. Even European scholars, writing on the native American past before Discovery, are under the spell of the archaeology "made in USA,"[10] as are the North American specialists, including Canadians.

This mirroring of an inert past in the changing eye of the present was first enriched, however, by historians of art in the early nineteenth century, with an accelerated exchange between them and anthropological archaeologists after 1880, which continues to the present.

Art historians like Spinden in 1909 translated anthropology. The reverse—anthropologists translating art history into social science—has occurred since the 1920s, beginning with Franz Boas. Today the boundary between anthropology and art history is more permeable than their present separation in university departments would suggest. Future development may draw their work more together, with redefinition by fields of interest shared among several disciplines.

Today many clues point to the need for a field theory to cover the multiplicity of Amerindian cultural existences. The many migrations of paleolithic bands ended with the closing of the western hemisphere after the melting of glaciers and ice caps. But many previous social identities

persist today. Their present residues disappear rapidly, and every shred thereby becomes more valuable in the search for the whole history of humanity from earliest animal awareness and thought.[11]

The indefinite extension backward of human art to hominid levels over a million years ago has the effect of bringing art closer to mind as a condition of cultural variety, rather than being merely among its external effects. Such a conclusion leads one to think that esthetic choices were among the "engines of change" since the remotest ages of humanity if only as ways to distinguish future from present conditions: such as inventing easier new ways of avoiding a disagreeable and dangerous present technology of wasting and destroying this world.

Notes

Preface

1. *La disputá del nuovo mondo: Storia di una polemica 1750–1900* (Milan and Naples 1955).
2. G. Kubler, *The Art and Architecture of Ancient America*, 3d ed. ([1962] New York, 1984), 41–42.
3. Ibid., 41.

Introduction

1. G. Willey and J. Sabloff, *A History of American Archaeology* (London, 1974), 40: "As of 1840, American archaeology as a scholarly entity simply did not exist."
2. M. León-Portilla, *Toltecáyotl, aspectos de la cultura náhuatl* (Mexico, 1980).
3. Alfredo López Austin, *Hombre Dios: Religión y política en el mundo náhuatl* (Mexico, 1972).
4. A recent appreciation of Kugler's *Handbuch* appears in Udo Kultermann, *Geschichte der Kunstgeschichte* (Vienna, 1966), 165–69, but without remarks on his American contribution. Earlier than Kugler's *Handbuch* is the work by J. D. von Braunschweig (*Über die alt-americanischen Denkmäler* [Berlin, 1840]). Kugler referred to its illustrations, but he rejected by silence its diffusionist theories, which defended Asiatic, Indic, Polynesian, Pacific, Japanese-Korean, Buddhist, and African components, prefiguring the neodiffusionists of this century and recalling Gregorio Garcia's *Origen de los indios* (Valencia, 1607).
5. Willey and Sabloff, *History*, 18, 88–130. F. T. Kugler, *Handbuch der Kunstgeschichte* (Stuttgart, 1841–42); 2d ed., rev. Jakob Burckhardt (Stuttgart, 1847); 3d ed., rewritten by Kugler (Stuttgart, 1856), with eight illustrations of American works. An atlas of engraved plates, edited by A. Voit (*Denkmäler der*

Kunst [Stuttgart, 1851–56]), also appeared in New York (n.d.) in two volumes as *Monuments of Art,* using portions of Kugler's text on ancient America with W. Lübke's name.

6. F. de A. Ixtlilxóchitl, *Obras históricas,* ed. E. O'Gorman (Mexico, 1975), 2:137.

7. Ibid., 1:9 (estudio introductorio).

8. C. Dibble, *Codice Xólotl* (Mexico, 1951). The post-Conquest original is in the Bibliothèque Nationale, Paris.

9. Other pictorial histories among his native sources were the Mapas of Tepechpan, Tlotzín, and Quinatzín. O'Gorman, *Obras,* 1:85 (introduction).

10. E. O'Gorman, ed., *Nezahualcóyotl Acolmiztli (1402–1472)* (Mexico, 1972), 12. O'Gorman here regards Fernando as a *castizo,* with three Spanish grandparents and one Indian.

11. Hernán Cortés, *Letters from Mexico,* trans. A. R. Pagden (New York, 1963). J. Fernandez, *Coatlicue* (Mexico, 1954), 56–62; Ramón Iglesia, *Cronistas, el ciclo de Hernán Cortés* (1942), 17–69. L. Villoro, *Indigenismo* (Mexico, 1950), 17–22.

12. *Letters,* 85; G. Baudot, *Utopie et historie au Mexique* (Toulouse, 1977), 9–10.

13. *Letters,* 360–61.

14. A. Maravall, "La Utopia político-religiosa de los Franciscanos en Nueva España," *Estudios Americanos* 1 (1949):199–227.

15. Ibid.

16. P. Henriquez Ureña, *Siete ensayos en busca de nuestra expresión* (Buenos Aires, 1928) (trans. in B. Keen, *Aztec Image,* 60).

17. J. Phelan, *The Millennial Kingdom of the Franciscans in the New World* (Berkeley, 1956), chap. 3, "Hernán Cortés, the Moses of the New World," citing Mendieta, *Historia,* 13–15.

18. Letter to the emperor, opposing Bartolomé de Las Casas (20.xi.1555), analyzed by Baudot, *Utopie,* 300, 309–17.

19. *Apologética historia sumaria,* ed. E. O'Gorman (Mexico, 1967), 654. Chapters 61–65 discuss the manufactures of laborers and artisans.

20. By the president of the Audiencia, Ramírez de Fuenleal (Mendieta, *Historia,* 1870, 73). The commission prefigures that from Madrid of Guillermo Dupaix nearly four centuries later (p. 92).

21. *Memoriales,* ed. E. O'Gorman (Mexico, 1971), 248 (composed 1531–43).

22. Baudot (*Utopie,* 470) transposes Phelan's "millennial kingdom" from Mendieta's generation (1524–1604) to Motolinia's.

23. Mendieta, *Historia,* chaps. 18, 65.

24. *Memoriales,* 62–83 (written as of 1535–36); E. J. Palacios (*Tenayuca* [Mexico, 1935]), proved seven rebuildings by excavation.

25. *Memoriales,* 235–44.

26. The illustrations collected by Durán are discussed by D. Robertson, in the edition translated and edited by F. Horcasitas and D. Heyden as *Book of the Gods and Rites and the Ancient Calendar* (Norman, 1971), xxi–xxiii.

27. *Monarquía indiana,* ed. M. León-Portilla (Mexico, 1964), 1:xiii–xx.

28. Torquemada's method owes much to J. Román (c. 1536–c. 1597). His *Repúblicas del mundo* (1575) is a comparative study of non-Christian peoples.

29. Antonello Gerbi, *La disputa del nuevo mundo*, (Mexico, 1960) (first published in Italian [Milan, 1955]).

30. Gerbi, *Disputá*, 56–58.

31. F. J. Clavigero, *Historia antigua de Mexico* (Mexico, 1945) (1st ed. Cesena, 1780–81). J. G. von Herder, *Outlines of a Philosophy of the History of Man* (1784), trans. T. Churchill (1799; repr. New York, 1966).

32. G.-L. Buffon, *Histoire naturelle*, Vol. 3 (1749): see O. E. Fellows (*Buffon* [1972], 142), on Buffon's "esthetic absolutes" and unawareness of "cultural relativity."

33. Gerbi, *Disputá*, 139–41.

34. *Recherches philosophiques sur les Américains* (Berlin, 1768), 1:4–12.

35. *Histoire philosophique et politique des établissements et du commerce dans les deux Indes* (Amsterdam, 1770). Over seventy editions in twelve languages in twenty years (Keen, *Aztec Image*, 263).

36. *History of America* (London, 1777); R. A. Humphreys, *William Robertson and His History of America* (London, 1954); E. A. Hoebel, "William Robertson, An 18th Century Anthropologist-Historian," *American Anthropologist* 62 (1960):648–55.

37. *History of America*, 1:282.

38. *Reflexionen zur Anthropologie*, par. 890 Berlin, Akademische Ausgabe, 15, (1913) 1:388–89.

39. *Vorlesungen über Philosophie der Geschichte*, ed. Lasson (Leipzig, 1920), 1:189–91 (written 1822–31).

40. Boturini, *Idea de una nueva historia general de la América septentrional* (Madrid, 1746), 7; Keen, *Aztec Image*, 235–36.

41. M. Ballesteros Gaibrois, introduction to Boturini's *Idea*, in *Documentos inéditos para la historia de España* 6 (1948):i–lxvi; on Vico, liii–lvii, 25–31. J. Torre Revello, "Lorenzo Boturini y el cargo de cronista de las Indias," *Boletín del Instituto de Investigaciones Históricas* (Buenos Aires) 5 (1926–27):52–61. The Boturini collection is studied by J. Glass, *Contributions to the Ethnohistory of Mexico*, nos. 4, 5, 8, 9, 10 (Lincoln, Mass., 1976–81).

42. *Historia antigua de Méjico*, ed. C. F. Ortega (1836; repr. Mexico, 1944). Victor Rico Gonzalez, *Historiadores mexicanos del siglo XVIII* (Mexico, 1949), 77–100; Keen, *Aztec Image*, 237–40.

43. Clavigero's manuscript in Spanish was used in the edition by M. Cuevas (Mexico, 1945) and is cited here.

44. J. F. Ramírez, in his notes to the Mexican edition of Prescott's *Conquest of Mexico*, in 1845, 2:xi, considered Clavigero as supreme for antiquity and Prescott for "medieval time," praising them as Romulus and Tatius in Mexican historical studies.

45. Gerbi, *Disputá*, 170; Baudot, *Utopie*, 510.

46. Clavigero, *Historia* (1945), 4.

47. Clavigero, *Historia*, 2, 225. (Also Villoro, *Indigenismo*, 93).

48. Herder, *Outlines* (1966), 154–62. *Historia*, 4,275, 305–23. *Cultura* is opposed to *inculto, bárbaro,* and *bestial,* and the Mexicans and Peruvians to the Caribs and Iroquois.

49. W. Waetzoldt, *Deutsche Kunsthistoriker*, 121, I, 146–51; K. Gilbert, *History of Aesthetics* (Bloomington, 1953), 315.

50. Keen, *Aztec Image*, 328. Gerbi (*Disputá*, 258–62) considers these themes as variations on Rousseau's.

51. A. O. Lovejoy, "Herder and the Philosophy of History," in *Essays in the History of Ideas* (Baltimore, 1948), 167, 181.

52. M. Rojas-Mix, "Die Bedeutung A. von Humboldts für die künstlerische Darstellung Lateinamerikas," in *Alexander von Humboldt, Werk und Geltung,* ed. H. Pfeiffer (Munich, 1969).

53. J. Alcina Franch, *Guillermo Dupaix* (Madrid, 1969), 2 vols.

54. This procedure conformed to royal instruction: "the main purpose and wish of His Majesty refers to knowledge of ancient Mexican arts, and their consequent classification." Dupaix, in Alcina, 1:84.

55. Ibid., 73.

56. Ibid., 78. The last words allude to views held by Robertson (1777).

57. Ibid., 87–88.

58. Ibid., 90.

Chapter 1. American Antiquity

1. Desmond Morris, *The Biology of Art* (London, 1962), 144.

2. D. R. Hofstadter, *Gödel, Escher, Bach* (New York, 1979).

3. E. Kurzweil, "The Neo-Structuralism of Michel Foucault," in *Cultural Analysis,* ed. R. Wuthnow et al. (Boston, 1984), 133–78.

4. D. H. Porter (*Emergence of the Past* [Chicago, 1981], 158–59) defines ninety-eight "categories of development" by fourteen "plots" in seven "levels of abstraction" that he compared to the periodic chart of atomic weights or to the species of a genus in their finitude.

5. R. Layton, "Art and Visual Communication," in *Art in Society,* ed. M. Greenhalgh and V. Megaw (London, 1978), 28.

6. R. Arnheim, *Visual Thinking* (Berkeley, 1964), 18, 134.

7. Antonello Gerbi (*La disputá del nuovo mondo* [Milan, 1955]) wrote the history of this long quarrel of opinions over America's worth to the Old World.

8. M. Foucault, "Nietzsche, Genealogy, History," in *Foucalt Reader,* ed. P. Rabinow (New York, 1984), 83–97.

9. Amerigo is an Italian variant of Amalric, a Visigothic king in Spain. Other variants are Aimeric, Emmerich, etc.

10. Edmundo O'Gorman (*The Invention of America* [Bloomington, 1961], 118–19) estimates "the path opened up by Vespucci" as "the only one with a historical future."

11. On the Spanish claim to Australia since before 1562 (G. Kubler, *Essays* [New Haven, 1985], 191), the claim for the Crown was made in 1606 by Pedro Fernandez de Quiróz (C. Sanz, *Australia: Su descubrimiento y denominación* [Madrid, 1963]).

12. *Invention of America,* 9–11.

13. M. H. Abrams, "Art as Such: The Sociology of Modern Aesthetics," *Bulletin, American Association of Anthropological Sciences* 38, no. 6 (1982): 8–33.

14. "Nietzsche, Genealogy, History," 83, 93, 96–97.

15. Oxford English Dictionary cites *archaeography* as first used in 1804 (*Monthly Magazine,* 18, 289) to mean the "systematic study of antiquities." This use is closer to mine than Foucault's in *Archaeology of Knowledge* (New York, 1972 [written in 1960]), 4–13.

16. Perhaps adapted from the "New Archaeology" of the Americanist followers of L. R. Binford since 1959 (J. R. Caldwell, "The New American Archaeology," *Science* 129, no. 3345 [1959]: 303–07).

17. *The Order of Things* ([1966] New York, 1971), xxiii.

18. Ibid.

19. In P. Veyne, *Comment on écrit l'histoire* (Paris, 1971), 203–42.

20. "Selon les époques, le même institution servira á des fonctions différentes et inversement: de plus la fonction n'existe qu'en vertu d'une pratique et ce n'est pas la pratique qui répond au 'défi' de la fonction . . . il n'y a pas d'éternelle fonction de rédistribution ou de dépolitisation á travers les siècles" (Veyne, "Foucault révolutionne l'histoire," in *Comment on écrit l'histoire,* 231).

21. *Information Theory and Esthetic Perception* (Urbana, 1966), 134.

22. M. Greenhalgh, "European Interest in the Non-European: The Sixteenth Century and Pre-Columbian Art and Architecture," in *Art in Society,* ed. M. Greenhalgh and V. Megaw (London, 1978), 101.

23. Kubler, *The Art and Architecture of Ancient America* 3d ed. (London, 1984), 37–42.

24. *Edinborough Review* 68 (1828): 61, where *virtú,* related to *worth,* is used also of objects of fine craft, as in French.

25. "Ästhetik der gegenwart," *Philosophische Forschungsberichte,* heft 15, 1932.

26. Subtitled *An Inquiry into the Historical Meaning of the New World and the Meaning of Its History* (Bloomington, 1961). This edition, sharpened, corrected, and expanded by O'Gorman, is superior to the original in Spanish, subtitled *El universalismo de la cultura de occidente.* Quotations here are from the version in English.

27. *Admiral of the Ocean Sea* (Boston, 1942), 1:308.

28. Peter Martyr, *Décadas del nuevo mundo,* ed. E. O'Gorman (Mexico, 1964).

29. November 1, 1495, from Barcelona, to Ascanio Sforza (O'Gorman, *Invention,* 84, 145).

30. O'Gorman, *Invention,* 4. Ontology is about the being of reality. L. E. Huddleston, *A Study of the European Concepts of the Origins of the American Indians, 1492–1729* (Austin, 1967), writes about the traditions he calls Acostan and Garcian, for José de Acosta and Gregorio Garcia.

31. O'Gorman, *Invention,* 84. The letters are quoted from O'Gorman's edition *Décadas del nuevo mundo,* 2 vols. (Mexico, 1964). To O'Gorman, Martyr's work is like journalism, as an assemblage of other travelers' letters (1:11).

32. Irving Rouse ("Peopling of the Americas," *Quaternary Research* 6, no. 4 [1974]: 597–612) begins with 30,000 B.P. (Lower Lithic), to Middle Lithic, and Upper Lithic to "retreat of the ice ca. 80,000 B.P.").

33. M. Sauter, ed., *L'homme, hier et aujourd'hui* (Paris, 1972), bibliography, 5–14.

34. C. Hampden-Turner, *Maps of the Mind* (New York, 1980), 84.

35. F. Galton in 1883, p. 73, ed. of 1973. Whitney Davis ("The Origins of Image-Making," *Current Anthropology* 27, no. 3 [1986]: 193–215) refers only to "visual perception" in "image-making" as a "competence . . . differentiating *Homo sapiens sapiens* from *Homo sapiens neanderthalensis* and from earlier hominids." Kubler, "Eidetic Imagery and Palaeolithic Art," *Journal of Psychology, Interdisciplinary and Applied* 119 (Nov. 1985): 557–66.

36. K. H. Pribram, *Languages of the Brain* (Englewood Cliffs, 1971).

37. Marc Sauter, ed., *Le fil du temps* (Paris, 1983), 5–13, provides a bibliography 1935–72.

38. *American Anthropologist*, 65, no. 5 (1963): 1180–81.

39. "L'art animalier dans les bronzes chinois," in *Fil du temps*, 11–33.

40. "Problèmes artistiques de la préhistoire," in *Fil du temps*, 271–84.

41. The method was first published in 1961 ("Sur une méthode d'étude de l'art pariétal paléolithique," in *Fil du temps*). The critique by Anthony Stevens appeared in *Antiquity* 49 (1975): 54–57.

42. E. Lartet and G. Christy, "Sur des figures d'animaux," *Revue Archéologique* (1863): 264–65; F. Galton, *Inquiries into Human Faculty*, 3d ed. (New York, 1973), 73; H. Breuil, "Les origines de l'art décoratif," *Journal de Psychologie Normale et Pathologique* 23 (1926): 364–75; G. H. Luquet, *The Art and Religion of Fossil Man*, trans. J. T. Russell, Jr. (New Haven, 1930; 1st French ed., 1926); K. Groos, *The Play of Man*, trans. E. L. Baldwin (New York, 1919; written 1901).

43. D. B. Tylor, *Anthropology* (London, 1881); J. G. Frazer, *The Golden Bough*, 2 vols. (London, 1890); E. Durkheim, *Les formes elémentaires de la vie religieuse* (Paris, 1912); S. Reinach, *Répertoire de l'art quaternaire* (Paris, 1913).

44. P. Ucko and A. Rosenfeld, *Palaeolithic Cave Art* (London, 1967). Breuil, *Four Hundred Centuries of Cave Art* (Montignac, [1952]).

45. G. H. Luquet, *L'art et la religion des hommes fossiles* (Paris, 1926), 201.

46. Luquet's "disinterestedness" may derive from the condition called "indifférence," arising from the resolution of opposites, noted in art by F. Schelling in 1802–03 as a "condition of absolute art" ("Philosophische Kunst," in *Sämmtliche Werke* [Stuttgart/Augsburg, 1859], 5:411).

47. *Préhistoire de l'art occidental* (Paris, 1965), 29.

48. Ucko and Rosenfeld, *Palaeolithic Cave Art*, 163.

49. Morris, *Biology of Art*, 142: "No ape, no matter how old or experienced, has yet been able to develop graphically to the pictorial stage of simple representation."

50. *Les religions de la préhistoire* (Paris, 1971), 3, 30, 64, 77, 79, 142.

51. "Les rêves," in ibid., 362–80.

52. *Les religions de la préhistoire*, 79.

53. *Préhistoire*, 1965, Avant-propos.

54. The page references are to the edition in two volumes, *Le geste et la parole*: Vol. 1, *Technique et language*, and Vol. 2, *La mémoire et les rhythmes* (Paris, 1965).

55. M. H. Levine (*American Anthropologist* 68 [1966]: 1568–72) denies both the new chronology and his "eschewing comparative ethnology in interpreting the art" (review of *Préhistoire de l'art occidental*, 1965).

56. Kubler "Eidetic Imagery."

57. *Origin and Diversification of Language*, ed. F. Scherzer (Chicago, 1971), 182–83, 224.

58. On the method, G. Willey (*Introduction to American Archaeology*, (1966), 1:17–19) is supportive, unlike K. Bergsland and H. Vogt, "On the Validity of Glottochronology," *Current Anthropology* 3 (1962): 128–29.

59. W. S.-Y. Wang, "Language Change," *Annals of the New York Academy of Sciences* 280 (1976):71.

60. G. H. Hewes, "Current Status of the Gestural Theory Language Origin," *Annals of the New York Academy of Sciences* 280 (1976): 491.

61. "Protolinguistics," ibid., 104.

62. Between Altonian (70,000 B.C.?) and Farmdale (22,500 B.C.) substages of the Wisconsin glacial sequence (Willey, *Introduction*, 1:28, fig. 2–I).

63. C. W. O'Nell, *Dreams, Culture, and the Individual* (San Francisco, 1976), 57–68.

64. O'Nell (17, 7576) cites R. L. Van de Castle (*The Psychology of Dreaming* [Morristown, 1971, New York, 1971]) on the decline of "animal content" in American children's dreams from age four (61 percent) to age sixteen (9%) to early adult (7.5 percent). The dreams of Australian aboriginals about animals are 50 percent, and only 7 percent in this country. The parallel decline in eidetic imagery with age may be significant, more for the faculty of imagery than for its meaning.

65. *Préhistoire*, 1965, 146–59.

66. J. Mukarovsky, "Art as Semiotic Fact," in *Semiotics of Art. Prague School Contributions*, ed. L. Matejka and I. R. Titunik (Cambridge, 1976), 3–10.

67. J. D. von Braunschweig, *Ueber die alt-americanischen Denkmäler* (Berlin, 1840).

68. *Essai politique sur le royaume de la Nouvelle-Espagne* (Paris, 1811), chaps. 6, 7.

69. Alexander von Wuthenau, *Altamerikanische Tonplastik: Das Menschenbild der neuen Welt* (Baden-Baden, 1965), 45.

70. "Significant Parallels in the Symbolic Arts of Southern Asia and Middle America," International Congress of Americanists, ed. Sol Tax, vol. 1, *The Civilizations of Ancient America* (Chicago, xxix, 1951), 299–309.

71. A. Caso, writing in 1962, "Relations between the Old and New Worlds: A Note on Methodology," *Congreso Internacional de Americanistas, Actas y Memorias*, vol. 1 (Mexico, xxxv, 1964), 55–71.

72. *Amerika, neue oder alte Welt?* (Berlin, 1982), esp. 198, 207.

73. *Mythes et symboles lunaires: Chine ancienne, civilisations anciennes de l'Asie, peuples limitrophes du Pacifique* (Antwerp, 1932). Others are R. von Heine-Geldern, Carl Schuster, Paul Kirchhoff, and Gordon Ekholm.

74. Grieder, *Origins of Pre-Columbian Art* (Austin, 1982).

75. E. Sapir, *Time Perspective in Aboriginal American Culture: A Study in Method* (Ottawa, 1916), 51–54.

76. A. L. Kroeber, *Anthropology, Race, Language, Culture, Psychology, Prehistory* (New York, 1948).

77. G. Ekholm, "Transpacific Contacts," in *Prehistoric Man in the New World*, ed. J. D. Jennings and E. Norbeck (Chicago, 1964), 489–510.

78. *Pre-Columbian Art*, trans. J. Mark (New York, 1983) (originally published as *L'art précolombien* [Paris, 1978]).

79. José Imbelloni, "Los grupos raciales aborígenes," *Cuadernos de Historia Primitiva* 2 (1948); and Paul Rivet, *Les origines de l'homme américain* (Montreal, 1943).

80. Neoartids, Columbids, Planids, Appalachids, Sonorids, Pueblo-Artids, Isthmids, Amazonids, Pampis, Laguids, Fuegids.

81. J. Imbelloni and S. M. Garn, *Human Races* (1969). J. Comas, *Antropología de los pueblos iberoamericanos* (Barcelona, 1974).

82. Willey, *Introduction* (1966), 12–16.

83. Robert Wauchope, *Lost Tribes and Sunken Continents: Myth and Method in the Study of American Indians* (Chicago, 1962).

84. Nigel Davies (*Voyagers to the New World* [New York, 1979]) notes the

inadequacy of "parallel art forms" (251) and rejects cultural continuity between Old and New Worlds prior to Discovery (chap. 3), although retaining the view of ancient America as a "melting pot for people of varied stock" (47), as in Wuthenau's "faciologie" (1965) or anticipating Mueller's "amphiatlantic" origins at pre-Mesolithic date (1982).

85. G. Kubler, "Written Sources on Andean Cosmogony," in *Recent Studies in Andean Prehistory and Proto-History,* ed. D. P. Kvietok and D. H. Sandweiss (Ithaca, 1983), 197–211.

86. Kubler, *Art and Architecture of Ancient America,* 20.

87. Sanders and Price (*Mesoamerica* [New York, 1968], 168, 204) regard Teotihuacanos as of more "civilized" rank than the Maya people.

88. J. Rowe, "Radiocarbon Measurements," in *Peruvian Archaeology,* ed. J. Rowe and D. Menzel (Palo Alto, 1971), 16–30.

89. J. W. Smith and R. A. Smith, "New Light on Early Sociocultural Evolution in the Americas," in *Peopling of the New World,* ed. J. E. Ericson, R. E. Taylor, and R. Berger (Los Altos, 1982) (Ballena Press anthropological papers, 23).

90. In "Peruvian Archaeology in 1942," (*Viking Fund Publications in Anthropology,* no. 4 [New York, 1944]) to designate "pan-Peruvian" spreads of Chavín, Tiahuanaco, and Inca "styles."

91. Kubler, "Period, Style and Meaning in Ancient American Art," in *Essays,* ed. T. Reese (New Haven, 1985), 385–95.

92. J. M. Schaefer, "Galton's Problem in a New Holocultural Study on Drunkenness," *Studies in Cultural Diffusion* (1974), 1:113–42.

93. Ibid., 2:144.

94. S. Witkowski, "Galton's Opportunity: The Hologeistic Study of Historical Processes," in *Galton's Problem,* ed. J. M. Schaefer (1974), 1:84a, finds that "material culture traits diffuse the fastest, symbolic traits second fastest and social traits slowest."

Chapter 2. Salvaging Amerindian Antiquity before 1700

1. G. B. Vico, *The New Science,* trans. T. G. Bergin and M. H. Fisch (Ithaca, 1944). J. Moebus, "Über die Bestimmung des Wilden und die Entwicklung des Verwertungsstandpunkts bei Kolumbus," in *Mythen der neuen Welt zur Entdeckungsgeschichte Lateinamerikas,* ed. K.-H. Kohl, (Berlin, 1982), 49–56.

2. M. Wilcox, *Encyclopedia Americana* (1953), 1:478: Old High German Amalrich (among the Goths of northern and central Europe) became *Americo* in Italy (*ric* can mean powerful in the *Beowulf,* and *am* may signify labor or endurance of great toil, according to W. v. Humboldt).

Vespucci first mentioned the island hemisphere as *Mundus Novus* in a letter of 1504, and as a hemisphere later on (A. Magnaghi, *Amerigo Vespucci: Studio critico* (Rome, 1926).

3. *Los cuatro viajes,* 3d ed., ed. I. B. Anzoátegui (Buenos Aires, 1958), 41.

4. S. E. Morison, *Admiral of the Ocean Sea* (Boston, 1942), 556.

5. The late Antonello Gerbi, in his last book (*La natura delle Indie Nove,* [Naples, 1975], 15–29), was concerned to lessen Columbus, Peter Martyr, Cortés, and others in order to magnify Gonzalo Fernández de Oviedo, to whom most of the

study is devoted. Gerbi was searching for the sixteenth-century antecedents to the theory in vogue from Buffon to Hegel (see pp. 84–108) of the inferiority of America, both biological and cultural, as studied in Gerbi's earlier work, *La disputa del nuevo mundo* (Mexico, 1960) (1st ed. in Italian, 1955).

6. Morison, *Admiral of the Ocean Sea*, 1:71, denied by E. O'Gorman (*Pedro Martir* (1964), 1:13–15), who compares the *Décadas* to the travel-books by non-travelers, like the majority of "cronistas de Indias."

7. *Regius sum rerum Indicarum Senator* (H. Heidenheimer, *Petrus Martyr Anglerius und sein Opus epistolarum* [Berlin, 1881], 28).

8. *Décadas*, IV, bk. 7, 423, on seeing in Spain the labrets (lower-lip jewel plugs) of Mexico, worn by the Aztec nobles sent in 1520 to Charles V: "I never saw anything uglier, but they believe there is nothing more elegant under heaven. . . . The ethiop thinks his black color more beautiful than white, while the white man thinks the opposite."

9. M. de Foronda y Aguilera, *Estancias y viajes de Carlos V* (Madrid, 1895), 161, 169–70, 171, 179. The emperor left Valladolid for Brussels in March. Peter Martyr's letters (*Opus epistolarium* [Amsterdam, 1670]) record his presence in Valladolid during March, June to November, and October to January of 1520–21 (662–65; 670–94; 696–709). In *Décadas*, II, 473, Martyr writes of the treasure sent by Cortés in 1520 as those he had "ocasión de examinarlas . . . en la célebre ciudad de Valladolid y de describirlas en nuestra cuarta Década."

10. *Décadas*, I, 1964, 430 (Déc. IV, Libro IX).

11. "I have also seen the things brought to the king from the new golden land: a sun all of gold a whole fathom broad, also a moon all of silver and just as large; also two chambers full of instruments of these [people], likewise of all kinds of weapons, armor, catapults, wonderful shields, strange garments, bed hangings, and all kinds of wonderful things for many uses, more beautiful to behold than prodigies. These things were all so precious that they are valued at a hundred thousand gulden. All the days of my life I have not seen anything that gladdened my heart as these things did. For I saw among them wonderful works of art and marvelled at the subtle ingenuity of people in strange lands. I do not know how to express all that I experienced there." The best text of these remarks is Hans Rupprich's *Schriftlicher Nachlass* (Berlin) 1:146–202; Jantz finds E. Panofsky's translation (*Albrecht Dürer*, 2d ed. [1945], 1:209) "not quite accurate." That of Jantz is used here (H. Jantz, "Images of America in the German Renaissance," in *First Images of America*, ed. F. Chiappelli [Berkeley, 1972], 1:94, 105).

12. *Décadas*, 1964, I: 3, 131.

13. Ibid. 141–42.

14. *Décadas* V, Book 4, 480–81.

15. A. M. Salas, *Tres cronistas de Indias* (Mexico, 1959), 27; J.-H. Mariéjol, *Pierre Martyr d'Anghera: Sa vie et ses oeuvres* (Paris, 1887), 159–61.

16. R. Ricard, *La "Conquête spirituelle" du Mexique* (Paris, 1933). J. Phelan, "Hernan Cortés, the Moses of the New World," in his *The Millennial Kingdom of the Franciscans in the New World* (Berkeley, 1956); G. Mendieta, *Historia* (1945), 13–15.

17. *Coatlicue* (Mexico, 1954), 56–52, with citations from Cortés's letters, as well as contemporaries (Conquistador anónimo, Bernal Diaz del Castillo, Fernández de Oviedo, and Fray Bernardino de Sahagún). R. Iglesia (*Cronistas, el ciclo de Hernán Cortés* [Mexico, 1942]) mentioned Peter Martyr and Gómara. L. Vil-

loro (*Indigenismo* [Mexico, 1950], 17–22) stresses Cortés's "actitud de admiración y encomio" for the order, art and magnificence of native society, and his conceding "al pueblo indígena todos los derechos que concedería a cualquier pueblo civilizado," Cortés being himself a humanist lawyer opposed to feudality and chivalric ideals, by encouraging some "intercambio de valores" between Europeans and Amerindians (21–24).

18. "Mental World of Hernán Cortés," *Transactions, Royal Historical Society*, series 5, 17 (1967): 41–58.

19. Hernán Cortés, *Letters from Mexico*, trans. A. R. Pagden (New York, 1971), 85. The vividness of his impressions is also noted by G. Baudot, *Utopie*, 9–10.

20. *Letters*, 100.

21. *Letters*, 104–05.

22. *Letters*, 360–61.

23. Evidence that this was a legend promoted in the 1540s by his Franciscan admirers, Motolinia and Sahagún, is suggested by Elliott ("Mental World," 52), following H. R. Wagner, *The Rise of Fernando Cortés* (Berkeley, 1944), 187–98. J. Lafaye (*Quetzalcóatl and Guadalupe* [Chicago, 1976], 149–50) assigns "the genesis of the creole myth" to the statements of Sahagún (*Historia general*, 1:90) and Bernal Diaz (*Historia*, ed. Ramirez Cabañas [Mexico, 1966], 1:266).

24. Lafaye, *Quetzalcóatl*, 150, supposes that Marina translated Moctezuma's words for Cortés; that Sahagún reported a native account; that Moctezuma took Cortés for Quetzalcoatl; and that Fray Diego Durán, Las Casas, and Pedro de los Rios all shared in creating the colonial legend that Quetzalcoatl was the forerunner of Cortés.

25. *Letters*, 258.

26. *Cronistas*, 17–69.

27. Hernán Cortés, *Cartas* (Mexico, 1963).

28. *Letters*, 113.

29. Cortés *Cartas*, (1963), 176.

30. *Letters*, 442–43, 525.

31. F. de Lejarza, "Franciscanismo de Cortés," *Missionalia Hispanica* 5 (1948): 43–136.

32. R. Konetzke, "Hernán Cortés como poblador de la Nueva España" in *Estudios Cortesianos* (Madrid) (1948): 341–81. V. Frankl, "Hernán Cortés y la tradición de las Siete Partidas," *Revista de Historia de América* (1962), 53–54, and "Imperio," in *Cuadernos Hispanoamericanos* (1963): 443–82.

33. Elliott, "Mental World," 42.

34. Compiled 1256–63, first published at Seville in 1491.

35. M. Gimenez Fernandez, "*Hernán Cortés y su revolución comunera en la Nueva España*" (Seville, 1948) and *Anuario de Estudios Americanos* (Seville, 1949); R. S. Chamberlain, "La controversia Velázquez-Cortés," *Anales de la Sociedad de Geografía e Historia de Guatemala* 19 (1942): 23–56.

36. Sandoval represented the king as a bailiff (*alguazil mayor*) to collect revenues.

37. M. Hernandez Sanchez-Barba, *Hernán Cortés, cartas y documentos* (Mexico, 1963), i–xxi.

38. G. Kubler, "Indianism, Mestizaje, and Indigenismo," *Essays*, ed. T. F. Reese (New Haven, 1985), 3–4, 75–80.

39. G. Baudot, *Utopie* (Toulouse, 1977), 300, writing about Francisco de las Navas, Motolinia, and Martín de la Coruña. This work, p. 49.

40. B. Keen, *Aztec Image* (New Brunswick, 1971), 98. The epigram on comparative barbarism is from the edition by E. O'Gorman (Mexico, 1967), 654.

41. G. Baudot (*Utopie*, 399) attributes the *Relación de Michoacán* to Fray Martín as being planned ("en germe") as early as 1536 and written 1539–41. The calendar was added in 1549 (407–08). See *Relación de las ceremonias y ritos . . . de Michoacán* (ed. José Tudela [Madrid, 1956]).

42. Baudot (*Utopie*, 410–11) views Sahagún as following in Coruña's steps.

43. F. Ocaranza, *El imperial Colegio de Santa Cruz de Santiago de Tlatelolco* (Mexico, 1934); F. B. Steck, *El primer colegio de América* (Mexico, 1944).

44. *Relación*, ed. Tudela, 3; Baudot, *Utopie*, 421–25.

45. The manuscript at the Escorial is incomplete, multilated, and mispaged.

46. Mendieta, *Relación* (1947), 174–75.

47. Baudot, *Utopie*, 123–24.

48. M. León-Portilla, "Ramirez de Fuenleal y las antigüedades mexicanas," *Estudios de Cultura Náhuatl* 8 (1969): 23–28.

49. Baudot, *Utopie*, 45.

50. S. J. K. Wilkerson, "The Ethnographic Works of Andrés de Olmos, Precursor and Contemporary of Sahagún," in *Sixteenth-Century Mexico: The Work of Sahagún*, ed. M. S. Edmonson (Albuquerque, 1974), 27–77. Both manuscripts were taken by Ramirez de Fuenleal to Spain in 1547 (Baudot, *Utopie*, 59).

51. Baudot (*Utopie*, 41). Baudot also believes that Olmos aimed to produce manuals in Náhuatl language to accelerate Indian christianization, without being a visionary theoretician (*Utopie*, 119–240).

52. Baudot (*Utopie*, 198–294), attributes to Olmos parts of the *Hystoire du Mechique* of 1543–47, on the genesis of man (chap. 1) and on giants (chaps. 6, 7).

53. L. B. Simpson, *Encomienda* (1929; repr. Berkeley, 1950).

54. Baudot (*Utopie*, 89) notes that Motolinia thought of Cortés as the "new Moses" sixty years before Mendieta (J. Phelan, *Millennial Kingdom* [1956], 29–30).

55. *Memoriales*, ed. E. O'Gorman (Mexico, 1971). The edition is a reconstruction from scattered sources. The Introduction is criticized by G. Baudot (*Utopie*, 241–386) for "constructions téméraires" (395) and "acrobatie intellectuelle" (357). The Memoriales were composed 1531–43.

56. Mendieta, *Historia*, III, xii, 53. Diaz del Castillo, *Historia*, chap. 71; Phelan, *Millennial Kingdom*, 33; Baudot, *Utopie*, 248–49.

57. H. R. Wagner ("Three Studies on the Same Subject," *Hispanic-American Historical Review* 25 [1945]: 155–211) had "grave doubts as to his veracity." Part was written in the 1550s, and the rest before 1568 (190), all of it "more as an autobiography than as a history" (179).

58. *Historia verdadera*, ed. J. Ramirez Cabañas (Mexico, 1950), 1:349, 3:241–42, 248.

59. Baudot, "Last Years," in *Sixteenth-Century Mexico*, ed. M. S. Edmonson, 165–86. Sahagún was excommunicated in 1587 during a conflict between Creole and Spanish-born churchmen.

60. J. Fernandez, *Coatlicue*, 60; A. López Austin, "The Research Method of Sahagún," in *Sixteenth-Century Mexico*, ed. M. S. Edmonson, 119; E. E. Calnek, "Sahagún Texts," in ibid., 189–204.

61. Villoro, *Indigenismo*, 36–87.
62. W. Jimenez Moreno, "Enigma," *Cuadernos Americanos* 1, no. 5 (1942): 113–45; M. Covarrubias, *Mexico South* (New York, 1946).
63. *Historia general*, ed. Acosta Saignes (1946), 2:161.
64. D. Robertson, "The Sixteenth-Century Mexican Encyclopedia of Sahagún," *Cuadernos de Historia Mundial* 9, no 3 (1966): 617–28.
65. J. McAndrew, *Open-Air Churches of Sixteenth-Century Mexico* (Cambridge, 1965), 241–42; *Catálogo de construcciones religiosas del Estado de Yucatán* (Mexico, 1945), 1:241. F. V. Scholes, "The Beginnings of Hispano-Indian Society in Yucatan," *Scientific Monthly*, 44 (1937): 530–38.
66. N. M. Farriss, *Maya Society under Spanish Rule* (Princeton, 1984), 291, 313, 335, 341.
67. H. Perez Martinez, ed., *Relación de las cosas de Yucatán* (Mexico, 1938), Doc. 4, 291: Landa declared that he had written a *doctrina christiana* in Maya for printing together with his sermons in that language.
68. D. Robertson, "The Sixteenth-Century Mexican Encylopedia of Fray Bernardino de Sahagún," *Cuadernos de Historia Mundial* 9, no. 3 (1966): 617–28. The model may have been *De proprietatibus rerum,* by Bartolomaeus Anglicus in the thirteenth century.
69. Tozzer, *Landa's Relación* (1941), 44, n. 219: Juan Cocom was "a man of great reputation, learned in their affairs," who showed Landa "a book which had belonged to his grandfather [the XIVth Cocom], a son of the Cocom [XIIIth] killed at Mayapán. Gaspar Antonio de Herrera Xiu (or Chi) wrote a *Relación sobre las costumbres de los indios* (1582), published by Tozzer as Appendix C in his edition (1941, 230–323). It is mainly about the customs and laws of Mayapán. J. K. Kowalski, *The House of the Governor at Uxmal* (Norman, 1987) disproves the Xiu claims, showing that the site predates A.D. 686 (p. 177).
70. Tozzer, *Relación*, 84, n. 354. An earlier editor (J. de la Rada y Delgado, "Relación," *Colección de documentos ineditos de ultramar*, series II, vol. 13 [1900], 409–10) compiled an index-guide with forty-two topics.
71. F. Saxl, "Illustrated Medieval Encyclopedias," *Lectures* (London, 1957), vol. 1.
72. *Historia eclesiástica indiana*, ed. F. de Solano (Madrid, 1973), 1:xci–xcii, table of correspondences by Johanna Broda de Casas.
73. Solano, introduction to Mendieta, *Historia*, 2:lxxiii: "La visión prehispánica novohispana, se caracteriza por su serenidad," and its "estilo, algo aséptico."
74. Mendieta adds a title page (after 1: cxii: an ascension of St. Francis (facing 126) and friars killed by Chichimec arrows and weapons (facing 224).
75. E. J. Palomera, *Valadés* (Mexico, 1963), 2: 150.
76. Before 1800 it was the most widely read history of America. Madrid, 1590, 1608; Mexico, 1940, ed. E. O'Gorman; Madrid, 1954, ed. F. Mateos, S. J. Books 1–2 were written in Peru in Latin (1588, 1589, 1602). Books 3–7 were written in Europe, and the entire work was first published in Spanish (1590). Translations: German, 1605; Italian, 1596; French, 1598, 1600, 1606, 1616, 1617, 1621; Dutch, 1598, 1624; English, 1604, 1880, 1949. The soundest editions are those of O'Gorman (1940) and Mateos (1954), both in Spanish.
77. Acosta, *Historia* (1954), 1, chap. xx, 32–33.
78. Ibid., 5, chap. II, 140–41.

79. Ibid., 7, chap. III, 211.
80. As to floods in native Andean cosmogony, he noted incorrectly that Indian "memories extend only 400 years" in Peru.
81. Acosta here also mentions the Chiriguano tribes of the northwestern Chaco in Bolivia (Ibid., 6, chap. 19, 198, 199).
82. Ibid., 1, chap. III, 10.
83. Ibid., 1, chap. XIX, 31.
84. Ibid., 1, chap. XXII, 165–66.
85. Ibid., 6, chap. I, 182–83; chap. III, 184–85.
86. J. D. Burckhardt, *Cultur der Renaissance in Italien* (Basel, 1860).
87. J. F. Ramirez used the copy in Madrid for his edition in 1867–80 with illustrations (2 vols, atlas), as *Historia de las Indias* (reissued, Mexico, 1951). The edition by A. M. Garibay in 1967 is also taken from the manuscript in the Biblioteca Nacional at Madrid believed by Garibay to be in the author's hand ([Mexico, 1967] 1:xvi). The English translations by D. Heyden and F. Horcasitas are incomplete (*Book of the Gods and Rites and the Ancient Calendar* [Norman, 1971]). C. Gibson, *The Aztecs under Spanish rule* (Stanford, 1984), 31: "Durán and Alvarado Tezozomoc relied on [a lost] Crónica X," (following R. H. Barlow, *Revista Mexicana de Estudios Antropológicos* 7 [1945]: 65–87). Acosta borrowed much of his book V from Durán, as shown by Heyden and Horcasitas *Book of the Gods*, xviii–xxi).

Garibay (*Historia*, 1:xxxv, xxxvii–xxxix) noted Durán's *mexicanismo*, followed by Baudot (*Utopie*, 72): Durán differs from earlier chroniclers by "un souci d'expliquer et de réhabiliter le passé précolombien qui est déjà une sorte de revendication nationale."

88. Keen, *Aztec Image*, 118, pairs Durán with Sahagún as "seeing persistence of paganism in every aspect of Indian life."
89. *Historia*, ed. Garibay, 36.
90. Durán, *Historia*, 2:583–90.
91. *Book of the Gods*, transl. Heyden and Horcasitas 75.
92. Ibid., 121.
93. Ibid., 57, 61, 63, 185: "I believe there actually was an evangelist in this land" whose teachings were "corrupted with abominable idolatry."
94. Ibid., 287, 290.
95. Ibid., xxx–xxxii.
96. *Monarquía indiana*, ed. M. León-Portilla (Mexico, 1964), 1:16.
97. H. F. Cline ("A Note on Torquemada's Native Sources and Historiographical Methods," *The Americas* 20 (1969): 372–86) sees Torquemada as "a skilled and careful historian, constrained only by some obvious usages and common attitudes of his age."
98. *Monarquía indiana*, 14–15.
99. Medina del Campo, 1575, enlarged second edition 1595.
100. *Monarquía indiana* (1977), 4:29–30.
101. Mendieta, bk. IV, chaps. 33–39 and 46, on the reign of Philip II, and on colonists and secular clergy, J. Phelan (*Millennial Kingdom*, 107).
102. *Monarquía indiana*, 1:vii. A table of Torquemada's sources by J. Broda de Casas appears in F. de Solano's introduction to Mendieta's *Historia eclesiástica*, 1:xci–xcii. Only Olmos, Motolinia, and Las Casas are mentioned. Acosta's books I

and II in Latin (1588) and the *Rhetorica cristiana* by Valadés (1579) are omitted.

103. Keen, *Aztec Image,* 182.

104. *Origen de los indios* (Valencia, 1607); revised in Madrid, 1729, edited by Andrés Gonzalez de Barcia, and edited anew in facsimile by F. Pease (Mexico 1981).

105. Garcia, *Origen,* xxxviii, 43–45.

106. Garcia, *Origen,* 44, 46–48.

107. L. E. Huddleston, *A Study of European Concepts of the Origins of the American Indians, 1492–1729* (Austin, 1967), 48–76.

108. *Origen,* xviii–xxiv.

109. The editor of the Madrid edition of 1729 added others, such as Garcilaso and Torquemada (Huddleston, *Study,* 106–09).

110. Pease, in Garcia, *Origen,* xl.

111. R. Wauchope, *Lost Tribes and Sunken Continents* (Chicago, 1962); N. Davies, *Voyagers to the New World* (New York, 1979).

112. M. J. MacLeod, "Las Casas, Guatemala, and the Sad but Inevitable Case of Antonio Remesal," *Topic* 20 (1970):53–64.

113. A. de Remesal, *Historia general de las Indias Occidentales,* ed. C. Saenz (Madrid, 1964), 2:423.

114. Kubler, "The Quechua in the Colonial World," in *Handbook of South American Indians,* ed. J. Steward (Washington, 1946), 2:400–03.

115. Ibid., 341–45.

116. M. Coe and G. Whittaker, *Aztec Sorcerers in Seventeenth-Century Mexico* (Albany, 1982), 15, 22. His view is characterized by his modern editors as "uniformly contemptuous" of Indians.

117. "Memorias antiguas historiales del Perú," in *Colección de libros españoles raros o curiosos,* ed. Marcos Jiménez de la Espada (1882), 16.

118. M. Gonzales de la Rosa ("El padre Valera" *Revista Histórica* (Lima) 2 (1907):193–97) proved that the anonymous *Las costumbres antiguas del Perú y la Historia de los Incas* was by Valera.

119. F. A. Loaysa, ed., *Las costumbres antiguas del Perú y la historia de los Incas* (Lima, 1945), xi–xv.

120. *Historia del reino y provincias del Perú* (Lima, 1895), 70–71, where they are quoted from "un bocabulario antiguo de mano del Padre Blas Valera," as material copied in a notebook, mentioning ancient "kings of Peru." Anello Oliva began his chronicle (*Historia del reino y provincias del Peru,* ed. Pazos Varela [Lima, 1895]) in 1598, continuing it until 1626 (J. Murra, ed. *Guaman Poma,* 1980, vol. 3, 1962).

121. H. Bingham, *Machu Picchu* (New Haven, 1911); P. A. Means, *Biblioteca andina* (1928; repr. New Haven, 1967).

122. Jimenez, introduction to Montesinos, *Memorias,* vii–viii.

123. Imbelloni, "La capaccuna de Montesinos," *Anales del Instituto de Etnografía Americana* 2 (1941):260, 276–77, as known in 1628 by Antonio de León Pinelo (*Epítome de la biblioteca oriental y occidental* [Madrid, 1629], 103).

124. G. Kubler, "Written Sources in Andean Cosmogony" (1983), 197–211. The theme was first suggested for Peru by Imbelloni ("Capaccuna," 306–08, 347), who also perceived that Montesinos echoes Valera as [Buenaventura] Salinas resembles [Guaman] Poma (305).

125. Imbelloni, "Capaccuna," 347–48.

126. Brought to Copenhagen from the library of the Conde Duque de Olivares in 1662 by Pedersen Lerche, Danish ambassador to Madrid in 1650–53. A. Padilla Bendezú, *Huaman Poma: El indio cronista dibujante* (Mexico, 1979), 119.

127. Palafox, *Obras* (Madrid, 1762), 10:444–93. J. Rojas Garcidueñas, *Ideas Políticas* (1946).

128. Keen, *Aztec Image*, 186.

129. In Rojas Garcidueñas, *Ideas*, 59, 63, 102.

130. I. Leonard, *Don Carlos de Sigüenza y Góngora: A Mexican Savant of the Seventeenth Century* University of California Publications in History, vol. 18 (Berkeley, 1929).

131. *Teatro de virtudes políticas* (Mexico, 1680), and *Obras* (Mexico, 1928), 23–127.

132. The name of the painter is given as José Rodriguez Carnero (obit 1725 at Puebla), and the verses were in part by a young friar, Alonso Carrillo y Albornos (F. Perez Salazar, in Sigüenza, *Obras* (1928), xxxiii).

133. Drawings of emperors by Sigüenza were used in 1700 by F. Gemelli Carreri (*Giro del mondo*, ed. Berthe [Paris, 1968], 144–45, 240–41).

134. *Obras* (1928), xlviii–xlix, describing paintings in the university at Mexico by Alonso Vazquez (active in Mexico 1590–1603), Andrés de la Concha (active 1575–1612), Luis Juarez (active 1600–35), Fray Diego Becerra, Franciscan (active 1640–82), Sebastián Lopez de Arteaga (Sevilla 1610, to Mexico 1643, obit 1656), Fray Alonso Lopez de Herrera, "el divino" (Dominican, active 1609–54), the three Echaves (Baltasar Orio, before 1458–1607; Baltasar Echave Ibia, born 1583/4–c. 1650; Baltasar Echave Rioja, 1632–1682), Nicolas Daza y Angulo (1666). The style of each artist or group is described in a few lines.

135. Lafaye, *Quetzalcóatl and Guadalupe*, 65.

136. This title was granted in 1627 to Pedro de Tezifón de Moctezuma, a lineal descendant of Isabel Moctezuma (1509–50). Her daughter by Hernán Cortés married Juan Cano before 1547, and the 32nd viceroy of New Spain (1696–1701), the Conde de Moctezuma, was her descendant (J. de la Villa, in *Diccionario de historia de España*, 2d ed. directed by Germán Bleiberg [Madrid, 1969], 621). Other genealogies are also claimed from the many offspring of Hernán Cortés (e.g., Baudot, *Utopie*, 61–62).

137. Ramón Iglesia, "La mexicanidad de Don Carlos Sigüenza de Góngora," in *El hombre Colón y otros ensayos* (Mexico, 1944) (cited by B. Keen, *Aztec Image*, 192–93, and 589, n. 39.

138. I. Leonard, *Sigüenza*, 117, 120, 244–48.

139. A. Cavo, *Tres siglos de Méjico*, ed. C. M. de Bustamante (Mexico, 1852), 115–16.

140. F. Perez Salazar, *Obras* (1928), xxxix, quoting Sigüenza after 1681, as in correspondence also with scholars in London, Madrid, Sevilla, and Lima.

141. Chapters 8 and 9 recount Sigüenza's activities exploring the Bay of Pensacola, and the "aftermath" of the expedition.

142. *Obras*, 2:137.

143. *Handbook of Middle American Indians*, ed. R. Wauchope (Austin, 1964–), vols. 12–15, ed. H. Cline.

144. Tezozomoc's *Crónica* was first edited by M. Orozco y Berra (Mexico, 1878) and reprinted in Mexico in 1944 and 1975. Barlow, "La Crónica X," 65–83.

145. *Crónica* (1975), 253–54.

146. Ursula Dyckerhoff, *Die Crónica Mexicana, quellenkritische Untersuchungen* (Hamburg, 1970), 2:65–87.

147. *Crónica,* chaps. 11–15.

148. *Crónica,* chaps. 27–30. Axayacatl ordered this brought down from the top platform (chap. 47, p. 398).

149. *Crónica,* chaps. 36–39. Six Atlantean sculptures as well as tables and seats were shaped by one hundred stonecutters.

150. *Crónica,* chaps. 66–69. The figure of Coyolxauhqui then was near the image of Huitzilopochtli.

151. *Crónica* (1975), 503, 521.

152. Diego Valadés, *Rhetorica christiana* (Perugia, 1579). E. J. Palomera, SJ, *Fray Diego Valadés,* 2 vols. (Mexico, 1962–63), 57. F. de la Maza, *Anales del Instituto de Investigaciones Estéticas* (1945), 13. Nicolás León (*Anales del Museo Nacional de México* 1 [1903]:234) first assumed that his mother was Indian, and Palomera states that she was Tlaxcalan (xiv), followed by J. McAndrew (*Open-Air Churches* [1965], 42): "probably a Tlaxcalteca mother".

153. *Rhetorica,* opp. 206. Standing before class, signed "Didacus Valadés fecit," and 210, showing Gante in the pulpit.

154. *Rhetorica,* 224, 225.

155. Palomera, *Valadés* (1963), 159–60.

156. Palomera, *Valadés,* (1962), 319; F. de la Maza, *Anales* (1945).

157. C. Chanfón Olmos returned to the words by Valadés in his recent article on this scene ("Antecedentes mexicanos," *Cuadernos de Arquitectura Virreinal* [1985]).

158. The paging of the edition of 1579 has errors of numbering in the four copies consulted, where 206 and 210 are numbered as 106 and 110. 216 and 217 are also misnumbered in the copy at Yale University and in the three copies at the Library of Congress and in the copy at the University of California at Los Angeles.

159. Mendieta used a copy of this drawing for his *Historia,* and it has the slipknot correctly drawn. (Palomera (1962), fig. 29).

160. J. G. Varner, *El Inca* (Austin, 1968), 243–48.

161. Carmel Sáenz, introduction to *Comentarios reales* (Madrid, 1963), 1:xv–xvii, 2:vii–viii.

162. *Diálogos de amor* (Madrid, 1590). The license to publish this "traduciõ del Indio" is dated 7.IX.1588 (3r.). A dedication to Maximilian of Austria (4r.) mentions three drafts (12.III.1587.) Another to Philip II specifies that it was translated from "Toscano en Español," and "offered as tribute" from his "vassals, the natives of the New World" (19.I.1586). It was Garcilaso's opinion that Leo wrote in Italian. See C. A. Mackehenie, "Apuntes sobre las traducciones castellanas de León Hebreo," *Mercurio Peruano* 22, no. 165 (1940), year 15 (Lima). The study is bibliographic only.

163. Agustín de Herrera, Gerónimo de Prado, SJ (Villalpando's associate), Pedro Sanchez de Herrera (of Montilla, Garcilaso's instructor in theology), and Fernando de Zarate, OSA (11r.). Garcilaso also could have used two Spanish editions of the work (Venice, 1568, and Zaragoza, 1582).

164. Varner (*El Inca,* 279) sees Garcilaso's interest in Leo Hebraeo only as "a gentlemanly exercise" in "the art of translation," but A. Miró Quesada (*El Inca Garcilaso* [Madrid, 1971], 121)explains the *Diálogos* by the Inca's "spiritual affinity" with a "philosophy of measure, ponderation and harmony."

165. *Obras* (1965), 1:119–20.

166. Heinz Pflaum, "Die Idee der Liebe, Leone Ebreo," *Heidelberger Abhandlungen zur Philosophie und ihrer Geschichte* 7 (1926):65–67, 104. Leo Hebraeus (b. Lisbon, after 1460, in Spain, 1484–92, obit Zurich, 1542).

167. *Diálogos*, 146. All this material is attributed by Leo to "Hebenzabron in *Fonte vitae*," yet nothing in the *Fons vitae* of Ibn Gabirol (c. 1021–1070) (ed. J. Schlanger [Paris, 1970]) resembles these words. The reference does suggest the scope of Leo's sources for the *Dialoghi*.

168. R. Porras, *Los cronistas del Perú* (Lima, 1962), 312. Varner (*El Inca*, 249) stressed only his willingness to serve" and a "modicum of sympathy for the victims" Rafael Guevara Bazán ("El Inca Garcilaso y el Islam," *Boletín del Instituto Caro y Cuervo* 22, no. 1 [1967], 467–77) reviews Garcilaso's service in the army in 1570.

169. A. Dominguez Ortiz and Bernard Vincent, *Historia de los moriscos* (Madrid, 1978).

170. A. Bonet, "Superchería y fe," *Historia* 61 (1981). M. J. Hagerty, *Los libros plúmbeos del Sacromonte* (Madrid, 1980).

171. *Enciclopedia universal ilustrada europeo-americano* (Barcelona, 1942), 36:696.

172. Porras (*Los cronistas*, 313) noted that the *Comentarios* both seek reconcilation in *mestizaje*. See also José Durand, "Garcilaso el Inca, platónico," *Las Moradas* (Lima) 3 (1949):121–29 (also in *Diogène* [1963], 24–46); "La biblioteca del Inca," *Nueva Revista de Filología Hispánica* 2 (1948):238–64. Nathan Wachtel, *La vision des vaincus*, (Paris, 1971), 244–45; T. A. Perry, *Léon Hébreu, dialogues d'amour* (Chapel Hill, 1974), 24–25.

173. *Nueva corónica y buen gobierno* (Paris, Institut d'Ethnologie, facsimile edition, 1936). John Murra and R. Adorno edited the manuscript, providing full translation and commentaries (*Guaman Poma* [Mexico, 1980]). The translation of parts in Quechua is by J. L. Urioste. In it R. Adorno (1:xiii) assigns pp. 1–437 to 1612–13 and the remainder as of 1613–15.

174. L. Millones y Gadea ("Un movimiento nativista del siglo XVI: El Taki Onqoy," *Revista Peruana de Cultura* 3 [1964]:134–39) lists papers in the Archivo de Indias in Seville from 1570 to 1584 bearing on the services of Albornoz as an "extirpator of idolatry." Albornoz also wrote an "Instrucción para descubrir todas las guacas del Pirú y sus camayos" [1580s], *Journal de la Société des Américanistes* 56 (1967):17–39.

175. Murra, *Guaman Poma*, 1:5–7.

176. C. Dilke, *Letter to a King* (London, 1978).

177. Murra, *Guaman Poma*, 1:xiii.

178. Ibid., 1:40–63.

179. P. 69. T. Zuidema (*The Ceque System of Cuzco* [Leyden, 1964], 103–13) and J. M. Ossio ("Guaman Poma: Nueva corónica o carta al rey? Un intento de aproximación a las categorias del pensamiento del mundo andino"), in *Ideología mesiánica del mundo andino,* both treat cyclic creations as Andean in origin without considering the Mesoamerican parallels as possible origins, whether palaeolithic or post-Conquest or both.

180. Examples are the engravings on wood of Roman provinces and cities in Europe and Asia Minor (*Notitia utraque cum Orientis tum Occidentis* etc. [Basel, Froben, 1552]), e.g., Dalmatia (pl. 52), displaying an imaginary Roman architecture within an arcaded wall and Renaissance gateway.

181. *Historia general del Perú,* 2 vols., ed. M. Ballesteros Gaibrois (Madrid, 1962–64), J. H. Rowe (in *Miscellanea P. Rivet* [1958], 2:510–11) describes his two books (*Historia del origen,* ed. C. Bayle [1946]).

182. Only five drawings (now at Loyola in Spain) were published by Bayle in 1946 (G. Kubler, *Hispanic American Historical Review* 27 (1947):299–300, 561–62). In the manuscript by Murua at the Getty Museum (Malibu, California), two drawings (84r. and 89r.) are clearly by Guaman Poma. 79r. may have been retouched in the heralded shield by Guaman Poma's black-line drawing, which resembles woodcut workmanship.

183. Her semiotic purpose precludes consideration of figural art before the Conquest as well as of coeval European figuration. Her semiology is that of Roland Barthes, *Mythologies* (New York, 1972); J. Burnham, *The Structure of Art* (New York, 1971); B. A. Uspensky, "The Language of Ancient Painting," *Dispositio* 1 (1976):220; M. Serres, "Peter-Stephen Isomorphisms, 2," *Diacritics* 5 (1975), and M. Schapiro, "Semiotics of Visual Art," *Semiotica* 1 (1969).

184. Nathan Wachtel, "Pensée sauvage et acculturation," *Annales Économies, Sociétés, Civilisations* 26 (1971): 793–840; J. M. Ossio, "Guaman Poma," in *Ideologia mesiánica* (Lima, 1973), 155–213.

185. R. Adorno, "Icon and Idea: A Symbolic Reading of Pictures in a Peruvian Indian Chronicle, "*The Indian Historian* 12, no. 3 (1970):29–49.

186. R. Ricard, *La "conquête spirituelle" du Mexique* (Paris, 1933); *Handbook of Middle American Indians* (Guide to ethnohistorical sources), ed. H. Cline, vols. 12–16 (Austin, 1972–75). Edmonson, *Sixteenth-Century Mexico.*

187. *Obras históricas,* ed. E. O'Gorman (Mexico, 1975), 2:37: Itzcoatzin and Xiuhcoxcatzin, whom he presents as *infantes* (royal princes) and sons of Huitzilihuitl, who ruled in the fourteenth century at Tenochtitlán. Another *infante,* the biographer of Nezahualpilli, was Quauhtlatzacuilotzin of Chiauhtla. Descendants of Nezahualpilli in Texcoco who wrote histories were Pablo, Toribio, and Hernando Pimentel as well as Juan de Pomar (Ixtlilxóchitl's probable source for this chapter). Alonso Axayacatzin was son of Cuitláhuac and nephew of Moctezuma II.

188. A. M. Garibay, *Historia de la literatura náhuatl* (Mexico, 1953), 1:45.

189. The only securely dated one is the "Compendio histórico de los reyes e Texcoco" in 1628 (*Obras históricas,* ed. E. O'Gorman, 1:88–116), preceded by the *Sumaria Relación,* begun c. 1600 (completed in 1625?). These were composed in Náhuatl (*Obras,* 1:517–21, testimony, 1608), but the original manuscripts are all lost (*Obras* (1975), 1:97).

190. *Obras* (1975), 1:25–28 and Appendix 9, 334–35.

191. C. Gibson, *The Aztecs under Spanish Rule* (Stanford, 1964), 220.

192. O'Gorman, Introduction to Ixtlilxóchitl's *Obras* (1975), 1, Registro de Citas, 49–85, listing 320 sources, of which only nine are surely known to survive. (Indice, 1:75–85). These are *Códice Xólotl,* the letters of Cortés, the histories by Gómara, Herrera, and Torquemada, the *Relación* of Juan Bautista Pomar, and the *mapas* of Quinatzín, Tepechpan, and Tlotzín.

193. E. O'Gorman, ed., *Nezahualcoyotl Acolmiztli (1402–1472)* (Mexico, 1972), 12–13.

194. *Obras,* 1:11.

195. Keen (*Aztec Image,* 200–01) stresses Ixtlilxóchitl's "reading of Spanish medieval chronicles, romances of chivalry, and pastoral romances" as well as his "immense bitterness" about "Spanish treatment of the Indians in his time."

196. "Relación," *Obras* 1:399.
197. G. Zimmermann, *Die Relationen Chimalpahin's zur Geschichte Mexiko's* (Hamburg, 1963); S. Rendón, *Relaciones originales de Chalco Amaquemecan* (Mexico, 1965).
198. R. Siméon, *Annales* . . . *1258–1612* (Paris, 1889), xix, 42.
199. *Die Kultur der Renaissance in Italien. Ein Versuch* (Basel, 1955) (Gesammelte Werke, III) 1, 88.

Chapter 3. Idealist Studies of Amerindia from Above

1. Benjamin Keen, Gerbi "Obituary," *Hispanic-American Historical Review* 58 (1978):80–81.
2. *La politica del settecento* (Bari, 1928), n. 3.
3. *La disputá del nuovo mondo: Storia di una polemica, 1750–1900* (Milan-Naples, 1955) (editions in Spanish, 1960, and English, 1973). *La natura delle Indie Nove* (Naples, 1935) (Spanish edition, Mexico, 1978) is in two parts: writers from Columbus to Verrazzano, (15–148) and Gonzalo Fernández de Oviedo (149–480).
4. Gerbi, *Disputá* (1960), on Kant, 300–06; on Hegel, 385–409.
5. Gerbi, *Disputá*, (1960), 139–41.
6. *Recherches philosophiques sur les Americains* (Berlin, 1768), 1:4–12.
7. *Histoire philosophique et politique des etablissements et du commerce dans les deux Indes* (Amsterdam, 1770), 6 vols., Keen, *Aztec Image*, 263.
8. *Disputá*, 411–519.
9. Gerbi, *La naturaleza de las Indias Nuevas* trans. A. Alatorre (Mexico, 1978). The Italian original (*La natura delle Indie Nove* [Naples, 1975]) appeared after Benjamin Keen's *Aztec Image,* who made no room for Gerbi beyond one reference on Herder as the antithesis of de Pauw ([1971] 328, 600). Keen, however, wrote Gerbi's obituary (*Hispanic-American Historical Review* 58 (1978): 80–81), praising *Naturaleza* as "the first thorough study" of Oviedo.
10. Gerbi, *Naturaleza,* 40.
11. Ibid., 57.
12. Ibid., 105.
13. Ed. J. Amador de los Rios (Madrid, 1855–56), 4 vols.; Gerbi, *Naturaleza,* 212, 213–16.
14. Gerbi, *Naturaleza,* 216.
15. M. Moreno Bonett, *Nacionalismo novohispano* (Mexico, 1983).
16. *Vico and Herder* (London, 1976), xvi, 64.
17. Eric Auerbach, "Vico and Aesthetic Historism," *Journal of Aesthetics and Art Criticism* 8 (1949):110–18, does not mention Boturini or America.
18. G. Kubler, "Vico's Idea of America." In *Corrected Essays,* ed. T. Reese, 296–300. New Haven, 1985.
19. A. Matute, *Lorenzo Boturini y el pensamiento histórico de vico* (Mexico, 1976), 13–18.
20. Edited by Manuel Ballesteros y Gaibrois (Madrid, 1947), chap. 2; cited from Matute, *Boturini,* 59.
21. Gustavo Costa, "A proposito del rapporto Vico-Boturini" *Bollettino del Centro di Studi Vichiani* 9 (1979):137.

22. M. León-Portilla, ed., *Idea* (Mexico, 1974), including the text of the address in 1750. Other recent studies are by A. Matute, *Boturini,* and Pietro Piovani, "Notizie," *Bollettino del Centro di Studi Vichiani* 5 (1975):168–72; also Franco Venturi, "Un Vichiano tra Messico y Spagna: Lorenzo Boturini Benaduci," *Rivista Storica Italiana* 87 (1975):770–84.

23. R. Vargas Ugarte, *Tres figuras señeras del episcopado americano* (Lima, 1966), 166.

24. M. Maticorena Estrada, "Informe sobre el archivo del seminario de Santo Toribio," Ms prepared in Lima during 1949 in the archival survey directed by G. Kubler. Toribio Alfonso Mogrovejo, archibishop of Lima 1580–1606, beatified 1679, canonized 1726, had founded the seminary there in 1591, following a decree of the Council of Trent. Promulgated in 1565 (R. Vargas Ugarte, *Historia del Seminario de Santo Toribio de Lima* [1969], 8, 57).

25. Vargas, *Historia,* 44.

26. J. Dominguez Bordona, ed., *Trujillo del Perú a fines del siglo XVIII: Dibujos y aquarelas que mandó hacer el obispo D. Baltasar Martinez Compañon* (Madrid, 1936).

27. Vargas, *Tres figuras,* 205–09, "Carta a su Majestad, Trujillo, 15 de Mayo de 1786." Only one-fifth of the drawings were reproduced; the small facsimile appeared in 1978 (*La obra del Obispo Martiñez Compañon sobre Trujillo del Perú en el siglo XVIII,* 3 vols., ed. Cultura Hispánica, Madrid, Centro Iberamericano de Cooperación).

28. Vargas, *Tres figuras,* 205–06. The indignation expressed by Martinez recalls that of Felipe Guaman Poma before 1615, who also traveled on church business in southern Peru for many years and sent a report to Philip III illustrated with his own drawings of Indians abused by the other castes of colonial society.

29. Ibid., 210–13.

30. Ibid., 221–22, 227–29.

31. Ibid., 208: the estimated annual cost divided by the individual cost per pupil (62,346 pesos/170 pesos = 366.7) of Indian tuition and board.

32. Vargas, *Tres figuras,* 200.

33. Vargas, *Tres figuras,* 169.

34. R. L. Brunhouse, *In Search of the Maya: The First Archaeologists* (Albuquerque, 1973), 5–16.

35. J. Alcina Franch, *Guillermo Dupaix* 2 vols., (Madrid, 1969). It is thought that he was born in the Duchy of Luxembourg, coming to the attention of Charles III when he ruled in Naples (1734–60.

36. Ibid., 2:103. Supposing natural crystals in these carved jade objects, he made his principle clear.

37. Guillermo Dupaix, *Expediciones 1805–1808,* 2 vols., ed. J. Alcina Franch (Madrid, 1969), 1:225.

38. "Cartas mejicanas escritas por D. Benito María de Moxó en 1805." Documents and bibliography of his publications in Vargas *Tres figuras,* 65–163.

39. D. Botting, *Humboldt and the Cosmos* (New York, 1973), 30, 189, 192, 227. Through Humboldt, Gérard got commissions for portraits of Frederick William of Prussia, Alexander of Russia, "various princes," and Wellington for 12,000 to 15,000 francs each (217).

40. Volume 2 was first printed in 1846.

41. *Views of Nature,* trans. Mrs. Sabine (Philadelphia, 1849), 244–45.

42. Ibid., 363–64, citing the examples of "the Carracci, Gaspar Poussin, Claude Lorrain, Ruysdael, and Everdingen."

43. The passage is quoted from *Cosmos* (1846): 88–90 (Sabine trans. 86–87). Also M. Rojas-Mix, "Die Bedeutung A. von Humboldts für die künstlerische Darstellung Lateinamerikas."

44. Paris (1810–); translated by H. M. Williams as *Researches Concerning the Institutions and Monuments of the Ancient Inhabitants of America*, 2 vols. (London, 1814).

45. Ibid., 1:37.

46. Ibid., 1:101.

47. Ibid., 1:35–37.

48. R. Löschner, "Humboldts Naturbild und seine Vorstellung von künstlerisch-physiognomischen Landschaftsbildern," in *Mythen der Neuen Welt*, ed. Karl-Heinz Kohl (Berlin, 1982), 245–53.

49. Ibid., 245, citing Humboldt, *Ideen zu einer Georgraphie der Pflanze* (Tübingen and Paris, 1807) (dedicated to Goethe).

50. His low estimate of Amerindian monuments in world history appeared in 1810 in Williams, *Researches*: "The works of the early inhabitants of Mexico stand between those of the Scythian peoples and the ancient monuments of Hindustan" (1:38).

51. I. Bernal, "Humboldt y la arqueología mexicana, in *Ensayos sobre Humboldt*, ed. M. O. Bopp (Mexico, 1962), 121–32.

52. N. León-Portilla, "Humboldt, investigador de los códices y la cosmología náhuatl," in ibid., 133–48.

53. P. Kirchhoff, I. Bernal, and M. León-Portilla all noted that Humboldt accepted Asiatic influences in postglacial America. This was before Alfonso Caso's public rejection of transpacific diffusion in 1962, ending its official approval by the Instituto Nacional de Antropología since 1950 ("Relations," 1965.)

54. *Aztec Image*, 328, 330, 331.

55. *Mañanas de la alameda de México*, 2 vols. (Mexico, 1835), and J. J. Granados y Galvez, *Tardes americanas* (Mexico, 1778).

56. Keen, *Aztec Image*, 231.

57. Keen (ibid., 318, 320) notes that Bustamante was a disciple of Fray Servando de Mier, who linked Mexican Christianity to the presence of the apostle.

58. Luis Villoro, *Los grandes momentos del indigenismo en México* (Mexico, 1950).

59. P. J. Márquez (*Due antichi monumenti di architettura mexicana* [Rome, 1804]; also in Spanish, *Sobre lo bello en general* [Mexico 1972]) on Tajín and Xochicalco; Franch, *Dupaix*.

60. C. E. Mace "Brasseur de Bourbourg," *Handbook of Middle American Indians* 13 (1975): 311. Keen (*Aztec Image*, 340–46) observed that Brasseur "owed much to Boturini and perhaps to Vico" in his *Historie des nations civilisées du Mexique et de l'Amerique Centrale*, 4 vols. (Paris, 1857–59), 1:33, where the gods are "the base for the national institutions of ancient peoples."

61. *Letters* (Mexico, 1851), 7.

62. A. Chapman, *Puertos de intercambio en Mesoamérica* (Mexico, 1959). Less credible is the recent theory of L. Schele that Palenque was a cemetery, painted red in antiquity. Refuted by M. Foncerrada de Molina, "Reflexiones en torno a Palenque como necrópolis," *Primera Mesa Redonda de Palenque* (Part II) (Pebble Beach, 1974), 77–79.

63. Brasseur, *Histoire*, 1:109. Contrast M. Coe, *The Maya Scribe and His World* (New York, 1973), 12.

64. *Histoire*, 1:116.

65. G. Willey, "Mesoamerican Civilization and the Idea of Transcendence," *Antiquity* 50 (1976): 205–15.

66. *Lettres pour servir d'introduction á l'histoire primitive des nations civilisées de l'Amerique septentrionale* (Mexico, 1851). His use of "North America" reflects his belief that it "early extended its benefits" to Mexico and Central America (*Histoire*, 1:33), as well as a geographic usage of long standing that includes Mexico with the North American land mass.

67. *Histoire*.

68. Brunhouse (*In Search of the Maya*, 113–35) tells of Brasseur and Prescott in Boston in 1846; his studies in Rome until 1848; his residence in Mexico City 1848–50; writing the *Lettres* in Paris (1851–54); return to America 1854–60; editing the *Popol Vuh* in 1861 and Landa's *Relación* in 1863.

69. His source was Sahagún, vol. 3, chap. 5.

70. Marvin Harris, *The Rise of Anthropological Theory* (New York, 1968).

71. Boturini, *Idea* (1746); "Historia" [1748], ed. Ballesteros (Madrid, 1948).

72. D. H. Porter, *Emergence of the Past* (1981); P. J. Watson et al., *Explanation in Archaeology: An Explicitly Scientific Approach* (New York, 1975), 28: historical explanation cannot be tested but only assessed as to "competence of the person proposing the reconstruction."

73. *Rise and Fall of Maya Civilization* (Norman, 1954).

74. Willey (*History* [1980], 65) mentions Brasseur once, but more as an antiquary than as a philologist.

75. Brasseur, (bk. VIII, chap. 4, 578) rewrote the legend of King Nohpat, collected by Stephens and Cazares, as published in the *Registro yucateco*, vol. 2 (1845), "Dos dias en Nohpat."

76. *Histoire*, bk. XII, chap. 6, 647–80, is a brief history of arts and crafts in ancient Mesoamerica, based on Acosta, *Historia* [1590], bk. V, chap. 30, taken from Diego Durán [1570]. Brunhouse (*In Search of the Maya*, 134) concludes that Brasseur's "positive contributions still tower over his mistakes."

77. *L'Anthropologie*, (1904), 15:608–09.

78. Pliocene (or Tertiary) : 1 to 10 million years ago.

79. Page references here are from the original edition (*L'Amérique préhistorique* [Paris, 1982]), translated by N. D. Anvers into English, appearing in New York and London, 1883, as *Prehistoric America*, with illustrations added from E. G. Squier's works.

80. *Ancient Cities*, xiii, xxvi.

81. Ibid., 104, 153.

82. Ibid., 163, 173, 175. See Diehl and Mandeville, "Wheeled Animal Effigies," 241–46.

83. Ibid., 412.

84. Ibid., vii. This argument is also that of J. L. Stephens, *Yucatan*, (1843), 2:445, and Brasseur de Bourbourg, *Histoire*, although Charnay models his narrative on Stephens and mentions his compatriot Brasseur only when quoting (307–08) from documents published in Bernardo de Lizana's *Nuestra* history of the church at Izamal (*Historia de Yucatán*, first published in 1633 and reprinted in 1893]. Charnay's American agent was the editor of the *North American Review*, Allen Thorndike Rice, who wrote the introduction to *Ancient Cities* and intervened

both with Lorillard and the French government to back Charnay financially. Rice here joined H. H. Bancroft in rejecting Brasseur's "Atlantis theory" drawn from the "Codex Chimalpopca" in Brasseur's *Lettres* of 1851 (*Ancient Cities*, xiv–xxiii).

85. Ibid., xxviii.

86. Friedrich Kofler in Darmstadt, the sponsor of a supportive review article on Charnay's opinions ("Charnays Ansichten," *Zeitschrift für Ethnologie* 14 [1882]: 10–25) as of that year, was a travel acquaintance of Charnay's in American.

87. *Cités et ruines américaines* (Paris, 1862–63), 543 pages and folio atlas of forty-nine photographs.

88. Often signed with names on the lower corners of the blocks, these illustrations should be compared with the negatives and prints in the Musée de l'Homme. Lemaire (153) was also "a promising topographer, a good draughtsman," credited with the plans of Tula (105) and Palenque (225).

89. As the Tlaloc (fig. 28) from Tlaxcala was more "archaic" in appearance than the Chac Mool at Chichén Itzá (365–66), Charnay was the first and not the last to argue that Tula was older than the Maya site, by assuming (21) that "all the monuments in North America were of Toltec origin." This chronology is credited by Charnay to Baron Friedrichsthal, a German traveler whom he quotes at length (410–11) from the appendix published by Friedrichsthal in an edition of Diego Lopez de Cogulludo's *Historia de Yucatán* [1688] at Campeche in 1842.

90. *Quatre lettres* (Paris, 1868), 32–142.

91. Biddiss, *Father of Racist Ideology*, 177. This "investigation of Errors" places Gobineau's "formulation of his racist creed around 1850."

Chapter 4. Empiric Esthetics from Below

1. "Idea of the Folk Artifact," in *American Material Culture and Folklife*, ed. S. J. Bronner (Ann Arbor, 1985), 7–8.

2. "Editor's Statement: Art History vs. the History of Art," *Art Journal* 44, no. 4 (1984): 313–14.

3. Daniel Miller and Christopher Tilley, eds., *Ideology, Power and Prehistory* (Cambridge [England], 1984), preface.

4. *Oxford English Dictionary*, "a forcible separation (*rare*)."

5. Bronner, "Idea of the Folk Artifact," 8.

6. K. Groos, *The Play of Animals* (New York, 1892); J. Piaget, *Play, Dreams and Limitation in Children* (New York, 1951); K. Lorenz, "Plays and Vacuum Activities," in *L'Instinct*, ed. Masson (Paris, 1956), 633–46; S. Chevalier-Skolnikoff, "The Primate Play-face," *Rice University Studies* 60, no. 3 (1974): 9–29.

7. *Letters upon the Aesthetical Education of Man* (London, 1906), Letter 15.

8. C. Darwin, *The Expression of the Emotions in Men and Animals* (London, 1872): E. Norbeck, "The Anthropological Study of Human Play," *Rice University Studies* 60, no. 3 (1974): 3.

9. W. Wundt, *G. T. Fechner* (Leipzig, 1901); Fechner, *Annalen der Physik und Chemie* vol. 120 (1838), 211, 513, and vol. 126 (1840), 193, 427. Julian Jaynes, "Fechner," *Dictionary of Scientific Biography* 4 (1971): 556–59.

10. *Vorschule der Ästhetik* (1876), 1:1–7.

11. K. Gilbert, *History of Esthetics* (Bloomington, 1953), 525–27, 581.

12. "Über die subjektiven Nachbilder und Nebenbilder," *Annalen für Physik und Chemie,* 120 (1838), 221–45, 513–35; 126 (1840), 193–221, 427–70.

13. Ibid., 120, 517.

14. Ibid., 126, 195.

15. Ibid., 126, 443–45.

16. Leipzig, 1846.

17. K. Lasswitz (*Fechner* [Stuttgart, 1896], 191) compares him to Columbus: "He did not find what he was looking for but he discovered more than he found."

18. Ibid., 83.

19. Gilbert, *History of Esthetics,* 528; "The *Vorschule* is a collection of essays loosely strung together rather than a systematic treatise."

20. *Autobiography* (London, 1904), vol. 2.

21. *Information Theory and Esthetic Perception,* trans. J. E. Cohen (Urbana, 1966).

22. H. Quitzsch, *Die ästhetischen Ansichten Gottfried Sempers* (Berlin, 1962), 2–5. On his teaching and writing in England, L. Ettlinger, "On Science, Industry and Art: Some Theories of Gottfried Semper," *Architectural Review* (London) 136 (1964): 57–60.

23. G. Cuvier, *Laçons d'anatomie comparée* (Paris, 1805). G. Klemm, *Allgemeine Cultur-Geschichte der Menschheit* (Braunschweig, 1843).

24. *Die Vier Elemente* (1851).

25. First enounced in *Die Vier Elemente* and elaborated as *Der Stil in den technischen und tektonischen Künsten, oder praktische Ästhetik,* 2d ed. (1860, repr. Munich, 1878).

26. Thus Semper's *Urfunktion:* $Y = F (x, y, z \ldots)$ (*Der Stil* [1860], ed., A. v. Buttlar [1977]), where Y stands for art and x, y, z for forces or agencies.

27. E.g., "Evolution of the Aesthetic" (1892), passim. See pp. 117–22.

28. W. Waetzoldt, *Deutsche Kunsthistoriker* (Leipzig, 1924), 2:135 (quoting Goethe to Herder).

29. Reissued with a preface by Konrad Lorenz (Chicago, 1965).

30. Darwin, *Expression* (1965), 2.

31. Ibid., 15–17.

32. Ibid., 9 n. 11.

33. Ibid., 14. Darwin used the translation by W. Ross (1836), 19.

34. "Vorlesungen," ed. J. Minor, *Deutsche Litteraturdenkmale des 18. und 19. Jahrhunderts* (1884).

35. M. A. Lifshitz, *Karl Marx und die Ästhetik* (Dresden, 1967), 41. No evidence is now known that Marx read or knew Kugler.

36. Ibid., 66–67. These writings were in collaboration with Bruno Bauer, from whom Marx soon separated as being a bourgeois liberal and romantic.

37. See K. Marx and F. Engels, *Über Kunst und Literatur,* 2 vols. (Berlin, 1968). O. K. Werckmeister mentions other East German and Russian studies of Marx and esthetics in his study "Marx on Ideology and Art," *New Literary History* 4 (1972–73): 500–19 (reprinted in German as *Ideologie und Kunst bei Marx u. a. Essays* [Frankfurt, 1974]).

38. The "Brief Biography" (*Ohio Archaeological and Historical Quarterly* 36, no. 4 [October, 1927]: 493–511) was probably written by the editor C. B. Galbreath in Columbus with the subtitle "Artist, Geologist, Archaeologist and Art Gallery Director."

39. H. H. Bancroft, *The Book of the Fair* (Chicago, 1895), vol. 3, *Anthropol-*

ogy and Ethnology, 629–63. Louis Sullivan and Frank Lloyd Wright both knew the exhibition and used its forms in their own ways.

40. Ibid., 631–33.

41. Introduction to the reissue in 1977 of the *Holmes Anniversary Volume,* vii, first published in 1916.

42. L. M. Fink, introduction, *Descriptive Catalogue of Painting and Sculpture in the National Museum of American Art* (Boston, 1983), ix–xii.

43. G. Willey and J. Sabloff, *A History of American Archaeology,* 2d ed. (San Francisco, 1980), 49–50.

44. *Transactions of the Anthropological Society of Washington* 2 (1882–83), 94–119; *Annual Report of the Bureau of Ethnology* 2 (1880–81): 179–305 [Washington, 1883].

45. "Origin and Development of Form and Ornament in Ceramic Art," *Annual Report of the Bureau of Ethnology* 4 (1882–83): 437–65; "Pottery of the Ancient Pueblos" ibid., 257–360 (Washington, 1886).

46. "A Study of the Textile Art in Its Relation to the Development of Form and Ornament," *Annual Report of the Bureau of Ethnology* 6 (1884–85): 13–187 [Washington, 1888].

47. "On the Evolution of Ornament: An American Lesson," *American Anthropologist* 3 (1890): 137–46.

48. "Evolution of the Aesthetic," *Proceedings, American Association for the Advancement of Science* 41 (1892): 239–55; "Order of Development of the Primal Shaping Arts," ibid., 42 (1894): 289–300. Holmes's relation to Semper was first noted by R. H. Lowie (*Selected Papers* [Berkeley, 1960], 88–89).

49. Semper, *Der Stil.* On Leroi-Gourhan, see above, pp. 20–27, and Semper, pp. 114–15.

50. Such graphs are named "unimodal" by Willey and Sabloff (*History of American Archaeology,* 100) and described as representing "type frequencies." See also this volume, p. 187.

51. Holmes, "Order of Development," 88 n. 5.

52. Ibid., 291, 293.

53. C. M. Nelson, "William Henry Holmes: Beginning a Career in Art and Science," *Records of the Columbia Historical Society* 50 (1980): 254.

54. Ibid., 263–64.

55. Ibid., 265–69. F. V. Hayden, who led the eleven-man division, had Holmes appointed as assistant geologist in 1874.

56. Ibid., 272. A watercolor of a Mancos Valley cliff house by Holmes illustrates the exhibition catalogue by C. C. Eldredge, J. Schimmel, and W. W. Truettner, *Art in New Mexico, 1900–1945* (Washington, 1986), 200, fig. 9, dated 1875.

57. Nelson, "Holmes," 273.

58. W. Stegner, *Beyond the Hundredth Meridian* (Boston, 1954), 189, 191.

59. *Archaeological Studies among the Ancient Cities of Mexico,"* Field Columbian Museum Publication, 2 vols., Anthropological Series I (Chicago, 1895–97).

60. Mr. and Mrs. Chain, with W. H. Jackson, were the photographers (*Brief Biography,* 503), Mr. and Mrs. Chain provided the private car.

61. Part 1: Monuments of Yucatán. Part 2: Monuments of Chiapas, Oaxaca, and the Valley of Mexico. Publications of the Field Columbian Museum, Anthropological Series (Chicago, 1895–97). A third part (not published) was to be on "Ceramic Art of Mexico" (p. 7).

62. For part 1 he depended on books by J. L. Stephens, D. Charnay, A. Le Plongeon, A. Maudslay, A. Bandelier, and H. H. Bancroft. On ancient writings he also knew the works of E. Seler, E. H. Thompson, C. Thomas, D. G. Brinton, E. W. Förstemann, P. Schellhas, and P. Valentini.

63. *Archaeological Studies,* 1:48–52.

64. Ibid., 89.

65. Ibid.

66. Ibid., 53–55.

67. Ibid., 2:226. Confirmed by R. Blanton, *Monte Albán: Settlement Patterns* (New York, 1978).

68. *Archaeological Studies,* 2:303. Compare R. Millon, *The Teotihuacán Map,* 2 vols. (Austin, 1973).

69. *Archaeological Studies,* 2:303.

70. *Bulletin* 30, Bureau of American Ethnology, pt. 1, 1907; pt. 2, 1910.

71. *The Bureau of American Ethnology. A Partial History* (Norman, 1967), 23–25.

72. The National Gallery of Art, *Catalogue of Collections,* Smithsonian Institution (Washington, 1922).

73. "On the Evolution of Ornament: An American Lesson," *American Anthropologist* 3 (April, 1890) 137–46. P. Kelemen notes Holmes's importance as a writer on art ("Pre-Columbian Art and Art History," *American Antiquity* 11, no. 3 [1946]: 148).

Chapter 5. Americanist Historians of Art since 1840

1. *Central America* (1841), 1:32. Herder said in 1784 that "the peaceful pencil . . . has scarcely entered the minds of travellers, the words do not paint forms" (*Philosophy of History,* 161).

2. *Central America,* 1:97.

3. Ibid., 102, 105, 158. From his previous travels in Egypt, Arabia, Greece, Turkey, and Russia, he concluded on leaving Copán that its sculpture was "excellent, rich in ornament, different from the works of any other people in its tone . . . of deep solemnity."

4. *Central America,* 1:137; 2:309.

5. Ibid., 2:298, 343, 346.

6. Ibid., 313–14, 319–20. For present opinions, see the articles in *Mesa Redonda de Palenque,* edited by Merle Greene Robertson.

7. *Central America,* 2:442, 445.

8. *Yucatán,* 1:149, 306.

9. Ibid., I, 273–75.

10. *Yucatán,* 2:445.

11. *Handbuch der Kunstgeschichte* (Stuttgart, 1841–42). See footnote 4, Introduction.

12. W. Waetzoldt, *Deutsche Kunsthistoriker* (Leipzig, 1924), 2:215. J. G. von Herder, *Outlines of a Philosophy of the History of Man* (1784), trans. T. Churchill (1799) (New York, 1966).

13. C. Petranu, *Inhaltsproblem und Kunstgeschichte* (Vienna, 1921), 64–67.

14. *Handbuch* (1841–42), 5.

15. Ibid., ix.

16. *Handbuch* (1856), 1:29.

17. K. E. Gilbert, *A History of Esthetics* (Bloomington, 1953), 268, on *La Scienza Nuova* (1725).

18. Ursula Francke, *Die Kunst als Erkenntnis* (Wiesbaden, 1972), on Baumgarten's proposition that *Aesthetica est scientia cognitionis sensitivae* (1750).

19. *Geschichte der Kunst des Altertums* (1764); Waetzoldt, *Deutsche Kunsthistoriker*, 2:52.

20. Waetzoldt, *Deutsche Kunsthistoriker*, 2:162. Other sources of Kugler's illustrations in 1841–42: J. D. von Braunschweig, *Denkmäler* (1840), Alcide d'Orbigny, *L'homme américain* (Paris, 1839), G. Dupaix in Kingsborough, *Antiquities* (London 1831–38), C. Nebel, *Viaje pintoresco* (Paris 1829–34), J. F. Waldeck, *Voyage pittoresque* (Paris, 1838), G. Beltrami, *Le Mexique* (Paris, 1830). As though encouraged by Kugler's success, Anton Springer published *Die Bildenden Künste in ihrer weltgeschichtlichen Entwicklung* (Prague, 1857). The American section brings nothing new in its five pages, using only the illustrations of Voit's atlas prepared for Kugler.

21. *Kunsthistorische Briefe. Die Bildenden Künste in ihrer weltgeschichtlichen Entwicklung,* 8. The ninety-three Letters are divided as four "books": (1) Art of Asiatic peoples; (2) Art of classical antiquity; (3) Art of the Middle Ages; (4) Completion of medieval art by the renewal of ancient studies and the beginning of modern art. Springer's remarks on America are in the second and third letters (delivered as a lecture in 1856 at Cologne). The first letter acknowledges his debt to F.-T. Vischer (1807–87), the Hegelian who denied Hegel's "belief in a lawful development of world history" (8).

22. Springer used the same repertory of engravings by A. Voit that had accompanied the later editions of Kugler's *Handbuch* as the *Kunstatlas*.

23. Waetzoldt, *Deutsche Kunsthistoriker*, 2:116.

24. *Manuel de l'archéologie américaine* (Paris, 1912).

25. Ibid., 179.

26. *Isis* (1913), 1:530–37.

27. This positivist phrase is H. Taine's, from *Philosophie de l'art* (Paris, 1875).

28. J. F. de Nadaillac, *L'Amérique préhistorique* (Paris, 1883).

29. *Memoirs* (Peabody Museum), 6 (1913). Reissued at Indian Hills (Colorado) in 1957 (Part I, "A Study of Maya Art," and Part II, "The Nuclear Civilization of the Maya and Related Cultures"). Part II (267–368) is a reprint of the third revised edition (1928) of *Ancient Civilizations of Mexico and Central America*. The Epilogue, subtitled "Maya Dynamic Dating and the Fallacy of Time," is a new essay on astronomy (369–95) in Spinden's style of lecturing with many asides relating to history and ecology. A poem in 1913 by Spinden, *To the Maya,* precedes the reprints. This in turn was reissued by Dover Publications in New York in 1975 with an introduction and bibliography by J. Eric S. Thompson.

30. On symbolism in Mexico he cited works by K. T. Preuss, Z. Nuttall, F. W. Putnam, and C. C. Willoughby.

31. D. W. Ross, "Design as a Science," *Proceedings, American Academy of Arts and Sciences,* 36, no. 21 (1901): 357–74.

32. *Transactions, American Philosophical Society* 15 (1881): 279–351.

33. "Representation of Deities of the Maya Manuscripts," *Peabody Museum Papers* 4, no. 1 (1904): 7–47.

34. Spinden (12.9.0.0.0–A.D. 1536) differs from Goodman-Thompson-Martinez as under 260 years earlier. The Goodman-Thompson-Martinez equation is favored by most archaeologists (Willey, *Introduction* [1966], 1:136).

35. *Ancient Civilizations of Mexico and Central America*, New York, American Museum of Natural History, no. 3 (New York, 1917). The third edition in 1928 carried eight more bibliographic references.

36. G. Willey and J. Sabloff, *A History of American Archaeology* (London, 1974), 175: "The horizon style concept was formalized by Kroeber in 1944" ("Peruvian Archaeology in 1942" [New York, Viking Fund Publ. #4, 1944]) as the rapid spread of a style (complex of traits or elements) over a large area.

37. Spinden's "archaic hypothesis" is approvingly discussed by Willey and Sabloff, *A History*, 124–25, who do not comment on Spinden's exclusion of developed religion and symbolic art from the "horizon." Also Willey, "Spinden's Archaic Hypothesis," in *Antiquity and Man*, ed. J. D. Evans, B. Cunliffe, and C. Renfrew (London, 1981), 35–42.

38. "The Reduction of Maya Dates" *Papers, Peabody Museum* 6, no. 4 (1924), is an example.

39. *Summa artis, historia general del arte*, 16 vols., J. Pijoan and Manuel Bartolomé Cossio (Bilbao-Madrid, 1931–67). Vol. 16 appeared posthumously. A prior epitome in three volumes was Pijoan's *Historia del arte a través de la historia*, 3 vols. (Barcelona, 1913–16), translated by R. L. Roys (the Maya scholar) as *History of Art* (New York, 1927–28); reissued by Batsford, London in 1933. Pijoan also issued a four-volume *Historia del arte* in Barcelona that reached a sixth edition in 1961.

40. "Cuicuilco and the Archaic Culture of Mexico," *University of Arizona Bulletin* 4, no. 8 (Social Science Bulletin, no. 4, 1–56), (Tucson).

41. José Tudela, ed., *Relación de las ceremonias y ritos . . . de Michoacán* (Madrid, 1956). This work is attributed to Fray Martin de la Coruña, OFM, by G. Baudot (*Utopie et histoire au Mexique* [Toulouse, 1977], 398) following Mendieta.

42. T. Proskouriakoff, "Historical Implications of a Pattern of Dates at Piedras Negras, Guatemala," *American Antiquity* 25, no. 4 (1960): 449–75. T. Maler, "Researches in the Central Portion of the Usumacintla Valley," *Memoirs Peabody Museum* (Harvard University), 2, no. 1 (1901): 59–60 on Lintel 2, Piedras Negras.

43. The *Summa artis* volume on "Arte precolombino" has not been translated, and it was not reviewed as it deserved in the archaeological journals in English. Reviews in Spanish by Juan Comas (*Acta Americana* 5 (1947): 127) and José Tudela (*Revista de Indias* 8 (1947): 28–29, 592–94) were noncommittal, being more concerned with anthropology than with art history. Tudela lamented the absence of codices and featherwork and of North and South America but praised Pijoan's "potente intuición artística."

44. *L'Art ancien du Mexique* (Paris, 1922). K. E. Gilbert (*A History of Esthetics* 547) saw the problem clearly: "Riegl's 'will to art' leaves us in doubt as to whether we have to do with a psychological hypothesis or with a rudimentary metaphysics."

45. *Arte antiguo de México*, (Mexico, 1950) (trans. by V. Bernard [Garden City, N.Y., 1965] as *The Art of Ancient Mexico*.)

46. Mexico, 1945 (translation of *An Essay on Man* [New Haven, 1944], vii).

47. Other sources used by Westheim for theogony are Alfonso Caso (see pp. 189–90), Frazer, Preuss, Vaillant, Spence, and Lehmann and Seler. Native chroni-

cles (Sahagún, Gómara, Popol Vuh, Book of Chumayel) are also among his references (*Arte,* 13–42).

48. *La religión de los aztecas,* Mexico, 1936.

49. "Caracteres esenciales del arte antiguo mexicano. Su sentido fundamental." *Revista de la Universidad* 5, nos. 27–30 (1933).

50. Westheim here cites the prehistorian Herbert Kühn (*Arte de los primitivos*).

51. H. Wölfflin, *Kunstgeschichtliche Grundbegriffe* (1915).

52. Westheim cites (223–26) W. Worringer, *Griechentum und Gotik.*

53. H. Spinden, *A Study of Maya Art* (Cambridge, 1913), 155, 198, called them First and Second epochs; S. G. Morley, *The Ancient Maya* (Stanford, 1946), 50–97, New and Old empires.

54. The "secular" nature of West Mexican figuration was unchallenged until Peter Furst reinterpreted it by analogy with modern ethnological observations among northwest Mexican peoples ("West Mexican Tomb Sculpture as Evidence for Shamanism" *Antropológica* 15 [1964]: 29–80).

55. *Obras maestras del México antiguo* (Mexico, 1977).

56. Alcina, *Pre-Columbian Art* (1985), 45.

57. The family name in Europe is La Fontaine-d'Harnoncourt Unverzagt (Hubert Harnoncourt, *Gesammelte Nachrichten* [Vienna, 1894]).

58. *Art of Oceania, Africa and the Pre-Columbian Americas from the Museum of Primitive Art* (New York, 1958), unnumbered fo. 3r.

59. Mexico City and New York, 1949, in collaboration with the Mexican government. Essays by A. Castro Leal, A. Caso, M. Toussaint, R. Montenegro, M. Covarrubias.

60. "A Belief in 'Things We Can't Conceive of Yet,'" *Art News* 78 (1979): 138–40. E. Shaw was director of public relations at the Museum of Modern Art from 1949 to 1977 and since then vice-president of Christie's in America.

61. R. F. Schrader, *The Indian Arts and Crafts Board: An Aspect of New Deal Indian Policy* (Albuquerque, 1983), 124–28.

62. Schrader, *Indian Arts and Crafts Board,* 124–241, discusses the history of the board, the San Francisco Exposition, the fieldwork, and the exhibit of Indian arts and crafts at the Museum of Modern Art in 1941.

63. *Arts of the South Seas, in collaboration with René d'Harnoncourt.* Color illustrations by Miguel Covarrubias (New York, 1946).

64. "Arts of the South Seas," *Art Bulletin* 28, no. 2 (1946): 119–23.

65. *Art of Ancient Peru. Selected Works from the Collection* (New York, 1958).

66. *Primitive Art Masterworks: An Exhibition* (New York, 1974).

67. *Art of Oceania, Africa and the Americas,* unpaged; folio 3r.

68. *Art of Ancient Peru,* unnumbered folio 2r. v (Introduction).

69. "North American Indian arts," *Magazine of Art* 32 (1939): 164–67; "Living Arts of the Indians," *Magazine of Art* 34 (1941): 72–77.

70. F. H. Douglas and R. d'Harnoncourt, *Indian Art of the United States* (New York, 1941). The writing is by Douglas, the exhibition design is by d'Harnoncourt.

71. *American Journal of Archaeology* 45 (1941): 650.

72. Schrader, *Indian Arts and Crafts Board,* 3.

73. M. D. Coe (*America's First Civilization* [1968], 145), calls Covarrubias "a

caricaturist at heart" in a study meant to convey admiration. The value of caricature is present in all illustration by simplification for essentials. Coe's is the only posthumous appreciation other than that by Daniel F. Rubín la Borbolla (*American Antiquity* 23 [1957]: 63–64), who knew Covarrubias better than most; saying of him that "as a believer in Transpacific contacts" for earliest "seaborne" man in America "he talked too much, knew too much, and felt too deeply."

74. *The Eagle, the Jaquar, and the Serpent*. The subtitle as *Indian* art of the Americas reflects his intention to include the entire hemisphere.

75. Ibid., 10–11.

76. "Is American Culture Asiatic?" *Natural History* 59, no. 8 (1950); H. S. Gladwin, *Men Out of Asia* (New York, 1947), and "Excavations at Snaketown," Medallion Papers 25–26 (1937); R. v. Heine-Geldern and G. F. Ekholm, "Significant Parallels in the Symbolic Arts of Southern Asia and Middle America," in *The Civilizations of Ancient America*, ed. Sol Tax (Papers, 29th Contress of Americanists, Chicago, 1951).

77. Gladwin, *Men Out of Asia*. J. Imbelloni, "Los grupos raciales aborigines, *Cuadernos de Historia Primitiva* 2 (1948). P. Rivet, *Los origenes del hombre americano* (Mexico, 1943). Covarrubias (25–29) followed Gladwin in 1954.

78. *Mythes et symboles lunaires* (Antwerp, 1932); *Objets rituels, croyances et dieux de la Chine antique et de l'Amérique* (Antwerp, 1936).

79. Covarrubias, *Eagle*, fig. 4, pp. 33, 34–72; hocker figures (bilaterally split); totemic posts; interlocking spirals; eyes and faces on joints and hands; serpent head enframing human face; cults of birds, felines, and serpents; carved jades; funerary mounds; turquoise and feather mosaics; lacquer and fresco painting; pottery, basketry, and cloth techniques; skull and head trophy cults.

80. Ibid., 63.

81. Ibid., 90–96.

82. He was not heeded in 1985 when the Museum of Modern Art organized an exhibition, *"Primitivism" in 20th Century Art*, 2 vols., ed. W. Rubin (New York, 1984).

83. *Primitive Art* (Oslo, 1927).

84. *The Eagle, the Jaguar, and the Serpent* (New York, 1954), 198. Covarrubias praises Franz Boas (91) for recognizing in 1938 (*Encyclopedia of Social Sciences*) the "similarities among artists everywhere."

85. *Indian Art of Mexico and Central America* (New York, 1957), p. xviii, "now unhappily never to be completed" (H. Weinstock, editor, in Publisher's Note) (posthumous).

86. *Tlatilco, Archaic Art and Culture, DYN*, no. 6 (1943), nos. 4, 5.

87. M. W. Stirling, "Stone Monuments of Southern Mexico," *Bulletin of the Bureau of American Ethnology* 138 (Washington, D.C., 1943).

88. Covarrubias, *Indian Art*, 79.

89. *Anales del Instituto de Investigaciones Estéticas* 20 (1957): 99–100.

90. E. Pasztory, "Masterpieces in Pre-Columbian Art," *Actes, 42nd International Congress of Americanists*, (Paris) 7 (1976): 377–90.

91. See pp. 141, 153.

92. *Coatlicue: Estética del arte indígena antigua* (Mexico, Centro de Estudios Filosóficos, 1954).

93. Manuel Toussaint, *Arte colonial en México* (Mexico, 1948); Justino Fernandez, *Arte moderno y contemporáneo de México* (Mexico, 1952).

94. H. R. Jauss, ed., *Die nichtmehr schönen Künste* (Munich, 1968), 13, 239. The topics of these twenty essays by historians of art and literature are on ugliness, horror, loathing, obscenity, disgust, excess, and dissolution. The discussions are on "esthetic limits" (707–22), such as arts of unconscious and pathological content.

95. *The Aztec Image in Western Thought* (New Brunswick, 1971), 517–22. Keen's term for the historiographical position of Fernández as "historicist" in a "historical humanist current" is taken from Samuel Ramos (prólogo to *Coatlicue,* by Fernández, 10–11, as cited above).

96. M. León-Portilla, "Historia, conocimiento del hombre," in *Del arte: Homenaje a Justino Fernandez* (Mexico, 1977), 277.

97. Fernandez, *Estética del arte mexicano* (Mexico, 1972), 19, citing Vico, *Scienza nuova,* 1, chap. 11, and Boturini, *Historia general* (Madrid, 1949), vol. 4.

98. *Revista de Occidente* 1, no. 4 (1923): 67.

99. Introduction to *Coatlicue,* 2d ed. (1959), 51.

100. Reviewing M. Coe (*The Maya* [New York, 1966]), *American Anthropologist* 70 (1968): 166.

101. "A Study of Classic Maya Sculpture," *American Antiquity* 12 (1951): 161–62.

102. "Studies on Middle American Art," in *Anthropology and Art,* ed. C. M. Otten (New York, 1971), 129.

103. M. León-Portilla, prologue to *Arte precolombino,* 3d ed. (1970), 5.

104. *Arte precolombino de México y América Central* (Mexico, 1944). Copious footnotes and new references were added for the third edition by Beatriz de la Fuente at the request of Justino Fernandez in 1970. Their economy, however, is to be noted in the omission of G. E. Lessing (1729–81), J. F. Herbart (1776–1841), J. J. Winckelmann (1717–68), A. Riegl (1858–1905), and W. Worringer (1881–1965), whom Toscano cited (13–14) as his predecessor in esthetic analysis.

105. Lionello Venturi is credited by Toscano with this characterization of Riegl's work, in L. Venturi, *History of Art Criticism,* trans. Marriott (New York, 1936).

106. Toscano was unaware of Kugler and his followers.

107. Here also his passing references to Kant, Rudolf Otto, and Samuel Ramos were elliptical and not expanded in the third edition.

108. *Coatlicue.*

109. Toscano's sources are indexed among the names, but not in the bibliography of the third edition.

110. *Medieval American Art,* 2 vols. (New York, 1943). Toscano did not know Kelemen and does not cite him, nor is he cited in the third edition of 1970. When I began work on *Art and Architecture of ancient America* my first and discarded draft was also in this pattern, which seemed appropriate to the prevailing state of archaeological knowledge (during the war, 1940–45). With the discovery of radiocarbon dating (G. Willey, and J. Sabloff, *A History of American Archaeology* [San Francisco, 1980], 155–57), I rearranged my book by regions alone in 1950. I had met Toscano in 1941, but I did not see his work until 1944.

111. León-Portilla, prologue to *Arte precolombino,* 3d ed., 5. Of Kelemen's work (1943) he writes that it is "impressionistic" and "archaeologically inadequate" (6).

112. Günter Vollmer, "Gerdt Kutscher, 1913–1979," *Indiana* 10, pt. 2 (1984):

485–584. Founded in 1930, the library had 220,000 volumes in 1945 under his care (501) and 400,000 in 1966.

113. Listed by Vollmer, ibid., 543–60.

114. Quoted by Vollmer, ibid., 514.

115. "Zum Gedächtnis von Walter Lehmann," *Archiv für Anthropologie*, n.s. 25 (1949): 140–49. Kutscher here was Lehmann's bibliographer, commenting in detail on most of his ninety publications in American linguistics and ethnohistory.

116. "Berlin als Zentrum der Altamerica-Forschung: Eine bio-bibliographische Übersicht," *Jahrbuch der Stiftung Preussischer Kulturbesitz* 4 (1966): 88–122. Forty-one scholars are discussed.

117. "Zum Gedächtnis" 149, entry 82. The *Katalog* (131, p. 14 plates) does not mention the sixth-form (*Primaner*) student (Kutscher).

118. C. B. Donnan, *Moche Art of Peru* (Los Angeles, 1978), 52.

119. *Los Mochicas,* 2 vols. (Lima, 1938–39).

120. *Chimu: Eine altindianische Hochkultur* alone was printed (Berlin, 1949), 110 pages, 80 plates, 72 figures, map (reprint Hildesheim, 1972).

121. Günter Vollmer, "Gedenkschrift," *Indiana* 10, no. 2 (1984): 574–84.

122. *Nordperuanische Keramik: Figürlich verzierte Gefässe der Früh-Chimu* (Berlin, 1954).

123. Benson, *The Mochica Culture of Peru* (London and New York, 1972); C. Donnan, *Moche Art and Iconography* (Los Angeles, 1976). Donnan's superb archive of Moche art began in 1968, accompanied by summer fieldwork in Peru, including excavations and ethnohistorical research that still continue.

124. Best seen in his *Nordperuanische Keramik* (*Monumenta Americana,* vol. 1) and in other books and articles enumerated by G. Vollmer, "Verzeichnis," *Indiana* 10 (1984): 543–60.

125. E. von Sydow, *Die Kunst der Naturvölker und der Vorzeit* (Berlin, 1925).

126. E. Seler, *Gesammelte Abhandlungen,* (1915), 5:115–25; M. Uhle (A. Kroeber, "Uhle," *University of California Publications in American Archaeology and Ethnology* 21, no. 5 [1925]: 191–234), A. Baessler, *Altperuanische Kunst,* 4 vols. (Berlin, 1902–03) (mostly from the hand of W. v.d. Steinen).

127. The best bibliography in it was prepared by Kutscher for E. von Sydow's *Afrikanische Plastik: Aus dem Nachlass, herausgegeben von Gerdt Kutscher* (Berlin, 1954).

128. "Studien zur Form und Formgeschichte der mexikanischen Bilderschriften," *Zeitschrift für Ethnologie* 72 (1940): 197–234.

129. D. Robertson, "Clio in the New World," in *The Historian's Workshop,* ed. L. P. Curtis, Jr. (New York, 1970), 103–21, esp. 118–19.

130. "Mexican Manuscript Painting of the Early Colonial Period: The Metropolitan Schools" (New Haven, 1959).

131. *Hispanic-American Historical Review* 40 (1960): 282–83.

132. *Painted Architecture and Polychrome Monumental Sculpture in Mesoamerica: A Symposium at Dumbarton Oaks,* ed. E. H. Boone (Washington, D.C., 1985), 3–4.

133. *Lecture* (London, 1957), 1:228–54.

134. F. Saxl, "Illustrated Medieval Encyclopaedias," ibid., 230, 240–41. Isidore entitled his work *Etymologiae,* being "deduced through the explanation of words," as Saxl shows (240).

135. M. S. Edmonson, ed., *Sixteenth-Century Mexico: The Work of Sahagún* (Albuquerque, 1974).

136. *Medieval American Art* (reprinted 1956 and 1969). The ancient America presented by Kelemen includes the "Southwest," Mexican, and Maya areas, the "interlying area" [circum-Caribbean], and the Andean area. The beginning of "Archaic" is placed at A.D. 100. But ancient Amerindian art has nothing "medieval" about it other than its position in Kelemen's chronology as "beginning" after Christ.

137. "The Tulum Murals: The International Style of the Late Post-Classic," *36th International Congress of Americanists*, 2:77–88 (Stuttgart-Munich,).

138. Henri Focillon thought of the *"style international 1375–1425"* as being L. Courajod's coinage, with which Focillon disagreed, finding that all medieval art was international, and preferring "Gothic mannerism" (lecture 13, Nov. 1933, Yale University). Also "International Gothic Painting," Stanley Ferber, in *McGraw-Hill Dictionary of Art* (New York, 1969), 3:176–78.

Chapter 6. Anthropologists and Archaeologists after 1875

1. Foreword, *Vorschule der Asthetik,* vol. 2 (1876).

2. *International Congress of Americanists,* I, vol. 2, 278–83.

3. Juan Comas, *Cien años de Congresos Internacionales de Americanistas* (Mexico, 1974), 45.

4. Ibid., 48.

5. *Die Denkschöpfung umgebender Welt aus kosmogonischen Vorstellungen* (Berlin, 1896). Neither Annemarie Fiedermutz-Lain (*Der Kulturhistorische Gedanke bei Adolf Bastian* [Wiesbaden, 1970]) nor Klaus-Peter Koepping (*Adolf Bastian and the Psychic Unity of Mankind* [St. Lucia, Australia, 1983]) mentions this work. After 1889 (26) Koepping finds Bastian's literary output "becoming unintelligible," although his expansion of a lecture in 1895 is a return to the *Elementargedanken* with which Bastian began *Die Culturländer,* after definition in *Der Mensch in der Geschichte* (1860, 1:9–10) as "psychological kernels" beneath "local and temporal variations in language and idiom."

6. C. G. Jung, *Collected Works* (Princeton, 1969), 8, par. 353.

7. Jung, "Psychological Aspects of the Mother Archetype," *Collected Works,* 9:1, par. 155.

8. *Adolf Bastian and the Psychic Unity of Mankind,* 81–82, 100, 141, 144–45, 150–53. Koepping's sense of "authentic" is clearly the accepted one of *authoritative.*

9. *Sammlung gemeinverständlicher Vorträge,* ed. R. Virchow and Baron von Holtzendorff, III series, heft 62, 463–502.

10. *Apologética historia,* ed. E. O'Gorman (Mexico, 1967).

11. *Repúblicas del mundo, Medina del Campo,* 2d ed. (1595).

12. "The State as a Work of Art," *Civilization of the Renaissance in Italy,* 3d ed., trans. Middlemore (1860; London, 1950), chap. 1.

13. *Die Völker des Östlichen Asien (Reisen in Siam)* (1867), 3:vi.

14. Koepping, *Adolf Bastian,* 107: Bastian "perceives the irony of the fact that the very moment when ethnology came into its own, through contact with foreign

societies, that very contact destroyed the materials with which ethnology works."
(Koepping cites an article by Bastian in 1867 [p. 243 n. 12] that is lacking in his
bibliography).

15. *Die ersten Menschen und die prähistorischen Zeiten, mit besonderer
Berücksichtigung der Urbewohner Amerikas,* trans. W. Schlösser and E. Seler.
(Stuttgart, 1884). Chapters 8–13 on the natives of America (146–351) are by Seler.

16. F. Anders, *Wort- und Sachregister zu Eduard Seler* (Graz, 1967), 1888–
94. For Seler's career, see L. Höpfner, "De la vida de Eduard Seler," *México Anti-
guo* 7 (1949): 58–74.

17. Marshall Saville was its first professor, and Duncan Strong its last. This
chair no longer exists.

18. J. F. Loubat, *Narrative of the Mission to Russia* (New York, 1873); *A
Medallic History of the United States* (New York, 1878); *Yachtsman's Scrapbook*
(New York, 1888); *Le Duc de Loubat* (New York, 1894).

19. Borrowed from Lotte Höpfner, a second cousin of Seler's wife, Caecilie
Seler-Sachs. ("De la vida de Eduard Seler," *México Antiguo* 7 (1949): 69). "The
Iliad gives a humorous, kindly portrait of an old and respected but rather ineffective
man full of advice generally either platitudinous or unsuccessful" (H. J. Ross,
Oxford Classical Dictionary [London, 1970], 731).

20. J. Eric S. Thompson, *Maya Hieroglyphic Writing* (1962), 81. Seler actu-
ally said (*Gesammelte Abhandlungen*, 1:862) in 1900, "In all den auf den Kultus
bezüglichen Dingen bestand grosse Uebereinstimmung zwischen den ver-
schiedenen mexikanisch-Zentralamerikanischen Stämmen."

21. *Ges. Abh.,* 2:1.

22. *Ges. Abh.,* 2:17.

23. *Ges. Abh.,* 2: 15: "als besonderen Reiz und besonderen Vorzug."

24. *Ges. Abh.,* 2:20.

25. *Ges. Abh.,* 2:30: about A.D. 35 by the B.-T.-M. correlation favored among
most Mayanists today.

26. M. W. Stirling, "Stone Monuments of Southern Mexico," *Bulletin of the
Bureau of American Ethnology* 138 (1943).

27. *Ges. Abh.,* 1:836: "könnte naturlich aber auch beträchtlich älter sein."

28. *Ges. Abh.,* 2:30.

29. Seler wrote in 1892 (*Ges. Abh.,* 1:567), "In the present state of things it
would be far more appropriate to point out the real meaning as to the matter
expressed, of each hieroglyph. The determination of their phonetic value will then
follow . . . with much more accuracy" [than in the Landa "phonetic" system
favored by Cyrus Thomas]. This article first appeared in *Science* 20, no. 499
(August 26, 1892).

30. H. B. Nicholson, "Eduard Georg Seler," *Handbook of Middle American
Indians* 13 (1973): 353.

31. *Ges. Abh.,* 3:729.

32. Y. V. Knorozov, "Maya Hieroglyphic Writing" *American Antiquity* 23
(1957–58): 284–91; F. G. Lounsbury, "The Inscription of the Sarcophagus Lid at
Palenque," *Primera Mesa Redonda de Palenque* (1976), 2:5–20; D. H. Kelley,
Deciphering the Maya Script (Austin, 1976); L. Schele, *Maya Glyphs: The Verbs*
(Austin, 1982).

33. "Altmexikanischer Schmuck und soziale und militarische Rangab-
zeichen," *Ges. Abh.,* 2:519: "Mit Generalideen, Hineindeutungen und

Auffassungen wird man nicht zur Klarheit gelangen. Das erste ist die Feststellung des Thatsächlichen. Und dass das Verfolgen der Einzelheiten weitere Ausblicke nicht ausschliesst, wird dem Leser auch in der obigen rein technischen Studie nicht entgangen sein."

34. F. Termer, "Eduard Seler," *México Antiguo* 7 (1949): 11.

35. *Beiträge zur genaueren Erkenntnis der Mondgottheit bei den Griechen* (Berlin, c. 1885); *Die Liebesgeschichte des Himmels* (Strasbourg, 1892); *Drachen-kämpfe: Untersuchungen zur indogermanischen Sagenkunde* (Leipzig, 1907; re-issued, New York, 1978); *Urreligion der Indogermanen* (Berlin, 1897); *Mythologische Briefe* (Berlin, 1901); indexed in Anders, *Wort-und Sachregister,* 404.

36. Nicholson, *Handbook,* 354.

37. Ibid.: (1) directional color glyphs; (2) differing year-bearer glyphs in Dresden I and northern Yucatán; (3) glyphs for names and titles of deities; (4) the Katun as 20 × 360 days; (5) comparative day-name signs in Mesoamerica; (6) readings of glyphs and glyph groups in the pre-Conquest manuscripts; (7) work on the "Seating" glyph.

38. Ibid., 360.

39. *Ges. Abh.,* 3:283.

40. *Ges. Abh.,* 3:284.

41. *Ges. Abh.,* 3:328–45.

42. *Beobachtungen und Studien in den Ruinen von Palenque* (Berlin, 1915), 128.

43. Willey and Sabloff (*History of American Archaeology,* 65, 85) assign Seler with Brasseur to their "Classificatory-Descriptive Period" (1840–1914).

44. On L. H. Morgan: L. A. White, *Pioneers in American Anthropology: The Bandelier–Morgan Letters, 1873–1883* (Albuquerque, 1940), 8–10. On J. Garcia Icazbalceta: L. A. White and I. Bernal, *Correspondencia de Adolfo F. Bandelier* (Mexico, 1960), 87–100. On Leo XIII: *A History of the Southwest,* 2 vols., ed. E. J. Burrus S. J. (Rome and St. Louis, 1969), 1:29.

45. *The Romantic School in American Archaeology* (New York, 1885).

46. *Delight Makers* (1890; reprint New York, 1918), preface.

47. *Romantic School,* 10, 11.

48. Willey and Sabloff, *History of American Archaeology,* 51.

49. *The Romantic School,* 6–7, 13.

50. *The Unpublished Letters of Adolph Bandelier Concerning the Writing and Publication of* The Delight Makers, ed. Paul Radin (El Paso, 1942), xi: letter to T. Janvier, 2 September 1888.

51. Pp. 10, 26–27.

52. Pp. 195, 208.

53. A concern not fully shared by other scholars until the book by Vincent Scully (*Pueblo* [New York, 1972]), whose own emotional absorption matched that of the dancers themselves.

54. *Romantic School,* 12–13.

55. Only Pedro de Castañeda de Nacera, *Relación de la jornada de Cibola* . . . (1540), and Mota Padilla are mentioned without any identification on p. 347, but Bandelier's detailed knowledge of these sources was exceptional. The context is Indian cremation at Rito de los Frijoles in chapter 16 on the funeral of the *maseua* (war chief), Topanashka.

56. He asked Thomas Janvier, his friend assisting him in getting a publisher, to be allowed to write a "few short explanatory footnotes and supporting arguments" for his beliefs but was presumably discouraged from doing so (Radin, ed., *The Unpublished letters of Adolph F. Bandelier*, x, 2–3).

57. F. W. Hodge, "Obituary of A. Bandelier," *American Anthropologist* 16 (1914): 349–58, bibliography of fifty-five items.

58. J. H. Rowe ("Max Uhle, 1856–1944: A Memoir of the Father of Peruvian Archaeology," *University of California Publications in American Archaeology and Ethnology* 46 [1954]: 5), says that "each told the other as little as possible of his own research and each was critical of the other's results."

59. J. H. Rowe, Max Uhle, 1856–1944: A Memoir of the Father of Peruvian Archaeology," *University of California Publications in American Archaeology and Ethnology* 46 (1954): 1–2. Uhle's *Kultur und Industrie südamerikanischer Völker*, 2 vols. (Berlin, 1889–90), was based on their work (Reiss and Stübel, *Das Totenfeld von Ancon in Peru* [Berlin, 1880–87]).

60. Rowe, "Max Uhle," 2, 20.

61. Ibid., appendix A, 54–100, esp. 67–70.

62. Ibid., 16.

63. Ibid., 21.

64. Uhle, *Die alten Kulturen von Peru im Hinblick auf die Archäologie und Geschichte des amerikanischen Kontinents* (Berlin, 1935), 7.

65. Fiedermutz-Lain, *Adolf Bastian*, 227, citing Bastian's *Ethnische Elementargedanken* (1895), 2:24. Koepping (*Adolf Bastian*, 93, 232) quotes from a supposed letter to E. B. Tylor by Sir Frank Livingston, that Bastian's "style resembled an owl's cast."

66. L. White, "Ethnography and Ethnology of Franz Boas" *Bulletin of the Texas Memorial Museum*, (Austin), no. 6 (1963): 11 (letter by Boas, February 5, 1886).

67. Ibid., 10–13: he was in America each year for two to four months.

68. "Über eine neue Form des Gesetzes der Unterschiedsschwelle," *Pflüger's Archiv* 26 (1881): 499.

69. "Über den Unterschiedsschwellen als ein Maass der Intensität psychischer Vorgänge," *Philosophische Monatshefte* 18 (1882): 367–75.

70. Boas's titles were "Über die Berechnung der Unterschiedsschwellenwerthe nach der Methode der richtigen und falschen Fälle," *Pflüger's Archiv* 28 (1882): 84–95, and "Die Bestimmung der Unterschiedsempfindlichkeit der Methode der übermerklichen Unterschied," ibid., 562–65.

71. J. C. Stevens, "Psychophysics," *International Encyclopedia of Social Science* (1968), 13:123: "Weber's law stands as one of the oldest and broadest empirical generalizations of psychophysics—psychology's 'law of relativity.' "

72. "Ueber die Grundaufgabe der Psychophysik," *Pflüger's Archiv* 28 (1832): 566–76.

73. J. Alden Mason, "Franz Boas as an Archaeologist," *Memoir* 61, *American Anthropologist* 45, no. 3, pt. 2 (1943) 59–64.

74. A. L. Kroeber, "History and Science in Anthropology," *American Anthropologist* 37 (1935): 539–40.

75. *American Anthropologist* 31 (1929): 139 (review by Kroeber of Boas, *Primitive Art*).

76. Boas, *American Anthropologist* (reply to Kroeber) 38 (1936): 138–39.

77. E. B. Smith, *American Journal of Archaeology* 33 (1929): 166–67; W. S. Rusk, *Art and Archaeology* 28 (1929): 194.
78. Kroeber, *Style and Civilizations* (Ithaca, 1957).
79. *Configurations of Culture Growth* (Berkeley, 1944).
80. R. H. Lowie, *History of Ethnological Theory* (New York, 1937), 131, 147.
81. R. Benedict, "Franz Boas as Ethnologist," *Memoir* 61, *American Anthropologist* 45 (1943): 29, 31.
82. Boas, "The Decorative Art of the North American Indians," reprinted from *The Popular Science Monthly* (Oct. 1903) in *Race, Language and Culture* (Toronto, 1966), 546–63.
83. Boas, "Representative Art of Primitive People," *Holmes Anniversary Volume* (Washington, 1916), reprinted in *Race, Language and Culture*, 535–40.
84. "Decorative Designs of Alaskan Needlecases," *Proceedings of the U.S. National Museum* 34 (1908), reprinted in *Race, Language and Culture*, 564–92.
85. Reprint, 1951, (Capitol), 349.
86. *Science* 97, no. 2507 (1943): 60–62.
87. "Beiträge zur Erkenntnis der Farbe des Wassers" (Kiel, 1887).
88. Paul Hochstim, *Alfred Vierkandt: A Sociological Critique* (New York, 1966), 10: Vierkandt bridged "between speculative and empirical approaches" to "social behavior between a traditionally anthropological and a sociological point of view."
89. *Systematic Sociology in Germany: A Critical Analysis of Some Attempts to Established Sociology as an independent Science* (New York, 1929).
90. "Prinzipienfragen der ethnologischen Kunstforschung," *Zeitschrift für Ästhetik und allgemeine Kunstwissenschaft* 19 (1925): 338–49.
91. K. E. Gilbert, *A History of Esthetics* (Bloomington, 1953), 527.
92. Defended also by Spencer, Tylor, and Wundt.
93. Cleveland, 1963, xii + 541 pp.
94. *Art Bulletin* 52 (1970): 354–56.
95. This term is Julian Steward's, in contrast to "historic personages and episodes," *Alfred Kroeber* (New York, 1973), 5.
96. *Essays in Anthropology Presented to A. L. Kroeber* (Freeport, 1936), (reprinted 1968), xix.
97. *Horizon and Horizon Style in the Study of Ancient American Objects: Concept, Category and Challenge*, Dumbarton Oaks Conference, 1986, in press. As a concept, "horizon" is spatial; as category, it places style in periods of time, like "bins," for sorting objects; and as challenge, horizons induce exploration of visual properties (Stone, *Horizon*, 2).
98. A. L. Kroeber, "Peruvian Archaeology in 1942," *Viking Fund Publications in Anthropology*, no. 4 (New York, 1944), 108.
99. Rowe, *Max Uhle*, 10.
100. Ibid., 24.
101. *An Anthropologist Looks at History* (Berkeley, 1963), 66, 209. Thirteen of these fourteen essays postdate 1950.
102. "Great Art Styles of Ancient South America," in *The Nature of Culture* (Chicago, 1952), 289–96.
103. *American Anthropologist* 61 (1959): 303–05.
104. According to Leslie White (*The Science of Culture* [New York, 1949],

409–14) "culturology" is a term at least as old as E. B. Tylor's *Primitive Culture* (London, 1871).
J. Steward (*Alfred Kroeber*, 48) noted that White's use of "culturology" was like Kroeber's "superorganic." For Kroeber, according to Steward (61), this level of assumption "avoided any contention that . . . genetically determined features were part of culture."

105. L. White, *The Science of Culture*, 409.

106. "The Superorganic" [1917]. In *The Nature of Culture*, 22–51. Superorganic phenomena are "culture history" residing in social psychology as "values" (*Nature of Culture*, 54).

107. *Style and Civilizations* (Ithaca, 1957), 26: "The fine arts achieve values," that "afford satisfactions . . . sought as ends in themselves."

108. *México Antiguo* dedicated three volumes in tribute to its founder: vol. 9, 1959, by colleagues and students, and vols. 10 and 11 in 1965 and 1969. Beyer was founder in 1919 and an editor of this learned journal of the Sociedad Alemana Mexicanista until his death.

109. "Homenaje," *México Antiguo* 9 (1959): 24 (written in 1943). Caso says he was already ill with uremia in 1927.

110. Caso, "Homenaje," 24. Caso said that Beyer was "más que nada . . . un autodidacta y . . . discípulo indirecto" of Seler.

111. "Comparative Mythology," in *Oxford Essays* (London, 1856), 2:1–87. L. Spence, *An Introduction to Mythology* (London, 1921), 47–51.

112. Beyer, "The Symbolic Meaning of the Dog in Ancient Mexico," *American Anthropologist* 19 (1908): 419–22.

113. "El cuauhpilolli, la borla de plumas del dios Mixcoatl," *México Antiguo* 2 (1924): 34–49.

114. "Die Serie der kosmischen Gegensätze, ein Abschnitt aus zwei mexikanischen Bilderhandschriften," *Archiv für Anthropologie*, n.f. 11 (1912): 293–319.

115. "The Natural Basis of Some Mexican Gods," *American Antiquarian and Oriental Journal* 31 (1909): 19–22.

116. "Existe en el Códice Fejérváry-Mayer una representación de Huitzilopochtli?" *Anales del Museo Nacional* 2 (1910): 531–36 (reprinted in *México Antiguo* 10 [1965]: 369–71).

117. "Huitzilopochtli, el dios azteca del sol y del verano," reprinted in *México Antiguo* 10 (1965): 427–30.

118. "Über die mythologischen Affen der Mexikaner und Maya," 18th *International Congress of Americanists* (1913), 149–54 (reprinted in *México Antiguo* 10 [1965]: 444–60).

119. *Göttergestalten in den mexikanischen Bilderhandschriften der Codex Borgia-Gruppe. Eine ikonographische Untersuchung* (Wiesbaden, 1964).

120. "Introducción," *México Antiguo* 10 (1965): xvi–xvii.

121. R. H. Lowie, *Primitive Religion* (New York, 1924), 260.

122. *History of Ethnological Theory* (New York, 1937), 3.

123. *Pain, Pleasure, and Aesthetics* (New York, 1894), and *Aesthetic Principles* (New York, 1895).

124. "A Note on Aesthetics" (*American Anthropologist* 23 [1921]: 170–74) used G. T Fechner's "Golden cut" to establish the kinship of Crow rawhide parfleches with those of the Shoshone Plains Indians, by comparing the ratios of height

to width in rectangles. See also G. T. Fechner, *Vorschule der Ästhetik* (Stuttgart, 1876), 1:199–202.

125. *American Anthropologist* 32 (1930) 130, 302.

126. R. H. Hofstadter, *Gödel, Escher and Bach* (New York, 1979).

127. R. L. Brunhouse (*Sylvanus G. Morley and the World of the Ancient Mayas* [Norman, 1971], 333) questions that Morley only "attended Harvard to take courses under George A. Reisner," because the Egyptologist did not join the faculty until a year after Morley's arrival "on campus" in 1904.

128. R. L. Roys and M. W. Harrison, obituary, *American Antiquity* 5 (1949): 215–21.

129. Stanford and Oxford, 1946; revised by G. W. Brainerd, 1956, and rewritten by Robert J. Sharer in 1983.

130. Indianapolis, 1930, 1936, and *Pajarito*.

131. Albuquerque, 1938.

132. E. L. Hewitt, *Pajarito* (1938), 13.

133. *Ancient Maya*, table XI, opp. 48.

134. *The Inscriptions of Petén* (Washington, 1937–38).

135. *Ancient Maya* (Stanford, 1956), 424–31.

136. Ibid., 425.

137. Ibid., 441.

138. Reviewed by E. W. Andrews V, *American Antiquity* 51 (1986): 184–86: "Sharer's book is now by far the best on the Maya, and it will probably remain so for the next quarter century."

139. Published by Porrúa Hermanos with the subtitle *Pronacionalismo* and reissued in 1960 by the same publisher.

140. Fernandez, prologue to *Forjando Patria* (Mexico, 1960), xii–xvi.

141. Willey and Sabloff, *A History of American Archaeology*, 84–85. Before this in the Americas "archaeological chronology was in its infancy," Seler and his colleagues having had only a "descriptive, typological, and iconographical point of view. Although aware of ethnohistory, their perspective was blurred and foreshortened."

142. Gamio, "Arqueología de Atzcapotzalco," *Proceedings, 18th International Congress of Americanists* (London, 1913), 180–87.

143. Juan Comas, "La vida y obra de Manuel Gamio," in *Homenaje al Dr. Manuel Gamio*, ed. H. Gonzalez Casanova (Mexico, 1956), 1–17.

144. M. Gamio, *Forjando Patria* (1916), 26–28, and II, "Introducción, Síntesis y Conclusiones," *La población del Valle de Teotihuacán* (Mexico, 1922) (published in Spanish and English). Vols. 2 and 3 (also 1922) are in Spanish only.

145. G. R. Willey, "Prehistoric Settlement Patterns in the Virú Valley," *Bureau of American Ethnology, Bulletin* 155 (Washington 1953); R. S. MacNeish, *Prehistory of the Tehuacán Valley* (Austin, 1967), vol. 1.

146. R. Wauchope, review of T. Proskouriakoff's *Study of Classic Maya Sculpture*, in *American Antiquity* 12 (1951): 161.

147. *Biographical Memoirs (National Academy of Sciences)* 39 (1964): 308.

148. Wauchope (*American Antiquity* 31: 152) notes Chase's influence on Kidder's analysis of Southwestern ceramics (R. B. Woodbury, *Alfred Vincent Kidder, Life and Work* [New York, 1973], 21).

149. Ibid., 162.

150. Willey, "Alfred Vincent Kidder," *Biographical Memoirs* 39 (1964): 196.

151. H. E. D. Pollock, "Final Report," *Year Book* 57 (1957–58), 435–55. This history of the activities of Carnegie Institution of Washington in anthropology and archaeology covers more than fifty years.

152. Clyde Kluckhohn, "The Conceptual Structure in Middle American Studies," in *The Maya and Their Neighbors,* ed. C. L. Hay et al. (New York, 1940), 41–51: Walter W. Taylor, Jr., *A Study of Archaeology,* Memoir Series no. 69, American Anthropological Association, 1948.

153. Carnegie Institution of Washington, *Yearbook* 49 (1949–50): 192.

154. G. Willey, *Biographical Memoirs* (National Academy of Science) 39 (1964): 293–322; R. Wauchope, "Obituary," *American Antiquity* 31 (1954): 151–64; Woodbury, *Alfred Vincent Kidder.*

155. Wauchope, "Obituary," 163.

156. *El Universal,* Mexico City, October 20, 1917. The abstract bears Caso's date as 27 September, for communication to the *Facultad de Altos Estudios* at the University of Mexico.

157. The only philosopher named by Caso is Hegel.

158. A footnote states that Aztec "statuary" is as much sculpture as ornament (hence Caso seems to suggest a category intermediate between architecture and sculpture).

159. *El Universal,* June 27, 1919.

160. Caso's early publications also included "Categorra del pensamiento como fundamento de la creencia," *Revista de Filosofia* 7, no 1 (1921) (Buenos Aires). See the bibliography of Alfonso Caso by Antonio Pompa y Pompa in the book edited by Antonio Salas Ortega, *Alfonso Caso* (Mexico, 1975), 81–101.

161. *El teocalli de la guerra sagrada: Descripción y estudio del monolito encontrado en los cimientos del Palacio Nacional* (Mexico, 1927).

162. "Influencia de Seler en las ciencias antropológicas," *México Antiguo* 7 (1949): 25–28. Caso here first mentions Beyer as an "indirect" disciple of Seler, affected by the writings alone.

163. "La tumba de Monte Albán es Mixteca," *Universidad de México* 4, no. 26 (1932): 116–50. *El Tesoro de Monte Albán* (Memoria del Instituto Nacional de Anthropologia e Historia, 3 [1969]) is the most complete publication.

164. *Los calendarios prehispánicos* (Mexico, 1967). *Reyes y reinos de la Mixteca,* 2 vols. (Mexico, Fondo de Cultura Económica, 1977–79).

165. "El mapa de Teozacoalco," *Cuadernos Americanos* 8, no. 5 (Sept.–Oct. 1949), 145–81. Others, like Emily Rabin and Nancy Troike, question Caso's results, which they shorten by several generations.

166. "Definición del indio y lo indio," *América Indígena* 8, no. 4, (1948).

167. "La religión de los Aztecas," *Enciclopedia Ilustrada Mexicana,* no. 1 (1936): 1–36.

168. Pijoan (*Arte precolombino* [1946], 10) characterized his *El teocalli* of 1927 as an "apologetic" defense of Aztec thought, of *cobrizo* [coppery] color, as if "spoken by a high priest of the Templo Mayor in the time of Moctezuma." Pijoan was here contrasting Caso's "indigenous thought" with Seler's as "clásico, racional del hombre blanco," to Caso's advantage, whom he quotes at length.

169. Caso proposes that "kinematic individuality," as known by disinterested intuition, is the final cause of art (*el fin del arte*).

170. "The Character of the Maya" (1953), 36–40.

171. Ibid.

172. *Maya Indians of Yucatan* (Washington, D.C., 1942).

173. "Character of the Maya," 37.

174. K. J. Ruppert, J. E. S. Thompson, T. Proskouriakoff, *Bonampak* (Washington, D.C., 1955).

175. *The Murals of Bonampak* (Princeton, 1986); also L. Schele and M. E. Miller, *The Blood of Kings* (Fort Worth, 1986).

176. "Food of the Gods," *New York Review of Books*, February 26, 1987, 3.

177. Kubler, *Art and Architecture of Ancient America* (1959; Baltimore, 1962), 9.

178. "The Classic Maya Ballgame and Its Architectural Setting: A Study of Relations between Text and Image," *Res* 14 (1987), footnote 11: "The revolution in the historical understanding of the Maya began with the articles of Heinrich Berlin (1958) and Tatiana Proskouriakoff (1960)." Berlin wrote on emblem glyphs [place names?] in "El glifo 'emblema' en las inscripciones mayas," *Journal de la Société des Américanistes* 47 (1958): 111–19; Proskouriakoff, "Historical Implications of a Pattern of Dates," (*American Antiquity* 25, no. 4 [1960]: 454–73).

179. *Artists and Craftsmen* (New York, 1935) was reprinted from articles written for *Natural History*, vols. 34 and 35, and reissued in 1945 and 1949. *Aztecs of Mexico* (New York, 1941, reissued in 1944 in New York and London; in 1947, 1948, and 1950 in New York; 1950 and 1951, 1955 by Penguin; 1953 and 1960 in Melbourne by Penguin; 1953, 1955 in New York; *Les Aztèques du Mexique*, trans. Guy Stresser-Péan (Paris, 1951); *La civilización azteca*, trans. Samuel Vasconcelos (Mexico, 1944, 1955).

180. The obituaries by Duncan Strong (*American Antiquity* 11 [1945–46]: 113–16) and Alfred V. Kidder (*American Anthropologist*, n.s. 47 [1945]: 59–60) comment in detail on this part of his life. See Vaillant, "Shadow and Substance in Cultural Relations," *Scientific Monthly* 60 (1945) 373–78.

181. Miguel León-Portilla (*Toltecáyotl, aspectos de la cultura náhuatl* [Mexico, 1980], 7) identifies artistry in sixteenth-century Mexican usage as *toltecáyotl*, and the artist, *toltécatl*, as having marked individual identity, a striving for excellence, and as being of moral worth.

182. W. F. Libby, *Radiocarbon Dating*, 2d ed. (Chicago, 1955).

183. *Aztecs of Mexico*, table I, 26–27: "Principal Culture Sequences in Middle, North and South America," spanning 20,000 B.C. to A.D. 1600. Although incomplete, its relationships in time and space are still partly valid.

184. Ibid., 36. Compare tables II, III, 48–49.

185. A. V. Kidder, *American Anthropologist* 47 (1945): 594.

186. Mesoamerica, coined by Paul Kirchhoff ("Mesoamerica," *Acta Americana* 1 (1943): 92–107), excluded the Caribbean islands.

187. Vaillant, "Chronology and Stratigraphy in the Maya Area," *Maya Research* 2 (1935).

188. W. C. Bennett and J. Bird (New York, 1949). Recently Rebecca Stone called attention to the Andean coexistence in one place of different styles at any given time, questioning the assumption that similarities of style necessarily indicate contemporaneity of objects. "Horizon and Horizon Style," in review, Dumbarton Oaks, Washington, typescript, 1986, 2.

189. G. Willey, review, *American Anthropologist* 52 (1950): 90. J. H. Rowe (review, *American Antiquity* 12 [1950]: 170–72) is critical of areal division, chronology, and labeling.

190. C. Wissler, *The American Indian* (New York, 1917).

191. Bennett, "The Peruvian Co-Tradition," *Memoirs of the Society for American Anthropology*, no. 4, (1948): 1.

192. G. Kubler, "A Reductive Theory of Visual Styles," in *The Concept of Style*, 2d ed., ed. B. Lang (Ithaca, 1987), 163–73.

193. J. H. Rowe, "Cultural Unity and Diversification in Peruvian Archaeology," *International Congress of Anthropological and Ethnological Sciences* 5 (1956): 627–31.

194. "Cultural Unity and Disunity in the Titicaca Basin," *American Antiquity* 16, no. 2 (1950): 89–98.

Epilogue

1. G. Willey ("The Convergence of Humanistic and Scientific Approaches in Maya Archaeology," *Indiana* 10 (1985): 215–27) notes convergence in only three directions: the Maya subsistence problem; Teotihuacán-Lowland Maya contacts; Lowland Maya political organization. Few nonarchaeologists are among twenty-five authors cited.

2. *Causality and Modern Science* (New York, 1979), 352.

3. *Historiography and Causation in Psychoanalysis: An Essay in Psychoanalytic and Historical Epistemology* (Hillsdale, N.J., 1985), 122–32.

4. *A History of Mexican Archaeology: The Vanished Civilizations of Middle America* (London, 1980), 189.

5. *New York Times*, April 12, 1987, Book Review, 43, quoting Italo Calvino.

6. G. Kubler, "Written Sources on Andean cosmogony," in *Recent Studies in Andean Prehistory and Protohistory*, ed. D. P. Kvietok and D. H. Sandweiss (Ithaca, 1983), 197–211.

7. The doctrine that "form follows function," as stated by Louis Sullivan, was anticipated by empiricist philosophy in the eighteenth century (E. Lucie-Smith, *Art Terms* [London, 1983], 86. Also appropriate (and more so today) is the dictum that "form follows meaning."

8. The polarities of ethnological structuralism were often in the class of a word game with rules to accept contrasted opposite terms (e.g., *vanilla* and *villain*) as having cultural meaning, although the written languages give only the mere orthographic pattern, as recorded by ethnologists.

9. John N. Deely, "Towards the Origins of Semiotic," in *Sight, Sound, and Sense*, ed. Thomas A. Sebeok (Bloomington, 1978), 1–30.

10. "Madinusa" in current spelling, with a medusaean overtone, of the slain Gorgon with her severed head on the shield of Athena.

11. Donald R. Griffin, *Animal Awareness* (Los Altos, Cal., 1981); *Animal Thinking* (Cambridge, Mass., 1984).

Bibliography

Abel, Theodore. *Systematic Sociology in Germany: A Critical Analysis of Some Attempts to Establish Sociology as an Independent Science.* New York, 1929.

Abrams, M. H. "Art as Such: The Sociology of Modern Aesthetics." *Bulletin, American Association of Anthropological Sciences* 38 (1982): 8–38.

Acosta, José de. *Historia natural y moral de las Indias.* Edited by E. O'Gorman. Mexico, 1940.

_____. *Historia natural y moral de las Indias.* Edited by F. Mateos S.J. Madrid, 1954.

Adorno, Rolena. "Icon and Idea: A Symbolic Reading of Pictures in a Peruvian Indian Chronicle." *The Indian Historian* 12, no. 3 (1970): 29–49.

_____. *Writing and Resistance in Colonial Peru.* Austin, 1986.

Albornoz, Cristóbal de. "Instrucción para descubrir todas las guacas del Pirú y sus camayos." [1580s]. *Journal de la Société des Américanistes* 56 (1967): 16–39.

Alcina Franch, J. *Guillermo Dupaix.* 2 vols. Madrid, 1969.

_____. "Writing and Resistance in Colonial Peru." *Guaman Poma.* Latin American Monographs, no. 68. Austin, 1986.

_____. *Pre-Columbian Art.* New York, 1983. (First published as *L'art précolombien* [Paris, 1978]).

Allen, H. "Analysis of the Life-Form in Art." *Transactions, American Philosophical Society* 15 (1881): 279–351.

Anders, F. *Wort- und Sachregister* (Vol. 6 of E. Seler, *Gesammelte Abhandlungen,* reprint). Graz, 1967.

243

Andrews, E. W. "Review of Sharer's Rewriting of Morley's *Ancient Maya*." *American Antiquity* 51 (1986): 184–86.

Anello Oliva, Juan. *Historia del reino y provincias del Perú*. Lima, 1985.

Arnheim, R. *Visual Thinking*. Berkeley, 1964.

———. *Art in Society*. Edited by M. Greenhalgh and V. Megaw. London, 1978.

Auerbach, Eric, "Vico and Esthetic Historism." *Journal of Aesthetics and Art Criticism* 8 (1949): 110–18.

Baessler, A. *Altperuanische Kunst*. 4 vols. Berlin, 1902–03.

Bancroft, H. H. *The Book of the Fair*. Chicago, 1895. *Anthropology and Ethnology*, 3:629–63.

Bandelier, Adolph. *The Romantic School in American Archaeology*. New York, 1885.

———. *A History of the Southwest*. 2 vols. Edited by E. J. Burrus S.J. Rome and St. Louis, 1969.

———. *The Unpublished Letters of Adolph Bandelier Concerning the Writing and Publication of* The Delight Makers. Edited by Paul Radin. El Paso, 1942.

———. *The Delight Makers*. 1890. Reprint. New York, 1918.

Barlow, R. H. "La crónica 'X.'" *Revista Mexicana de Estudios Antropológicos* 7 (1945): 65–87.

Bartholomaeus Anglicus. See Seymour, M. C.

Bastian, Adolf. *Der Mensch in der Geschichte*. 3 vols. in 1. Leipzig, 1860.

———. *Die Völker des Östlichen Asien (Reisen in Siam)*. Vol. 3. Leipzig, 1867.

———. "Mexiko." *Sammlung gemeinverständlicher Vorträge*. Edited by R. Virchow and Baron von Holtzendorff. III series, heft 62, 463–502, 18 January 1868.

———. *Die Culturländer des Alten America*. 3 vols. Berlin, 1878–89.

———. *Ethnische Elementargedanken*. 2 vols. in 1. Berlin, 1895.

———. *Die Denkschöpfung umgebender Welt aus kosmogonischen Vorstellungen*. Berlin, 1896.

Bateson, Gregory. "Arts of the South Seas." *Art Bulletin* 28, no. 2, (1946): 119–23.

Baudot, Georges. "Last Years of B. de Sahagún (1585–1590)." In *Sixteenth-Century Mexico*, edited by M. Edmonson, 165–87. 1974.

———. *Utopie et histoire*. Toulouse, 1977.

Beltrami, G. *Le Mexique*. Paris, 1830.

Benedict, R. "Franz Boas as Ethnologist." *Memoir* 61, *American Anthropologist* 45 (1943): 27–34.

———. "Obituary, Franz Boas." *Science* 97, no. 2507 (1943): 60–62.

Bennett, W. C. "The Peruvian 'Co-tradition.' " *Memoirs of the Society for American Anthropology,* no. 4 (1948): 1–8.

———. "Cultural Unity and Disunity in the Titicaca Basin." *American Antiquity* 16, no. 2 (1950): 89–98.

Bennett, W. C., and J. B. Bird. *Andean Culture History.* New York, 1942.

Benson, Elizabeth P. *The Mochica Culture of Peru.* London and New York, 1972.

Bergsland, K., and H. Vogt. "On the Validity of Glotto-Chronology." *Current Anthropology* 3 (1962): 128–29.

Berlin, H. "El glifo 'emblema' en las inscripciones mayas." *Journal de la Société des Américanistes* 47 (1958): 111–19.

Berlin, Isaiah. *Vico and Herder.* London, 1976.

Bernal, Ignacio. "Humboldt y la arqueología mexicana." In *Ensayos sobre Humboldt,* edited by M. O. Bopp, 121–32. Mexico, 1962.

———. *A History of Mexican Archaeology. The Vanished Civilizations of Middle America.* London, 1980.

Beuchat, H. *Manuel de l'archéologie américaine.* Paris, 1912.

Beyer, H. "Der Drache der Mexikaner." *Globus* 93 (1908): 157–58.

———. "The Symbolic Meaning of the Dog in Ancient Mexico." *American Anthropologist* 19 (1908): 419–22.

———. "The Natural Basis of Some Mexican Gods." *American Antiquarian and Oriental Journal* 31 (1909): 19–22.

———. "Die Serie der kosmischen Gegensätze, ein Abschnitt aus zwei mexikanischen Bilderhandschriften." *Archiv für Anthropologie,* n.f. 11 (1912): 293–319.

———. "El cuauhpilolli, la borla de plumas del dios Mixcoatl." *México Antiguo* 2 (1924).

———. *Göttergestalten in den mexikanischen Bilderhandschriften der Codex Borgia Gruppe. Eine ikonographische Untersuchung.* Wiesbaden, 1964.

———. "Existe en el Códice Fejérváry-Mayer una representación de Huitzilopochtli?" *Anales del Museo Nacional* 2 (1910): 510–36. Reprinted in *México Antiguo* 10 (1965): 427–30.

"Huitzilopochtli, el dios azteca del sol y del verano," Reprinted in *México Antiguo* 10 (1965): 427–30.

Biddiss, R. M. *Father of Racist Ideology. The Social and Political Thought of Count Gobineau.* London, 1970.

Bingham, H. *Machu Picchu.* New Haven, 1911.

Blanton, Richard, et al. *Monte Albán: Settlement Patterns at the Ancient Zapotec Capital.* New York, 1978.

Boas, F. "Über eine neue Form des Gesetzes der Unterschiedsschwelle." *Pflüger's Archiv* 26 (1881): 449.

——. "Über den Unterschiedsschwellen als ein Maass der Intensität psychischer Vorgänge." *Philosophische Monatshefte* 18 (1882): 367–75.

——. "Über die Berechnung der Unterschiedsschwellenwerthe nach der Methode der richtigen und falschen Fälle." *Pflüger's Archiv* 28 (1882): 84.

——. "Die Bestimmung der Unterschiedsempfindlichkeit der Methode der übermerklichen Unterschied." *Pflüger's Archiv* 28 (1882): 565.

——. "Über die Grundaufgabe der Psychophysik." *Pflüger's Archiv* 28 (1882): 556–76.

——. "Beiträge zur Erkenntnis der Farbe des Wassers." Dissertation, Kiel, 1887.

——. "The Decorative Art of the North American Indians." 1903. In *Race, Language and Culture,* 546–63. Toronto, 1966.

——. "Representative Art of Primitive Peoples." 1916. Reprinted in *Race, Language and Culture,* 535–40. Toronto, 1966.

——. *Primitive Art.* Oslo, 1927. Reprinted 1951.

Bonet y Correa, A. "Superchería y fe." *Historia* 61 (1981): 50.

Boone, E. H. *The Codex Magliabechiano.* Berkeley, 1983.

——, ed. *Painted Architecture and Polychrome Monumental Sculpture in Mesoamerica: A Symposium at Dumbarton Oaks.* Washington, 1985.

Botting, D. *Humboldt and the Cosmos.* New York, 1973.

Boturini Benaduci, L. *Idea de una nueva historia general de la América septentrional.* 1746. 1949. Reprint. Edited by M. León-Portilla. Mexico, 1974.

——. *Historia general de la América septentrional. De la cronología de sus principales naciones.* Edited by Manuel Ballesteros Gaibrois. Madrid, 1947, and Mexico, 1974.

Brasseur de Bourbourg, C. E. *Histoire des nations civilisées du Mexique et de l'Amerique Centrale.* 4 vols. Paris, 1857–59.

——. *Lettres pour servir d'introduction à l'histoire primitive des nations civilisées de l'Amérique septentrionale.* Mexico, 1851.

——. *Quatre lettres sur le Mexique.* Paris, 1868.

Braunschweig, J. D. von. *Ueber die alt-americanischen Denkmäler.* Berlin, 1840.

Breuil, Henri. "Les origines de l'art décoratif." *Journal de Psychologie Normale et Pathologique* 23 (1926): 364–75.

——. *Four Hundred Centuries of Cave Art.* Montignac, 1952.

Bronner, S. J. "The Idea of the Folk Artifact." In *American Material Culture and Folk Life,* edited by S. J. Bronner. Ann Arbor, 1985.

Brunhouse, R. L. *Sylvanus G. Morley and the World of the Ancient Mayas.* Norman, 1971.

_____. *In Search of the Maya. The First Archaeologists.* Albuquerque, 1973.

Buber, Martin. *Ich und du.* Leipzig, 1922.

Bunge, Mario. *Causality and Modern Science.* New York, 1979.

Burckhardt, J. D. *Cultur der Renaissance in Italien.* Basel, 1860.

_____. *Die Kultur der Renaissance in Italien. Ein Versuch.* Basel, 1955. (*Gesammelte Werke,* vol. 3).

Bustamante, C. M. de. *Mañanas de la alameda de México.* 2 vols. Mexico, 1835.

Caldwell, J. R. "The New American Archaeology." *Science* 129, no. 3345 (1959): 303–07.

Calnek, E. E. "Sahagún Texts." In *Sixteenth-Century Mexico,* edited by M. S. Edmonson, 189–204. Albuquerque, 1974.

Carreri, G. F. G. "Le Mexicque à la fin du XVIIe siécle." *Giro del mondo.* 1700. Reprint. Edited by J. P. Berthe. Paris, 1968.

Caso, A. "Ensayo de una clasificación de las artes." *El Universal,* Mexico City, 20 October 1917.

_____. "Qué es el derecho?" *El Universal,* Mexico City, 27 June 1919 [abstract].

_____. *El teocalli de la guerra sagrada.* Mexico, 1927.

_____. "La tumba de Monte Albán es Mixteca." *Universidad de México* 4 no. 26 (1932): 116–50.

_____. *La religión de los Aztecas.* Mexico, 1936.

_____. "Homenaje a Hermann Beyer" [1943]. *México Antiguo* 9 (1959): 23–30.

_____. "Definición del indio y lo indio." *América Indígena* 8, no. 4 (1948).

_____. "Influencia de Seler en las ciencias antropológicas." *México Antiguo* 7 (1949): 25–28.

_____. "El mapa de Teozacoalco." *Cuadernos Americanos* 8, no. 5 (1949): 145–61.

_____. "Relations between the Old and New Worlds." *35th Congreso Internacional de Americanistas,* 1:55–71. Mexico, 1964.

_____. *Los calendarios prehispánicos.* Mexico, 1967.

_____. *Reyes y reinos de la Mixteca.* 2 vols. Mexico, Fondo de Cultura Económica, 1977–79.

Cassirer, Ernst. *Antropología filosófica.* Mexico, 1945. (Translation of *An Essay on Man* [New Haven, 1944]) (p. vii, a reprise of his *Philosophy of Symbolic Forms* [Berlin 1923–39]).

Cavo, A. *Tres siglos de México.* Edited by C. M. de Bustamante. Mexico, 1852.

Centro Iberoamericano de Cooperación. *La obra del obispo Martinez Compañon sobre Trujillo.* 3 vols. Madrid, 1978.

Chamberlain, R. S. "La controversia Velázquez-Cortés." *Anales de la Sociedad de Geografía e Historia de Guatemala* 19 (1942): 23–56.

Chanfón Olmos, C. M. "Antecedentes del atrio Mexicano del siglo XVI." *Cuadernos de Arquitectura Virreinal* 1 (1985): 4–16.

Chapman, A. *Puertos de Intercambio en Mesoamérica.* Mexico, 1959.

Charnay, C-J.-D. *The Ancient Cities of the New World.* New York, 1888.

Chevalier-Skolnikoff, S. "The Primate Play-face." *Rice University Studies* 60, no. 3 (1974): 9–29.

Chimalpain, Francisco de San Antón Muñon. *Relaciones originales de Chalco Amaquemecan.* Edited by S. Rendón. Mexico, 1965.

Cline, H. F. "A Note on Torquemada's Native Sources and Historiographical Methods." *The Americas* 20 (1969): 372–86.

Coe, M., *The Maya Scribe and His World.* New York, 1973.

Coe, M., and G. Whittaker. *Aztec Sorcerers in Seventeenth-Century Mexico.* Albany, 1982.

Columbus, Christopher. *Los cuatro viajes.* Edited by I. B. Anzoátegui. Buenos Aires, 1958.

Comas, Juan. "Review of Pijoan, *Arte precolombino.*" *Acta Americana* 5 (1947): 127.

———. "La vida y obra de Manuel Gamio." In *Homenaje al Dr. Manuel Gamio,* ed. H. Gonzalez Casanova, 1–17. Mexico, 1956.

———. *Antropología de los pueblos iberoamericanos.* Barcelona, 1974.

———. *Cien años de Congresos Internacionales de Americanistas.* Mexico, 1974.

Cook de Leonard, Carmen. "Introducción." *Mexico Antiguo* 10 (1965): xvi–xvii.

Cortés, Hernán. *Letters from Mexico.* Translated and edited by A. R. Pagden. New York, 1971.

———. *Cartas y documentos.* Mexico, 1963.

(Coruña, Martín de la, attributed). *Relación de las ceremonias y ritos . . . de Michoacán.* Edited by José Tudela. Madrid, 1956.

Costa, Gustavo. "A proposito del rapporto Vico-Boturini." *Bollettino del Centro di Studi Vichiani* 9 (1979): 137.

Covarrubias, M. *Island of Bali.* New York, 1937.

———. "Tlatilco, Archaic Art and Culture." *DYN,* nos. 4, 5, 6 (1943).

———. *Mexico South.* New York, 1946.

———. *The Eagle, the Jaguar and the Serpent. Indian Art of the Americas.* New York, 1954.

———. *Indian Art of Mexico and Central America.* New York, 1957.

Cummings, B. C. "Cuicuilco and the Archaic Culture of Mexico." *University of Arizona, Bulletin* 4, no. 8 (1933).

Cuvier, F. *Leçons d'anatomie comparée.* 5 vols. Paris, 1800–05.

Darwin, Charles. *The Expression of the Emotions in Men and Animals.* London, 1872.

———. *Expression of the Emotions in Men and Animals.* 1872. Reprint. Preface by K. Lorenz. Chicago, 1965.

Davis, Nigel. *Voyagers to the New World.* New York, 1979.

Davis, Whitney. "The Origins of Image Making." *Current Anthropology* 27, no. 3 (1986): 193–215.

Deely, John N. "Towards the Origins of Semiotic." In *Sight, Sound, and Sense,*" ed. Thomas A. Sebeok, 1–30. Bloomington, 1978.

D'Harnoncourt, R. "North American Indian Arts." *Magazine of Art* 32 (1939): 164–67.

———. "Living Arts of the Indians." *Magazine of Art* 34 (1941): 72–77.

———. *Arts of the South Seas.* Color illustrations by Miguel Covarrubias. New York, 1946.

———. *Art of Ancient Peru. Selected Works from the Collection.* New York, 1958.

———. *Art of Oceania, Africa and the Pre-Columbian Americas from the Museum of Primitive Art.* New York, 1958.

———. *Primitive Art Masterworks: An Exhibition.* New York, Museum of Primitive Art, 1974.

Diaz del Castillo, Bernal. *Historia verdadera de la conquista de la Nueva España.* Edited by J. Ramirez Cabañas. Mexico, 1950.

Diehl, R. A., and M. D. Mandeville. "Tula and Wheeled Animal Effigies in Mesoamerica." *Antiquity* 61 (1987): 241–46.

Dilke, C. *Letter to a King.* London, 1978.

Dominguez Bordona, J., ed. *Trujillo del Perú a fines del siglo XVIII: Dibujos y aquarelas que mandó hacer el obispo D. Baltasar Martinez Compañon.* Madrid, 1936.

Dominguez Ortiz, A., and Bernard Vincent. *Historia de los moriscos.* Madrid, 1978.

Donnan, C. B. *Moche Art and Iconography.* Los Angeles, 1976.

———. *Moche Art of Peru.* Los Angeles, 1978.

d'Orbigny, Alcide. *L'homme américain.* Paris, 1839.

Douglas, F. H., and René d'Harnoncourt. *Indian Art of the United States.* New York, 1941.

Dupaix, Guillermo. *Expediciones 1805–1808.* 2 vols. Edited by J. Alcina Franch. Madrid, 1969.

Durán, D. *Book of the Gods and Rites and the Ancient Calendar.* Tran-

slated by D. Heyden and F. Horcasitas. Introduction by M. León Portilla. Norman, 1971.

———. *Historia de las Indias.* Edited by A. M. Garibay. Mexico, 1967.

Durand, José. "La biblioteca del Inca." *Nueva Revista de Filología Hispánica* 2 (1948): 238–64.

———. "Garcilaso el Inca, platónico." *Las Moradas* (Lima) 3 (1949): 121–29. Also in *Diogène* [Paris] (1963): 24–46.

Durkheim, Emile. *Les formes élémentaires de la vie religieuse.* Paris, 1912.

Dyckerhoff, Ursula. *Die Crónica Mexicana, quellenkritische Untersuchungen.* Hamburg, 1970.

Edmonson, M. S., ed. *Sixteenth-Century Mexico: The Work of Sahagún.* Albuquerque, 1974.

Ekholm, G. F. "Is American Culture Asiatic?" *Natural History* 59, no. 8 (1950): 344–51, 382.

———. "Transpacific Contacts." In *Prehistoric Man in the New World,* edited by J. D. Jennings and E. Norbeck, 489–510. Chicago, 1964.

Eldridge, C. C. *Official Exhibition Catalogue.* Philadelphia Centennial. Philadelphia, 1876.

Elliott, J. H. "The Mental World of Hernán Cortés." *Transactions, Royal Historical Society,* series 5, 17 (1967): 5–14.

Engerrand, J. "(Review of) H. Beuchat, *Manuel.*" *Isis* 1 (1913): 530–37.

Ettlinger, L. "On Science, Industry and Art: Some Theories of Gottfried Semper." *Architectural Review* 136 (1964): 57–60 (London).

Farriss, N. M. *Maya Society under Spanish rule.* Princeton, 1984.

Fechner, G. T. "Über die subjektiven Nachbilder und Nebenbilder." *Annalen für Physik und Chemie* 120 (1838): 211–45, 513–35; 126 (1840): 193–221. 427–70.

———. ["Dr. Mises"] *Vier Paradoxa.* Leipzig, 1846.

———. *Vorschule der Ästhetik.* 2 vols. Stuttgart, 1876.

Ferber, Stanley. "International Gothic Painting." *McGraw-Hill Dictionary of Art,* 3:176–78. New York, 1939.

Fernandez, Justino. *Catálogo de construcciones religiosas del Estado de Yucatán.* 2 vols. Mexico, 1945.

———. *Arte moderno y contemporáneo de México.* Mexico, 1952.

———. *Coatlicue: Estética del arte indígena antigua.* Mexico, 1954.

———. "Review of Covarrubias, *Indian Art.*" *Anales del Instituto de Investigaciones Estéticas* 20 (1957): 99–100.

———. *Estética del arte mexicano.* Mexico, 1972.

Fernández de Echeverría y Veytia, Mariana. *Historia antigua de Méjico.* Edited by C. F. Ortega. Mexico, 1944.

Fiedermutz-Lain, A. *Der Kulturhistorische Gedanke bei Adolf Bastian.* Wiesbaden, 1970.

Fink, L. M. *Descriptive Catalogue of Painting and Sculpture in the National Museum of American Art.* Boston, 1983.

Foncerrada de Molina, M. "Reflexiones en torno a Palenque como necrópolis." *Primera Mesa Redonda de Palenque,* Part II. Pebble Beach, 1974.

Foronda y Aguilera, M. de. *Estancias y viajes de Carlos V.* Madrid, 1895.

Foucault, Michael. *The Order of Things.* New York, 1971.

_____. *Archaeology of Knowledge.* New York, 1972.

_____. "Nietzsche, Genealogy, History." *Foucault Reader.* Edited by P. Rabinow. New York, 1984.

Francke, Ursula. *Die Kunst als Erkenntnis.* Wiesbaden, 1972.

Frankl, V. "Hernán Cortés y la tradición de las Siete Partidas." *Revista de Historia de América,* 1962.

Frazer, J. G. *The Golden Bough.* 2 vols. London, 1890.

Fuentes, Carlos. Book Review. *New York Times,* 12 April 1987, 43.

Furst, Peter. "West Mexican Tomb Sculpture as Evidence for Shamanism." *Antropológica* 15 (1964): 29–80.

(Galbreath, C. B., attributed). "Brief Biography [W. H. Holmes]." *Ohio Archaeological and Historical Quarterly* 36 (1927): 493–511.

Galton, F. *Inquiries into Human Faculty.* 3d ed. New York, 1973.

Gamio, Manuel. "Arqueología de Atzcapotzalco." In *Proceedings, 18th International Congress of Americanists,* 180–87. London, 1913.

_____. *Forjando patria.* Mexico, 1916. Reissued 1960 with preface by J. Fernandez.

_____. *La población del Valle de Teotihuacán.* 3 vols. Mexico, 1922.

Gaos, José, trans. "Ästhetik der Gegenwart," by Rudolf Odebrecht, in *Philosophische Forschungsberichte* 15 (1932).

Garcia, Gregorio. *Origen de los indios.* 1607. Edited and translated by F. Pease, facsimile of Madrid edition of 1729 by Andrés Gonzalez Barcia. Mexico, 1981.

Garcilaso de la Vega, El Inca. *Comentarios reales.* Introduction by Carmel Sáenz. Madrid, 1963.

Garcilaso Inca. *Obras.* Edited by C. Sáenz. Madrid, 1965. *Diálogos del amor,* 1:1–227.

Garibay, A. M. *Historia de la literatura náhuatl.* Mexico, 1953.

Gaudry, A. "Nadaillac obituary." *L'anthropologie* 15 (1904): 608–09.

Gemelli Carreri, G. F. *Giro del mondo.* [1700]. Edited by J. P. Berthe. Paris, 1968.

Gerbi, Antonello. *La politica del settecento.* Bari, 1928.

———. *La disputá del nuovo mondo: Storia di una polemica 1750–1900.* Milan-Naples, 1955.

———. *La natura delle Indie Nove.* Naples, 1975.

Gibson, Charles. "Review of D. Robertson, *Mexican Manuscript Painting.*" *Hispanic-American Historical Review* 40 (1960): 282–83.

———. *The Aztecs under Spanish Rule.* Stanford, 1964.

Gilbert, K. E. *A History of Esthetics.* Bloomington, 1953.

Gimenez Fernandez, M. *Hernán Cortés y su revolución comunera en la Nueva España.* Sevilla, 1949.

———. "Las regalías mayestáticas en Indias." *Anuario de Estudios Americanos* (Seville) 6 (1949): 799–811.

Gladwin, H. S. "Excavations at Snaketown." Medallion Papers 25–26 (1937).

———. *Men out of Asia.* New York, 1947.

Gobineau, A. *Sur l'inégalité des races humaines.* Paris, 1853–55.

Gonzalez de la Rosa, M. "El padre Valera." *Revista Histórica* (Lima) 2 (1907): 193–97.

Granados y Galvez, J. J. *Tardes americanas.* Mexico, 1778.

Greenhalgh, M. "European Interest in the non-European: The Sixteenth Century and Pre-Columbian Art and Architecture. In *Art in Society,* edited by M. Greenhalgh and V. Megaw, 89–104. London, 1978.

———, and V. Megaw, eds. *Art in Society.* London, 1978.

Grieder, Terence. *Origins of Pre-Columbian Art.* Austin, 1982.

Griffin, D. R. *Animal Awareness.* Los Altos, 1981.

———. *Animal Thinking.* Cambridge, Mass., 1984.

Groos, K. *The Play of Animals.* New York, 1892.

———. *The Play of Man.* 1901. Reprint. New York, 1919.

Guaman Poma de Ayala, Felipe. *Nueva corónica y buen gobierno.* Paris, 1936 (facsimile ed.).

Guevara Bazán, Rafael. "El Inca Garcilaso y el Islam." *Boletín del Instituto Caro y Cuervo* 22, no. 1 (1967): 467–77.

Guzmán, Eulalia. "Caracteres esenciales del arte antiguo mexicano." *Revista de la Universidad* 5, nos. 27–30 (1933).

Hagerty, M. I. *Los libros plúmbeos del Sacromonte.* Madrid, 1980.

Hampden-Turner, C. *Maps of the Mind.* New York, 1980.

Harnoncourt, Hubert. *Gesammelte Nachrichten.* Vienna, 1894.

Harris, Marvin. *The Rise of Anthropological Theory.* New York, 1968.

Heidenheimer, H. *Petrus Martyr Anglerius und sein Opus epistolarum.* Berlin, 1881.

Heine-Geldern, R., and Gordon Ekholm. "Significant Parallels in the Symbolic Arts of Southern Asia and Middle America." *29th International Congress of Americanists* 1 (1951): 299–309.

Hentze, Carl. *Mythes et symboles lunaires.* Antwerp. 1932.

_____. *Objets rituels, croyances et dieux de la Chine antique et de l'Amérique.* Antwerp, 1936.

Herder, J. G. von. *Outlines of a Philosophy of the History of Man* [1784]. Translated by T. Churchill, 1799. New York, 1966.

Hernandez Sanchez-Barba, M. *Hernán Cortés, cartas y documentos.* Mexico, 1963.

Hewes, G. H. "Current Status of the Gestural Theory of Language Origin." *Annals of the New York Academy of Sciences* 280 (1976): 482–504.

Hewitt, Edgar Lee. *Ancient Life in Mexico and Central America.* Indianapolis, 1930.

_____. *Pajarito Plateau and Its Ancient People.* Albuquerque, 1938.

Hochstim, Paul. *Alfred Vierkandt. A Sociological Critique.* New York, 1966.

Hodge, F. W., ed. "Handbook of American Indians." *Bulletin 30, Bureau of American Ethnology.* Washington, pt. 1, 1907, pt. 2, 1910.

_____. "Obituary of A. Bandelier." *American Anthropologist* 16 (1914): 349–58.

Höpfner, L. "De la vida de Eduard Seler." *México Antiguo* 7 (1949): 58–74.

Hofstadter, D. R. *Gödel, Escher, Bach.* New York, 1979.

Holmes, W. H. "Origin and Development of Form and Ornament in Ceramic Art." *Annual Report of the Bureau of Ethnology* 4 (1882–83): 437–65.

_____. "Art in Shell." *Transactions of the Anthropological Society of Washington* 2 (1882–83): 94–119.

_____. "Art in Shell." *Annual Report of the Bureau of Ethnology* 2 (1880–81): 179–305. [Washington, 1883].

_____. "Pottery of the Ancient Pueblos." *Annual Report of the Bureau of Ethnology* 4 (1882–83): 257–360. [Washington, 1886].

_____. "A Study of the Textile Art in Its Relation to the Development of Form and Ornament." *Annual Report of the Bureau of Ethnology* 6 (1884–85): 13–187. [Washington, 1888].

_____. "On the Evolution of Ornament—An American Lesson." *American Anthropologist* 3 (1890): 137–46.

_____. "Evolution of the Aesthetic." *Proceedings, American Association for the Advancement of Science* 41 (1892): 239–55.

———. "Order of Development of the Primal Shaping Arts." *Proceedings, American Association for the Advancement of Science* 42 (1894): 289–300.

———. *Archaeological Studies among the Ancient Cities of Mexico.* 2 vols. Field Columbian Museum, Anthropological Series. Chicago, 1895–97.

———. *Representative Art of Primitive People.* Holmes Anniversary Volume. Washington, 1916.

———. The National Gallery of Art. Catalogue of Collections, Smithsonian Institution. Washington, 1922.

Huddleston, L. E. *A Study of European Concepts of the Origins of the American Indians, 1492–1729.* Austin, 1967.

Humboldt, Alexander von. *Ideen zu einer Geographie der Pflanze.* Tübingen-Paris, 1807.

———. *Essai politique sur le royaume de la Nouvelle Espagne.* Paris, 1811. London, 1814.

———. *Vues des Cordillères.* Paris, 1810.

———. *Views of Nature.* Translated by Mrs. Sabine. Philadelphia, 1849.

———. *Kosmos, Entwurf einer physischen Weltbeschreibung.* Stuttgart, 1845–62.

Iglesia, R. *Cronistas, el ciclo de Hernán Cortés.* Mexico, 1942.

———. "La mexicanidad de Don Carlos Sigüenza de Góngora." In *El hombre Colón y otros ensayos.* Mexico, 1944.

Imbelloni, José. "La capaccuna de Montesinos." *Anales del Instituto de etnografía Americana* 2 (1941).

———. "Los grupos raciales aborigenes." *Cuadernos de Historia Primitiva* (Madrid) 2 (1948).

Ixtlilxóchitl, F. de Alva. *Obras históricas.* Edited by A. Chavero. 1891–92. Reprint. Mexico, 1952.

Jantz, H. "Images of America in the German Renaissance." In *First Images of America,* edited by F. Chiappelli, 1:91–106. Berkeley, 1972.

Jauss, H. R., ed. *Die nichtmehr schönen Künste.* Munich, 1968.

Jaynes, Julian. "Fechner." *Dictionary of Scientific Biography* 4 (1971): 556–59.

Jimenez Moreno, W. "El enigma de los olmecas." *Cuadernos Americanos* 1, no. 5 (1942): 113–45.

Judd, N. M. *The Bureau of American Ethnology: A Partial History.* Norman, 1967.

Jung, C. G. "Psychological Aspects of the Mother Archetype." In *Collected Works.* 2d ed. Vol. 8, 353; vol. 9, part 1, 149–98. Princeton, 1969.

Keen, B. *The Aztec Image in Western Thought.* New Brunswick, 1971.

_____. "Antonello Gerbi" [obit.]. *Hispanic-American Historical Review* 58 (1978): 80–81.

Kelemen, P. *Medieval American Art.* 2 vols. 1943, Reprint. New York, 1969.

_____. "Pre-Columbian Art and Art History." *American Antiquity* 11, no. 3 (1946): 145–54.

Kelley, D. H. *Deciphering the Maya Script.* Austin, 1976.

_____. "Glyphic Evidence for a Dynastic Sequence at Quiriguá, Guatemala." *American Antiquity* 27 (1962): 323–35.

Kidder, Alfred V. "Obituary, G. Vaillant." *American Anthropologist,* n.s. 47 (1945): 589–602.

Kingsborough, Edward, *Antiquities of Mexico.* 2 vols. 1831–38. Reprint. Mexico, 1964.

Kirchhoff, Paul. "Mesoamerica." *Acta Americana* 1 (1943): 92–107.

Klemm, G. *Allgemeine Cultur-Geschichte der Menschheit.* Braunschweig, 1843.

Kluckhohn, C. "The Conceptual Structure in Middle American Studies." In *The Maya and Their Neighbors,* edited by C. L. Hays et al., 41–51. New York, 1940.

Knorozov, Y. V. "Maya Hieroglyphic Writing." *American Antiquity* 23 (1957–58): 284–91.

Koepping, K.-P. *Adolf Bastian and the Psychic Unity of Mankind.* St. Lucia, Australia, 1983.

Kofler, F. "Charnays Ansichten." *Zeitschrift für Ethnologie* 14 (1882).

Konetzke, R. "Hernán Cortés como poblador de la Nueva España." *Estudios Cortesianos* (Madrid) (1948): 341–81.

Kowalski, J. K. *The House of the Governor at Uxmal.* Norman, 1987.

Kroeber, A. L. "The Uhle Pottery Collection from Moche." *University of California Publications in American Archaeology and Ethnology* 21, no. 5 (1925): 191–234.

_____. "History and Science in Anthropology." *American Anthropologist* 37 (1935): 539–69.

_____. "Peruvian Archaeology in 1942." *Viking Fund Publications in Anthropology,* no. 4. New York, 1944.

_____. *Anthropology, Race, Language, Culture, Psychology, Prehistory.* New York, 1948.

_____. *Configurations of Culture Growth.* Berkeley, 1944.

_____. "Great Art Styles of Ancient South America." In *The Nature of Culture,* 289–96. Chicago, 1952.

_____. *Style and Civilizations.* Ithaca, 1957.

———. *An Anthropologist Looks at History.* Berkeley, 1963.

———. *Essays in Anthropology Presented to A. L. Kroeber.* Edited by R. H. Lowie. 1936. Reprint. Berkeley, 1968.

Kubler, George. "The Quechua in the Colonial World." In *Handbook of South American Indians,* edited by J. Steward, 2:331–54. Washington, 1946.

———. "Review of Bayle's Edition of Martín de Murua." *Hispanic-American Historical Review* 27 (1947): 299–300, 561–62.

———. *Mexican Architecture of the Sixteenth Century.* 2 vols. New Haven, 1948.

———. *Studies in the Iconography of Classic Maya Art.* New Haven, 1969.

———. "Vico e l'America Precolombina." *Bollettino del Centro di Studi Vichiani* 7 (1977): 58–66.

———. *Art and Architecture of Ancient America.* 3d ed. New York, 1984.

———. "Written Sources on Andean Cosmogony." In *Recent Studies in Andean Prehistory and Proto-history,* edited by D. P. Kvietok and D. H. Sandweiss, 197–211. Ithaca, 1983.

———. "Eidetic Imagery and Palaeolithic Art." *Journal of Psychology, Interdisciplinary and Applied* 119 (Nov. 1985): 557–66.

———. *Collected Essays.* Edited by T. F. Reese. New Haven, 1985.

———. "Indianism, *Mestizaje* and *Indigenismo.*" [1966] In *Collected Essays,* edited by T. F. Reese, 75–80. New Haven, 1985.

———. "Period, Style and Meaning in Ancient American Art." In *Collected Essays,* edited by T. Reese, 385–95. New Haven, 1985.

———. "A Reductive Theory of Visual Styles." In *The Concept of Style,* 2d ed., edited by B. Lang, 163–73 (Ithaca, 1987).

Kühn, Herbert. *Die Kunst der Primitiven.* Munich, 1928.

Kugler, F. T. *Handbuch der Kunstgeschichte.* Stuttgart, 1841–42.

Kultermann, Udo. *Geschichte der Kunstgeschichte.* Vienna, 1966.

Kurzweil, E. "The Neo-Structuralism of Michel Foucault." In *Cultural Analysis,* edited by R. Wuthnow et al. Boston, 1984.

Kutscher, Gerdt. "Zum Gedächtnis von Walter Lehmann." *Archiv für Anthropologie,* n.s. 25 (1949): 140–49.

———. *Nordperuanische Keramik.* Monumenta Americana, 1. Berlin, 1954.

———. *Nordperuanische Keramik: Figürlich verzierte Gefässe der Früh-Chimu.* Berlin, 1954.

———. *Chimu—Eine altindianische Hochkultur.* 1949. Reprint. Hildesheim, 1972.

———. "Berlin als Zentrum der Altamerica-Forschung: Eine bio-bibli-

ographische Übersicht." *Jahrbuch der Stiftung Preussischer Kulturbesitz* 4 (1966): 88–122.

Lafaye, J. *Quetzalcóatl and Guadalupe.* Chicago, 1976.

Laguna, Frederica de. "Review of d'Harnoncourt Exhibition." *American Journal of Archaeology* 45 (1941): 650.

Landa, Diego de. "Relación." In *Colección de documentos inéditos de ultramar,* edited by J. de la Rada y Delgado, series II, vol. 13 (1900).

––––––. *Landa's* Relación. Edited by A. M. Tozzer. Cambridge, 1941.

Larco Hoyle, R. *Los Mochicas.* 2 vols. Lima, 1938–39.

Lartet, E., and G. Christy. "Sur des figures d'animaux." *Revue archéologique* (1863): 264–65.

Las Casas, Bartolomé de las. *Apologética historia de las indias.* Edited by E. O'Gorman. Mexico, 1967.

Lasswitz, K. *Fechner.* Stuttgart, 1896.

Layton, R. "Art and Visual Communication." In *Art and Society,* edited by M. Greenhalgh and V. Megaw. London, 1978.

Lejarza, F. de. "Franciscanismo de Cortés." *Missionalia Hispanica* 5 (1948): 48–136.

Leo Hebraeus. *Diálogos del amor.* Translated by Garcilaso Inca. Madrid, 1590.

León Nicolas. "Fr. Diego Valadés, Nota biográfica." *Anales del Museo Nacional de México,* 2a. época, I (1903) 234–41.

León Pinelo, Antonio de. *Epítome de la biblioteca oriental y occidental.* Madrid, 1629.

León-Portilla, M. "Humboldt, Investigador de los códices y la cosmología náhuatl." In *Ensayos sobre Humboldt,* edited by M. O. Bopp, 133–48. Mexico, 1962.

––––––. "Ramirez de Fuenleal y las antigüedades mexicanas." *Estudios de Cultura Náhuatl* 8 (1969): 9–55.

––––––. "Historia, conocimiento del hombre." In *Del arte: Homenaje a Justino Fernandez,* 277–82. Mexico, 1977.

––––––. *Toltecáyotl, aspectos de la cultura náhuatl.* Mexico, 1980.

Leonard, I. *Don Carlos de Sigüenza y Góngora.* Berkeley, 1929.

Leroi-Gourhan, André. "L'art animalier dans les bronzes chinois." In *Le fil du temps,* edited by M. Sauter, 11–33. Paris, 1983.

––––––. "Review of S. Giedeon, *Eternal Present.*" *American Anthropologist* 65, no. 5 (1963): 1180–81.

––––––. *Le geste et la parole.* 2 vols. Paris, 1965.

––––––. "Problèmes artistiques de la préhistoire." In *Le fil du temps,* edited by M. Sauter, 271–84. Paris, 1983.

––––––. *Les religions de la préhistoire.* Paris, 1965.

———. *Le fil du temps: ethnologie et préhistoire, 1935–1970.* Paris, 1983.

Levine, M. H. "Review of Leroi-Gourhan's *Le geste et la parole.*" *American Anthropologist* 68 (1966): 1568–72.

Libby, W. F. *Radiocarbon Dating.* 2d ed. Chicago, 1955.

Lifshitz, M. A. *Karl Marx und die Ästhetik.* Dresden, 1967.

Lizana, Bernardo de. *Historia de Yucatán.* 1633. Reprint. Mexico, 1893.

Loaysa, F. A., ed. *Las costumbres antiguas del Perú y la historia de los Incas.* Lima, 1945.

Löschner, R. "Humboldts Naturbild und seine Vorstellung von Künstlerisch-physiognomischen Landschaftsbildern." In *Mythen der neuen Welt,* edited by K.-H. Kohl, 245–53. Berlin, 1982.

Lopez Austin, A. "The Research Method of Sahagún." In *Sixteenth-century Mexico,* edited by M. S. Edmonson. 1974.

Lopez de Cogolludo, Diego, *Historia de Yucatán* [1688] Campeche, 1842.

Lorenz, K. "Plays and Vacuum Activities." In *L'instinct,* edited by Masson, 633, 646. Paris, 1956.

Loubat, J. F. *Narrative of the Mission to Russia.* New York, 1873.

———. *A Medallic History of the United States.* New York, 1878.

———. *Yachtsman's Scrapbook.* New York, 1887.

———. *Le Duc de Loubat.* New York, 1894.

Lounsbury, F. G. "The Inscription of the Sarcophagus Lid at Palenque." *Primera Mesa Redonda de Palenque* (1976), 2:5–20.

Lowie, R. H. "A Note on Aesthetics." *American Anthropologist* 23 (1921): 170–74.

———. *Primitive Religion.* New York, 1924.

———. *Selected Papers on Anthropology.* Berkeley, 1960.

———. "Reviews of Hjalmar Stolpe, *Collected Essays.*" *American Anthropologist* 32 (1930): 302.

———. *History of Ethnological Theory.* New York, 1937.

Lucie-Smith, E. *Art Terms.* London, 1983.

Luquet, G. H. *L'art et la religion des hommes fossiles.* Paris, 1926.

———. *The Art and Religion of Fossil Man.* Translated by J. T. Russell, Jr. New Haven, 1930.

Magliabechi, Codex. 2 vols. Edited by E. H. Boone. Berkeley, 1983 (facsimile; notes and commentary).

McAndrew, John. *Open-Air Churches of Sixteenth-Century Mexico.* Cambridge, 1965.

Mace, C. E. "Brasseur de Bourbourg." *Handbook of Middle American Indians* 13 (1975): 298–325.

Mackehenie, C. A. "Apuntes sobre las traducciones castellanas de León Hebreo." *Mercurio Peruano* 22, no. 164, year 15 (1940): 678–97.

MacLeod, M. J. "Las Casas, Guatemala, and the Sad but Inevitable Case of Antonio Remesal." *Topic* 20 (1970): 53–64.

MacNeish, R. S. *Prehistory of the Tehuacán Valley*, vol. 1. Austin, 1967.

Magnaghi, A. *Amerigo Vespucci: Studio critico*. Rome, 1926.

Maler, T. "Researches in the Central Portion of the Usumacintla Valley." *Memoirs Peabody Museum* (Harvard), 2, no. 1. (1901).

Mariéjol, J.-H. *Pierre Martyr: Sa vie et ses oeuvres*. Paris, 1887.

Marquez, P. J. *Sobre lo bello en general*. Mexico, 1972.

Marshall, H. R. *Aesthetic Principles*. New York, 1895.

———. *Pain, Pleasure, and Aesthetics*. New York, 1894.

Martinez de Compañon, J. *La Obra del Obispo Martinez Compañon*. 3 vols. Madrid, 1936. (See Dominguez Bordona, J.)

Martyr, Peter. *Décadas del nuevo mundo*. Edited by E. O'Gorman. Mexico, 1964.

Marx, K., and F. Engels. *Über Kunst und Literatur*. 2 vols. Berlin, 1968.

Mason, J. A. "Franz Boas as an Archaeologist." *Memoir 61, American Anthropologist 45*, no. 3, pt. 2 (1943): 59–64.

Maticorena Estrada, M. "Informe sobre el archivo del seminario de Santo Toribio." MS, 1949.

Matute, Alvaro. *Lorenzo Boturini y el pensamiento histórico de Vico*. Mexico, 1976.

Maza, F. de la. "Fray Diego de Valadés, escritor y grabador franciscano del siglo XVI." *Anales del Instituto de Investigaciones Estéticas* 13 (1945): 15–44.

Means, P. A. *Biblioteca andina*. 1928. Reprint. New Haven, 1967.

Mendieta, Gerónimo de. *Historia eclesiástica indiana*. Edited by F. de Solano. Madrid, 1973.

Mendizabal Lozack, E. "Las dos versiones de Murúa." *Revista del Museo Nacional* 23 (1963): 153–85.

Miller, Daniel, and Christopher Tilley, eds. *Ideology, Power and Prehistory*. Cambridge, 1984.

Miller, M. E. "A Reexamination of the Mesoamerican Chacmool." *Art Bulletin* 67 (1985): 7–17.

———. *The Murals of Bonampak*. Princeton, 1986.

Miller, M. E., and S. Houston. "The Classic Maya Ballgame and Its Architectural Setting: A Study of Relations between Text and Image." *Res* 14 (1987): 46–65.

Millon, René. *The Teotihuacán Map*. 2 vols. Austin, 1973.

Millones y Gadea, Luis. "Un movimiento nativista del siglo XVI: El Taki Onqoy." *Revista Peruana de Cultura* 3 (1964): 134–40.

Miró Quesada, A. *El Inca Garcilaso*. Madrid, 1971.

Moebus, J. "Ueber die Bestimmung des Wilden und die Entwicklung des Verwertungsstandpunkts bei Kolumbus." In *Mythen der neuen Welt,* edited by K.-H. Kohl. Berlin, 1982.

Moles, Abraham. *Information Theory and Esthetic Perception.* Translated by J. E. Cohen. Urbana, 1966.

Montesinos, Fernando de. "Memorias antiguas historiales del Perú." In *Coleccíon de libros españoles raros o curiosos,* 16. edited by Marcos Jiménez de la Espada. Madrid, 1882.

Moreno Bonett, M. *Nacionalismo novohispano.* Mexico, 1983.

Morison, S. E. *Admiral of the Ocean Sea: A Life of Christopher Columbus.* 2 vols. Boston, 1942.

Morley, S. G. *The Inscriptions of Petén.* 5 vols. Washington, 1937–38.

————. *The Ancient Maya.* Stanford and Oxford, 1946. Revised by G. W. Brainerd, 1956, and rewritten by Robert J. Sharer in 1983.

Morris, Desmond. *Biology of Art.* London, 1962.

Motolinia (Fray Toribio Paredes de Benavente). *Memoriales.* Edited by E. O'Gorman. Mexico, 1971.

Moxó, B. M. de. "Cartas mejicanas escritas por D. Benito María de Moxó en 1805." (See Vargas Ugarte, *Tres figuras,* 65–163.)

Müller, Friedrich Max. "Comparative Mythology." In *Oxford Essays,* 2:1–87. London, 1856.

Mueller, Werner. *Amerika, neue oder alte Welt?* Berlin, 1982.

Mukarovsky, J. "Art as Semiotic Fact." In *Semiotics of Art, Prague School Contributions.* Edited by L. Matejka and I. R. Titunik, 3–10. Cambridge (Mass.), 1976.

Munro, T. *Evolution in the Arts and Other Theories of Culture History.* Cleveland, 1963.

Murra, John, ed. *Guaman Poma.* 3 vols. Mexico, 1980.

Murúa, Martín de. *Historia del origen y genealogía de los reyes incas.* Edited by C. Bayle. Madrid, 1946.

————. *Historia general del Perú.* 2 vols. Edited by M. Ballesteros Gaibrois. Madrid, 1962–64.

Museum of Modern Art (New York). *Twenty Centuries of Mexican Art.* Mexico City and New York, 1949.

Nadaillac, J. F. de. *Prehistoric America.* New York, 1883.

————. *Die ersten Menschen und die prähistorischen Zeiten, mit besonderer Berücksichtigung der Urbewohner Amerikas.* Translated by W. Schlosser and E. Seler. Stuttgart, 1884.

Nebel, C. *Viaje pintoresco.* Paris, 1829–34.

Nelson, C. M. "William Henry Holmes: Beginning a Career in Art and Science." *Records of the Columbia Historical Society* 50 (1980).

Nicholson, H. B. "Eduard Georg Seler." *Handbook of Middle American Indians* 13 (1973): 348–60.

Norbeck, E. "The Anthropological Study of Human Play." *Rice University Studies* 60, no. 3 (1974).

Nuix, Juan. *Reflexiones . . . contra los pretendidos filósofos.* Madrid, 1782.

Ocaranza, F. *El imperial Colegio de Santa Cruz de Santiago de Tlatelolco.* Mexico, 1934.

Odebrecht, Rudolf. "Ästhetik der Gegenwart." *Philosophische Forschungsberichte* 15 (1932).

O'Gorman, Edmundo. *The Invention of America: An Inquiry into the Historical Meaning of the New World and the Meaning of Its History.* Bloomington, 1961.

———, ed. *Nezahualcoyotl Acolmiztli (1402–1472).* Mexico, 1972.

O'Nell, C. W. *Dreams, Culture and the Individual.* San Francisco, 1976.

Ortega y Gasset, J. "Qué son los valores?" *Revista de Occidente* 1, no. 4 (1923): 39–70.

Ossio, J. M. "Guaman Poma: Nueva corónica o carta al rey?" In *Ideología mesiánica del mundo andino.* Lima, 1973.

Oviedo, Gonzalo Fernandez de. *Historia general y natural de las Indias.* 4 vols. Edited by J. Amador de los Rios. Madrid, 1855–56. Facsimile edition, Chapel Hill, 1969.

———. *Natural History of the West Indies.* Edited by S. A. Stoudemire. Chapel Hill, 1959.

Padilla Bendezú, A. *Huaman Poma. El indio cronista dibujante.* Mexico, 1979.

Palafox y Mendoza, Juan de. *Obras.* Madrid, 1762.

Palomera, E. J. *Fray Diego Valadés.* 2 vols. Mexico, 1962–63.

Panofsky, E. *Albrecht Dürer.* 2 vols. Princeton, 1945.

Pasztory, E. "Masterpieces in Pre-Columbian Art." *Actes, 42nd International Congress of Americanists* (Paris) 7 (1976): 377–90.

Pauw, Corneille de. *Recherches philosophiques sur les américains.* Berlin, 1768.

Paz, Octavio. "Food of the Gods." *New York Review of Books,* Feb. 26, 1987, p. 3.

Perez Martinez, H., ed. *Relación de las cosas de Yucatán.* Mexico, 1938.

Perez Salazar, F. *Obras.* 1928.

Perry, T. A. *Léon Hébreu, dialogues d'amour.* Chapel Hill, 1974.

Petranu, C. *Inhaltsproblem und Kunstgeschichte.* Vienna, 1921.

Pflaum, Heinz. "Die Idee der Liebe, Leone Ebreo." *Heidelberger Ab-*

handlungen zur Philosophie und ihrer Geschichte 7 (1926): 65–67, 104.

Phelan, J. L. *The Millennial Kingdom of the Franciscans in the New World*. Berkeley, 1956.

Piaget, J. *Play, Dreams and Imitation in Children*. New York, 1951.

Pijoan y Soteras, José. "Arte precolombino." Vol. 10 (Barcelona, 1946) of *Summa artis, historia general del arte,* 16 vols. Bilbao-Madrid, 1931–67.

———. *Arte precolombino*. Barcelona, 1946.

Piovani, Pietro. "Notizie." *Bollettino del centro di studi vichiani* 5 (1975): 168–72.

Pollock, H. E. D. "Final Report." Carnegie Institution of Washington, *Year Book,* 57 (1957–58): 435–55.

Porras Barrenechea, Raúl. *Los cronistas del Perú, 1528–1560*. Lima, 1962.

Porter, D. B. *Emergence of the Past*. Chicago, 1981.

Pribram, K. H. *Languages of the Brain*. Englewood, 1971.

Proskouriakoff, T. "Historical Implications of a Pattern of Dates at Piedras Negras, Guatemala." *American Antiquity* 25, no. 4 (1960): 449–75.

———. "Review of M. Coe, *The Maya*." *American Anthropologist* 70 (1968): 166.

———. "Studies on Middle American Art." In *Anthropology and Art,* edited by C. M. Otten, 129–39. New York, 1971.

Prown, Jules. "Editor's Statement: Art History vs. The History of Art." *Art Journal* 44, no. 4 (1984): 313–14.

Quitzsch, H. *Die ästhetischen Ansichten Gottfried Sempers*. Berlin, 1962.

Raynal, G.-T. F. *Histoire philosophique et politique des établissements et du commerce dans les deux Indes*. 6 vols. Amsterdam, 1770.

Reinach, S. *Répertoire de l'art quaternaire*. Paris, 1913.

Remesal, Antonio de. *Historia general de las Indias occidentales*. Edited by C. Saenz. Madrid, 1964.

Reyes Valerio, C. "Iconografía de un grabado de Fray Diego Valadés."

Ricard, Robert. *La "Conquête spirituelle" du Mexique*. Paris, 1933.

Rivet, Paul. *Les origines de l'homme américain*. Montreal, 1943.

Robertson, Donald. "The Sixteenth-Century Mexican Encyclopedia of Fray Bernardino de Sahagún." *Cuadernos de Historia Mundial* 9, no. 3 (1966): 617–28.

———. "The Tulum Murals: The International Style of the Late Postclassic." *36th International Congress of Americanists,* 2:77–88. Stuttgart-Munich, 1968.

_____. *Mexican Manuscript Painting of the Early Colonial Period: The Metropolitan Schools.* New Haven, 1969.

_____. "Clio in the New World." In *The Historian's Workshop,* edited by L. P. Curtis, Jr., 103–21. New York, 1970.

Rojas Garcidueñas, J. *Ideas políticas.* Mexico, 1946.

Rojas-Mix, M. "Die Bedeutung A. von Humboldts für die künstlerische Darstellung Lateinamerikas." In *Alexander von Humboldt, Werk und Geltung,* edited by H. Pfeiffer. Munich, 1969.

Román y Zamora, Jerónimo. *Repúblicas de Indias, Medina del Campo* [1575]. 2d ed., 1595 (enlarged).

_____. *Repúblicas del mundo.* 2 vols. Madrid, 1897.

Ross, D. W. "Design as a Science." *Proceedings, American Academy of Arts and Sciences* 36, no. 21 (1901): 357–74.

Rouse, Irving. "Peopling of the Americas." *Quaternary Research* 6 (1974): 597–612.

Rowe, J. H. "Review of Andean Culture History." *American Antiquity* 12 (1950): 170–72.

_____. "Max Uhle, 1856–1944: A Memoir of the Father of Peruvian Archaeology." *University of California Publications in American Archaeology and Ethnology* 46 (1954).

_____. "Cultural Unity and Diversification in Peruvian Archaeology." *International Congress of Anthropological and Ethnological Sciences* 5 (1956): 627–31.

_____. "The Age-Grades of the Inca Census." *Miscellanea Paul Rivet,* 2:499–582. Mexico, 1958.

_____. "Radiocarbon measurements." In *Peruvian Archaeology,* edited by J. Rowe and D. Menzel, 16–30. Palo Alto, 1971.

Roys, R. L., and M. W. Harrison. "Obituary of S. G. Morley." *American Antiquity* 5 (1949) 215–21.

Ruppert, K. J., J. E. S. Thompson, T. Proskouriakoff. *Bonampak.* Washington, D.C., 1955.

Rupprich, Hans. *Schriftlicher Nachlass Albrecht Dürer.* Berlin 1956–.

Ruz Lhuillier, A. "Semblanza" [Obituary of Eric Thompson]. *Estudios de Cultura Maya* 10 (1976–77): 337–43 (including bibliography by Enrique Viloria V.).

Sabloff, J. A., L. R. Binford, P. A. McAnany. "Understanding the Archaeological Record." *Antiquity* 61 (1987): 203–09.

Sahagún, B. de. *Historia General de las Cosas de Nueva España.* Edited by F. del Paso y Troncoso. Madrid, 1905–07.

_____. *Historia General de la Cosas de Nueva España.* 3 vols. Edited by Acosta Saignes. Mexico, 1946.

————. *General History of the Things of New Spain.* 13 vols. Edited by A. J. O. Anderson and C. E. Dibble. Santa Fe, 1950–75.

Salas, A. M. *Tres cronistas de Indias.* Mexico, 1959.

Salas Ortega, Antonio. *Alfonso Caso.* Mexico, 1975 (bibliography 81–101).

Salinas y Cordova, Fray Buenaventura de. *Memorial de las historias del nuevo mundo Piru.* Edited by L. Valcarcel and Warren Cook. Lima, 1957.

Sanders, W., and B. Price. *Mesoamerica.* New York, 1968.

Sanz, C. *Australia: Su descubrimiento y denominación.* Madrid, 1963.

Sapir, Edward. *Time Perspective in Aboriginal American Culture: A Study in Method.* Ottawa, 1916.

Sauter, Marc, ed. *Le fil du temps.* Paris, 1983.

————, ed. *L'homme, hier et aujourd'hui.* Paris, 1972.

Saxl, F. "Illustrated Medieval Encyclopaedias." Vol. 1 of *Lectures.* London, 1957.

Schaefer, J. M. "Galton's Problem in a New Holocultural Study on Drunkenness." In *Studies in Cultural Diffusion.* 2 vols. (1974), 1:113–42.

Schapiro, Meyer. "Review of Kroeber's *Style and Civilizations.*" *American Anthropologist* 61 (1959): 303–05.

Schele, L. *Maya Glyphs. The Verbs.* Austin, 1982.

Schele, L., and M. E. Miller. *The Blood of Kings.* Fort Worth, 1986.

Schellhas, Paul. "Representation of Deities of the Maya Manuscripts." *Peabody Museum Papers* 4, no. 1 (1904): 7–47.

Schelling, F. "Philosophische Kunst." Vol. 5 of *Sämmtliche Werke.* Stuttgart, 1859.

Schiller, J. C. F. von. "Letters upon the Aesthetical Education of Man." Letter 15. London, 1906.

Schimmel, J., and W. W. Truettner. *Art in New Mexico, 1900–1945.* Washington, 1986.

Schlegel, A. W. "Vorlesungen über schöne Litteratur und Kunst." *Deutsche Litteraturdenkmale.* Edited by J. Minor. Heilbronn, 1884.

Scholes, F. V. "The Beginnings of Hispano-Indian Society in Yucatan." *Scientific Monthly* 44 (1937): 530–38.

Scholes, F. V., and B. E. Adams. "Biblioteca histórica mexicana de obras inéditas (Documentos sacados de los archivos de España)." *Mexico* 15 (1935): 392–435.

Schrader, R. F. *The Indian Arts and Crafts Board: An Aspect of New Deal Indian Policy.* Albuquerque, 1983.

Scott, J. F. *Post-Olmec Art in Preclassic Oaxaca.* (University Microfilms, 72-10464) Ann Arbor, 1971.

Scully, Vincent. *Pueblo*. New York, 1972.

Seler, E. G. *Gesammelte Abhandlungen*. 5 vols. Berlin, 1902–23. Reprinted 1967, with F. Anders's index.

———. *Beobachtungen und Studien in den Ruinen von Palenque*. Berlin, 1915.

———. *Observations and Studies in the Ruins of Palenque*. Translated by G. Morgner. Pebble Beach, Cal., 1976.

Semper, G. *Die vier Elemente*. Braunschweig, 1851.

———. *Der Stil in den technischen und tektonischen Künste, oder praktische Ästhetik*. 2 vols. Frankfurt, 1860–63. 2d ed. Munich, 1878.

Seymour, M. C., et al., eds. *On the Properties of Things. John Trevisa's Translation of Bartholomaeus Anglicus, De Proprietatibus Rerum. A Critical Text*. 2 vols. Oxford, 1975.

Shaw, E. "A Belief in 'Things We Can't Conceive of Yet.'" *Art News* 78 (1979): 138–40.

Siecke, Ernst. *Beiträge zur genaueren Erkenntnis der Mondgottheit bei den Griechen*. Berlin, c. 1885.

———. *Die Liebesgeschichte des Himmels*. Strasbourg, 1892.

———. *Urreligion der Indogermanen*. Berlin, 1897.

———. *Drachenkämpfe: Untersuchungen zur indogermanischen Sagenkunde*. Leipzig, 1907.

———. *Mythologische Briefe*. Berlin, 1901.

Sigüenza y Góngora, Carlos de. *Teatro de virtudes políticas*. Mexico, 1680.

———. *Parayso occidental*. Mexico, 1684.

———. *Obras*. Mexico, 1928.

Siméon, Rémi, ed. and trans. *Annales . . . de Chimalpahin (1258–1612)*. Paris, 1889.

Simpson, L. B. *The Encomienda in New Spain: The Beginning of Spanish Mexico*. Berkeley, 1950.

Smith, J. W., and R. A. Smith. "New Light on Early Sociocultural Evolution in the Americas." In *Peopling of the New World*, edited by J. E. Ericson, R. E. Taylor, and R. Berger. Los Altos, 1982.

Smith, E. B. "Review of Boas, *Primitive Art*." *American Journal of Archaeology* 33 (1929): 166–67.

Solano, F. de. *Homenaje*. Madrid, 1983.

Spencer, Herbert. *Autobiography*. 2 vols. London, 1904.

Spence, L. *An Introduction to Mythology*. London, 1921.

Spinden, H. J. "A Study of Maya Art, Its Subject Matter and Historical Development." [1909], *Memoirs, Peabody Museum* (Harvard), 6 (1913). Reissued at Indian Hills, Colorado, in 1957 and at New York, 1975.

_____. *Ancient Civilizations of Mexico and Central America* 3d ed. 1917. Reprint. New York, 1928.

_____. "The Reduction of Maya dates." *Papers, Peabody Museum* 6, no. 4 (1924).

_____. Introduction to American Indian Art. Edited by F. W. Hodge, H. Spinden, and O. LaFarge. New York, 1931.

_____. "As Revealed by Art." America South of U.S. Brooklyn Museum [exhibition], 1941.

Springer, A. H. *Kunsthistorische Briefe. Die bildenden Künste in ihrer weltgeschichtlichen Entwicklung.* Prague, 1857.

Steck, F. B. *El primer colegio de América.* Mexico, 1944.

Stephens, John Lloyd. *Incidents of Travel in Central America, Chiapas, and Yucatan.* 2 vols. New York, 1841.

_____. *Incidents of Travel in Yucatan.* 2 vols. New York, 1843.

Stevens, Anthony. "Review of Leroi-Gourhan, 'Sur une méthode d'étude de l'art pariétal-paléolithique.' " *Antiquity* (London), 49 (1975): 54–57.

Stevens, J. C. "Psychopysics." *International Encyopedia of Social Science*, 13:123. 1968.

Steward, Julian. *Alfred Kroeber.* New York, 1973.

Stirling, M. W. "Stone Monuments of Southern Mexico." *Bulletin of the Bureau of American Ethnology* 138 (1943).

Stone, Rebecca. *Horizon and Horizon Style in the Study of Ancient American Objects: Concept, Category and Challenge.* In review, 1986.

Strong, Duncan "Obituary of G. Vaillant." *American Antiquity* 11 (1945–46): 113–16.

Swadesh, Morris. *Origin and Diversification of Language.* Edited by F. Scherzer. Chicago, 1971.

Sydow, E. von. *Die Kunst der Naturvölker und der Vorzeit.* Berlin, 1925.

_____. "Studien zur Form und Formgeschichte der mexikanischen Bilderschriften." *Zeitschrift für Ethnologie* 72 (1940): 197–234.

_____. *Afrikanische Plastik: Aus dem Nachlass herausgegeben von Gerdt Kutscher.* Berlin, 1954.

Taine, H., *Philosophie de l'art.* Paris, 1875.

Taylor, W. W., Jr., *A Study of Archaeology.* Memoir Series no. 69, American Anthropological Association, 1948.

Termer, F. "Eduard Seler." *México Antiguo* 7 (1949): 11–15.

Tezozomoc, Hernando Alvarado. *Crónica mexicana.* Edited by M. Orozco y Berra. 1878. Reprint. Mexico, 1944.

Thompson, J. E. S. *Maya Indians of Yucatan.* Washington, 1942.

———. *Maya Hieroglyphic Writing.* 1950.

———. "The Character of the Maya." *30th International Congress of Americanists, Proceedings,* 1952, 36–40. London, 1953.

———. *Rise and Fall of Maya civilization.* Norman, 1954.

Torquemada, Juan de. *Monarquía indiana.* Edited by M. León-Portilla. Mexico, 1964.

Toscano, Salvador. *Arte precolombino de México y América Central.* Mexico, 1944.

Toussaint, Manuel. *Arte Colonial en México.* Mexico, 1948.

Toussaint, Manuel, Justino Fernández, and E. O'Gorman. *Planos de la ciudad de Mexico.* Mexico, 1938.

Trenton, P., and P. H. Hassrick. *The Rocky Mountains.* Norman, 1983.

Tudela, José. "Review of Pijoan, 'Arte precolombino.'" *Revista de Indias* 8 (1947): 28–29, 592–94.

———, ed. *Relacíon de las ceremonias y ritos . . . de Michoacán.* Madrid, 1956.

———. *Las primeras figuras de indios pintadas por Españoles: Homenaje a Rafael Garcia Granados.* Edited by R. Martinez del Rio. Mexico, 1960.

Tylor, E. B. *Primitive Culture.* London, 1871.

———. *Anthropology.* London, 1881.

Ucko, P., and A. Rosenfeld, *Palaeolithic Cave Art.* London, 1967.

Uhle, Max. *Kultur und Industrie südamerikanischer Völker.* 2 vols. Berlin, 1889–90.

———. *Die alten Kulturen von Peru im Hinblick auf die Archäologie und Geschichte des amerikanischen Kontinents.* Berlin, 1935.

Vaillant, G. C. "Chronology and Stratigraphy in the Maya Area." *Maya Research* 2 (1935).

———. *Artists and Craftsmen.* New York, 1935.

———. *Aztecs of Mexico.* New York, 1941.

———. Shadow and Substance in Cultural Relations." *Scientific Monthly* 60 (1945): 373–78.

Valadés, Diego. *Rhetorica cristiana.* Perugia, 1572.

Valera, Blas. *Las costumbres antiguas del Perú y la historia de los Incas.* Edited by F. A. Loaysa. Lima, 1945.

Van de Castle, R. L. *The Psychology of Dreaming.* New York, 1971.

Vargas, Ugarte, R. *Tres figures señeras del episcopado americano.* Lima, 1966.

———. *Historia del Seminario de Santo Toribio de Lima.* Lima, 1969.

Varner, J. G. *El Inca.* Austin, 1968.

Veitia. See Fernandez de Echeverría y Veytia, Mariano.

Venturi, Lionello. *History of Art Criticism*. Translated by Marriott. New York, 1936.

Venturi, Franco. "Un Vichiano tra Messico y Spagna: Lorenzo Boturini Benaduci." *Rivista Storica Italiana* 87 (1975): 770–84.

Veyne, Paul. *Comment on écrit l'histoire*. Paris, 1971.

Vico, G. B. *The New Science*. Ithaca, 1944.

Vierkandt, A. "Prinzipienfragen der ethnologischen Kunstforschung." *Zeitschrift für Ästhetik und allgemeine Kunstwissenschaft* 19 (1925): 338–49.

Villa, Justa de la. "Moctezuma y Tula." *Diccionario de historia de España*. 2d ed. Edited by G. Bleiberg. Madrid, 1969.

Villor, L. *Los grandes momentos del indigenismo en México*. Mexico, 1950.

Viollet-le-Duc, E. E. "Antiquités américaines." In C-J.-D. Charnay, *Cités et ruines américaines*. Paris, 1863.

Voit, A. *Denkmäler der Kunst*. 4 vols. Stuttgart, 1851–56. Also as W. Lübke, *Monuments of Art*. New York, n.d.

Vollmer, Günter. "Gerdt Kutscher, 1913–1979." *Indiana* 10, pt. 2 (1984): 485–584.

Wachtel, Nathan. *La vision des vaincus*. Paris, 1971.

Waetzoldt, W. *Deutsche Kunsthistoriker*. 2 vols. Leipzig, 1924.

Wagner, H. R. *The Rise of Fernando Cortés*. Berkeley, 1944.

———. "Three Studies on the Same Subject." *Hispanic-American Historical Review* 25 (1945): 155–211.

Waldeck, J. F. *Voyage pittoresque*. Paris, 1838.

Wallace, E. R. *Historiography and Causation in Psychoanalysis: An Essay in Psychoanalytic and Historical Epistemology*. Hillsdale, N.J., 1985.

Wang, W. S.-Y. "Language Change." *Annals of the New York Academy of Sciences* 280 (1976): 61–72.

Watson, P. J., et al. *Explanation in archaeology*. New York, 1975.

Wauchope, R. "Review of Proskouriakoff, *Study of Classic Maya Sculpture*." *American Antiquity* 12 (1951): 161–62.

———. *Lost Tribes and Sunken Continents: Myth and Method in the Study of American Indians*. Chicago, 1962.

———. "Obituary of A. V. Kidder." *American Antiquity* 31, no. 2, pt. 1 (1964): 149–71.

Welsh, P. "Review of Munro." *Art Bulletin* 52 (1970): 354–56.

Werckmeister, O. K. "Marx on Ideology and Art." *New Literary History* 4 (1972–73): 500–19.

Wescott, R. W. "Protolinguistics." *Annals of the New York Academy of Sciences* 280 (1976): 104–16.

Westheim, Paul. *L'art ancien du Mexique*. Paris, 1922.
_____. *Arte antiguo de México*. Mexico, 1950.
_____. *The Art of Ancient Mexico*. Translated by V. Bernard. Garden City, 1955.
_____. *Obras maestras del México antiguo*. Mexico, 1977.
White, L. A. *Pioneers in American Anthropology: The Bandelier–Morgan Letters, 1873–1883*. Albuquerque, 1940.
_____. *The Science of Culture*. New York, 1949.
_____. "The Ethnography and Ethnology of Franz Boas." *Bulletin of the Texas Memorial Museum* (Austin), no. 6 (1963): 1–76.
White, L. A., and I. Bernal. *Correspondencia de Adolfo F. Bandelier*. Mexico, 1960.
Wilcox, M. "Amalric," *Encyclopedia Americana*, 1:478–79. New York, 1953.
Wilkerson, S. J. K. "The Ethnographic Works of Andrés de Olmos, Precursor and Contemporary of Sahagún." In *Sixteenth-Century Mexico*, edited by M. S. Edmonson, 27–77. Albuquerque, 1974.
Willey, G. R. "Review of *Andean Culture History*." *American Anthropologist* 52 (1950): 90.
_____. "Prehistoric Settlement Patterns in the Virú Valley." *Bureau of American Ethnology, Bulletin 155*. Washington, 1953.
_____. *An Introduction to American Archaeology*. 2 vols. Englewood Cliffs, 1966–71.
_____. "Alfred Vincent Kidder," *Biographical Memoirs (National Academy of Sciences)*, 39 (1964) 308–22.
_____. "Mesoamerican Civilization and the Idea of Transcendence." *Antiquity* 50 (1976): 205–15.
_____. "Spinden's Archaic Hypothesis." In *Antiquity and Man*, edited by J. D. Evans, B. Cunliffe, and C. Renfrew, 35–42. London, 1981.
_____. "The Convergence of Humanistic and Scientific Approaches in Maya Archaeology." *Indiana* 10 (1985): 215–27.
Willey, G. R., and J. Sabloff. *A History of American Archaeology*. 2d ed. San Francisco, 1980.
Williams, Stephen. Introduction to 1977 reissue of the Holmes Anniversary Volume [1916].
Winckelmann, J. J. *Geschichte der Kunst des Altertums*. Dresden, 1764–67.
Wissler, C. *The American Indian*. New York, 1917.
Witkowski, S. "Galton's Opportunity: The Hologeistic Study of Historical Processes." In *Studies in Cultural Diffusion*. Vol. 1. New Haven, 1974.
Wölfflin, H. *Kunstgeschichtliche Grundbegriffe*. Munich, 1915.

Woodbury, R. B. *Alfred Vincent Kidder, Life and Work,* New York, 1973.

Worringer, W. *Griechentum und Gotik.* Munich, 1928.

Wundt, W. *G. T. Fechner.* Leipzig, 1901.

Wuthenau, Alexander von. *Altamerikanische Tonplastik: Das Menschen-bild der neuen Welt.* Baden-Baden, 1965.

Zimmermann, G. *Die Relationen Chimalpahin's zur Geschichte Mexiko's.* Hamburg, 1963.

Zuidema, T. *The Ceque System of Cuzco.* Leyden, 1964.

Index

Index

Caricature, 147, 228–29n73
Carnegie Institution of Washington, 152, 186
Caso, Alfonso: on social organization, 142; archaeologist, 189–90
Castañeda, José Luis, 10
Castizo, 201n10
Catherwood, F., drawing by, fig. 36
Chac Mool, fig. 28
Chalchihuites (Zacatecas), 186
Chanchan (Peru), 171
Charnay, C.-J.-D., traveler, 104–08
Chase, George, 188
Chichén Itzá, Castillo (in Landa), fig. 12
Chichimec history, 81
Chimalpain, Francisco de San Antón, historian, 83
Chodowiecki, D. N., 97
Cholula, 9, fig. 24
Cihuacoatl, fig. 13
"civilized," degrees of, 207n87
Clavigero, Francisco Javier, 7, 8–9
Coatlicue, fig. 25, 151
Cochiti, pueblo, 170
Cocom, 211n69
Codex Magliabechi, fig. 8
Codex Tudela, fig. 8, 51, fig. 10
Collège de France, 165
Collier, John, 145
Columbia University, 165
Columbus, Christopher, 41–43
Comunero revolt, Spain, 48
Consumers of archaeology, 188
Cook, Warren, 79
Cook de Leonard Carmen, 182
Copán: drawn by Catherwood, 127; sculpture at, 135
Corbel vault, Maya, 124
Corcoran Gallery, 122
Correlations for Maya calendars, 138
Cortés, Hernan, 4; as "new Moses," 44–49; writings on Conquest, 47–48; as humanist lawyer, 208–09n17
Coruña, Martín de la, 50–51
Cosmogonies, Mexican and Andean, 34
Cosmos Club, 122
Costumbrismo, 128
co-tradition, areal, 194
Courajod, L., 232n138
Covarrubias, Miguel, 147–50
"Creole myth," 209n23
Crespillo, Indian artist, 54
Cuicuilco, 138
Culin, Stewart, 109–10
Cultural materialists, 102

Cummings, B. C., 128–29
Curiosity cabinets, 17
Curtis, Lewis, Jr., 158
Cyclic creations, Amerindian, 216n179

Daguerre equipment, 129
Darwin, Charles: on play, 110; on esthetics, 115–16
Davies, Nigel, as antidiffusionist, 206–07n84
Davis, Whitney, on "image-making," 204n35
de Pauw, Corneille, 7, 85
Delight Makers, novel by Bandelier, 169–70
desamor al indígena (aversion to Indians), 154
Dessoir, Max, 175–76
d'Harnoncourt, René, 143–46
Diaz del Castillo, Bernal, 54
diffusionism, 3, 27–33, 171, 207n94, 220n53
"disinterest" as esthetic, 189
Division of Historical Research, Carnegie Institution of Washington, 188
Donnan, C. P., 157
dream content, 206n64
Dürer, Albrecht, 14, 43, 208n11
Dupaix, Guillermo, explorer, 9, 92–96, fig. 39, 201n20, 32, 203n54
Durán, Diego, 6, 61–62
Duveneck, Frank, 122

Egypt, 183
eidetic imagery, 20, 110–11
elementary ideas, 163
Emeryville mound, 177
"empires" in America, 132
encomienda (royal award of native labor), 53
encyclopedic etymologiae, 159
Engerrand, Jorge, 132–33
"engines of change," 199
esthetics, xv; of Amerindians, 2; "laws," 115; and biology, 115; Holmes, 117–19; prior to culture, 177; evolutionary, 176; origins, 178; as impulse, 182; as intuition, 189; and invention, 191; as condition, 195; content, 195; as cause, 196; choices, 199; limits, 230n94
ethnohistory, xv

Fechner, Gustav Theodor, 110–13
Fejérváry-Mayer, Codex, 179, fig. 44
Fellows, O. E.: on Buffon, 202n32

Index

Fernandez, Justino, as historian of Mexican art, 151–52; on Covarrubias, 149; as "historicist," 230n95
Fernández de Echeverría y Veytia, Mariano, 87
Fernandez de Enciso, Martín, 87
Fernandez de Oviedo, Gonzalo, 85, fig. 19
Field Columbian Museum, Chicago, 117
Focillon, Henri, 138
form, follows function/meaning, 241n7
Foucault, Michel, 12, 15–16
Frazer, J. G., 163
Freud, Sigmund, 164
Friedrichsthal, Baron, 222n89
Fuentes, Carlos, 196

Galindo y Villa, Jesús, 186
"Galton's Problem," 40
Gamio, Manuel: esthetic experiments by, 153; anthropological archaeologist, 185–86; esthetic sense, 185; S. Miguel Amantla, 187
Gaos, José, 17
Garcia, Gregorio, 64–65
Garcia Icazbalceta, J., 169
Garcilaso de la Vega (el Inca): historian, 76–78; army service, 216n168; compared with Guaman Poma, 78
Gérard, François, 97
Gerbi, Antonello, 84–87, 202n50
Gibson, Charles, 158
Giedeon, S., 21
Gilbert, K. E., 109, 175
Gladwin, H. S., 147
Glanville, Bartholomew de, 159
Glass, John, 202n41
glottochronology, 205n58
Gobineau, Comte de, 108
Gothic "international style," 160
graded series, xvi, 17
Granada, Spain, 77
graphs on esthetics, 118–22, figs. 29–32
"great art": term used by Kroeber, 177
Grieder, T., 32–33
Guaman Poma, Felipe, 78–81; map by, fig. 17; influenced by engravings of Roman cities, 216n180
Gutierrez de Santa Clara, 69
Guzmán, Eulalia, 142

Hebraeus, Leo, 76, 215nn162–64
Hegel, G. W. F., 8, 132
Heine-Geldern, Robert, 147
Henry, Mary, 122
Hentze, Carl, 32, 147

Heraclitus, 151
Herbart, J. F., 154
Herder, J. G. von, 9, 100, 127, 130, 202n48
hermeneutic field, 197
Hewitt, Edgar Lee, 183
Historia de los mexicanos por sus pinturas, 51
historiography, as measure of error, 197–99
history: as anthropology, 177; tribal, 197
Hitchcock, H.-R., 143–44
Hodge, F. W., 125
Holbein, H., *Madonna,* 111
Holmes, William Henry, 117–26; influenced by Semper, 114–15; sources, 225n62
hologeistic (whole-earth) method, 40
horizon: cultural, 35, 136–37, fig. 38, 177, 193; style, 194, 227n36
Huamachuco (Peru), fig. 20
Huitzilopochtli, 47
human-heart sacrifice, 52
Humboldt, Alexander von, explorer, 9, 97–100, 131
Husserl, Edmund, 175

Iberoamerikanisches Institut, Berlin, 155
idealist racism, 108
idolatry extirpated, 65
Iglesia, Ramón, 47
Indianists, 6, 49–65
Indian manufacturers, 49
Indians, Jewish origin, 101
indifference (disinteredness), 205n46
indigenista movement, 190
Instituto de Investigaciones Estéticas, 101
International Congress of Americanists, 162–63
international medieval style, 232n138
Iturbide, emperor of Mexico, 164
Ixtlilxóchitl, Fernando de Alva, 3, 81–83; lost manuscripts, 217nn187, 189, 192
Izamal, 56

Jackson, W. H., 122
jaguar vessel, colossal stone, 181, fig. 45
Janson, H. W., 138
Juan de la Cruz, 54
Jung, C. G., 163

Kant, Immanuel, xvi, 7
katchina, 140
Kaufmann, Theodor, 122
Kaulbach, Wilhelm von, 122

Index

Index

Index